Modern Post

Workflows and Techniques for Digital Filmmakers

Modern Post
Workflows and Techniques for Digital Filmmakers

Scott Arundale and Tashi Trieu

Focal Press
Taylor & Francis Group

NEW YORK AND LONDON

First published 2015
by Focal Press
70 Blanchard Road, Suite 402, Burlington, MA 01803

and by Focal Press
2 Park Square, Milton Park, Abingdon, Oxon OX14 4RN

Focal Press is an imprint of the Taylor & Francis Group, an informa business

Library of Congress Cataloging in Publication Data

Arundale, Scott.
 Post modern : post-production workflows and techniques for digital filmmakers / Scott Arundale and Tashi Trieu ; foreword by Alan Baumgarten, A.S.C.
 pages cm
 1. Digital cinematography. 2. Motion pictures—Editing—Data processing. I. Trieu, Tashi. II. Title.
 TR860.A88 2014
 777'.8—dc23
 2014009894

ISBN: 978-0-415-74702-8 (pbk)
ISBN: 978-1-315-79727-4 (ebk)

Typeset in Times
By Apex CoVantage, LLC

To my wife, Jennifer: your humor, patience and inspiration make the journey all the more wonderful. And to my children, Isabella and Madeleine: may your boundless curiosity take you to places never imagined. SA

To my parents, family, friends, and mentors who have always supported me in my endeavors. TT

Contents

Part 3 Best Practices for Production

Part 4 Editing and Post-Production

Part 5 Visual Effects and Titles

Part 6 Sound Design and Final Mastering

Part 7 Restoration and Archiving

Part 8 Budgeting and Scheduling for Post

Part 9 Case Studies

Figures

Foreword

My first film, on Super 8 millimeter, was made when I was in high school, and little could I imagine where it would lead. I feel very fortunate that my career as a film editor, working on feature films, television shows and documentaries, is now going on more than 30 years.

When my good friend and colleague Scott Arundale approached me about writing a foreword for this book, it seemed only fitting – Scott and I have known each other since our days together in film school at New York University. We embraced every aspect of filmmaking, working various jobs on our student films, but it was picture editing that would end up being our shared passion. It led us to continue learning and working together for years to come. Scott once offered to let me take over his job as an assistant editor at a cutting room in London. He carefully wrote out detailed instructions about what my job duties would be while on his plane ride home. I would never have managed to keep that job without those notes.

Here, Scott and his co-author, Tashi Trieu, have written a book that is both timely and cogent: a guided journey through the modern post-production landscape. It examines the state of the industry as it exists today and explores all of the best practices and innovative techniques employed in finishing a film project.

I am often thankful that my career matured during a time that straddled both the physical aspects of working on 35 millimeter film and the transition to digital post-production. Scott and I started in the editing room handling film – working with splicers, synchronizers, rewinds, trim bins and other such equipment. The art and craft of filmmaking comes from a strong discipline where cameras were loaded with "mags" and eventually the film would end up on ten (or so) reels of "work print," ready to unspool through a projector. Modern editing rooms no longer employ the same techniques, yet this book devotes a chapter that celebrates those traditions. It takes note of the reasons why we do things today, reasons that are drawn from these earlier technologies.

Good storytelling will always be the ultimate goal, yet the tools now are different and they bring with them a new language. Enter this book, which lifts the veil on digital post-production, starting with camera selection and then mapping out a sensible post workflow. It takes us down the road, or pipeline, of sound, color, visual effects and, ultimately, on to the big screen for previews and final release. Producers, directors, post supervisors, as well as my editing colleagues will find valuable information waiting for them here. I wish we had been given access to such a roadmap when we were in film school. Young filmmakers should take this book with them on the adventure, as they plan their next project.

Alan Baumgarten, A.C.E.
February 3, 2014
Los Angeles, California

Preface

This book is the result of having taught editing and post-production for many years and discovering that there is a deficit of books on the subject from both an historical and forward-thinking point of view. While the internet offers many bits and pieces about new technology alongside the history of film, we felt that a compendium devoted to the *big picture* would be helpful to both the young filmmaker and the old pro, that they might form a better mental image of the post-production process.

Successful filmmaking combines the best of both art and science. Therefore, we deem it essential that filmmakers devote a considerable amount of time learning to master the technical aspects of their craft so that they can use these skills to become better storytellers. But while we have no intention of training a new generation of "button pushers," we acknowledge that there is a tradition to the art of filmmaking that goes back many generations. With the proliferation of cameras, expanding number of workflows and a quickly evolving world of post-production, there is a method to this madness, even in the digital world. And from the last 100 years, we may look to our predecessors to draw from, learn and embrace what are some of the best practices for creating and finishing filmed entertainment going forward.

Scott Arundale

Filmmaking is an art form that is in a constant state of renaissance. It's a marvelous combination of art and engineering that is amazing and intricate. There's always more to learn and never just one right way to achieve an artistic goal. Technology has been at the core of filmmaking since its inception, but it has historically been cost prohibitive for would-be filmmakers. The world itself, and the film industry, in particular, have undergone immense change over the past decade. Fifty years ago it would have cost millions of dollars to store just a gigabyte of data. Now almost everyone is carrying more storage capacity in the phone in his pocket than a super computer contained 20 years ago. Technical innovation and market demand have brought about a transition from expensive hardware to affordable (and sometimes free) software running on personal computers.

I was only six or seven years old when I started dabbling in Autodesk's 3D Studio for DOS. By the time I was twelve I was compositing in Flame. Almost no one in my generation had such early access to these technologies, and yet in the last five years the playing field has been leveled significantly. Computers are cheaper and software prices are a fraction of what they were in the 1990s. Today it is easier than ever for students and self-taught professionals to acquaint themselves with high-level applications and techniques. The only thing standing between them and professional success is the determination to become an expert in their craft.

This book has been written from the perspectives of industry professionals blessed with healthy budgets and an eye toward workflow and methodology. However, the goal is to convey tried and true practices of the industry in ways that can be applied to films of even modest budgets. The book aims to serve as a resource for the changing landscape of post-production. While best practices will continue to evolve, we've done our best to document the transition from film to digital, and the requisite changes in workflow. It's a tumultuous, wonderful time to be a filmmaker, and we're excited to experience it right along with you.

Tashi Trieu

Who Is This Book For?

This book is intended for film professionals, educators, and students alike. While it is not meant to be a "how to" guide for the DIY filmmaker, it documents the best industry practices currently in place, the very latest technologies, and sheds light on emerging trends in digital filmmaking. Our goal is to demystify many of the underlying concepts and philosophies behind those topics so that the reader can apply them to future innovations, as the industry is in a constant state of flux and technologies change daily.

What has been standard operating procedure in the past may not be the best way to do things in the current environment. While we have made every effort to stay up to date, more than likely some of the technologies referenced here will have become obsolete upon publication. To that end we do not endorse any particular manufacturer or vendor, and hope to keep the conversation focused on overarching workflows rather than specific products. More often than not a producer, director or even a working film editor may have questions that need answering. This book is the first desk reference that they should reach for. Our goal is to discuss current technologies and practices, but, more importantly, provide context and insight into the concepts behind them, their place in the industry, and how to adapt as filmmaking inevitably evolves. Within academia, the benefit offered here is an encapsulated history of the filmmaking process as well as an overview of digital filmmaking workflows, allowing today's students to tell their stories more effectively.

How to Read This Book

The film business uses countless abbreviations, shorthand, acronyms and jargon. It is assumed that the reader knows what the initials stand for; but should a phrase or shorthand name be unclear, a Glossary is available at the back of the book that takes the time to explain terms in more detail. Words in **bold** are featured there. Sidebars are used to explain certain key concepts or to serve as historical footnotes. They may also contain helpful tips or tricks for filmmakers.

There are also additional technical definitions that can be explored through the Glossary and data tables located at the back of the book, providing more granular discussions than those available in each chapter. While we celebrate gender diversity in the film industry, for the sake of expediency we have chosen to use only male pronouns.

See www.focalpress.com/cw/arundale for videos of techniques discussed in the book, as well as timely technological updates.

Acknowledgements

The authors would like to thank Erik Hustad, editor, and Jeremy Marrow, editorial assistant, as well as the following individuals for their support and contributions to this book:

Justin Lutsky, A. J. Ullman, Brian Gaffney, Dan Leonard, Mike Kowalski, Barbara Doyle, Jeff Olm, Bryan Singer, Greg Cotten, Vince Cerundolo, Wyndham Hannaway, Norm Hollyn, Paul Seydor, Chris Kutcka, Dan Lion, Oliver Peters, Russell Schwartz, Maura Kelly, Michael Wickstrom, Jennifer Bell, Jenni McCormick, Alex Oppenheimer, Mike Jacks, Esther Sokolow, Alan Baumgarten, Lori Jane Coleman, Steve Lovejoy, Lynn Abroms, Terra Abroms, Todd Ulman, John McCabe, Adam Wolfe, Ross Mathy, Pia Romans, John Vasey, Jim Mathers, Tod Withey, Ben Russell, Emily Koonse, Samuel Prince, Jim Smith, Kareem Marashi, James Brandenburg, Bill Kroyer, Adam Rote, Harry Cheney, Bill Dill, Roy Finch, Johnny Jensen, Jurg Walther, Tom Burton, Holly Schiffer-Zucker, Lauren Zuckerman, Thomas Calderon, Joe Fineman, Ben Benedetti, Richard Tucci, Helmut Kobler, Matt Feury, Wim Van den Broeck, Louis Diggs, Tim Landry, Robbie Carman, Nathan Grout, Shayna Cohen, Molly McKellar, Antonio Baca, Bryan Smaller, Susie Landau, Jona Frank, Chris Kursel, Richard Ragon, John August, Bill Nale, Dennis Alaniz, Jamie Reiff, Robert Shulevitz, Charles Myers, Farley Ziegler, Patrick Sheffield, Nancy St. John, Laura Jones, John David Currey, Dylan Highsmith, Nate Orloff, Robyn Buchanan, Daniel Iglesias, Jan-Christopher Horak, Andrea Kalas, Walt Rose, Herb Dow, Alex Fortunato, Thom Calderon, Josh Pines, Harry Miller III, Mick Hurbis-Cherrier, and Bob Schneider.

Retrospective on Traditional Filmmaking

Retrospective on Traditional Filmmaking

Filmmaking as a tradition spans over 100 years and has a language and a discipline that is specific to its craft. Students of film should be encouraged to study and learn the origins of this medium much in the same way that religious scholars will read the ancient manuscripts and pore over the writings of their predecessors. We must acknowledge the past in order to gain a greater understanding of where we are headed in the future. By examining the methodologies of traditional filmmaking, we gain a greater appreciation for the reasons why we do things today.

Even as we cross the threshold into an all-digital landscape, young filmmakers will some day marvel at the concept known as "celluloid," with all its moving parts and its chemistry. In the not-too-distant future, film will be considered "hip" and "cool" again. If they ever wish to experience the magic first hand, then before embarking on such a journey, they may elect to revisit the past.

1.1.1 HISTORICAL APPROACH IN SHOOTING AND PROJECTING FILM

For over 100 years the film industry relied on the tried and trusted method of exposing film negative to light in order to capture and store an image. Black-and-white or color pictures can be recorded on a variety of film stock using different emulsions. The most common gauges used in professional productions are 16mm and 35mm, running through the camera at a frame rate of either 24 fps (American) or 25 fps (European). Motion pictures are achieved through a succession of still images. When projected very quickly, they appear as a moving image, and our eyes can no longer distinguish individual frames. The illusion of continuous motion is known as **persistence of vision**.

The film negative is wound onto a reel, housed in a lightproof magazine and advanced behind the lens through a gate by means of sprockets that grab the film perforations. Each frame is exposed by use of a shutter that opens and closes in a precise timing pattern, allowing light to strike the **emulsion**. After a frame is exposed, it is advanced into the take-up side of the magazine until it is later removed and "downloaded" from the mag. The image is captured on this high-quality picture negative, but must first be developed at a laboratory before it can be seen. Before film can be viewed or projected, a positive print copy (generally a **contact print**) must be made from the negative.

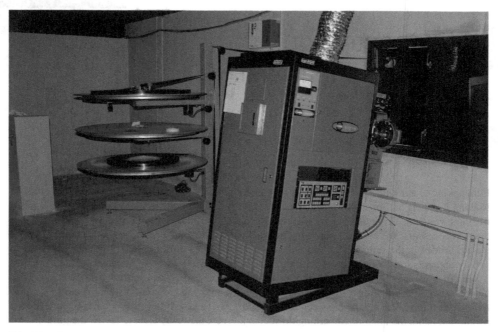

FIGURE 1.1

A film projector uses the same technique of transport and shutter as the camera but instead employs a Xenon lamp to beam bright light through the film print and into a lens which focuses and projects the image onto a screen

1.1.2 DEVELOPING AND PROCESSING AT THE LAB

After shooting ends each day, the exposed negative is downloaded from the camera magazines, carefully placed in cans and shipped along with camera reports to the lab for processing. Camera rolls are logged along with any special instructions for development, which consists of a series of chemical baths that are expertly regulated and controlled by laboratory technicians. Labs develop negative overnight and this may take three to six hours depending on their workload. There is usually a cut-off point where no further work is accepted for that shift.

BREAKING OFF

For productions that are in remote locations and require air transport to the lab, it is sometimes necessary for productions to "break off" during the middle of a shooting day in order for the exposed film to make a flight. Likewise, shows that start late in the day or plan on shooting through the night may elect to do the same. This allows for at least partial processing, and thus avoids delay in getting footage to the editor.

Once the film is processed, it is handed over to the negative assembly technicians where the sequential camera rolls are consolidated into lab rolls (up to 1000 feet for 35mm and up to 1200 feet for 16mm). This is done to streamline the efficiency of dailies review and **telecine** by eliminating excessive reel changes. Multiple camera rolls are spliced together to form longer lab rolls; however, the camera roll information is still vital to the editing process and is maintained through camera reports and reflected in the slate at the beginning of each take. The head of each roll is hole-punched in preparation for telecine. Blank plastic leader is added to the head and tail of each roll so that it can be threaded onto a telecine. The negative is cleaned in an ultrasonic cleaner, removing dust, hair and other debris that may have collected on it after development. The negative is then placed in a plastic bag and box.

At this point a **work print** may be struck from the original negative. Film "dailies" are made using positive film stock and require additional development. Before printing, a lab technician will measure the **densities** of the negative and create a report containing the "**timing lights.**" This set of values is obtained by viewing the color charts and gray scales shot on-set to balance both color and brightness to create an acceptable "look" for the work print. **Printer light** numbers are also used by directors of photography (DPs) to check that they are maintaining consistent exposure throughout the production.

If time permits at the start or end of each shooting day, dailies are screened at the lab or studio or even on location with a portable projector. Watching a physical print of the film allows the key creatives the opportunity to check focus, exposure, hair, makeup and lighting questions as well as performance issues. Watching dailies in a theater during the first few days (or weeks) of production is particularly helpful in catching and solving any problems.

A set of documents are collected by the assistant editor that reflects the previous day's work to include the lab reports showing the timing lights, sound and camera reports, and script continuity notes and logs. Additional comments made by the director can be added and duly noted during the dailies or at any time during the shoot schedule.

1.1.3 EDITING USING A FILM WORK PRINT

Work print dailies (or rushes) are delivered early in the morning from the lab to the cutting room where the assistant editor or apprentice will mark and identify the slates (clapboards) for each shot. The same is done for audio dailies, which are transferred to the same gauge of film (typically 35mm single stripe magnetic sound). With both picture and sound clearly labeled, the assistant spends the first part of each morning syncing the takes. This is done on a bench equipped with rewinds, sending picture and sound through a synchronizer and listening to the track with a "**squawk box**" (audio amplifier) to a pair of headphones. Depending on the amount of footage, this may take a few hours. Once the reels are matched perfectly they can be viewed in a theater or **flatbed** and editing can commence.

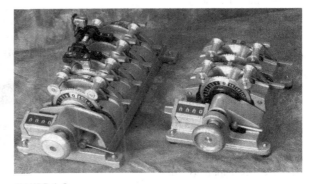

FIGURE 1.2

Two and four gang synchronizers

Flatbed editing tables allow the editor to view the reels, often stopping and starting, and have the ability to rewind or advance at high speed. Some systems carry an extra set of plates to accommodate a second picture or soundtrack. This method of "linear" editing requires winding through material to get to a specific point. When footage is taken out of the dailies' reels and placed in a "cut" as part of an assembled sequence, slug or filler is placed in the sound or picture reels to maintain synchronization.

As shots are trimmed or removed from the cut, they may end up being placed in bins. The bins contain several rows of pins upon which material may be hung and laid into a large soft canvas bag. This allows for quick retrieval should an editor require replacing or adding to a shot. Ultimately, footage is either returned to the daily roll or included as part of the cut. Waste film may be discarded and it is not unusual for unwanted footage to end up on the "cutting room floor."

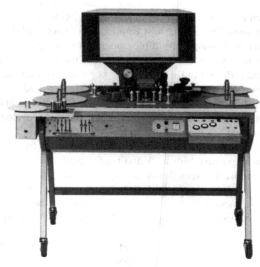

FIGURE 1.3

KEM Flatbed Editing Table

The work print may experience significant wear and tear as it is run through synchronizers and flatbeds, not to mention a projector. Each splice (or join) is achieved using an editing block (rivas butt splicer) consisting of a large blade, pins to hold the film and a tape dispenser. As splices are done and undone, film and sound elements may suffer damage or break. Reprints from the original negative or sound master can be ordered, but this may take up to a day.

Previews take place in the cutting room or theater. An additional track containing music and/or sound effects may accompany the reels. A feature film consists of ten or more reels each of picture and sound. A reel measures up to 1,000 feet in length constitutes about ten minutes of film time. The advantage to previewing on a flatbed is the ability to run back and forth, sometimes referred to as "**rock & roll**," a practice first developed by early sound mixers.[1] While it is convenient to play a film on a flatbed, it cannot replicate the experience of watching on a big screen. Previewing in a theater offers the filmmaker the best recreation of the audience experience in terms of sound and picture.

FIGURE 1.4

Rivas Butt Splicer

1.1.4 NEGATIVE ASSEMBLY AT THE LAB

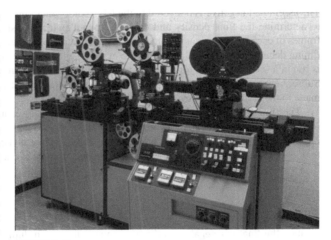

FIGURE 1.5

Oxberry Rostrum Camera (optical printer)

The process of original camera negative (OCN) being held pristine while the editing is accomplished with a work print is a precursor to the offline/online process in that **edgecode** frame numbers were the precursor to **timecode**, and **EDL**s (edit decision list) were used to ensure frame accurate **matchback**. Once the picture has been assembled and there are no further changes, the picture is "locked." The assistant will turn over the reels to a negative cutter, usually located at or near the lab where the negative is stored. The key numbers (or **keykode™**) are recorded by hand from each shot of the work print and the corresponding piece of negative is then placed in the same order to create a matching reel. This is referred to as "**conforming**" the negative. Both the print and negative are placed side-by-side in a synchronizer (see Figure 1.2) and carefully measured on a bench (with extra-special care given to the camera original) to ensure complete accuracy.

Shots involving transitions such as wipes, dissolve or visual effects may require that a duplicate negative be made. They are next sent to an optical effects house where the new negative is placed on an optical printer and shots are re-photographed in order to perform transitions such as wipes and dissolves, visual effects, and composites and titles.

While the work print is held together by clear tape at each splice, the negative must be "hot-spliced" using glue. This often destroys the adjacent frame at each end of the cut. Once the negative has been cut, it is very difficult if not impossible to reassemble. After the negative assembly is completed there are usually gaps where a visual effect or transition occurs. These are the last elements to be added along with titles and end credits.

> **WHY DO WE STILL WORK IN "REELS" TODAY?**
>
> 35mm reels of film have a capacity of either 1,000 or 2,000 feet. While editors find it more practical to work with "thousand footers," projectionists and labs prefer 2,000 foot loads since they don't have to change the reels as often. Today, we don't have the physical limitations that film does and though it may seem like a good idea to work on a single file containing a 2 hour movie, it may not be practical. Breaking the film into five or six reels of 20 minutes each is an efficient way of dividing and sharing in the labor. Different editors and departments can work on separate reels at the same time with revisions performed on a single reel and not the entire film.

1.1.5 COLOR TIMING USING PRINTER LIGHTS

The assembled negative is delivered to the lab's color timer who measures each scene, shot for shot, to determine the final density and color. A **"proof print"** consisting of a set of two or three still frames of each scene is created, which allows the cinematographer an opportunity to review the initial timing decisions. Further adjustments are made, resulting in the "first trial" **answer print**. The film is run in a screening room for the cinematographer and director to provide further notes to the timer. Subsequent answer prints (or sections, if need be) are struck of each reel as color adjustments are made to the satisfaction of everyone involved.

The **timing printer lights** consist of 50 points for three separate values of red, green and blue (or in the case of the negative: cyan, magenta and yellow dyes). They are combined in an **additive color** process to create an image. While timing lights cannot make up for poor lighting or exposure, they can balance the colors in a way that enhances the picture and creates a mood appropriate to the story.

> Since the final cut negative is the only copy, a fine grain duplicate negative is made as a "safety" copy. The original camera negative is subject to wear and tear each time it is copied and therefore should be handled with the utmost care. In preparation for release printing, the steps of making an Inter-positive (**IP**) and then Inter-negative (**IN**) using special stock allows for multiple "dupe negatives" to be created. Then a large release print order can be made without having to source the original negative. There is one disadvantage to the IP/IN method, as each subsequent copy suffers **"generational loss"** resulting in a slight degradation of the image.

1.1.6 RELEASE PRINTS

By the time the final answer print is created, the optical sound track is "married" to the picture. In addition to the analog optical track, there are multiple proprietary formats that can be included on the print, including Sony **SDDS**, Dolby Digital and **DTS**.

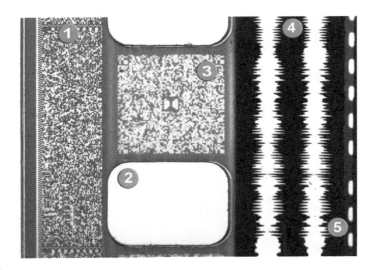

FIGURE 1.6

Numerous optical/digital audio formats are carried on a strip of 35mm film. The outermost strip (1) contains the SDDS track as an image of a digital signal. Next to that are the perforations (holes) (") used to pull the film through the projector. The Dolby Digital track is contained in the grey area (3) featuring the Dolby Double-D log. To the right of that are two channels of analog sound (optical track), where amplitude is represented by a waveform. These are generally encoded using Dolby Stereo (Lt, Rt) representing four channels of audio. Finally, to the very far right, there is a slim set of oval dots containing timecode used to synchronise the film with a DTS soundtrack via a separate CD-ROM.

For a studio release that may require prints numbering in the thousands, multiple Inter-positive (IP) and Inter-negative (IN) elements are created to ensure the safety of the original negative. Film labs create the final reels by **contact printing** from the new duplicate negative. Due to variances of print stock and timing lights, it is essential to create a **check print** to review with lab timers and make necessary adjustments to the Inter-negative in order to more closely match the original negative.

For video duplication, a low contrast (**lo-con**) answer print is created from the timed negative. This contains all of the color decisions made in the answer print process and is printed on low contrast stock which is optimized for the telecine process.

Evolution of Video Editing

During the 1960s, videotape splicing was explored as a method of rearranging and composing shots. TV shows such as *Rowan & Martin's Laugh-In* (1968–1973) utilized hundreds of physical cuts to the master tape but was prone to technical glitches.[2] As editing of videotape proved to be both expensive and largely impractical, there was a push by the big three broadcasters (ABC, NBC and CBS) to find new ways to assemble shows electronically. Engineers began to look at alternative media formats such as magnetic disk platters to serve up video.[3] The concept of "random access" and nonlinear editing was just beginning.

In 1970, CBS and Memorex teamed up to form a new company known as CMX that developed an innovative approach to video editing. Advances in videodisc technology allowed for up to 5 minutes of low-resolution video to be stored on a single platter. With an array of these platters, the CMX 600 system could call up 30 minutes of black-and-white content and perform edits. From the final assembled version, an edit decision list (EDL) was generated and used to create the finished program by sourcing the master reels using a companion tape-to-tape system known as the CMX 200.[4] With a staggering price tag of US$500,000, the CMX 600 system was never widely adopted.[5] However, it became the proto-type for nonlinear editing systems that were yet to be invented. In the decades that followed, CMX would become an industry leader as it chose instead to develop *linear tape-to-tape* editing systems based on early prototypes.

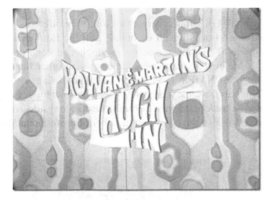

FIGURE 1.7

Rowan and Martin's Laugh-In launched in 1968 as a zany comedy/variety show featuring many fast cuts and jump cuts, yet it was shot on videotape and assembled afterwards

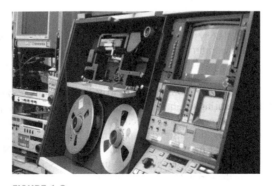

FIGURE 1.8

2 inch Quad tape recorder

1.2.1 EARLY OFFLINE NONLINEAR EDITING SYSTEMS

Non-linear editing is the ability to call up any shot or sequence and play it back in any order. It is sometimes referred to as "random access" as it is not constrained by a linear film or tape format and is considered a faster and more nimble approach to assembling a program. From the advent of the CMX 600 in 1970, considered the first nonlinear system, it would take another 20 years before computers were capable of playing back full frame video streams.

In the early 1980s, following the triumphal releases of his *Star Wars* trilogy, director George Lucas and his engineers began development on what became known as the EditDroid. It featured a Unix computer controlling an array of video laserdiscs using a controller called the "Touchpad."[6] While only 17 EditDroids were ever built, they offered a tantalizing glimpse into the future of non-linear editing.[7] Lucas would eventually sell the EditDroid to J & R Film Company (owner of the famed Moviola) and transfer the underlying technologies to Avid Corporation in 1993.[8]

Meanwhile, engineers came up with other linear approaches to help solve the nonlinear challenge. At **NAB** in 1984, a tape-based nonlinear system known as the Montage was presented. (Note: This was the same year that Apple came out with its first personal computer known as the Macintosh.) It used a bank of 0.5 inch **Betamax** decks alongside a controller. Seventeen consumer-grade decks were chosen since the equivalent number of professional decks was deemed cost prohibitive.[9]

FIGURE 1.9–1.10

Ediflex system (circa 1985) at CFI in Hollywood featured a light pen (at bottom) which allowed timecode tagging

The next year (1985) saw the arrival of the Ediflex system, offering eight JVC VHS consumer decks and featuring a light pen to control the screen. The company did not sell the systems but instead rented them to the studios, specifically for cutting episodic television. At its peak, Ediflex was cutting 80 percent of the dramas and 30 percent of comedies for network television.[10] Its creators were awarded a Technical Emmy for "Design and Implementation of Non-Linear Editing for Filmed Programs."[11] The Ediflex had a prescient new feature called "Script Mimic" that assigned a number to every line of dialog in the script. Using the light pen, the assistant editor was able to tag each take with a corresponding timecode. This allowed the editor the ability to preview multiple takes of the same line back-to-back. This remained an enduring concept since the patent was later sold to Avid and branded as "Script Sync," which offers instant access of shots by calling up a specific line of dialogue or action.

During this time, CMX (then known as CMX/Orrox) came to dominate online post-production with their tape-to-tape mastering solutions. In 1985, the company decided to revisit non-linear with a disc-based system known as the CMX 6000. Like its predecessor, the 6000 relied on a costly array of laser-discs, but now the editor could play the sequence forward or backward (rock & roll), which the Ediflex and Montage systems could not do. The CMX 6000 was presented at the 1986 SMPTE show and was able to present a "virtual master" in that it faithfully played back the edited sequence without using videotape.[12]

The latter half of the 1980s saw the arrival of two more systems: TouchVision (1986) featured a bank of up to 12 VHS decks with improved touchscreen controls, and E-PIX (1988), which employed lower-cost laserdisc systems that were recordable.[13]

While a handful of feature film projects in the 1980s (*Sweet Liberty, Full Metal Jacket, Power, Making Mr. Right*) used systems such as the Montage, there still remained one significant obstacle to wider adoption by the major studios: the ability of offline editing systems to accurately measure and display video timecode and establish a relationship with the negative key numbers.[14]

Amtel's E-PIX (1988) offered a timeline display with emphasis on timecode functionality and frame accuracy (again using recordable laserdiscs); but it was not until the next generation of non-linear systems that the precise correlation of the two sets of numbers became standard.[15] This would allow the original camera footage to be accurately tracked and conformed during post and generate both an EDL (for tape assembly) and a negative cut list (for negative assembly).

Another important development for modern nonlinear systems was the advances made in personal computers. As Apple and IBM became more prominent in the home and office, the cost to own and operate these platforms dropped. Developers began looking for solutions that could be bought "off the shelf" and configured to play back sound and picture using proprietary software.[16] Affordable PCs allowed for the transition from hardware-based to software-based solutions. As the cost vs. performance ratio of magneto-optical disks and hard drives continued to improve, the notion of desktop computers being able to satisfy professional film editors came closer to reality.

Editing Machine Corporation's EMC2 (1989) is regarded as the first digital offline nonlinear system as it relied on removable, recordable drives on a PC platform and featured a timeline with source and record monitors (stills only) in the display.[17] Priced at under US$30,000, EMC2 was considered a major breakthrough in desktop editing.[18]

At NAB that year, Avid Technology presented their prototype editing system, the Avid/1 Media Composer, on an Apple Macintosh which offered 30 frames per second playback with just one audio channel.[19] The software application was considered both elegant and intuitive. While the EMC platform sold for less than half the cost, Avid was able to leverage the already strong user-base the Apple platform enjoyed among graphic artists and thus command a higher price (US$60,000).[20] Both systems had done away with fancy controllers and now simply relied on a mouse and keyboard to operate the system.

FIGURE 1.11

Lightworks Shark

FIGURE 1.12

Lightworks "flatbed-style" controller

In 1991, a British group of engineers (O.L.E.) developed their own PC-based system that would rival Avid for a time, known as Lightworks. It featured a tactile control surface that mimicked the movements of flatbed editing machine and thus made veteran film editors more comfortable using it.[21] The race was on for the hearts and minds of Hollywood editors, with Avid being the preferred platform for episodic television while more feature film editors began using Lightworks.

While it would take another ten years for nonlinear to replace work print editing, two upstart editing programs entered the marketplace that offered powerful yet affordable toolsets for cutting picture and sound. The first was Adobe Premiere (1991), developed alongside a suite of popular graphic design programs such as Photoshop and Illustrator. Priced at under US$1000, this software application quickly became popular as a teaching tool in university computer labs. Although, at the time, it was not well suited to large-scale, long-form projects, Premiere was considered easy to use and affordable and introduced desktop editing to a whole new generation of filmmakers.

Premiere laid the groundwork for the next generation of NLEs when, in 1998, their developers left Adobe and, in partnership with rival software company Macromedia, began work on a new editing program. Originally intended for both the Mac and PC platforms, Apple purchased the software and made it exclusive to the Mac.[22] Final Cut Pro was released in 1999, and like Premiere, it took advantage of the flexibility and ease of use of Apple's QuickTime architecture. The software was later optimized for use with **FireWire** (**IEEE-1394**) and allowed for capture and playback of quality digital video (DV) using consumer cameras and decks.

For the next ten years, Final Cut Pro continued to grow in popularity and became Avid's biggest competitor in the commercial/professional arena, based on the growing number of improvements and features offered at a much lower price point. And while it has not overtaken its rival in terms of industry adoption, Apple's Final Cut Pro remains one of the leaders of innovation and advancement in digital editing technology.

Today, the three major editing software developers, Adobe, Apple and Avid, enjoy the bulk of market share in the consumer and professional worlds while Lightworks continues as an "open source" program with limited adoption.[23] The move away from large expensive computer platforms to off-the-shelf consumer devices means that today editing can even be done on a phone or tablet, a concept that only 20 years ago seemed out of reach.

1.2.2 TAPE-TO-TAPE ONLINES

After picture was locked from an offline session, an EDL was sent to the "online" edit bay along with a list of master reels necessary to do the final conform. The online editing system consisted of two videotape machines used for playback and a third **VTR** dedicated to record the final assembly. Two decks were necessary to play two separate video streams that allowed the online editor to cue dissolves or other real-time effects or transitions. Additional hardware such as a Digital Video Effects generator (**DVE**), Effects Switcher, Title Generator (**Chyron**) and audio processing gear were typically part of this package. The sweetened audio could be laid back and matched to picture at this time. The online system would often take up several racks of machine room space and require special air conditioning with a tape operator (machine room assistant) to be on hand to cue up tapes.

Long after CMX went out of business in 1989, the EDL that it founded remains an industry standard. The EDL was originally written and stored on a 1 inch perforated paper tape before it migrated to floppy disk.[24] Today, the digital equivalent is a simple ASCI text file that conveys all of the editing events, including effects and transitions, from one editing system to another, with

clip name information, reel IDs, and source/record timecode information. Different formats of EDLs were developed over time by different manufacturers, such as Sony and Grass Valley. While the EDL is limited in complexity with regards to layered effects and number of video channels, it remains an essential tool in the editor's arsenal. See Figures 10.3 and 10.4.

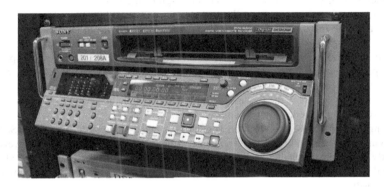

FIGURE 1.13

Digi-beta tape deck

In 1993, Sony unveiled its Digital Betacam format (sometimes referred to as **Digi-Beta** or DBC for short) which became the workhorse for mastering and archival of standard definition video and was the most widely adopted tape system in the world. It was the successor to the analog **Beta SP** format which enjoyed a successful run in the industrial and news broadcast arena for nearly 20 years.

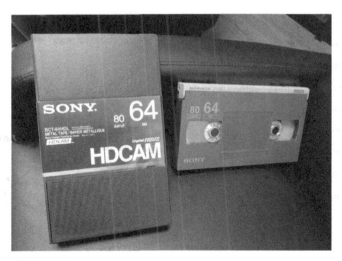

FIGURE 1.14

HDCAM SR succeeded Digi-Beta as the delivery format of choice when broadcasters moved to HD

1.2.3 DIGITAL ONLINE EDITING

As the performance of modern computers improved, they soon were able to capture and play-back high-quality video. The advent of computers featuring increased memory (RAM), larger storage, faster drives, and improved data bandwidth meant an entire show could be stored and played back digitally. Because of the relatively high cost and need for a larger networked storage infrastructure, these systems still resided at major post facilities during the 1990s. Projects still had to be *ingested from* tape and conformed and *output to* tape during the online process.

As a cost-cutting alternative to traditional online editing, Laser-Pacific, a Los Angeles post facil-ity, built a proprietary system in the late 1990s known as the "Super Computer Assembly System." Typically, tape-to-tape online sessions were supervised by the editor and scheduled during daylight hours. Instead, using this method, the footage was ingested overnight and stored on a massive **RAID** array to be played out the next day after assembly.

Also, during the late 1990s, post facilities began to use stand-alone systems, such as Softimage DS or Avid Symphony, to assemble shows in a manner similar to the Super Computer. However, they were frequently faced with the challenge of being able to provide enough storage. Editors had to care-fully monitor drive usage since the amount of storage on these systems was usually a finite number and relatively costly.

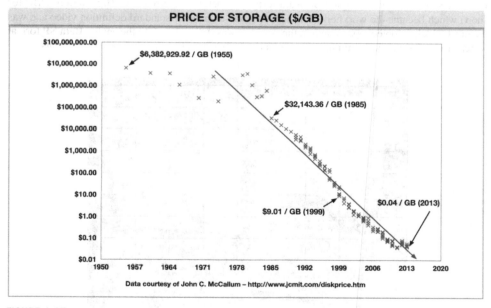

FIGURE 1.15

Price of storage, 1950–2013

1.2.4 TRANSITION FROM NTSC TO HDTV

FIGURE 1.16

NBC Peacock circa 1960s, with the backing of parent company RCA; NBC was the first network to offer regular color broadcasts

The catch-phrase "High Definition" has been around since the early days of broadcast television, starting in the 1930s.[25] Based on consumer demand and driven by manufacturers, engineers have continued to improve transmission, compression, and display technologies. North America was the first region to roll out over-the-air analog broadcast signals beginning in the 1940s using the standard known as **NTSC**. It was modified in 1953 to allow black-and-white TV sets to be able to receive a color signal.[26] NBC (fueled with technology owned by its parent company, RCA) was the first major network to begin color broadcasting a year later.[27] It still took nearly a decade for the other broadcasters to follow suit, with ABC presenting its first series in color in 1962. CBS didn't begin to offer regular color programming until 1965.[28] In Europe, **PAL** and **SECAM** standards were introduced much later (1967) than NTSC, resulting in significant improvements in the quality of the image.[29]

Standard Definition television remained popular with consumers for the greater part of the last century. The demand for TVs and consumer electronics saw the rise of Japanese companies such as Sony and Panasonic, who were also key players in the manufacturing of production gear such as cameras and recorders. With the introduction of digital, it became evident that broadcast and display technologies would need to replace standard def with a more robust system and be able to present filmed entertainment in true high definition.[30] In 1989, Japanese state television (NHK) began building and testing their own version of HDTV.[31] However, it was not adopted by any other nation. Studies had been under way since the 1970s to consider the feasibility of creating a worldwide standard for the next generation of TV broadcast. It would take nearly 20 years for the engineering advisory committee known as International Telecommunication Union (ITU) to agree on a format that would satisfy the interests of manufacturers, broadcasters and the general public. In 1998, they came out with *Recommendation ITU-R BT.709* or, as

it was subsequently referred to, **Rec. 709**. This was the "specifications for a single worldwide standard for HDTV production and program exchange, based on an image sampling structure of 1920x1080 pixels."[32] This gave the green light to manufacturers and broadcasters once that standard was settled. However, it would take approximately another ten years to be fully implemented and adopted and was not an easy transition for networks and studios, and particularly for the post-production companies.

In North America, the migration from Standard Definition (NTSC) to High Definition (HDTV) took nearly a decade due to a number of factors, including:

- Slow adoption by advertisers, broadcasters and studios due to high cost
- Resistance among consumers to pay for HDTV cable and new television sets
- Confusion in the marketplace due to a large number of formats
- Slow nationally mandated transition to digital broadcast (2009)

The Advanced Television Systems Committee (**ATSC**) was founded in 1982 to create a set of standards for broadcast.[33] This organization would replace NTSC, the group responsible for the analog format that had been in use since pre-war days. They produced a chart outlining 36 digital TV (DTV) formats, with 12 being High Definition. The Federal Communications Commission (FCC) formally adopted this set of standards in 1996.[34] However, this move drove the cost of post-production even higher as many editing systems, tape decks and displays required additional features and hardware to accommodate all of the formats. The number of formats also did not help to reassure the consumer as to which HDTV to buy.

Upgrading post-production facilities to accommodate hi-def production meant retiring older tape decks, **VGA** monitors and **CRT** displays, and investing in newer, faster computers, additional storage solutions, and expensive digital cameras and decks. For the larger organizations with deep pockets this was less of a challenge. For the smaller companies, it sometimes meant going out of business.

A "chicken or the egg" dilemma pervaded the early days of hi-def. Consumers were slow to trade in their existing TV sets for expensive HDTV due to the lack of quality high-definition content. Content providers were slow to produce new content due to the slow adoption by consumers. It required a concerted effort by content creators and manufacturers to eventually gain widespread acceptance by the consumer. By 2013, 75 percent of households had at least one HDTV.[35]

After more than a decade (and several postponements), the **FCC** decided to pull the plug on analog TV broadcast, ceasing over-the-air transmissions in 2009. Consumers can still use their standard definition TVs with the use of a converter box.[36]

NOTES

1. Maxwell Steer, "A Brief History of Film Dubbing, Part 1," www.msteer.co.uk/analyt/jfilmdubbing1.html, accessed October 20, 2013.
2. "Rowan and Martin's Laugh-In," http://wikipedia.org/wiki/Rowan_Martin's_Laugh-In
3. Michael Rubin, *Nonlinear: A Field Guide to Digital Video and Film Editing* (Gainesville, FL: Triad Publishing Company, 2000), 44.
4. Rubin, *Nonlinear*, 46.
5. "Reflections: Eulogy," News release, http://www.smpte-ne.org/articles/eulogy.html, accessed October 21, 2013.
6. "The EditDroid, Rise and Fall – preview," Vimeo video, 6:34, posted by "Tom van Klingeren," http://vimeo.com/4398241, accessed October 21, 2013.

7. Rubin, *Nonlinear*, 58.

8. Melinda C. Levin and Fred P. Watkins, Post: *The Theory and Technique of Digital Nonlinear Motion Picture Editing* (Boston, MA: Allyn & Bacon, 2002), 21.

9. Thomas Ohanian and Michael E. Phillips, *Digital Filmmaking: The Changing Art and Craft of Making Motion Pictures* (New York, NY: Focal Press, 2000), 190.

10. Interview with Herb Dow, one of the creators of Ediflex, January 2013.

11. "Non-linear editing system," http://en.wikipedia.org/wiki/Non-linear_editing_system.

12. Rubin, *Nonlinear*, 57.

13. Ibid, 58, 59.

14. The creators of Montage – Ronald Barker and Chester Schuler – were awarded an Oscar in 1987 for Achievement in Scientific Engineering.

15. Rubin, *Nonlinear*, 332.

16. Ibid, 333.

17. "EMC2 Editing Machines Corporation," 8:45, posted by "Jeff Krebs," http://www.youtube.com/watch?v=gxpQ0vnOVNE-t=31, accessed October 22, 2013.

18. Rubin, *Nonlinear*, 60.

19. "Demo AVID1 – 1989," 9:26, posted by "Adair Comaru," http://www.youtube.com/watch?v=Bzy94vWUitE, accessed October 22, 2013.

20. Scott Kirsner, *Inventing the Movies: Hollywood's Epic Battle Between Innovation and the Status Quo, from Thomas Edison to Steve Jobs* (CreateSpace Independent Publishing Platform, 2008).

21. Rubin, *Nonlinear*, 344.

22. "Final Cut Pro," http://en.wikipedia.org/wiki/Final_Cut_Pro.

23. While Lightworks remains a niche platform, it was used by famed editor Thelma Schoonmaker to cut *Wolf of Wall Street* in 2013 in conjunction with a team of Avids.

24. "EDLs," http://www.vtoldboys.com/editingmuseum/edls.htm.

25. "High Definition Television," http://en.wikipedia.org/wiki/High-definition_television.

26. Rubin, *Nonlinear*, 117.

27. "RCA–NBC Firsts in Color Television," http://colortelevision.info/rca-nbc_firsts.html, accessed October 24, 2013.

28. "CBS," http://en.wikipedia.org/wiki/CBS.

29. "PAL," http://en.wikipedia.org/wiki/PAL.

30. Philip Cianci, *High Definition Television: The Creation, Development and Implementation of HDTV Technology* (Jefferson, NC: McFarland, 2012), 22.

31. Ibid, 87.

32. See http://www.itu.int/dms_pub/itu-r/oth/0B/06/R0B0600000A0001PDFE.pdf.

33. Rubin, *Nonlinear*, 285.

34. Cianci, *High Definition Television*, 181.

35. See http://www.leichtmanresearch.com/research/hdtv_brochure.pdf.

36. Kim Hart, "Some Markets Pull Plug on Analog TV," *Washington Post*, February 19, 2009, http://www.washingtonpost.com/wp-dyn/content/article/2009/02/18/AR2009021803131.html.

The Digital Film Frontier

New Frontiers of 21st-Century Filmmaking

At the beginning of the last century, film as a medium was beginning to "take flight," as Walter Murch so aptly observed when comparing modern editing to the advent of manned powered flight by the Wright Brothers.[1] The possibilities seemed limitless despite the fact that cameras were large and cumbersome and the technology to include a synchronized soundtrack had not yet been invented. Film as a mass-market medium became quickly and firmly established throughout the world and it was then up to the artists and engineers to continually innovate.

The foundation for this came as the pioneers, principally Edison and the Lumiere Brothers, settled on certain standards – in this case, 35mm gauge film. Later a **frame rate** for sound was agreed on (24 frames per second, or fps) which also was the sweet spot for maintaining persistence of vision. These improvements allowed movies to further engage audiences and achieve their primary goal: engrossing entertainment. The establishment of these standards ensured that a film print could be played correctly in just about any theater across the globe.

While innumerable cameras and film stocks have come and gone, it is interesting to note that those early standards, such as 24 fps frame rate, have endured.[2]

The Academy of Motion Picture Arts and Sciences (**AMPAS**), founded in 1927, is best known for handing out awards to filmmakers each year for achievement in the *arts*, yet most audiences aren't even aware of the advances in film technology that the Academy recognizes. While not household names, it is those Oscar recipients who earn a gold statue through innovation and design in the *science* of filmed entertainment.

We now stand on the cusp of the digital domain, which promises a new era of dramatic improvements to both sound and picture acquisition and presentation. The number of choices that filmmakers are faced with regarding workflow paths may seem daunting. But the good news is that many of the hard questions raised during the genesis of digital filmmaking have been answered through trial and error and the steady development of worldwide standards. With consensus necessary amongst engineers, filmmakers, and audiences, the (re)birth of this new and improved medium has taken some time to become refined and remains an ongoing process. So while we examine the future of filmmaking and acknowledge that it will continue to evolve in ways we can't even imagine, we take comfort in knowing that good storytelling will always shine through no matter what technological innovations may come along.

What is a *workflow*? Where film processing and film editing had a clearly defined set of steps which endured for years, the new paradigm presented by digital technology is to define a clear path or workflow. This folds nicely into the notion of an end-to-end solution sometimes referred to as a data "pipeline." However, with the explosion in the number of cameras, codecs, software and hardware platforms, it is abundantly clear that no two workflows are identical. Therefore, the

filmmaker/producer/supervisor must define a workflow going forward and remain flexible enough to be able to adapt and change it where necessary due to innovations and technological advances, or alternately to avoid bottlenecks should they arise. (See also Chapter 2.2, "Workflow Best Practices.")

2.1.1 DIGITAL INTERMEDIATE

The Oxford Dictionary defines Intermediate as "coming between two things in time, place, order, character, etc.: an intermediate stage of development."[3]

The concept of a Digital Intermediate (**DI**) was initially intended as a bridge between the film negative and the final print projected in a theater, with digital steps in between. It eliminated the slow and cumbersome optical lab process which lacked flexibility in color management. DI became a viable option in the early 2000s as computers became fast enough to handle the enormous amount of data generated from each scanned frame. This data was intended to replicate the rich optical resolution of a film negative.

Before the Digital Intermediate, color timing was a slow and arduous process. The director of photography (DP) and the Colorist would preview a print of the film at the lab and share notes. Color correction was limited to varying the intensity of printer lights sent through the negative onto another strip of **celluloid** film through a contact printer. In this way a color-corrected, positive image print is created so that it can be checked. This is called the answer print. A color timer could adjust a shot's brightness by affecting all three channels at once (**RGB**), but there was no way to control contrast or selectively bring detail into the highlights or shadows. The Timer would create a precise timing list of when RGB printer light values would change during the film. Then a new answer print was struck for review with the filmmakers and this process was repeated until the color timing was satisfactory.

The DI grew out of the increasing need for greater image control in post-production. Commercial TV directors had already enjoyed powerful color correction tools used in **telecine** (film-to-tape transfer) and were asking for the same control for feature films. Because of the limitations of video, Digital Intermediate instead centers on a file-based method or **data-cine** where film is scanned to digital files at resolutions higher than video: either **2K** or **4K**. These files retain all of the exposure and color information present in the camera negative through a process of **logarithmic encoding**. Working in **log space** means more information is retained during transfer from film to digital, unlike a film-to-tape transfer which is a process of **linear encoding** and also represents a compromise in terms of precision[4] (see Figure 10.5 in the Appendix).

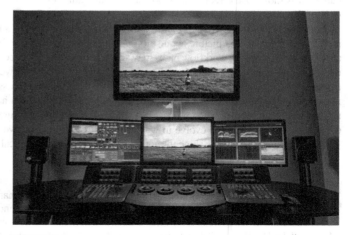

FIGURE 2.1

Color grading suite with trackball panel controls

Digital Intermediates were partially employed on sections of feature films throughout the 1990s as computer-generated (CG) visual effects became more common. This required scanning film negative at high resolutions for digital **compositing**. Some of these early projects include *Super Mario Brothers* (1993), *Jurassic Park* (1994), and *Pleasantville* (1998), to name just a few.

FIGURE 2.2

Super Mario Brothers (1993)

The first film to be entirely color graded using a DI process was *O Brother, Where Art Thou?* (2000). While previous films used the process mainly for visual effects, *O Brother* used it to achieve a specific look throughout the entire film. What began as a slow and clumsy workflow has quickly matured to be part of a streamlined method in feature film finishing. Modern all digital color grading systems are often capable of faster than real time rendering with support for **RAW** image formats from Digital Cinema cameras (see section 2.5.3, "What's RAW All About?") This provides for a flexible approach to color grading where a client can work directly with a colorist for longer periods of time at more affordable rates. Alternately, low-budget projects can use inexpensive software to color projects on their own and effectively bypass the lab or color grading facility.

FIGURE 2.3

O Brother Where Art Thou (2000)

The Digital Intermediate process has revolutionized the way in which films are finished and mastered. Previously, color correction processes were limited to printer offset lights or photochemical manipulation, which had the unwanted side effect of **generation loss**. Digital Intermediates, on the other hand, are non-destructive.[5] Modern color grading systems process images at 32-bit precision, ensuring that multiple grading passes, if handled properly, result in minimal quality loss. The new toolsets provide more image control than printer lights or photochemical manipulation ever could. Many common photochemical processes, such as **bleach-bypass** or adding sepia tones and tinting, can be recreated digitally with more subtlety and precision.

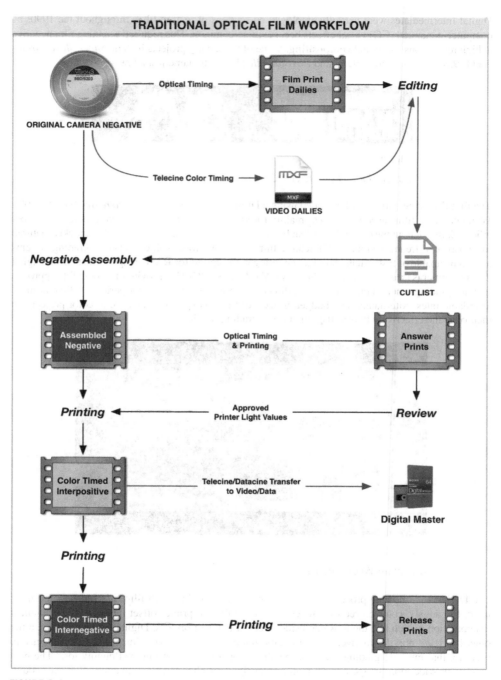

FIGURE 2.4

Traditional optical film workflow

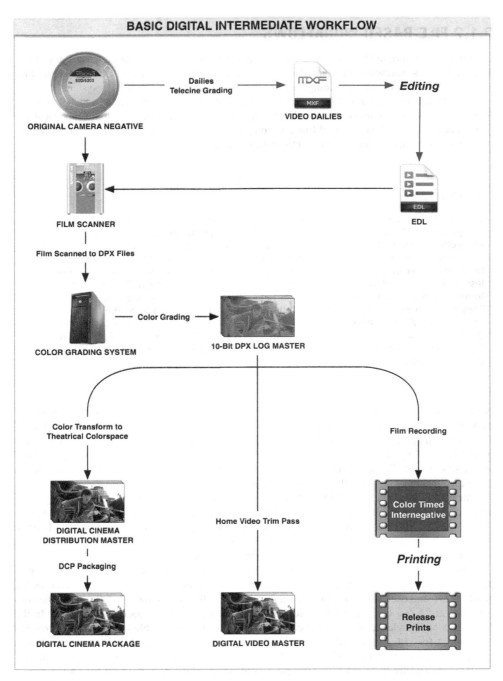

BASIC DIGITAL INTERMEDIATE WORKFLOW

ORIGINAL CAMERA NEGATIVE

Dailies
Telecine Grading

VIDEO DAILIES

Editing

FILM SCANNER

EDL

Film Scanned to DPX Files

COLOR GRADING SYSTEM

Color Grading

10-Bit DPX LOG MASTER

Color Transform to
Theatrical Colorspace

Home Video Trim Pass

Film Recording

DIGITAL CINEMA
DISTRIBUTION MASTER

DCP Packaging

Color Timed
Internegative

Printing

DIGITAL CINEMA PACKAGE

DIGITAL VIDEO MASTER

Release
Prints

FIGURE 2.5

Basic digital intermediate workflow

2.1.2 FILE-BASED WORKFLOWS

Digital video was originally recorded to linear tape. Companies such as Panasonic and Sony manufactured both the hardware (i.e., tape decks), as well as blank tape stock. For over 20 years they enjoyed a near monopoly by providing tools for finishing in a relatively closed ecosystem.

One advantage of digital video is that perfect copies or "clones" can be created which do not suffer from the generational loss experienced by its analog predecessors. However, digital tape must still be recorded and played back in **real time**, meaning that revisions to a completed sequence are time consuming and often require that a new master be created.

WHAT IS A CODEC?

The term loosely describes the method by which computers encode and decode sound and picture by the use of compression. Without the ability to compress data, computers and networks can suffer from slowdowns and dropped frames. Compression reduces media storage requirements and therefore saves money and makes it easier to transport. Over the years **SMPTE** engineers have developed more efficient codecs, meaning they require less data and look good to the typical viewer. While codecs are not strictly defined as formats, they should be considered methodologies for storing and playing back media. They can be measured by specific attributes such as data bitrates and whether or not they are **"lossy"** or **"lossless"** in terms of how much data is compromised or thrown out during compression. Examples of codecs in use today are Avid DNxHD and Apple ProRes. Also, H.264 is a versatile codec used in many cameras as well as satellite and cable delivery systems.

A major push in the industry occurred at about the same time that Digital Intermediate processes came into the mainstream: to design a complete "file-based" end-to-end workflow. Technological advances such as improved **codecs**, faster computers and cheaper storage solutions made the concept of a 100 percent digital pipeline more feasible and affordable. With improvements in computer hardware and software, file-based workflows have advanced to the point where many things can happen faster than real time, breaking the traditional barriers set by linear tape.

Panasonic (D-5) and Sony (HDCAM SR) remain the tape formats of choice for mastering to HD because they are tangible elements that can be easily duplicated and stored indefinitely. However, they fail to provide "future-proofing" as magnetic tape is subject to deterioration and can become unstable over time. More importantly, they impose limitations on the quality of the image because they cannot accommodate future upgrades in playback technologies.

After the processing and development of the negative, telecine used to be the first step to processing footage into a computer prior to editing. Early offline editing systems such as the Avid Film Composer were designed for tape ingest at 30 fps in standard definition. The film was shot at 24 fps, but could still maintain and track accurate timecode and keycode. In the early days of HD video, most offline editing systems were not capable of ingesting or managing true 24 fps video, nor could they record anything but a standard definition image. It was cost prohibitive to buy or rent HD decks. Therefore, it was common practice to "down-convert" the HD material from 24 fps (16 x 9 aspect ratio) to standard definition 30 fps (4 x 3 aspect ratio). Owing to the large industry infrastructure built around standard definition workflows, this approach persisted for many years amongst episodic television and, to a lesser degree, feature film projects.

With the introduction of **datacine** film scanners, the camera negative could be transferred directly to a digital file and thus avoid the additional step of having to ingest tapes into a nonlinear editor (NLE) in real time. With digital image acquisition, celluloid can be bypassed entirely. With a 100 percent data pipeline now representing the backbone of film production, the market for blank tape stock and down-conversions has been supplanted by an increased demand for larger data storage solutions and faster servers.

FIGURE 2.6

Spirit 4K film scanner

2.1.3 DEMISE OF FILM?

As digital camera systems continue to expand in use, the demand for film stock has experienced an all-time low. Fujifilm announced in 2012 that it would no longer be in the business of manufacturing raw stock and in September 2013 Kodak emerged from bankruptcy.[6] In the wake of these developments, nearly all television shows have opted to shoot digital. This resulted in lower production costs and less uncertainty as they no longer had to rely on Kodak, the sole remaining vendor, to supply film stock. TV productions have also benefited from the economy in time savings as they no longer must wait on lab processing and transfers.

The rise of digital imaging and the deprecation of film as an acquisition medium was a bitter pill for Kodak to swallow based on the extraordinary run they had enjoyed during the last century. Founded by George Eastman in 1888, the company has been the dominant player in both consumer and professional photography. Kodak created celluloid film, which provided a capable medium for Thomas Edison to develop motion picture cameras and projectors.[7] By 1900 the company had become a household name when it introduced the Brownie point-and-shoot camera to millions of Americans.[8] It was both ironic and tragic that Kodak would later go on to invent the digital camera, yet it failed to capitalize on this new technology and instead turned its back on it.[9] After reorganizing, Kodak has emerged as a smaller and leaner technology company, yet it still has deals in place with the major studios to continue to supply film for acquisition, exhibition and archival purposes.[10]

In the past three decades, the number of film labs has continued to drop as their business has dwindled. Companies such as Deluxe and Technicolor have managed to adapt and fully embrace digital technologies, further pushing photo-chemical lab services towards extinction. In the UK in 2011, the two companies made a pact not to compete in this ever-shrinking market by sub-contracting services to each other. Deluxe will continue to manufacture a limited number of prints for theaters while Technicolor will process negative for their customers. At the same time, Technicolor ceased film processing in the US.[11] Meanwhile, Fotokem has reaffirmed its commitment to film developing and may end up being the only facility remaining in Southern California that supports the photo-chemical process (see section 2.3.5, "Conversation with Walt Rose, Fotokem").

While the work print method of film editing was phased out at the end of the 20th century, film projection continues to be the surviving medium in venues abroad, particularly in South America and

Eastern Europe where exhibitors have been slow to replace their infrastructure. By the end of 2013, only 55 percent of theaters in South America had made the costly transition to digital cinema.[12]

The demise of film as an acquisition medium for theatrical motion pictures may not be a foregone conclusion as witnessed by the recent number of high-profile releases electing to shoot film. The Digital Cinema Society (**DCS**) used to produce an annual list each year of all major motion pictures and TV dramas that were acquired digitally and eventually ceased as the task became too enormous. Instead, in 2013, they undertook an informal survey to find the current ratio of digital compared to film production using IMDB Pro as the source. Approximately half of the features considered as contenders during awards season in early 2014 (*12 Years a Slave, Captain Phillips, American Hustle, Wolf of Wall Street, Inside Llewyn Davis*) were shot on film.[13] It remains to be seen if this percentage will hold in the next few years.

2.1.4 NEW EXHIBITION FORMATS

The number of cinemas projecting film continues to shrink as more locations convert to digital. By the end 2013, it is estimated that of the 125,000 theater screens worldwide, at least 80,000 of them have been outfitted with digital projectors, with just over half of those estimated to be capable of 3D projection. By the National Association of Theater Owner's (NATO's) estimation, less than 14 percent of screens in the US and Canada will still be able to project celluloid.[14]

35MM vs. DIGITAL PROJECTORS IN GLOBAL CINEMAS

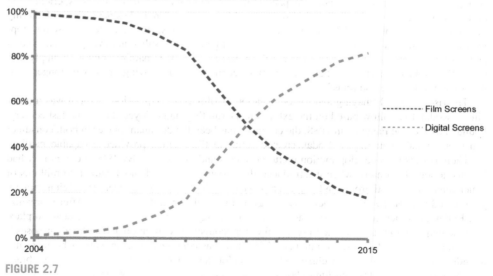

FIGURE 2.7

IHS Screen Digest, November 2011

The Digital Cinema Initiative (**DCI**) was founded in 2002 as a joint venture by seven major studios (Disney, Fox, MGM, Warner Bros., Paramount, Sony Pictures and Universal) to come up with a set of standards for quality control, digital delivery and projection. While there remain a myriad of formats for acquisition and mastering, there needed to be a uniform code and set of practices for how a "digital print" or **DCP** (Digital Cinema Package) is displayed. The DCI defines the technical specifications for file-based content and allows any DCI compliant projection system to play back material in a

consistent way around the world. Issues such as transportation, data security and quality control are addressed in these guidelines and allow for future developments in technology to be incorporated.[15]

A key component to digital delivery in theaters is the ability to ship product via satellite transmission. The advantage here is that it bypasses the web, which continues to represent an ongoing security threat from hackers and pirates. The Digital Cinema Distribution Coalition (DCDC) is a partnership of film studios (Warner Bros and Universal Pictures) and movie theater chains (AMC, Cinemark and Regal) which in 2012 announced their intention to ramp up wireless distribution.[16] The alternative for facilities not equipped with a satellite dish remains physical shipment of a hard drive, and while it offers significant savings over the cost of creating and transporting a film print (approximately US$1500), it would make economic sense for distributors not to carry any physical inventory at all.[17]

While theatrical exhibition still provides the best communal film-going experience, home video sales represent a significant portion of a film's revenue. High-definition televisions currently comply to the Rec. 709 standard and most new televisions support 1080p signal (1920 x 1080 **progressive scan**). This continues to be the gold standard for home video but will soon be replaced by **UHDTV (Rec. 2020)**, which supports 4K and 8K home video and defines new specifications for resolution, frame rate and **colorspace**.[18]

While DCP's **color gamut** currently eclipses Rec. 709, the new Rec. 2020 standard will improve upon that even further, once again forcing the theater industry to innovate and stay competitive with the home theater market. However, along with the introduction of new technologies come large-scale marketing efforts. Innovations such as these are great for the consumer, continually delivering better and better cinematic experiences. However, in the race to stay dominant, many highly touted "improvements" turn out merely to be marketing gimmicks.

Technologies such as 120Hz overdrive – or motion interpolation – are marketed to TV viewers as something they can't experience in theaters. They are promised "life-like" imagery. This process involves real-time analysis by hardware built into the display unit to compare a frame of video to the next and intelligently create an average in-between frame. This results in less display motion blur (due to display technologies such as LCD with slower refresh rates) and less judder, or visible lag between frames during a camera pan or quick motion. While, in theory, these enhancements should be positive, they ultimately undermine the look and feel of cinema that was carefully crafted by the filmmakers. The resulting image, derisively nicknamed "the Soap Opera Effect," has a hyper-real appearance that feels more jumpy than smooth.[19] While great strides have been made in TV technology to play movies back at 24 frames per second, motion interpolation represents a step backwards.

On the theatrical front, efforts to produce high frame rate (**HFR**) content have encountered mixed results. Peter Jackson's *The Hobbit* was shot and released in 48 frames per second HFR 3D. The result was as expected: very smooth motion, but with uncanny life-like qualities that undercut traditional cinematic qualities. The film was simultaneously released in 2D (24 fps), 3D (24 fps) and 3D HFR. The 24 fps versions were created by dropping every other frame from the 48 fps version. *The Hobbit* provides useful insight into what techniques can succeed in HFR, such as pairing it with 3D. Previously only short test films had been shot for demonstration purposes, but coming in at 169 minutes, *The Hobbit* serves as a continuing subject for in-depth analysis and debate among film enthusiasts.[20]

While the HFR experience appears to have received merely a lukewarm audience response, this suggests that the future of HFR as a new standard is still up in the

FIGURE 2.8

The Hobbit: An Unexpected Journey (2012)

air. Rather than further engrossing the viewer in the story, many audience members have reported that HFR was distracting and took them out of the experience while others praised the uncanny realism.[21]

2.1.5 IMPROVEMENTS IN DIGITAL ACQUISITION AND EDITING

The advances in Digital Cinematography and editing can be attributed to three areas:

- Faster computers and cheaper storage
- Development of more efficient codecs
- Innovations in sensor technology

FIGURE 2.9

Hewlett Packard HP Z820 is a powerful workstation and well suited for post-production

FIGURE 2.10

SD cards are used for media capture on many different camera systems for easy transfer to editing systems

FIGURE 2.11

Portable drives such as a G-RAID are used to store and transport data from the set to the lab or cutting room

Moore's Law states that the number of transistors that can fit on a chip doubles roughly every 18 months with a resulting improvement in both cost and speed of computing. This has transformed the digital acquisition process by making it more affordable and thus "democratizing" filmmaking by placing powerful toolsets in the hands of more people. While this may appear to level the playing field – allowing indie filmmakers the same access as the major studios – technological innovation has shown time and again that the bar for what is considered the "industry standard" will continue to be raised and along with it the cost. Engineers, on this inexorable march forward, continue developing new technologies for the benefit of manufacturers and the film industry. 2K production is currently the accepted standard in the industry, but the movement towards 4K and even 8K exhibition is gaining traction. The amount of picture information as measured by pixel count that is captured by sensors and processed by computers is expand-

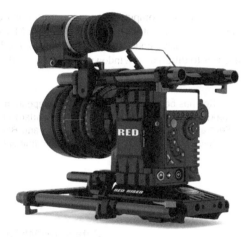

FIGURE 2.12

The RED Epic has proven to be a popular camera selection by professional and student filmmakers since its release in 2011

ing by leaps and bounds. Televisions meeting the UHD (Ultra-High Definition) standard offer an even greater color gamut than Digital Cinema.[22] '

As new technologies emerge and fight for dominance in an ever-changing landscape, studios and post-production facilities must be careful to make shrewd investments, minimizing the need to replace major pieces of hardware from year to year.

> Camera technology has moved away from the traditional 3 chip (**RGB**) cameras to the single **bayer sensor** with the ability to capture **RAW** footage (see section 2.5.3, "What's RAW All About?"). While having fewer (chip) sensors has allowed developers to build more efficient, compact cameras, the challenge presented by RAW is that the amount of data generated during production has increased dramatically, and makes the process by which we edit and view the material considerably more complex.

When the industry began to move away from standard definition towards high definition video, editing platforms were tasked with processing far greater amounts of data than ever before. For a computer to play and edit multi-stream full frame HD video sources, it needed more storage space, bandwidth, memory and processing power. To solve this challenge, new **compression** formats emerged to provide a lower **bandwidth** solution. Avid and Apple each came up with their own family of codecs that have become standards for **offline** and **online** editorial. Avid introduced **DNxHD** in 2004, featuring HD formats that are highly efficient (i.e., smaller file sizes) and scaleable in terms of resolution.[23] Apple's **ProRes** provided equal benefits with both formats allowing editors to use low-resolution **proxies** for offline to save on storage space and easily matching the sequence to a high-quality online version for mastering purposes.[24]

While Avid Media Composer and Apple's Final Cut Pro systems have been in steady competition over the years, it was only recently that each vendor's codec became usable on the opposing software platform. This means, in practice, that Apple ProRes files can now be imported into the Avid while DNxHD files can be imported into Final Cut Pro.[25] However, in order to render and export a ProRes

sequence a Mac computer is required with Final Cut Pro installed. Avid Media Composer is cross-platform, meaning it will operate on either a Mac or PC. DNxHD was designed from the ground up as an open-source codec using **MXF (Media Exchange Format)**, whereas Apple has rarely granted licenses to third-party Windows developers for the use of ProRes.

> ProRes has become a favorite in the independent feature, trailer and documentary world (when working in FCP), while DNxHD is the standard file-based deliverable for network television. Several cameras including the Arri Alexa and Blackmagic Design Cinema Camera include native ProRes and DNxHD recording to make offline/online workflows fast and easy.

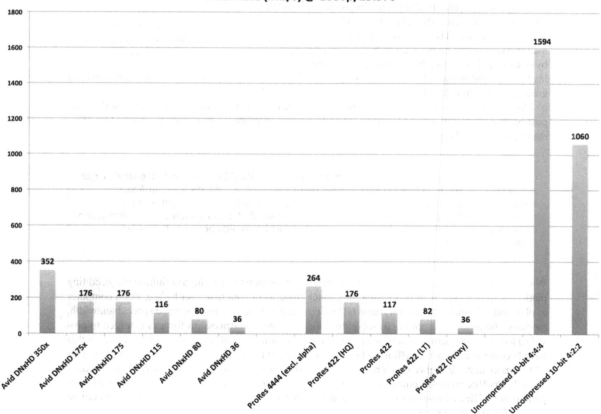

FIGURE 2.13

Avid DNxHD and ProRes comparisons

2.1.6 ARCHIVAL AND FUTURE PROOFING

While the major studios traditionally stored their own elements, independent filmmakers have relied on film labs to do the same (original camera negative and master inter-negatives). A proper vault is climate controlled (cool and dry). The life expectancy of a new negative, stored under optimum conditions (32° Farenheit, 30 percent relative humidity), is more than 500 years.[26] Film negative also offers the advantage for "future-proofing" in that it can be periodically rescanned at higher resolutions to new and improved digital formats as they become available, until the maximum scan-able resolution of the film is reached. What that ceiling is remains a subject of debate. Most 35mm negatives contain between 2K to 4K resolution depending on the stock and exposure characteristics.[27] Kodak asserts that their new rawstocks are capable of resolution equivalent to 6K (i.e Vista Vision) when exposed horizontally.[28]

Archiving on analog film has the benefit of proven longevity, but this results in generation loss by rescanning it. Some may argue that it's negligible, but ultimately archiving to film is about satisfying two camps: major studios who are more comfortable with maintaining physical elements, as the concept of digital files may seem risky; and the large labs who continue to earn profit from film processing. Creating a new negative of the final film may be cost prohibitive for the independent filmmaker, but ironically it is film that may end up being the most reliable method of archive due to the fleeting and impermanent nature of digital files.

While HD master tape formats such as Sony **HDCAM SR** and Panasonic **D-5** offer a reliable and stable format, they are often limited to a resolution of 1080 lines of information, but with appropriate hardware modules can support up to 2K. While perfectly suitable for use in broadcast or digital cinemas, they can't support future higher resolution technologies and are essentially "locked in" to a specific resolution.

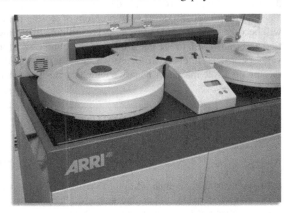

FIGURE 2.14

The ArriLaser Recorder is used to transfer a digital file to 35mm negative and sometimes referred to as a "film-out."

The bulk of modern film and TV projects are now shot using digital cameras with virtually no original film elements and thus are considered "born digital".[29] With 4K and HFR (High Frame Rate) production comes the added challenge of preserving the data after the film is completed. On a feature film, this represents an enormous amount of storage, not to mention ongoing overhead costs to store data in an archive. James Cameron's 3D blockbuster *Avatar* clocked in at over a petabyte (1,048,576 gigabytes) of data.[30] His planned sequels may be shot at 60 fps, a significant jump up from the 24 fps that the first film was shot at, resulting in even greater storage demands.[31]

Moreover, current archival and back-up techniques (see Part VII, "Restoration and Archiving") may not be supported 20 or 30 years from now. This will require periodic inspection and transfer of data from older to newer systems known as "data migration." Today's optical disk drives have proven to be effective tools for the short term but need to be powered up and spinning from time to time to maintain longevity. This has created a need for "cold storage" methods that are both reliable and cost effective.[32]

Computer systems since their inception have often used linear tape to store and retrieve data. While relatively slower than disc-based systems, they have proven to be fairly safe and reliable. The Linear Tape Open Consortium was formed in 2000 to develop a set of standards for storage media going forward.[33] **LTO** 5 and now LTO 6 are current tape formats (with a roadmap going all the way to LTO 8) whereby large amounts of data can be copied and saved with relatively competitive costs.

Even with digital tape archival methods, there is still an inherent risk in physically storing elements. During the past decade there have been multiple disasters that have destroyed critical parts of major studios' film archives.[34] This has resulted in the loss of vital elements, requiring that older digital tape masters become the new masters. In other cases, the digital masters have been lost and the films have undergone expensive restoration from the original negative. Storing data securely in the cloud is now an attractive option. Services such as Amazon S3 are used by small firms, large enterprises, websites such as Twitter and Facebook, as well government entities across the world for secure and redundant data storage. S3 and similar services are referred to as Content Delivery Networks (or **CDN**s). CDNs distribute content across multiple datacenters around the world in order to provide redundant fail-safe storage, systematic data integrity checks and automated self-healing. Distributed data storage provides for 99.999999999 percent durability of the files.[35] If multiple datacenters were destroyed, data would still survive.

Cloud storage also solves the problem of storing data on tape or disk systems which eventually will become obsolete and unreadable. By utilizing distributed data centers, the data is constantly verified and transferred to the latest in storage technology. Storing data in the cloud means that multiple vendors or departments can securely access the footage/data over the internet as needed, instead of relying on a sole master or negative which carries the risk of being lost or damaged during shipping.

2.1.7 NONLINEAR PRODUCTION

HOW NONLINEAR EDITING CHANGED THE INDUSTRY

The impact that nonlinear editing has had upon the film and television industry is profound. The scale and speed that computers have afforded us means that revisions can be made faster and creative decisions are easier to execute. And thanks to the internet, the sharing of media has become an integral part of modern post-production. Producers and directors expect more from their editing teams because they've grown accustomed to the power and flexibility of these platforms. However, after a decade (or more) of continual improvements, nonlinear editing systems are now faced with new challenges brought on by the advent of Digital Cinema cameras. During the past few years we have witnessed explosive growth in camera technologies, thus creating the need for further advances in editing technologies.

Avid, Final Cut Pro and Premiere Pro each came to prominence as nonlinear editing (NLE) systems in the 1990s. While each software program has its devotees and detractors, it can be argued that Avid Media Composer has the strongest track record of delivering filmed mainstream entertainment; thus, we often hear Avid referred to as the "industry standard." At one time content to rest on its laurels and invest much more heavily in marketing than innovation, Avid has encountered intense competition in recent years from Apple and Adobe, forcing it to respond to the needs of its users and deliver a continually great product. In just the past few years there have been some significant changes for these NLEs:

- Migration away from tape-based to file-based ingest and output
- Editing in high definition using 64-bit processing
- Improved visual effects and color grading tools as well as **LUT** (Look-up Tables) and **ACES** support

- Ability to mix in **Dolby 5.1** surround audio
- Expansion of the use of **metadata** for tracking assets

Upon its initial release in the early 2000s, most professional editors did not embrace Final Cut Pro, as it lacked then-essential features such as frame-accurate output to tape. While HD production had heretofore been cost prohibitive for those working on constrained budgets, the inclusion of HD editing over FireWire in 2004 catered to an untapped market of amateur filmmakers and boutique post houses, lending fresh exposure to Final Cut Pro as a platform.[36] In 2008, an informal survey of Hollywood film editors conducted by the American Cinema Editors (ACE) revealed that 21 percent were using Final Cut and these numbers were continuing to grow.[37] Around the same time, RED One camera systems appeared. The RED developers understood that much of their market was using FCP and offered a QuickTime proxy architecture that would allow FCP or Premiere to edit without having to **transcode**. In 2009, Apple released Final Cut Pro 7 and appeared to be on a steady growth curve. Then, in spring 2011, their new 64-bit application FCP X was announced and received less than stellar reviews from critics.

In 2012, Apple unveiled its latest version of Final Cut Pro (FCP X), which represented a radical departure from the timeline interface that most editors are familiar with. This was a ground-up reimagining of the basic toolset and caused quite a stir among Apple's fan base, and reactions from the film community were decidedly mixed.[38] Concepts such as the magnetic timeline, compound clips and keyword collections were not immediately embraced by the editing community. FCP X is one of the first systems designed to make full use of the metadata capabilities inherent in digital footage; however, many of the tools necessary to leverage this metadata were missing from its debut version. Responding to community feedback, Apple admitted that this was one of the worst rollouts in company history.[39] To remedy the situation the Final Cut development team worked diligently to add in essential features that were missing from the initial release. In the two years since then there have been ten minor software updates with one major update. In addition, third-party developers have seized the opportunity to deliver requested features and enhanced performance, leading many skeptical editors to take a second look at the product.[40] Intelligent Media is one such company that designs some of these Apps. Co-founder Philip Hodgetts makes the claim that Final Cut Pro X is the fastest editing system available today.[41] For many post facilities where time equals money, this is a strong selling point. Another draw is the platform's ability to edit in 4K natively and easily move back and forth between editing proxies and full res footage. For long-form TV and film projects, strong media management tools are an essential component (along with sound mixing, multi-cam and color correction tools to any NLE suite). Despite the benefits provided by third-party enhancements to FCP X, many editors and post supervisors are sticking with Media Composer for the time being.

While the latest iteration of Final Cut Pro proved a misstep on Apple's part, they've shown tenacity in producing a compelling product that addresses the needs of professional and amateur filmmakers alike. It should be noted that Apple has not targeted the studio feature film editors with FCP X. Instead, they have targeted *consumers* of all markets and made a product that appealed to the masses, not the elite Hollywood editors. There are simply more customers using FCP who are not "filmmakers" in the traditional sense. More industrial, corporate videos and local TV commercials are made than feature films and network television shows every year and this represents a substantial market for Apple.

The biggest benefactor of Apple's recent bad press has been Adobe's Premiere Pro. Like Final Cut, Premiere has always maintained a strong presence in academic and amateur filmmaking environments. However, it has struggled with professional adoption, owing to a lack of refinement of tools that are essential to large-scale projects, such as its media management interface. But much like Apple, Adobe has been attentive to the needs of its customers, and with recent efforts toward creating ever-tighter integration of Premiere Pro with other core Adobe applications such as Photoshop and After Effects, it may pose a compelling solution in the years to come.

Workflow Best Practices

When making critical pre-production decisions about the type of camera and workflow to utilize, a good place to start is determining both your editing format and the eventual exhibition format for the project. For a web or mobile audience, shooting 4K is overkill and will result in an expensive post-production process for which the audience will never enjoy the benefit. If, however, you're targeting the festival circuit, you may be dismayed to see what iPhone video looks like projected onto a 100 foot screen.

Producers therefore need to weigh their options and keep in mind that most modern cameras will capture and save to more than one format. In subsequent chapters, we will outline the key specifications of each camera, including resolution, frame size, and data rates. *The total volume of data to be generated is an absolutely crucial factor in determining the right camera and workflow.* This is particularly true for small handheld cameras that are capable of shooting RAW footage. Although the cameras may look small, their data rates are not. Before setting out on a certain path, a bit budget or data allowance must be calculated (see Figure 2.15). There are a multitude of apps available on the web and for handhelds that can assist in estimating the amount of data acquired.

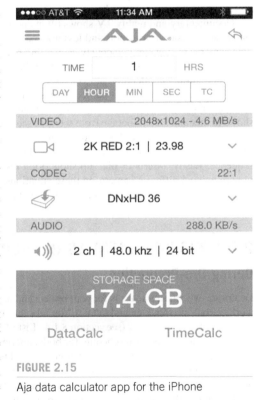

FIGURE 2.15

Aja data calculator app for the iPhone

How the footage is handled on-set and the subsequent steps of post-production should be clearly defined during pre-production. It is essential for filmmakers to form a mental picture of how and where the data is stored and transported. This can be outlined as a memorandum that is distributed both for on-set procedures as well as a flow chart describing the data pipeline:

> In the world of digital filmmaking, the minute you decide you're doing an Alexa show, a RED show or whatever the camera is – you want to interconnect your camera department with your post department with your finishing department – so that there is an understanding of what is

captured by the camera on the SxS card or mag, or whatever it is, what you capture and how the final colorist is going to be managing it. There needs to be clear communication on what's expected at the beginning and end of the process.

Holly Schiffer-Zucker, HBO, vice president of Post-Production

Studio pictures employ Digital Cinema cameras capable of producing RAW footage at extremely high data rates. The sheer volume of data may require multiple data wranglers and **digital imaging technicians (DITs)** (see Chapter 3.1, "The Digital Loader and the Digital Imaging Technician (DIT)"). Additional equipment is needed on-set to process the footage.

Episodic TV and low budget features may not find it feasible to capture so much data. A good compromise in this case is a compressed format that requires less processing such as Avid DNxHD 36. The footage can easily be backed up and transported back to the editing room where work on assembling the sequences can begin immediately.

Documentary and reality TV shows often choose lightweight and smaller cameras because they are cheaper, easier to transport and less noticeable while filming. In these cases, there may be multiple cameras rolling simultaneously, generating many hours of footage. The challenges this presents to the DIT are in finding enough downtime in between takes to download and transport the camera data since filming is often non-stop (see section 3.3.4 "Editorial Prep for Offline Dailies").

When determining which camera is best suited as "the B" camera, "crash" camera or camera best suited for tight spaces, don't lose sight of the overall look of the project. While it is common for shows to mix and match footage from scene to scene using two different camera systems, as a general rule only one camera should be used within each scene to maintain visual continuity. Exceptions may arise where a stylized look or point of view (POV) is desired, such as a security cam or flashback sequence. Lastly, inserts or pick-up shots often take place after principal photography which may require using a different camera. In these situations care should be given in choosing a camera that matches resolution, frame rate and color space of the original.

2.2.1 AVOIDING PITFALLS IN PRODUCTION THAT AFFECT POST
During Pre-Production

Determine who the audience is for your project and how you intend to show it to them (Theatrical, Network, Web, Video On Demand (VOD), YouTube, etc.) If you are fortunate enough to have a distributor, obtain a list of deliverables (see section 8.1.4 "List of Deliverables") before production commences.

Discuss and agree on a schedule for both shooting and post-production with your "key creative," such as the director, producer, cinematographer, editor and production designer, among others.

Create a list of key steps and deadlines including when the final project must be turned over for delivery and distribute it. Plan out your workflow, from acquisition to distribution.

Consult with as many experts and consultants as you can: visual effects supervisors, lab, post houses and other vendors. Obtain as many quotes as possible. To be forewarned is to be forearmed, so gather as much information as you can and make everyone aware of the goals/challenges/budget limitations that lie ahead.

Require careful location scouting for determining any sound and lighting issues. Bad sound will result in extra time needed during post to fix or replace. Poor lighting will require extra attention during color grading. Do not assume that all these issues can be corrected later on but rather that they should be addressed upfront.

Estimate the amount of storage needed by establishing a **shooting ratio** and data allowance. Ensure there will be enough back-up drives to be on hand at all times.

Estimate how much data will be generated *each day* and make provisions for enough storage devices to back up and transport. Plan for making at least two back-up copies of the footage. Three back-ups are even better.

Obtain pre-visualization for all computer-generated imagery (CGI) and composites for use as on-set reference and editorial placeholders.

Shoot tests. Test all your equipment before going out.

Create a post workflow and test it during a dry run so that you are confident it will succeed. Detail the process using charts, memos and create a post schedule in advance and distribute it.

During Production

Maintain the 3-2-1 rule: keep three copies in two different formats with at least one maintained at a separate location.

Establish an on-set protocol for handling and verifying your data. Create a tracking sheet or flow chart defining each person's responsibilities for who handles the cards and drives. Encourage communication among crew members and stick to the plan.

Create a memo/tracking sheet charting when and how the sound and picture files are to be transported back to the lab or cutting room. Establish rules as to when to "break off." What this means is that during extended shooting schedules, or while at distant locations, it is essential to send a partial batch in the middle of the day instead of waiting until wrap. This reduces the amount of time that editors and assistants must wait for dailies and keeps the footage flowing.

Slate every shot and assign scene numbers. Second Unit must also keep careful continuity notes and shooting logs.

Errors and anomalies in either sound or picture must be recorded in the respective camera and sound reports. They should be reported to the continuity script supervisor as well.

Always record sound (even if there is no intention to use this sound) in order to provide a guide track.

Location sound recordists should make certain to record room tones and ambience from each location. They should also take the time to work with the actors in between set-ups to record wild lines. Wild lines are repeated off camera and are necessary for dialog replacement should the need arise due to noise or other problems during the actual takes.

Try to light properly and avoid having to remove offending wires, backgrounds, and tracking markers possible.

Avoid adding shots that require VFX or composites without first consulting a VFX supervisor.

Never repeat the mantra: "We can fix it in post." Errors and problems that occur during principal photography have a tendency to compound themselves as they move through the post-production process and thus become even bigger problems, resulting in time delays and cost overruns. To assume a positive outcome will happen later on or to kick the can further down the road is a recipe for disaster.

The following are hypothetical examples of what NOT to do. They have been culled from the annals of production in an attempt to illustrate how quickly and easily things can go wrong.

"The Case of the Missing Lawn"

Bollywood's thriving film industry produces hundreds of film each year. One such production called for a house to be used as a practical location with a verdant green lawn surrounding it. When the

director arrived on-set he discovered the house was surrounded by a dirt lot. No greenery was present. Rather than call in greensmen to lay down new sod, the producers elected to add the lawn in post using **CGI** and avoid a delay in photography. This seemed like a cost-effective solution. The camera they were using had been in service for many years and was routinely inspected and repaired. However, after shooting this scene, it was later discovered there was a registration issue that caused the film to weave as it travelled through the gate of the camera. This lack of precise registration caused substantial problems for the VFX artists and required the footage to be stabilized in post, causing significant time delays and cost overruns.

"Dude, Where Did My Car Go?"

A young choreographer-turned-director decided to make a music video. The script called for two young lovers to sing and dance as they cruise around town in a shiny convertible sports car. With a modest $30,000 budget, the director decided it would be less expensive to shoot the project with a real car but use a **green screen**, believing that a VFX artist could **composite** the backgrounds in later. This method offered substantial savings over shooting on city streets, which usually involves expensive permits and a police presence. A green screen is used to separate the foreground action from the background and is achieved through proper lighting and placement of the screen. Unfortunately, no shooting or lighting tests were conducted beforehand. No one considered the reflective features of the sports car in the foreground, such as the windows, mirrors and shiny paint job. When it came time to replace the green screen with a new background, it became apparent that using **chroma-key** to make the green transparent also caused many parts of the car to literally disappear. The director took the footage to several different VFX houses to see what could be done to fix the problem. Their advice was to re-shoot the entire project, as this would ultimately be more cost effective than trying to fix it in post.

"The Data Tsunami Effect"

A cable TV pilot featuring extreme sports staged a day-long car rally and employed multiple cameras using many different formats. Over the course of ten hours, footage was captured using GoPro cameras, Arri Alexa, RED, as well as digital single-lens reflex (DSLR) and even two "legacy" Beta SP cameras that recorded to tape. The footage was backed up and transported to the cutting room. With nearly 40 hours of raw footage to log, transcode and organize, the single editing system that was allocated was quickly overwhelmed, so a second editing system was brought in. However, it became obvious after two weeks of dailies preparation, with not a single frame actually being cut or assembled, that this was not the best approach for dealing with the tidal wave of footage in different formats. The delay drew the ire of the director, who was not accustomed to such slowdowns. The project was eventually moved to a post facility that offered multiple editing stations, allowing for faster transcoding to a **SAN** (Storage Attached Network) which could support access to the shared media to the two editors. While the deadline remained the same, the post schedule was severely affected by this bottleneck.

"Last Mag Standing"

An infomercial was completing the last day of a week-long shooting schedule using the RED Epic camera. The tightly knit crew had worked together on many previous projects and were used to working fast and loose, which meant that no camera reports were being generated and a piece of

RED tape was placed on each fully recorded digital mag (magazine) before it was walked over to the editorial department next door for download and back-up. Once the footage was copied, the mag was erased and returned to the camera department. The last day went into significant overtime and the very tired crew wrapped close to midnight after the editors had gone home. On Monday morning, the production manager physically handed all of the RED mags to his production coordinator, along with instructions to return them to the rental house where the data was subsequently erased. Several days went by before anyone noticed that a significant portion of the last day's footage was missing. A re-shoot was required, resulting in a huge cost overrun in the tens of thousands of dollars and the coordinator was let go.

"Third Day is a Charm"

Following a successful Kickstarter campaign, a micro budget feature began principal photography using two RED Epic cameras. A data manager was hired at the last minute when the first candidate decided not to take the job. Arriving on-set for the first day's shoot, he noted that only three x 3 TB storage drives were on hand for back-up. He made an urgent request for 12 more drives to be purchased so that production would have enough room to safely store the material, pointing out that with two 5K cameras rolling they would run out of space at some point during day 3 of a 14-day shoot. The line producer duly noted this request and promised to take care of it. The situation became more urgent when a DSLR was added to production as the third camera. By morning of day 3, the drives had not arrived. A production assistant was quickly dispatched to the store to purchase the additional drives. At 10 am production ground to a halt while one of the three full mags was copied to a laptop's internal drive and then wiped and handed back to the camera team. The other two were copied to the laptop and returned. At this point the production had no other copies of the footage and was essentially flying without a safety net. Fortunately, no data was lost but this remains a cautionary tale and one to be avoided, as it places data at risk and causes production slowdowns.

"The Transcode Nightmare"

A color grading facility was hired by a producer to create looks for a music video starring a black hip-hop singer performing alongside a white ingénue. The color artist at the facility had a long history of grading commercials for the producer and it was customary for the footage provided to the grading suite be in the original RAW file format. Instead, the editors sent over a transcoded sequence consisting of **DPX** files (see Chapter 4.3, "Color Grading / Digital Intermediate (DI)"). While the footage appeared to be correct in that it looked flat and had low contrast (like most RAW material), it was discovered that there was a problem just minutes before the color grading session was set to begin. With the director of photography, producer and star client in the room, it quickly became apparent that there was not enough detail in the shadows to bring out the singer's facial expressions. The star client soon began making jokes, suggesting that his tablet had better correction tools than the facility. Since the ingénue was fair skinned and fell squarely in the mid-tones, she looked OK, but the color information in the brights and darks had been compromised. The client worked closely with the colorist to try and correct the situation, but after several hours and considerable expense, they were unsuccessful in defining an overall look for the piece.

Film

Film cameras and projectors have been the essential tools of the cinema for over 100 years. As digital formats began to gain traction as a viable medium, many in the industry had a viscerally negative reaction. The notion that "film is dead" was antithetical to everything they had built their careers upon. To them, an essential quality of film was the stock itself: something you could hold up to the light or run between your fingers. Sales of film and film cameras were at an all-time high by 1997 when Kodak claimed over two-thirds of the global market share with the company valued in excess of US$31 billion dollars.[42] However, the arrival of digital technology swiftly eroded film's dominance in the marketplace.[43] By 2012, Arri, Aaton and Panavision were no longer in the business of making film cameras.[44] Kodak sought bankruptcy protection that same year and the major labs – notably, Technicolor and Deluxe – began to prepare for the day when film processing would no longer be a part of their core business.[45] Paramount was the first major distributor to announce that they would no longer create celluloid release prints and it is expected that the others will do the same.[46]

2.3.1 TRADITIONAL FILM CAMERAS

Film cameras are relatively simple in concept. At the most basic level, they are mechanisms to reliably transport the film negative through an optical gate at a consistent speed. While modern film cameras have a significant amount of electronics governing their functions and operation, they are primarily mechanical devices, which also means that they generate some noise.

Early film cameras were bigger than people, weighed hundreds of pounds, and could not easily be moved around. This discouraged many types of camera movement, effectively limiting the film language at the time. In the early days of cinema, Thomas Edison went to great lengths to find ways to move the camera, such as placing it on a hot air balloon.[47] Buster Keaton shot much of his 1926 masterpiece *The General* from the vantage point of a moving train.[48] However, for most early productions the camera stayed in one place.

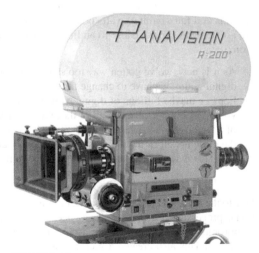

FIGURE 2.16

Panavision R-200

45

With the introduction of lightweight 16mm cameras in the 1960s, documentaries began to flourish as they allowed filmmakers such as D. A. Pennebaker and Jean Rouch to shoot improvisationally in the streets, or capture candid behind-the-scenes moments with his subjects.[49] As modern studio cameras evolved they could easily be rolled on dollies and "flown" on **Steadicams** and cranes. Advents in ergonomics and super-light cameras weighing only a few pounds have further liberated the filmmaker. Modern electronics and innovations in mechanical engineering allowed for variable speed photography, electronically controlled shutters, speed ramping, and more.

2.3.2 WHY FILM IS THE LOOK WE EMULATE

Early video cameras could not compete with the look and feel of film. They made the images appear flat and there was noticeable lack of definition in the shadows. Bright light sources tended to look blown out. The color didn't feel right. Instead of fast prime lenses on the early cameras, they usually came built in with fixed zooms, which were convenient for news organizations but not optimal for narrative filmmaking and also required more light.

The development of video cameras and film cameras was not complementary and ran in parallel. They were designed for different markets and different uses. It was not until filmmakers started using video cameras in narrative endeavors that the incompatibilities between the two began to arise. For years electronic news gathering (**ENG**)-style cameras have been quite successful in documentary and news – because they were designed for that. As video cameras were being adopted by filmmakers, there was an increased demand for video cameras to behave like film cameras.

As video cameras improved, the sharpness improved but introduced an unintended side effect: the picture was often regarded as TOO clear by viewers. This became particularly noticeable with the arrival of digital cameras and higher definition displays at home. Engineers were finding ways to create ever larger, more pixel-packed sensors, this increased sharpness was both a blessing and a curse for talent. Hair and make-up was so stark and cleanly presented that any problems were not as easily masked as they had been by film. Art departments had to play closer attention to backgrounds and faux-painted walls because flaws in paint and texture were more obvious. Because the artifice was more visible to audiences, scenic artists needed to take more time and produce more detail.

> As it is now, we've gotten way too sharp. To compare film resolution with resolution in the digital realm, we have to change all of these little granulations of silver in the film into millions or maybe billions of digits. Now, when you are now getting that kind of capture and you're shooting a close up, all of those digits make you see every individual pore in the skin of a face. Whereas, when you had silver, it created an organic situation that, when you cut to the close up, all of that silver sort of melted together, the particles just smoothed each other out. That is what I call the organic part of film that is now missing.
>
> Johnny Jensen, A.S.C.

Due to the enhanced precision of newer digital cameras, the increased data bandwidth required additional processing. Compression was necessary to capture and encode images, and in the process compromises were made in codecs to sacrifice **chroma sub-sampling**. (See Appendix Chroma Sub-Sampling) This also created a greater likelihood for errors being introduced as the images moved downstream in the post-production pipeline. At the same time, the art of look management and **color science** became essential components of the filmmaking process.

A trained technician, working from the scientific principles of Color Science, can help a filmmaker refine the look of his film to achieve maximum emotional impact. Is the picture warm or soft? Does it feel too crisp or clean? Does the picture have tremendous depth of focus or is it shallow? How rich and saturated are the colors? The aesthetic of watching a film print continues to resonate with audience members, and it is typically the goal of digital filmmaking to replicate this experience as closely as possible.

2.3.3 IMAGING CHARACTERISTICS OF FILM VS. VIDEO

The look and feel of film is principally organic. No two film frames have identical grain structures, and this uniqueness provides a living, breathing quality to film that digital capture often lacks. One of the most notable characteristics of film is the way in which shadows softly fall off to black and highlights softly become white. Analog and digital video have traditionally been characterized by sharp cutoffs in shadows and highlights that produce an unflattering loss of detail, known as **clipping**.

> Clipping is the result of recording a signal that is beyond the minimum or maximum signal limitations of a sensor or imaging technology. When this occurs, gradations in exposure beyond the clipping point are lost and recorded as a single maximum or minimum value. A vivid example is a bright light source such as a window or light bulb that may cause the image to become "blown out." Clipping can even occur in the highlights on subjects' shoulders and cheekbones.

Typically, video cameras result in a more contrast-y image relative to film. Blacks are generally more crushed with a loss of detail in the shadows. Much of this can be attributed to cameras with low **dynamic range** ("low latitude") and the desire of television producers to make poppy, crisp images for broadcast news and sitcoms.

Throughout the end of the 20th century, the majority of episodic television was shot on film and not video, in part because the film look was better suited to narrative projects. Film is also shot at 24 frames per second, whereas many traditional video cameras record at 60 fields per second (or 30 interlaced frames per second). The smooth look of video is partly caused by the 30 fps frame rate. By sampling movement with more frames, motion on video tends to appear sharper with less motion blur using faster shutter speeds. A rate of 24 fps tends to have a few motion smears which helps to create a softer film look. Over the last ten years, manufacturers have included 24 fps progressive recording options in digital cameras to get closer to the look and feel of film.

Only recently has a new generation of cameras emerged with qualities that match or surpass film. Systems such as the Arri Alexa, RED, and Sony's Cinealta series feature a wide latitude capture of 14+ film stops, capable of producing images with deep shadows and soft whites. All their sensors are *scene-referred* in that they record images in a manner analogous to negative with only the physical light captured with little or no treatment (curve) added by the camera manufacturer (see section 4.3.9, "ACES Workflow"), and as such they are referred to as "Digital Cinema" cameras.

2.3.4 ADDED EXPENSE OF SHOOTING ON FILM VS. DIGITAL

Oliver Peters is an editor and industry analyst. At the 2011 DV Expo in Pasadena, he presented a sample budget and breakdown of the difference in cost between shooting film vs. digital.[50] He based his numbers on a typical independent non-union production of over US$1 million. He determined at

that level of production, shooting film would add $175,000 to the bottom line. This is not an insignificant amount for a modestly budgeted film.

35MM Film	Cast and crew	$296,300.00
	Production equipment	$194,000.00
	Film production support	$185,900.00
	Editorial	$230,800.00
	Film (DI) finishing	$153,000.00
		$1,060,000.00
Digital Camera	Cast and crew	$296,300.00
	Production equipment	$194,000.00
	Digital camera support	$16,400.00
	Editorial	$230,800.00
	Digital video finishing	$88,000.00
		$825,500.00
	To record to film from a digital master - add **$75,000** to **$200,000** to either of these totals.	
	©2011 Oliver Peters	

FIGURE 2.17

Film budgeting

With Oliver's assumptions in mind, here are some of the factors that producers who are thinking about shooting on film will need to consider:

- Raw stock
- Lab processing
- Scanning back to digital
- Additional crew hires

What Is My Film Ratio?

This is a question that needs to be discussed before the shoot and requires input from the director of photography (DP) and the director to determine how much footage they intend to shoot. The film ratio is a measure of the total minutes of raw stock needed vs. the number of minutes up on the screen. 16:1 is a reasonable number for a low-budget feature, whereas 50:1 is more likely for a larger project, going all the way to 100:1 for tentpole films.

How Much Raw Stock Will I Need?

For 35mm:

(running time in minutes × shooting ratio) × 90 (feet per minute) = total footage

For 16mm:

(running time in minutes × shooting ratio) × 36 (feet per minute) = total footage

Assuming a two- hour feature with a 16:1 shooting ratio:

35mm:[51] (120 × 16) 90 = 172,800 feet of film (add 10 percent unused shortends) = 180 rolls of film (180 × 1000 feet)

16mm: (120 × 16) 36 = 69,120 feet of film = 180 rolls of film (180 × 400 feet)

What Is the Cost Per Foot of Film to Process?

35mm/16mm estimated at US$0.18 per foot.[52]

What Is the Cost Per Hour to Scan the Negative to HD?

30 hours × 1.5 (allows for set-up time and transfer using "best light").[53]
 45 hours × 600 per hour = $27,000.

What Additional Crew Hires Are Necessary to Shoot Film?

For a digital only production, a DIT and Data wrangler may be hired, whereas on a film shoot they would be replaced by a Film Loader and Video Assist playback operator with only a modest cost differential.

Digital Cam				
	DIT	4 Weeks	$1,000.00	$4,000.00
	Data wrangler	4 Weeks	$800.00	$3,200.00
	Video village equipment	4 Weeks	$1,000.00	$4,000.00
	Data backup equipment	4 Weeks	$1,000.00	$4,000.00
	Hard drives for archiving	6 Drives	$200.00	$1,200.00
	Digital Camera Support subtotal			$16,400.00
	Does not include back-up to LTO tape or video tape formats			

FIGURE 2.18

Digital camera support breakdown

Film					
	Loader	4	Weeks	$800.00	$3,200.00
	Video assist technician	4	Weeks	$800.00	$3,200.00
	Video assist equipment	4	Weeks	$1,000.00	$4,000.00
	Kodak - 35mm negative (30 hrs)	180	1000' rolls	$645.00	$116,100.00
	Film processing (CineFilm)	180,000	Ft	$0.18	$32,400.00
	Film transfer HD (CineFilm 1.5X)	45	Hours	$600.00	$27,000.00
	Film Support subtotal				**$185,900.00**
	Dailies transferred as "best light" for Avid or FCP edit				

FIGURE 2.19

Film support breakdown

Digital Finish					
	Post production supervisor	20	Weeks	$1,000.00	$20,000.00
	Composer with studio	1	Flat	$25,000.00	$25,000.00
	Re-recording mix with mixers	80	Hours	$250.00	$20,000.00
	Digital online edit / color grade	60	Hours	$250.00	$15,000.00
	Title graphics	20	Hours	$150.00	$3,000.00
	Deliverables media - masters	1	Flat	$5,000.00	$5,000.00
	Digital Video Finish subtotal				**$88,000.00**
	Does not include recording back to film, errors & omissions insurance				

FIGURE 2.20

Digital finish breakdown

Film (DI) Finish	Post production supervisor	20	Weeks	$1,000.00	$20,000.00
	Composer with studio	1	Flat	$25,000.00	$25,000.00
	Re-recording mix with mixers	80	Hours	$250.00	$20,000.00
	Retransfer film selects	40	Hours	$800.00	$32,000.00
	Digital online edit / color grade	60	Hours	$800.00	$48,000.00
	Title graphics	20	Hours	$150.00	$3,000.00
	Deliverables media - masters	1	Flat	$5,000.00	$5,000.00
	Film (DI) Finish subtotal				**$153,000.00**
	Does not include recording back to film, errors & omissions insurance				

FIGURE 2.21

Film (DI) finish breakdown

2.3.5 CONVERSATION WITH WALT ROSE, SALES AND STUDENT SERVICES, FOTOKEM

Q: What is the prognosis for film as a viable medium and how does your lab see things?

Rose: Fotokem is committed to film as long as film is available to the production market. But even beyond that, Fotokem will continue with lab services because of the significant amount of material that's been generated over many decades that would need to be addressed for archival purposes.

What I'm speaking to are the libraries, not only that the studios have amassed, but also major corporations and companies in the United States, which recorded their history on film for many decades. 16mm and 35mm were the way that information was captured.

So companies like General Motors, Goodyear Tire, etc. have these amazing film-based libraries that are going to require that those elements be either reproduced for an archival element because of film's longevity, or that the film items be brought out of retirement, and subject to some form of duplication – either telecine or digitizing – so that they can be available for commercial or public access. Currently, Fotokem is working with the PGA (the Professional Golfing Association), also with Indie 500 people in Indianapolis. We've also obtained the Goodyear library. All of these are elements that are going to be reviewed, inspected, duplicated and eventually digitized.

That means that the film lab is going to go on. There are no plans to stop production. We currently process the same formats that we have for 50 years. That's 16mm and 35mm. We now do large formats at 65mm, both color and black and white. We do separations and we do inter-positives. If they've shot on reversal, we can make inter-negatives. Those are all long-term archival storage preferences.

Q: When you say the word digitize, are you referring to scanning?

Rose: Well, beyond scanning, the client can either scan or transfer to 1920 by 1080 high def. Then they will take that data and digitize it to some form of file that they'll either use for editorial purposes or they will use perhaps to upload, for social media or educational aspects. So that's what I refer to when I talk about digitizing. It's creating a file that's commercially or educationally beneficial.

Q: But the telecine process, isn't that pretty much being phased out?

Rose: Actually, it's still quite strong based on two factors. One, there's still a great deal of film that is being exposed. There are a number of schools locally, such as New York Film Academy, Cal State Northridge (CSUN), the Academy of Art up in San Francisco and Columbia College in Chicago that are still shooting a lot of film. So we're catering to them. There are also a number of studio productions which are captured on film as well.

Q: So they are shooting on film and transferring to HD video in 1920 by 1280 format?

Rose: Yes, it gives them a high-quality format for dailies. What's interesting is I see that coming out of USC. USC counts itself as all digital. That was the goal that was put before the school by Lucas and partners and the structure was centered around creating that kind of campus. But there's a significant amount of filmmakers that come out of their program and for their thesis projects they now want to venture back and say: "You know what? We tried digital and that's all well and good, but now we want to shoot film." It's an interesting time. Chapman is one of the leading film schools in the world and where they still shoot film. I'm sure it's difficult for the schools to try and predict where they need to be in five years and gear up and actually have the capacity and equipment and the teaching capability.

Digital Video

When digital cameras emerged in the early 1990s, they still recorded to tape in standard definition – as did their analog predecessors – but with no generational loss. While the gauge of tape had narrowed over the years and sensor sizes increased (allowing for greater definition), there was a general lack of interest among mainstream filmmakers due to the limitations of video. A principal drawback was that digital video still produced **interlaced** images, whereas traditional film was, in the vernacular of digital filmmaking, **progressive**. Another drawback was that **NTSC** had inferior **chroma sub-sampling** as it was developed much earlier than its European counterpart **PAL**.[54] Phase Alternating Line is a legacy broadcast standard that was in use in much of Europe, the Middle East and South America (a third less popular standard, SECAM, was used in France and Russia). PAL was more attractive to independent filmmakers as its frame rate is 25 frames per second, which is closer to 24 fps film rate, and features 20 percent more lines of resolution.[55] An example of an early low-budget feature to go this route is *Chuck & Buck* (2000) directed by Miguel Arteta. It was shot in the U.S. using PAL equipment and output to film for its premiere at the Sundance Film Festival.

The logical next step then was for cameras to begin capturing high-definition images using progressive (instead of interlaced) recording methods at 24 fps. While the initial high costs of these HD cameras placed them out of reach for amateur filmmakers, some pioneers embraced digital video as the future. As more films employed these cameras, the cost consequently came down. As the cost of storage came down, more users came onboard. And as the picture quality improved, the differences between digital video and film began to narrow.

2.4.1 HISTORY OF DIGITAL VIDEO IN CINEMA

- *The Celebration (Festen)* (PAL Mini-DV, 1998)
- *Blair Witch Project* (various, 1999)
- *Star Wars: Episode II* (Sony CineAlta, 2002)
- *28 Days Later* (PAL DV, 2002)

Whether to stay within a miniscule budget or to achieve a highly specific look, professional filmmakers took notice of digital technology and began putting it to great use in their projects. In 1995, Danish filmmakers Lars von Trier and Thomas Vinterberg issued a manifesto (Dogme 95) which presented strict rules as to how they believed films should be shot, without artificial lighting and always handheld.[56] The advantage to using small unobtrusive cameras never got in the way of the story and characters. Technology and special effects were essentially banned. Von Trier's first film,

The Celebration, is a dark, yet comical portrayal of a family reunion rocked by revelations of incest by the patriarch. Clearly the formula of good storytelling without any artifice typically seen in feature films resonated with audiences as it was awarded the Jury Prize at Cannes in 1998.[57] Many films directed by von Trier and his colleagues were to follow this doctrine.

A group of young people posing as amateur filmmakers created a feature film with no apologies about the picture quality. *The Blair Witch Project* (1999) was shot on both 16mm and Hi-8 video and spawned a new genre of storytelling known as "found footage."[58] While the bodies were never found, the conceit of the film is that the police located the group's footage and it was edited together to create a timeline of their adventure. Replete with tape glitches, dropouts and shaky camera moves, these technical "flaws" helped to sell the "reality" aspect of the story. The original cost to make the film was US$100,000, but when Artisan Entertainment picked it up, after its premiere at The Sundance Film Festival, the company is reported to have spent over US$500,000 to further enhance the "found footage" aesthetic and prepare it for commercial release.[59] Despite its raw nature and ultra-low budget, *The Blair Witch Project* enjoyed a long run in theaters, ultimately grossing over US$248 million dollars worldwide and spawning a host of sequels and imitators.[60] Other comparable films are *Cloverfield*, *Project-X* and *Paranormal Activity*.

Resistance in the industry towards digital filmmaking was beginning to crumble by the year 2000 when George Lucas announced his intention of shooting *Star Wars: Episode II* (2002) using digital video and employing an all-digital post-production environment.[61] Sony and Panavision teamed up to provide Lucas with the first 24 frame progressive HD camera known as the HDW-F900, which became the first of the CineAlta family of cameras.[62] With new improvements in camera technology it made sense to develop a 100 percent digital pipeline which included presenting the film using digital projectors in a handful of theaters in New York and Los Angeles.

28 Days Later (2002) is a post-apocalyptic horror film set in the UK directed by Danny Boyle (*Trainspotting*, *Slumdog Millionaire*) for a modest budget of US$8 million dollars.[63] Several scenes required shutting down traffic and pedestrians in central London for brief stretches of time. With only 45 minutes set aside each dawn to obtain certain shots, it was determined that multiple cameras would be needed to provide a variety of angles and extra coverage. As many as eight Canon XL1 (PAL, MiniDV) were used as the lightweight and affordable option for shooting this project.[64] Director of photography Anthony Dod Mantle shot numerous tests with the goal to preserve as much detail as possible, and supervised each step towards color correction and printing back to a film negative. Fortunately, the subject matter is quite stark and gritty and the DV footage served to enhance the story rather than detract. It is worth noting that some scenes were still shot on film – possibly due to low light limitations of available digital cameras.

2.4.2 IDEAL USES OF HD DIGITAL VIDEO

Ideal uses include:

- Documentary
- News/broadcast
- Ultra low budget

Current HD video cameras offer high resolution in a compact body at an affordable price for independent filmmakers. Documentaries can afford to travel and shoot with multiple cameras. News broadcasts can use smaller cameras to conduct interviews, Electronic News Gathering (ENG), and collect **B-Roll** footage. Ultra low-budget films can shoot and edit using HD video cameras without

a great deal of extra support of crew and gear and without a steep learning curve. Further benefits include not having to pause shooting as often to download footage, and back-up is relatively easy and inexpensive.

In 2010, one of the first short films to be entirely shot on an iPhone 4 appeared on YouTube.[65] Two graduates of USC film school, Michael Koerbel and Anna Elizabeth James, shot *Apple of My Eye* in two days. It features a fantasy sequence involving a grandfather, his granddaughter and their love of model trains. The behind-the-scenes video demonstrates the extreme portability of the iPhone camera as it is strapped onto a tiny moving train and attached to various dollies. They even made use of the iPhone 4's built in LED light in some sequences.[66] Portions of the film were edited on the iMovie for iPhone app which retails for US$4.99.

FIGURE 2.22

CrowdSYNC timeline

FIGURE 2.23

CrowdSYNC multiple angles

A whole cottage industry of Smart Phone film festivals has since emerged, drawing filmmakers from all over the world and essentially leveled the playing field in terms of allowing access to nonprofessionals to be able to share their stories.[67] Another innovative use of these cameras is an iPhone App known as CrowdSYNC which allows users to upload their videos and be matched up with others who are shooting at the same time and place. Practical use of the App includes coverage of concerts and sporting events which, in effect, create an unlimited *ad hoc* "multi-cam" environment as more

FIGURE 2.24

CrowdSync creates an *ad hoc* multicam environment for iPhone users

users join in.[68] While it may not be practical to shoot a long form project with such small handheld devices, short form video including news pieces have appeared front and center on Facebook, Vimeo and YouTube. Take, for example, the conflict in Syria, which has rarely seen coverage by outside journalists or documentary filmmakers, due in part to the extreme risk involved in shooting there. It is left to the residents of the nation to capture the awful events as they unfold. The access that technology affords us is unprecedented and the impact upon society is profound in ways that are difficult to gauge.

2.4.3 PROS AND CONS OF DIGITAL VIDEO

In order for a digital camera to capture an image and present it in a viewable color space on a display (e.g., **LCD**), the raw sensor information must be interpreted and transformed. This requires a conversion of analog voltage values from the sensor into digital equivalents, which are then encoded to be

compatible with current displays. Digital video cameras produce an **output-referred** image that is ready for broadcast and is sometimes referred to as "what you see is what you get" (WYSIWYG). This is a highly efficient method of capture that allows a director of photography (DP) or producer to acquire an image "as is" and immediately deliver that to the client, editing station or straight to broadcast.

There are many adjustments a DP can make in a digital video camera: white balance, gain, color matrix, gamma curve and more. These allow a great deal of control over the image, but must be carefully decided upon *before* recording. Once the image is recorded there is no going back. It can be color corrected later, but you won't have the same flexibility in image control during post as you did on-set.

Because the footage is more or less finished upon acquisition, there is much less work to be done in post-production to color grade. Workflows are often fairly straightforward and editors may edit using the camera original media without lengthy or costly transcodes to proxies. This also adds the benefit of the edit being of online mastering quality and not requiring an additional conform in an online suite.

Digital video cameras traditionally are designed around broadcast standards and practices. Most of these cameras are designed with a single camera operator in mind. A camera assistant is not needed in most situations. These ENG cameras often sacrifice image quality for the sake of utility. Broadcast cameras are almost always variants on 2/3 inch sensor design and accept interchangeable lenses that conform to the B4 mount standard. This means that these cameras are not natively compatible with cine lenses (using the **PL lens mount**) and have a much greater depth of field, which is more charac-teristic of daytime television, documentary and reality television, and are not traditionally considered cinematic.

Most modern digital video cameras record in HD 1920x1080 at common frame rates. Not all support high frame rates for artistic effect. Additionally, many different compression schemes are used and it is not always possible to record to an external uncompressed or relatively uncompressed recorder. Cameras such as the Canon DSLRs (5D Mark II/III, 7D, 1D X) record H.264 with 4:2:0 chroma sub-sampling (see Figure 10.5 in the Appendix). These compression methods represent a compromise of color information, require transcoding and are often only avoided by using more expensive cameras and recorders.

Digital Cinema Cameras

While independent filmmakers and visual artists took advantage of inexpensive digital video (DV) cameras, the film industry as a whole did not immediately embrace digital acquisition due to its technical limitations. As the first cinema-style video cameras emerged on the market, adoption was slow due to the high cost and the persistence of tape-based acquisition, which limited the image to Rec. 709 (see section 4.3.8, "Essential Colorspaces"). However, it was not long before innovations in sensor technology and the introduction of the **bayer sensor** (see Figure 2.25) ushered in a new era of working with RAW data. In the past decade, upstart companies such as RED and Blackmagic Design have developed systems such as the RED One, RED Epic and the Blackmagic Design Cinema Camera, all of which are effective cinema cameras, but are housed in compact units at fairly modest price points. At an even more affordable level, digital single-lens reflex (DSLR) cameras – traditionally used for still photography – began embracing cinema-style video via high-quality lenses and looks.

WHAT IS BAYER SENSOR?

Sensors consist of millions of photosites that record light and convert it into electrical signals which are then saved as data. Photosites use filters to separate red, green and blue light so only one color is recorded per photosite. The Bayer sensor pattern is arranged in such a way that there are twice as many green photosites than red or blue. The reason for this is that humans perceive greater resolution from brightness rather than color, and green contributes more to our perception of brightness than red and blue. The values from these sensors are then combined to create a full raster pixel image through a process known as debayering (or de-mosaicing).[69] The only caveat is that this process of interpolating the RAW sensor data with the use of algorithms requires significant computing power and time.

2.5.1 HISTORY OF DIGITAL CINEMA CAMERAS

The movement toward digital cinema has its origins in digital video. The technology is fundamentally the same, but the application and goals are different. The Sony CineAlta HDW-F900 laid the groundwork by being the first professional 24p digital camera. One of the biggest hurdles in bringing digital video into the feature film world was overcoming resistance from filmmakers as well as the inherent differences that spanned earlier generations of cameras and displays. Until its release, all video cameras either shot 60i (NTSC) or 25p (PAL). Sony and Panavision worked together to marry Sony's knowledge of digital video with Panavision's design philosophies and optics to produce a system that

FIGURE 2.25

Bayer sensor pattern

would appeal to mainstream filmmakers. "Panavised" F900s were used by George Lucas in the making of *Star Wars Episode II: Attack of the Clones*, regarded as the first major studio picture to be shot 100 percent digitally. However, it was a French film, *Vidocq* (2001), that was the very first all-digital film to be released, which was also shot with the Sony HDW-F900. Subsequent generations of these cameras, such as the Sony F950, offered **4:4:4** recording (see "Chroma Sub-Sampling" in the Appendix) over dual-link **SDI** to **HDCAM SR**, as well as improvements in electronics and image processing.

In 2005, the Panavision Genesis was announced in collaboration with Sony, which integrated existing technologies from the CineAlta camera line with functions and design methodologies similar to traditional film cameras. Variable speed recording (1 to 50 fps) and a single-chip Super 35mm charge-coupled device (CCD) sensor gave much more creative flexibility to filmmakers. The larger sensor enabled compatibility with Panavision's entire line of 35mm cinema lenses, making the camera more attractive to the mainstream film community. The Genesis combined a digital video workflow, using HDCAM SR tapes, with a film-centric color encoding method. **Panalog** could be recorded instead of **Rec. 709** video. This offered filmmakers a way to capture and maintain the full dynamic range that the Genesis sensor had to offer and still maintain compatibility with existing digital intermediate workflows. Like most digital video camera that came before it, the Genesis performed all image pre-processing before recording to tape, yet stayed within the boundaries of existing editorial workflows at a time when RAW recording data rates and processing requirements were still out of reach for most filmmakers.

2.5.2 DIGITAL CINEMA TECHNOLOGY

Many technical aspects of Digital Cinema cameras are reflected from their counterparts in the Digital Video category. Similarities are seen so often that it is sometimes difficult to distinguish between the two. With larger Super 35mm sensors entering the consumer market in cameras such as Canon's T3i

and 7D Mark ii, as well as the introduction of lower fidelity video cameras into the cinema world (*The Blair Witch Project*, *28 Days Later*, *Paranormal Activity*, *Project X*), that line is blurred even more.

At the high end, most Digital Cinema cameras share similar technologies and methodologies. When we talk about cameras like the RED, Alexa and Sony's CineAlta lineup (F65, F55, F5), they include variations on the same technologies with subtleties in their implementations such as RAW encoding and the specific sensors and image characteristics.

Unlike traditional video, Digital Cinema cameras recording in RAW provide filmmakers with much greater flexibility in post-production workflow. Capturing RAW sensor values during production and leaving the interpretation of those values until a later time allows for a greater amount of choice in how that image is manipulated. Because those Camera RAW values are *scene-referred*, there is a significant amount of latitude in the recorded image. The process of translating the RAW values into something viewable is called ***debayering*** (or de-mosaicing in the case of non-bayer sensors). RAW images can be debayered to a number of different color spaces, such as Rec. 709, Log or scene-referred linear. Different workflows require different color spaces. If you are going straight to video and not planning a full color grading pass, you might set some basic look parameters in the debayering software, export Rec. 709 video and be done with it. If you are going to finish in a digital intermediate, then **log** would be the preferred encoding method. It is commonplace to export Rec. 709 dailies for editorial and then re-export necessary shots in log for digital intermediate. RAW provides the choices and flexibility to adapt your workflow rather easily without having to commit upfront and be locked into a single workflow. However, it does require budgeting the time and resources necessary for processing all of the RAW footage before editing can begin. Likewise, there is additional processing after picture lock as you near completion of your project.

One of the major characteristics associated with Digital Cinema cameras is having larger sensors sized similarly to Super 35mm film. Previous generations of digital video cameras often relied on separate chips for each RGB color channel (often referred to as **3-chip sensor** cameras). In 3-chip cameras a set of prisms inside the optical block would split the light onto each of three **CCD** sensors. This required exact precision from manufacturers of lenses and resulted in large, bulky cameras. A 3-sensor Super 35 camera would be impractical because of its size. This drove developers towards a single bayer pattern sensor (hence, debayering, as mentioned previously) that has **photosites** responsive to red, green and blue light. The majority of these sensors (50 percent) are made up of green photosites, with RED (25 percent) and blue (25 percent) contributing less color information. Different manufacturers use different approaches with bayer sensors and some use different patterns all together, but the philosophy remains the same: capture all visible light onto one sensor with photosites weighted for different colors in the spectrum.

2.5.3 WHAT'S RAW ALL ABOUT?

Like film negative, RAW is not ready for projection or viewing. It must first be "printed," or debayered, to a raster image format before being displayed and manipulated.

In a RAW workflow, the camera provides a preview of the destination colorspace for on-set monitoring and viewing, but is ultimately recording the RAW "unfiltered" sensor data with no color processing. Like a film negative, the RAW image contains all of the image data as seen by the sensor. This "digital negative" can be converted to many different flavors of offline proxies for editorial (Avid **DNxHD**, Apple **ProRes** or **H.264**) or uncompressed formats such as **DPX** (see Chapter 4.3, "Color Grading / Digital Intermediate (DI)") Because no color processing has been "baked in" to the image, multiple destination color and **gamma** spaces can be derived from the RAW image. This means that Rec. 709 QuickTimes can be made for offline editorial, uncompressed Log DPX are

generated for color grading, and scene-linear **OpenEXR**s prepared for visual effects. By starting with RAW, it's possible to maintain a much higher standard of quality while still providing many workflow choices.

What's the drawback? Typical digital video files are pre-processed in-camera and don't require heavy processing to view later. RAW files, on the other hand, must be debayered and transcoded in order to be displayed as a viewable image. The debayer process can be demanding even for high-end workstations. For that reason most editorial and visual effects will require debayered raster formats such as QuickTime, DPX or OpenEXR, as opposed to working natively in RAW. This requires skilled color management and supervision.

RAW imaging allows a superior flexibility in both workflow and color correction. Video cameras have always captured an image consisting of pixel data encoded based on the camera's color matrix and predefined color science. In a digital camera, photons pass through the lens and charge photosites on the sensor array. The voltage of the photosites is read by the sensor electronics and passed to an analog to digital converter (A-to-D converter, or ADC for short) where the voltage values are converted to digital values. At this stage, the sensor data has not yet been encoded to a viewable color and gamma space. To do that, it must first pass through a matrix defined by the camera manufacturer that translates the sensor data into a standard color and gamma space as raster RGB (red, green and blue) pixel data. In the case of digital video cameras, that destination is Rec. 709. The color processing involved in transforming sensor data to a video colorspace often results in clipping of highlights and shadows, limiting the dynamic range of the image. Even though the sensor may be capable of capturing a high dynamic range, some of that detail may be lost in the encoding.

2.5.4 RAW ALTERNATIVES (LOG ENCODING)

Despite the many advantages of RAW acquisition, the enormous file sizes and the time and processing power it takes to debayer RAW footage can be a serious challenge to smaller productions. For this reason many camera manufacturers offer alternative recording options. Recording traditional digital video is less attractive due to its limited dynamic range and color grading latitude in post. Arri built the Alexa camera around an alternative that struck a balance between the benefits of pre-processed imagery and the latitude and flexibility of RAW imaging.

Arri's alternative is a custom version of the **Cineon** logarithmic gamma curve used in film transfers and digital intermediate workflows. Alexa **LogC** is recorded to either 1080p or 2K **ProRes** QuickTimes in-camera, or through the use of an external recorder. The Alexa is also designed to record a higher resolution RAW format, **ARRIRAW**. The philosophy here is to provide an easier workflow with less transcoding and smaller data rates for episodic television and independent productions. As a result, the majority of prime-time hour-long dramas are shot on Alexa in ProRes LogC. These LogC images are conformed and sent to the color grading suite where they are graded and output to Rec. 709, but with much the same latitude as a film scan.

Sony offers similar log formats (**S-log, S-log2, S-log3**) for their professional Digital Cinema camera lineup (F3, F5, F55, F65) that can be recorded to a variety of onboard or external recorders. Additionally, the Blackmagic Design Cinema Camera is able to record both log (ProRes and DNxHD) and RAW natively. Having the option to shoot in either log or RAW provides flexibility, allowing the post-production supervisor to tailor the workflow to suit the scale and schedule of production. For theatrical films that involve visual effects, the higher resolution RAW formats are employed. When budgets are tight or the workflow resources modest, recording in log is an easy, high-quality alternative.

Major motion pictures typically record in RAW, whether on Alexa, F65, or RED. However many studio features such as *Chef* (2014) and *Drive* (2011) have shot on Alexa and recorded ProRes. The majority of prime-time dramas elect to capture in log, while most reality TV, daytime shows and sitcoms choose Rec. 709 video.

FIGURE 2.26

Drive (2011) was shot in Alex LogC 1080p *ProRes* resulting in substantial cost savings through economy of workflow

2.5.5 MAINSTREAM DIGITAL CINEMA CAMERAS

Arri Alexa

The Alexa lineup is the third series of Digital Cinema cameras produced by Arri, a German manufacturer of camera and imaging technologies. The Alexa was introduced in 2010 and features a single **Super 35mm sensor** with a standard PL mount for compatibility with traditional cinematography lenses and existing film camera hardware accessories. The Alexa has a built-in recording module that is capable of recording ProRes or DNxHD QuickTimes (at 1080p or 2K) as well as ARRIRAW (at 2880 pixels wide) using the Alexa XR Module, co-developed with Codex. Previously, ARRIRAW recording had only been possible with external recorders, such as ones made by Codex and S.Two. There are 16:9 and 4:3 (for **anamorphic**) variants of the Alexa to accommodate different projects. The Alexa has become the most common camera in prime-time network television and is also a major player in the feature film arena.

There are several different cameras in the Alex lineup: the Alexa Studio, which features a mechanical shutter and optical viewfinder; the Alexa M, which is smaller and contains a tethered processing unit. This latter feature is designed for situations requiring an especially small camera body such that two cameras can be set side-by-side and synced for shooting stereoscopic 3D footage. Arri recently introduced the Amira, which incorporates Alexa sensor and processing technology in a rugged camera body designed for use by a single operator in documentary and broadcast scenarios.

For more information about the Arri Digital camera line, see http://www.arri.com/camera/digital_cameras/.

RED Digital Cinema

Southern California-based RED Digital Cinema produces high-resolution Digital Cinema cameras geared towards a variety of markets, including high-end film and television as well as indie film and music video projects. The company's original camera model, the RED One, is still in wide use today.

The latest camera iterations are the Epic and Scarlet, which are both small, modular camera systems designed to be easily adapted to a variety of shooting scenarios and uses.

The RED philosophy has always centered on capturing RAW, using the company's proprietary Redcode RAW encoding. By reducing on-board image processing, the price and size of a camera is greatly reduced. REDs have been favorites of the indie filmmaking community and are frequently rented out by both high-end rental houses and owner-operators. The lower price point and customizable nature of REDs has attracted many owner-operators, resulting in a highly saturated market. The upside to filmmakers everywhere is that rental prices are within reach for many low-budget and independent productions.

For more information about RED's product line, see http://www.red.com/.

Sony CineAlta

Sony's CineAlta camera line has played a major part in the history of Digital Cinema. The CineAlta pedigree is Sony's enduring line of video cameras that dates back decades. Sony produces cameras for a variety of markets, from consumer to broadcast to the motion picture industry. The Sony F900 has the distinction of being the first camera to be employed on a major motion picture that was shot 100 percent digitally: *Star Wars Episode II: Attack of the Clones.*

The latest line in the CineAlta family includes the F3, F5, F55 and F65. These cameras all serve a variety of markets and users in different ways, but are built from fundamentally unified design philosophies to produce workflows that are compatible and complement each other. As a result, it is not uncommon to see a production mix and match cameras as needed for practical or budgetary reasons.

The F65 leads the pack as the larger, fully featured studio camera. One of the first studio features to employ it was *Oblivion* (2013), starring Tom Cruise. The F65 is equipped with a mechanical shutter system, internal neutral-density filters and high-end RAW recording from an 8K sensor. The F65 is also capable of recording 1080p SR Master files pre-debayered at either **4:4:4** or **4:2:2**, S-log2/3 or Rec. 709. This solution is ideal for episodic television without the budget or time necessary for a RAW workflow. This is comparable to the Alexa ProRes workflow.

The F5 and F55 are also capable of RAW recording, as well as SR Master, XAVC and MPEG2. The variety of recording formats and options provides a great deal of flexibility for filmmakers with challenging budgets or shooting scenarios, while still producing crisp, clear imagery. The F5, F55 and F65 all utilize the latest S-log2 gamma curve for recording 14-stops of dynamic range and S-Gamut – the native colorspace of CineAlta cameras, which is much wider than both Rec. 709 and DCI.

Blackmagic Design

In 2012, Blackmagic Design, a company renowned for making innovative hardware for post-production, announced it was building a camera. The Blackmagic Design Cinema Camera, recording at 2.5K Cinema DNG RAW and 1080p ProRes QuickTimes, quickly became the cheapest RAW digital cinema camera at US$2,995. By 2013, Blackmagic dropped the price to US$1,995 and introduced two new products, the Blackmagic Production Camera 4K at US$2,995 (both include a copy of DaVinci Resolve) and the Blackmagic Pocket Cinema Camera at US$995. As of NAB 2014 the Blackmagic URSA and Studio Camera have been added to their lineup.

With each of these cameras recording in either Cinema DNG RAW or ProRes (either BMD Film log or Rec. 709), they can easily and affordably create cinematic images. The Cinema Camera

and Production Camera 4K are both unconventional designs. Unlike the majority of broadcast and digital cinema cameras out there, some of the BMD cameras feature touch screen viewfinders on the back of the camera instead of the side. The cameras are very small with a short depth. Roughly the size of a DSLR, the Cinema and Production cameras can both easily fit into most DSLR rigs and use many of the same accessories. The Pocket Cinema Camera has a Micro Four Thirds (**MFT**) mount, the Cinema Camera comes in either MFT or EF models, and the Production Camera has an EF mount. These flexible mounting options enable filmmakers to use less expensive Canon lenses that are frequently used on DSLRs. The MFT mount allows for short, low-profile lenses, as well as adapters for using standard PL mount lenses commonly found at film/TV rental houses.

While none of these cameras are intended to compete with the Alexa, RED or F65 at the studio level, they do offer an extremely low-cost entry point for "up and coming" filmmakers, with higher quality recording technology than DSLRs in the same price range. The Blackmagic Pocket Cinema camera is a great value for high-end productions that often use a GoPro style camera as a crash-cam, or for other shots where it's too dangerous to utilize a larger, more expensive camera. The Pocket Cinema camera offers full raster 1080p recording in either RAW or ProRes, which is a significant improvement over GoPro and much cheaper than shooting film.

For more information about Blackmagic Design's product line, see http://www.blackmagicdesign.com/products

2.5.6 SPECIALTY DIGITAL CINEMA CAMERAS

There are many cameras that are purpose built for specialized conditions that are not generally considered practical for traditional narrative films. These include high-speed and miniature cameras. Camera manufacturers are faced with an interesting challenge: instead of making a camera that can do everything at an extremely high price, they must choose which features of the camera are most important to their customers. Some will target specific goals and make compromises that limit the likelihood of their camera being used in other scenarios. For example, a well-designed high-speed camera may not have the ideal color science or image qualities that a cinematographer wants when photographing human subjects. Yet, that camera is essential for filming slow-motion action shots. This is why it is not unusual for big productions to mix and match different formats in the same film, sometimes in the same sequence, resulting in different cameras filming separate plates used in the same composite.

Vision Research's Phantom is perhaps the most well-known specialty camera, synonymous with jaw-dropping slow motion photography. Vision Research offers a variety of Phantom models, ranging from standard-sized cameras to miniatures that can be used in tight quarters. Each of their cameras has their own specialties and capabilities. The Phantom principally records to a Phantom RAW (.cine) format, which can be debayered by a variety of software programs, including Black Magic's Davinci Resolve. The Phantom has been used in countless films, TV shows and commercials. However, producers should consider that recording with a Phantom means that there will be a lot of data to manage. Adequate resources, time and personnel must be made available to guarantee that those great looking high frame rate shots are safely stored and nothing is lost.

P+S Technik's Weisscam HS-2 and X35 are alternatives to the Phantom and are less common, but still great options for slow motion photography. The Weisscam records to high-speed internal memory. There is an optional RAW recording deck, which can be used to capture 2K RAW images, but it is typical to record to an external digital video recorder at 1920x1080 in Rec. 709. This generates less data and represents a more manageable and affordable solution for a production shooting a

lot of slow motion. The Weisscam utilizes a ring-buffer approach in which the camera is constantly recording images to memory, and once the memory is full, it starts writing over the oldest images. This makes it easier to record spontaneous action that is unpredictable – especially useful in wildlife photography. As soon as the action begins, you have a limited time (as defined by the frame rate and image quality) before the camera will start recording over older frames. It takes practice and skill for the camera operator to know when the opportune time to cut is, ensuring that they get the best parts of the action at the end without losing too much from the beginning. When shooting upwards of 2000 frames per second, you may only have room in the camera memory for a second or two of real-time action!

Silicon Imaging's SI-2K is an older camera, but has been used extensively in films such as *Slumdog Millionaire* and *127 Hours* by cinematographer Anthony Dod Mantle and director Danny Boyle, and was recently used in *End of Watch* (2012). The SI-2K Mini is a camera system that involves the camera head (containing the sensor and minimal image processing hardware) and a tethered computer (either a laptop in a backpack or a Cinedeck) that handles the recording. This provides a camera operator with a very versatile, low-profile camera that can be moved and set up quickly, in ways that larger traditional cameras cannot. The SI-2K has a 16mm sensor and records 2K Cineform RAW, which can be processed by a variety of third-party applications.

GoPro is now a household name and is used by millions of people around the world to capture amazing sports, action point of view (POV) and time-lapse photography that previously were out of reach to the general public. The GoPro is so light and small it can fit almost anywhere. The film industry has begun heavily utilizing the GoPro in car-mount, close quarters photography, found-footage films and reality TV projects. Some productions have been known to employ as many as 20 GoPros in a single set-up. Because they are so cheap, they are often used as crash cameras. The biggest challenge might be locating the camera after the shot is over!

Some of the drawbacks of the GoPro are that it produces heavily compressed footage, and the small sensor and extremely wide-angle lens do not always fit into narrative films. But their uses in action photography appear to be limitless and they will continue to be an essential part of the film experience on both the big and small screen.

Digital Single-Lens Reflex (DSLR) Overview

2.6

Digital Single-Lens Reflex (DSLR) cameras were originally developed by companies such as Olympus, Nikon and Canon to replace the traditional 35mm still cameras. They operate in the same way as their predecessors, employing a mirror system that allows the viewer to see directly through the lens. How they differ is in the back of the camera where celluloid film has been replaced by a powerful sensor.

During the development of DSLR, engineers realized that in addition to capture of stills, extra circuitry could be added to accommodate moving images. In 2008, the Canon 5D Mark II (and later the Canon 7D) emerged as one of the most promising new tools for the digital cinematographer. Allowing for interchangeable lenses along with large sensors that offered shallow depth of field (**DOF**), DSLRs were quickly embraced by indie filmmakers as the alternative to expensive, bulky Digital Cinema cameras.

The compromise in performance of the DSLR comes in the recording. The typical codec **H.264** is perfectly suited for web and Blu-Ray playback, but is not optimized for most editing systems. H.264 and **MPEG** codecs are highly efficient 8-bit formats and allow for a lot of footage to be stored on a small flash device or memory card. H.264 uses long **GOP** (group of pictures) compression, which means most frames are interpolated from keyframes making it more processor intense for nonlinear systems to edit "natively." When it comes time to edit, all the footage must be transcoded to a 10-bit format (such as ProRes or DNxHD) which takes time and requires additional processing.

2.6.1 HYBRID BETWEEN VIDEO AND DIGITAL CINEMA

The DSLR is considered a hybrid, not only because it captures both still and moving images, but also because it bridges the gap between video and Digital Cinema cameras. Similarities to video cameras include lightweight, highly portable camera bodies, as well as Rec. 709 referred recording, resulting in consumer-level compression and WYSIWYG color space. And like a Digital Cinema camera, it contains a much larger sensor (35mm or greater), offering increased dynamic range (latitude) and improved performance in low light conditions.

The Canon 5D Mark II was the first to offer an oversized, full aperture sensor (36mm by 24mm), which represented the equivalent of an 8 perf horizontal piece of 35mm film (similar to **Vistavision**, one of the early wide screen film formats). This scale created an extremely shallow depth of field which may be considered an integral part of the film experience and thus is highly sought after by filmmakers. Later model DSLRs offered a APS-C, close to Super 35mm sensor with a similar flange depth to earlier film cameras, and can be adapted to accommodate Canon PL lenses or Panavision PV lenses.

The DSLR has proven to be an essential tool in providing the cinematic look and feel at an affordable price, while still able to use prime lenses that most directors of photography (DPs) already own or rent.

2.6.2 USE IN INDEPENDENT PRODUCTIONS

Independent feature films and music videos have discovered the value that DSLRs offer in an inexpensive, compact and easy-to-use camera system. Many student filmmakers already own them and use them as a back-up camera. Low budget feature productions such as *Tiny Furniture* (2010) were able to use the cameras to their advantage, and as director Lena Dunham points outs:

> If you want to be a filmmaker and you have a small personal story to tell, it is very much within your reach. I've made 2 low budget features and each one was an incredible learning experience. It's almost like your own film school.[70]

With a modest budget of US$45,000 the team wisely shot tests and consulted with their colorist – Sam Daley at Technicolor NYC – prior to beginning production. Eventually they agreed upon a workflow where they would transcode the footage to ProRes for editorial, then **up-res** to **10-bit uncompressed 4:2:2** QuickTime once they had achieved picture-lock to perform the final color correction:

> The Apple ProRes codec worked very well. The image looked great and the file size was manageable for editorial. There was no need to return to the native H.264 files. The 10-bit QuickTime was important for color correction as it gave me the bit depth necessary to create windows and secondary isolations.[71]

Daley recommends a "save it for later" approach:

> Capture as much image information as possible, protecting highlights and shadow areas via either lighting or camera settings. Be particularly careful not to clip highlights on faces, heads, and hair; you can't get that detail back. With a simple gamma curve adjustment in your color correction system, you can get those images to a contrast level that is more rich and cinematic, and less flat and "video."

FIGURE 2.27

Tiny Furniture (2010), director Lena Dunham

2.6.3 USE IN SPECIAL CASES

DSLRs also perform well as a B camera, **crash camera** or for use in tight quarters. One of the first primetime TV shows to give the camera system a tryout, *House M.D.* opted to shoot an entire episode using the Canon 5D Mark II. Director Greg Yaitanes was able to work in tight spaces and still use three cameras:

> "I really was drawn to the DV aesthetic which was beyond a cinematic look, it just gave a new level of being able to pull the actors out of the background and pull them in right to your face and give an intimacy that I hadn't seen in digital or film."

Upon viewing the final episode, commercial photographer and director Vincent LaFloret made these observations on his blog:

> The Canon 5D MKII and HD DSLRS in general offer an incredible entry into filmmaking for a wide variety of individuals that would otherwise never have access to similar tools that would allow them to obtain the 'professional film' look. The economic barrier that has been around for so long (in terms of the incredibly high cost of cinema equipment) is being chipped away in part – due to the low cost of these camera bodies.[72]

2.6.4 PROS AND CONS

The limitations of DSLR photography systems include the following:

- Low dynamic range (greater than some HD video cameras, but considerably less than high-end Digital Cinema cameras)
- Extremely high compression and long **GOP** (using H.264 codec) making compatibility with editing systems tricky
- Low sharpness caused by pixel binning and improper optical low-pass filter (**OLPF**) resulting in **aliasing**
- Low spatial resolution (**MTF**) and inability to capture high frequency detail, resulting in **moiré** (example: patterns that shimmer on clothing)
- **CMOS** smear (also known as the "Jello Effect") causing straight lines to bend while panning

The advantages of DSLR are:

- Modest cost
- Lightweight, small and able to fit in tight spaces
- Use of professional interchangeable film-style prime lenses
- H.264, though heavily compressed, allows shooting for hours without running out of hard drive space

2.6.5 TECHNICOLOR CINESTYLE

In response to industry demands from cinematographers for better color management tools, Technicolor, in cooperation with Canon, created a film-style log curve known as Cinestyle Profile. It increases the dynamic range of DSLR-acquired footage and improves grading flexibility. It is a custom proprietary look preset offered as a free download that integrates DSLR into a "film-style" workflow. Instead of clipping the highlights and shadows, it helps to preserve them and allows for more choices during the color grading process. While not a perfect solution for dealing with DSLR footage, it represents a solid improvement.

From the Cinestyle FAQ page:

When the Technicolor Cinestyle Profile is selected in the camera, video images are recorded in log space. The image will appear flat and de-saturated, though there is actually more detail retained in the shadows and mid-tones which is excellent for color grading.[73]

2.6.6 MAGIC LANTERN

Magic Lantern is a third-party firmware hack for Canon DSLRs that has become very popular in the filmmaking community. It is completely *unsupported* by Canon. It is a freeware, use-at-your-own-risk product that enables additional functionality for power-users.[74] It is completely legal as it does not infringe on any Canon patents or software code, but instead is reverse engineered through trial and error and by analyzing documented hardware code.

Magic Lantern is compatible with most low to mid-range Canon DSLRs, primarily the Canon 5D Mark II and Mark III. It expands the hardware capabilities of the Canon DSLRs to provide additional features and functionality, such as:

- Audio meters
- Exposure helpers: **zebras**, false color, **histogram**, **waveform**, **vectorscope**
- Focus assist: **peaking**, zoom while recording, **trap focus**, follow focus
- Greater control over bitrate and frame rate
- **DNG RAW** recording

Some of these features are simple improvements; others are major. The addition of RAW recording capability greatly increases the camera's potential. It also greatly increases one's storage demands. Previously, the only way to preserve greater dynamic range in video mode was through Technicolor Cinestyle, which produces an 8-bit log output.

2.6.7 DOCUMENTARY SHORT: *BABY FACED ASSASSIN*

FIGURE 2.28

Baby-Faced Assassin (2014), director Jona Frank

Conversation with Director Jona Frank and Editor Chris Kursel on the Making of a Documentary Short, *Baby Faced Assassin* (2014)

Q: How did you come across the subject matter and decide to make a documentary film about a Super Flyweight boxer in Liverpool?

Frank: This is a connection made over 20 years ago when I first got out of college. I used to drive around the country taking photographs. At a youth hostel in New Orleans I met these two Englishmen and we just hit it off and wound up hanging out in New Orleans. They were from this small town outside of Liverpool, a suburb called Ellesmere Port.

One of the Englishmen talked a lot about how he wanted to be a writer and wanted to live a creative life. I was just trying to figure out how to be a photographer at the time. So we had this connection and this friendship and wrote to each other for a long time and saw each other a couple of times over the 20 years.

My husband, Patrick Loungway, was working on *Pirates of the Caribbean* in London in 2010. I went to visit him and during that trip I went to see my friend and he brought me to this gym. When I first went to the gym I became gripped by it and had this unique access to this community. It felt like it really fit with the other work I've done where I was looking at adolescents and examining this "point of decision." That is when adolescents start to build their identity and discover what they like about their lives and are just beginning to have dreams about what they want to pursue.

I loved how the gym was the place where people in this town came together. The boys developed this camaraderie with each other. There was this one boy that really stood out, Paul Butler. He became sort of a local hero because he was turning pro. He was 21. So over two years I traveled back and forth. I was photographing and trying to figure out how this could be a documentary project.

Then in June of 2012, I went to see a pro fight of Paul's in London. There was so much drama around this fight. It was amazing to witness it. I kept thinking this would make a great short film – the week leading up to this fight. The other fighter was 7 pounds overweight and there was a huge argument between the coaches and Paul's dad whether or not Paul should fight the guy and that he didn't honor his agreement to train the way he should have. It was hugely dramatic and so Paul said: "I want the fight." It went ten rounds and he got hit in the head and his eye was cut. It was super dramatic.

In November, I'd heard that he was going up for his first title fight. I thought: "Okay, I want to get myself there and I want to make a short film about this." So I scrambled to try to figure out how to shoot it. I wanted to shoot it in Super 16mm. We were going in that direction until about a week before. That's when I realized it was all out of pocket and it was going to cost me so much more money – acquiring Super 16 stock and getting the film developed and sent back to the U.S., but also the need for more camera support.

So we wound up shooting it with the Canon 5D. Andrew Turman shot it. Andrew and I flew over and I hired a sound person in Liverpool. My friend Steve Lawson (the one who introduced me to the gym) coordinated it. So, it was the four of us. Steve did all the driving and helped arranged for picking up all the equipment in Manchester.

So we shot for a week. We were so ridiculously prepared to shoot the fight and had all these different places mapped out about where to shoot. However, the fight, as you know, lasted 1 minute and 9 seconds, [Laughter] which in the end worked really well for the film, because we didn't have to show a ten round fight. Essentially what we're looking at is the result of about a week or so of shooting in Liverpool.

It was a single camera with Andrew shooting the majority of it. I had a 5D as well for some B roll. Then Patrick and I made one trip this February to do pick-ups.

Q: What was your routine for backing up and verifying the material?

Frank: We downloaded every night. We had three drives. So we did a triple back-up.

Q: How much footage did you end up with?

Frank: About 7 hours.

Q: Chris, how did you two meet and when did you come on board?

Kursel: I work at a company called Lost Planet, which is owned and operated by Hank Corwin, who is an amazing editor. Gary is the executive producer here and he's friends with Jona. I had worked with Jona on some other small projects. I had colored something for her and we crossed paths again. Another producer, who was working here at the time, Jacqueline Paris, became involved with Jona's production of this film and she made the case for me to cut it. Jona and I met about it and talked with Gary and we decided from there that I would edit it.

Q: So, it was already in the can. When did the fight take place?

Frank: The fight took place in November. Afterwards, I looked at everything and went back in February. And then we were sort of talking back and forth, but it didn't get more serious about which direction to go until about June. I didn't do any cutting myself. I made a lot of notes and tried to get a real sense of direction by giving Chris a couple of places to start the film, kind of how to get into it, all of which he ignored. [Laughter]

But I was so happy with the first five minutes when I saw it, I felt like it didn't matter.

I'd been trying to do more commercial stuff. Knowing different people in the commercial world kind of connected me with Chris and seeing another doc that he cut that I thought was really well done – and feeling through our conversations that he had a really good sensibility. I wanted someone to understand how Paul was this super athlete. How he was a total oddity in this town and that his super athleticism and the attention to his body and his health was uncommon for this town. I think that everybody around him seems so much older than they actually are. They're out of shape. Here he is this kind of baby face.

Chris and I talked a lot about how I wanted the film to have this sense of just being layered with audio and with visual, and that the visuals could repeat themselves. He really connected with that. I think my favorite part of editing the movie is that it's better than I could've wanted it to be. In this case Chris was able to take it much further.

Q: What did you cut it on, Chris?

Kursel: I cut it with Final Cut Pro 7. I've actually never used 10. So I can't speak to that. But I'm holding onto 7. I really like it.

Q: How do you go back and forth in terms of collaboration?

Kursel: I like to talk with a director early on. To me those conversations serve more to get on the same page philosophically and tonally. It's hard to speak to themes

before seeing everything. We can talk in generalities about what themes you wish to present.

It does help for me to have a new fresh conversation once I've seen everything, which we did. I like to watch footage with an open mind and allow it to say what it wants to say. I like to perceive whatever's happening in that 7 hours of footage or, in the case of a feature, 80 hours of footage, and trust what my perception is, and then my task is to try and turn that into 20 minutes.

We are talking about what themes I see in the footage, but the director has actually been there and has experienced the place in way more depth than I have. I have this very limited view of that place from the footage. On the other hand, I have a more objective view of what has been shot. In those discussions, Jona would say: "I'm interested in telling this kind of story." And then I may say: "Well that story is there to some extent but this one over here is more prevalent."

I cut the first 5 or 6 minutes pretty fast and then showed it to Jona. My preference would be to show a full cut with a beginning, middle and end. I prefer not to show a director just sections by themselves because that that can lead to criticisms or opinions of material that haven't totally jelled yet. But because of time constraints, I showed her the first section and she was into the tone and the pace and everything. It was like: "All right, let's just keep going." So over the next month and a half I worked sparsely just because I was very busy with other projects.

Frank: It was important for me that the movie felt like you were in Paul's head. From the first minute of the movie with him running and talking about what he wants out of his life, I felt like we were in his head and I loved that choice. I thought that that was a super smart decision. I kept saying that I wanted to start in the gym, but by starting outside, with him running, we immediately feel like we're not in the United States. We hear his voice. It's a different location and we're being taken somewhere and I love that about the opening.

Q: How long was the first cut?

Kursel: It was about 18 minutes. I think that was the first full rough cut. It actually got a little longer because there was some footage that I didn't realize was in there. I had more footage of the actual fight than I thought I did. So the fight became a bit more robust and the film got a little longer. The fight is basically 100 percent comprised of broadcast footage. There were three or four cameras set up for TV broadcast.

Q: I really enjoyed the temp music selections and the way that you weaved in both the narration and voice-over. How did you go about selecting the music and are you able to clear it? I see you've got Unkle in there and The Pogues, along with Swedish House Mafia.

Frank: If we can't clear those tracks then I'm going to have to remix and find new music. The Unkle music choice was all Chris. I didn't know the band at all. I love that music. So it's going to be hard to let that go. We'll see what we can do.

Kursel: Unkle is a group that I've enjoyed for a long time. Picking music is very mysterious. I don't have a great memory and I don't have a huge catalog of music in my brain. Often times the music that I like using in a film or commercial, it's by chance as to what happens at the time. I listen to a lot of music while I'm watching dailies or thinking about the movie. I let chance take a role in finding music for scenes. It's so subjective. I've always enjoyed that aspect of editing. But I'd

be lying if I said I knew that music would work. It was more like it felt right for that moment. And once we tried it and went with it, then it actually took on a life of its own.

Q: Chris, with your background editing commercials, how did that prepare you for cutting a documentary?

Kursel: It's hard to say. I guess editorially it prepares me because you're forced to be very economical. You're forced to collaborate with people and internalize their intention, and then add in your own intentions. Psychologically for me, it feels good to cut something of length and substance after cutting 30 second commercials for a while. Conversely, it feels good to cut a 30 second spot after cutting something of length and substance too. Cutting commercials can be fun. It can also be frustrating. But I think it's been a valuable exercise and practice for me.

Q: It certainly makes you quick.

Kursel: Yes, which is something I also enjoy. I like to work fast and go instinctually with it. Commercials, because of the deadline, work perfectly for that.

Frank: There's one other thing that I really appreciate about Chris. Andrew and I laughed about it after we saw the first cut. On the first day of shooting, it was at Arney's Gym. My 5D kept locking up. It was frustrating and we kept trying to figure out why. So we ended up with these random shots on it just rolling and then it would lock and Andrew was trying to fix it. We were not looking through the camera. Nothing was intended. Yet some of those shots ended up in the movie. Everybody's just sort of laughing about it now because it was a testament to Chris that he really did look at everything. Also they worked really nicely, like the empty boxing glove on the floor of the ring, and these different pieces that added to that sense of layering the film but also of looking at things from multiple perspectives.

Q: That's an important concept because it just goes to show that you have to look at *everything* including the outtakes and the false starts because you never know what you'll find.

Kursel: There's a lot of gold in there. There's a lot of movement that you just can't execute. I love finding things like that. They're little diamonds.

NOTES

1. *The Cutting Edge: The Magic of Movie Editing*, DVD, directed by Wendy Apple (Hollywood, CA: American Cinema Editors, British Broadcast Corporation and NHK Japan, 2004).

2. An example is seen in modern railways and the origins of determining the gauge of their tracks (4 feet, 8.5 inches). In antiquity when Imperial Rome sent armies down roads they built throughout Europe, the chariots formed distinct ruts and this happens to be almost the exact distance between wheels used back then as today. Cecil Adams, "Was Standard Railroad Gauge Determined by Roman Chariot Ruts?," February 18, 2000, http://www.straightdope.com/columns/read/2538/was-standard-railroad-gauge-48-determined-by-roman-chariot-ruts

3. "Definition of Intermediate," http://www.oxforddictionaries.com/definition/english/intermediate, accessed October 7, 2013.

4. See "Log" vs. "Lin" in Appendix.

5. As digital acquisition becomes the norm and film prints are phased out, the term Digital Intermediate no longer applies and is more commonly referred to as color grading.

6. "Announcement on Motion Picture Film Business of Fujifilm," September 13, 2012, http://www.fujifilm.com/news/n120913.html.

7. "Chronology of Film History," http://www.digitalhistory.uh.edu/historyonline/film_chron.cfm, accessed October 7, 2013.

8. "The Brownie Camera @ 100: A Celebration," http://www.kodak.com/US/en/corp/features/brownieCam/ accessed October 6, 2013.

9. Beth Jinks, "Kodak Moments Just a Memory as Company Exits Bankruptcy," September 3, 2013, http://www.bloomberg.com/news/2013-09-03/kodak-exits-bankruptcy-as-printer-without-photographs.html

10. David Cohen, "Kodak Emerges from Bankruptcy," *Variety*, September 3, 2013, http://variety.com/2013/biz/news/kodak-emerges-from-bankruptcy-1200597234/

11. Carolyn Giardina and Adrian Pennington, "CinemaCon: End of Film Distribution in North America Is Almost Here," *The Hollywood Reporter*, April 15, 2013, http://www.filmjournal.com/filmjournal/content_display/news-and-features/features/technology/e3if39ea13de8833fabf6e97b4c2a8c7f79

12. See http://www.filmjournal.com/filmjournal/content_display/news-and-features/features/technology/e3if39ea13de8833fabf6e97b4c2a8c7f79

13. "Informal Survey Shows 50% of Major Features Acquired on Film," December 31, 2013, http://www.digitalcinemasociety.org/news/informal-survey-shows-50-major-features-acquired-film.

14. David Cohen, "Filmmakers Lament Extinction of Film Prints," *Variety*, April 17, 2013, http://variety.com/2013/film/news/film-jobs-decline-as-digital-distribution-gains-foothold-1200375732/.

15. "Digital Cinema Technology Frequently Asked Questions," http://mkpe.com/digital_cinema/faqs/tech_faqs.php, last modified June 2013.

16. David Lieberman, "Digital Cinema Distribution Coalition Launches Satellite Movie Deliveries And Names A CEO," October 23, 2013, http://www.deadline.com/2013/10/digital-cinema-distribution-coalition-launches-satellite-movie-deliveries-and-names-a-ceo/.

17. David Hill, "Movie Theaters Ramp Up for the Next Big Thing: Satellite Delivery of Digital Films," SingularityHUB, April 27, 2012, http://singularityhub.com/2012/04/27/movie-theaters-ramp-up-for-the-next-big-thing-satellite-delivery-of-digital-films/.

18. "Ultra High Definition Television Wikipedia page," http://en.wikipedia.org/wiki/Ultra_high_definition_television_-_Color_space_and_frame_rate accessed October 2. 2013.

19. Geoffery Morrison, "What Is the 'Soap Opera Effect'?," http://www.cnet.com/uk/news/what-is-the-soap-opera-effect/ last modified December 15, 2013.

20. "The Hobbit: An Unexpected Journey IMDb page," http://www.imdb.com/title/tt0903624/, accessed September 29, 2013.

21. Gen Yamato, "The Hobbit 48 FPS Preview Divides Audiences at CinemaCon," April 25, 2012, http://movieline.com/2012/04/25/the-hobbit-48-fps-preview-divides-audiences-at-cinemacon/.

22. "Ultra High Definition Television Wikipedia page," http://en.wikipedia.org/wiki/Ultra_high_definition_television_-_Color_space_and_frame_rate accessed October 2, 2103.

23. "Avid DNxHD Technology," http://www.avid.com/static/resources/US/documents/dnxhd.pdf, accessed October 19, 2013.

24. "Apple ProRes White Paper," last modified July 2009, http://www.apple.com/support/finalcutpro/docs/Apple-ProRes-White-Paper-July-2009.pdf

25. Avid MXF files must be rewrapped using QuickTime in order to be compatible with Final Cut Pro.

26. Q & A with Dr. Jan-Christopher Horak, director of UCLA Film and Television Archive, Folino Theater, Dodge College of Film and Media Arts, Chapman University, September 10, 2013.

27. "How does 4K compare to 35mm film?," RED Cinema support page, https://support.red.com/entries/22820071-How-does-4K-compare-to-35mm-film, accessed October 17, 2013.

28. Germain Lussier, "/Film Interview: IMAX Executives Talk 'The Hunger Games: Catching Fire' and IMAX Misconceptions," December 2, 2013, http://www.slashfilm.com/film-interview-imax-executives-talk-the-hunger-games-catching-fire-and-imax-misconceptions/.

29. "The Digital Dilemma 2: Perspectives from Independent Filmmakers, Documentarians and Nonprofit Audiovisual Archives," accessed October 13, 2013, http://www.oscars.org/science-technology/council/projects/digitaldilemma2/

30. "Believe It or Not: Avatar Takes 1 Petabyte of Storage Space, Equivalent to a 32 YEAR Long MP3," accessed October 20, 2013, http://thenextweb.com/2010/01/01/avatar-takes-1-petabyte-storage-space-equivalent-32-year-long-mp3/#!q4Zf9

31. Jeff Bertolucci, "'The Hobbit' Creates Big Data Challenge For Moviemaker," *InformationWeek*, January 2, 2013, http://www.informationweek.com/big-data/big-data-analytics/the-hobbit-creates-big-data-challenge-for-moviemaker/d/d-id/1107980?

32. "LTO Ultrium Generations," http://www.lto.org/technology/generations.html, accessed September 18, 2013.

33. "Ultrium LTO Technology," http://www.lto.org/technology/index.html

34. Marc Graser, "Archive Prints Lost in Universal Fire," *Variety*, June 3, 2008, http://variety.com/2008/film/news/archive-prints-lost-in-universal-fire-1117986831/

35. Jon Brodkin, "For One Cent a Month, Amazon Glacier Stores Your Data for Centuries," August 21, 2012, http://arstechnica.com/information-technology/2012/08/for-one-cent-a-month-amazon-glacier-stores-your-data-for-centuries/.

36. "Final Cut Pro Wikipedia page," http://en.wikipedia.org/wiki/Final_Cut_Pro, accessed October 19, 2013.

37. "American Cinema Editors Society 2008 Equipment Survey," American Cinema Editors Society, June 21, 2009.

38. Josh Ong, "Final Cut Pro X Draws Mixed Reactions from Consumers, Professionals," *Apple Insider*, June 22, 2011, http://appleinsider.com/articles/11/06/22/final_cut_pro_x_draws_mixed_reactions_from_users_professionals

39. "Larry Jordan – Is FCP X Ready for Professional Use?," YouTube video, 52:52, posted by "CPUG Network SuperMeet", September 20, 2013, https://www.youtube.com/watch?v=sk4eTu5nEWc

40. Founder and CEO of Light Iron Digital, Michael Cioni has started a conversation about industry resistance to change and innovation: "Sampling Technology: Examining Noteworthy Innovations in Production & Post," Vimeo video, 18:56, posted by "Light Iron," http://vimeo.com/73797466 accessed September 16, 2013.

41. Philip Hodgetts, "Final Cut Pro X is faster!," August 4, 2013, http://www.philiphodgetts.com/2013/08/final-cut-pro-x-is-faster/

42. "The Rise and Fall of Kodak: A Brief History of The Eastman Kodak Company, 1880 to 2012," http://photosecrets.com/the-rise-and-fall-of-kodak, accessed October 14, 2013.

43. 1997 was a milestone year as it also marked the arrival of the DVD. Frederik L. Nebeker, "STARS: Motion Pictures," http://www.ieeeghn.org/wiki6/index.php/STARS:Motion_Pictures, accessed October 15, 2013.

44. Matt Zoller Seitz, "R.I.P., The Movie Camera: 1888–2011," October 13, 2011, http://www.salon.com/2011/10/13/r_i_p_the_movie_camera_1888_2011/.

45. "Introduction to Film Gauges by Jan-Christopher Horak," http://archive.today/xt5rw, accessed September 16, 2013.

46. Richard Verrier, "Paramount Stops Releasing Major Movies on Film," *Los Angeles Times*, January 18, 2014, http://www.latimes.com/entertainment/envelope/cotown/la-et-ct-paramount-end-to-film-20140118-story.html

47. "Bird's Eye View of San Francisco, CA, from a Balloon," Thomas Edison, (Library of Congress, Motion Picture, Broadcasting, and Recorded Sound Division, 1902). https://www.youtube.com/watch?v=7epAKTXJCpQ

48. "Buster Keaton – The General," YouTube video, 1:15:07, posted by "Bernard Welt," January 18, 2012, http://www.youtube.com/watch?v=ilPk-SCHv30.

49. "D.A. Pennebaker," http://en.wikipedia.org/wiki/D._A._Pennebaker.

50. Oliver Peters has an excellent blog detailing all aspects of editing and post-production. The complete budget can be downloaded at http://digitalfilms.wordpress.com/2012/08/21/film-budgeting-basics.

51. Film raw stock commonly comes in rolls of 1000 feet/400 feet for 35mm and 400 feet for 16mm. A good rule of thumb for 35mm is to allow for 10 percent waste of unused portion of some roll known as "short ends."

52. Processing usually takes place overnight and requires transporting the camera original to a lab prior to their "cut-off" deadline. The developed negative is then prepped and made ready for scanning.

53. Scanning is billed by the hour and often takes place at the lab very soon after processing. Budget for time and half (or 1.5 X the amount of footage) to allow time for set-up (aligning the film for color and framing charts) and for the operator to start and stop occasionally in order to achieve what is referred to as "best light" color timing for dailies.

54. "NTSC," http://en.wikipedia.org/wiki/NTSC.

55. "PAL," http://en.wikipedia.org/wiki/PAL.

56. "Dogme 95: The Vow of Chastity (abridged)", http://cinetext.philo.at/reports/dogme_ct.html, accessed February 15, 2014.

57. "FESTEN – Festival de Cannes," http://www.festival-cannes.com/en/archives/ficheFilm/id/4907/year/1998.html accessed February 15, 2014.

58. "Blair Witch – Discovered Footage," http://www.blairwitch.com/legacy.html, accessed October 7, 2013.

59. "'The Blair Witch Project' 10 Years Later: Catching Up with the Directors of the Horror Sensation," July 9, 2009, http://popwatch.ew.com/2009/07/09/blair-witch/.

60. "The Blair Witch Project Box Office Mojo page," http://boxofficemojo.com/movies/?id=blairwitchproject.htm, accessed October 7, 2013.

61. Jim Mendrala, "A Brief History of Film and Digital Cinema," Tech-Notes.tv, last modified April 23, 2011, http://www.tech-notes.tv/Dig-Cine/Digitalcinema.html.

62. "CineAlta," http://en.wikipedia.org/wiki/CineAlta.

63. "28 Days Later Box Office Mojo page," http://www.boxofficemojo.com/movies/?id=28dayslater.htm accessed October 7, 2013.

64. Douglas Bankston, "Anthony Dod Mantle, DFF, Injects the Apocalyptic 28 Days Later with a Strain of Digital Video," *American Cinematographer Magazine*, July 2003, http://www.theasc.com/magazine/july03/sub/index.html.

65. 13 "APPLE OF MY EYE – an iPhone 4 movie / film," YouTube video, 1:28, posted by "majek pictures," June 27, 2010, http://www.youtube.com/watch?v=6amrKRmI1bI.

66. Bryan M. Wolfe, "Filmmaking on an iPhone 4," AppAdvice.com, June 29, 2012, http://appadvice.com/appnn/2010/06/film-making-iphone-4.

67. "iPhone Film Festival" Facebook page, https://www.facebook.com/iphoneff, accessed January 15, 2014.

68. "CrowdSYNC – The Rolling Stones with John Mayer," Vimeo video, 1:36, posted by "CrowdSYNC," http://vimeo.com/71854696.

69. "The Bayer Sensor Strategy," December 5, 2012, http://www.red.com/learn/red-101/bayer-sensor-strategy.

70. "YouTube: Making of: Lena Dunham talks Tiny Furniture," http://www.makingof.com/posts/watch/2491/lena-dunham-talks-tiny-furniture, accessed July 21, 2013.

71. "Shooting Tiny Furniture," FilmmakerMagazine.com, November 17, 2011, http://filmmakermagazine.com/10882-shooting-tiny-furniture/.

72. Vincent LaFloret, "Thoughts on 'House' Finale," May 18, 2010, http://blog.vincentlaforet.com/2010/05/18/thoughts-on-house-finale/.

73. "Technicolor Cinestyle Frequently Asked Questions," https://www.technicolorcinestyle.com/faq/#who-developed-cinestyle-profile, accessed October 22, 2013.

74. For more information, visit magiclantern.fm.

Best Practices
for Production

The Digital Loader and the Digital Imaging Technician (DIT)

With the advent of file-based workflows, a new crew position has been added to support the look of the project and manage camera data and settings. This mission-critical job serves as the bridge between production and post as the lab has now moved on-set. Depending on the size and complexity of the show, the role of the Digital Imaging Technician (DIT) may vary to include camera troubleshooting and look management, verifying and backing up data, and preparing dailies for editorial. While often a PA is drafted and quickly trained to perform some of these tasks, it is strongly recommended that a production invest in a seasoned DIT. The nominal fee you pay this team member may save untold thousands of dollars by ensuring that all footage is captured, stored and backed up successfully.

3.1.1 ORIGINS OF THE DIT

Most jobs on a film production have stayed relatively the same for many years. During the evolution of modern film production, the crew has become the engine: an efficient, purpose-driven entity. While the size of a crew may vary, their jobs are more or less well defined. The Digital Imaging Technician has been the subject of more debate, and constitutes one of the most misunderstood positions on production teams in the last ten years. Adding to this confusion is the fact that the expectations and demands of this job change depending on the scale and scope of a project.

The DIT, has its roots in the Video Engineer. In the early days of analog video, an experienced engineer was often needed to ensure that the video signal was correctly processed and recorded. This role required a great deal of technical knowledge and problem-solving skills. Video Engineers would often be responsible for camera "painting," or setting the look and color of the video through on-set color manipulation of the signal prior to it reaching the recorder. As the industry transitioned to use of digital video cameras in TV production, the Video Engineer's role evolved with it. Broadcast cameras are known for having dozens if not hundreds of menus and sub-menus, most of which are not the easiest to navigate and require a skilled technician to correctly set. That skilled person would eventually become the Digital Imaging Technician.

As the industry segued from tape to file-based recording, the complexities of digital recording expanded. Despite its limitations, linear tape has always represented a fairly straightforward path. Once the image is on tape, there is little concern about its integrity or safety. In a file-based world, reusable/recyclable media is now the norm and careful file management has become tantamount. Today it is necessary to download the footage, verify that everything shot has made it to a safe destination without corruption, and then make a back-up of the footage at least once before reusing the camera media/volume. This means that the Digital Imaging Technician must not only be familiar with camera settings, formats, timecode and frame rates; they must also have strong computer skills and serve as their own IT support. Today they must deal with the challenges of disc and data

management, input/output (I/O), redundant back-ups, organizing and prepping media for delivery to the lab or editorial, as well as providing quality control (QC) and feedback to production.

Just as Video Engineers used to "paint" cameras in the video world, many Digital Imaging Technicians are involved in on-set "look management" with the cinematographer. This can be done in a variety of ways, but usually involves the collaboration of cinematographer and the DIT to shape the look of the image during or after recording. This means the DIT must have both the technical know-how and the artistic sensibilities of a colorist. On-set grading and look management have empowered many cinematographers to harness better control in crafting their images with immediate feedback from the "Key Creatives,"[1] all the while bypassing the traditional lab-based process that relies on notes and conversations with a colorist who may be in another city. Today cinematographers can fine-tune their work on-set in real time, and obtain approvals for the intended look almost instantaneously.

The Digital Imaging Technician is at the heart of this operation and is responsible for making sure that signal from the camera and previously recorded data goes through the proper chain of conversions, look-up tables (LUTs), and color correction processes. He can then convey the color decisions made on-set through the use of **ASC CDL** (see Figure 4.17) or **3D LUT**s using hardware interfaces, or grading application tools such as Blackmagic Design's DaVinci Resolve or Colorfront's On-Set Dailies. The resulting metadata must then be tracked and maintained in collaboration with the post-production facility.

With the convergence of digital acquisition and post-production on-set, there are more challenges to overcome and pitfalls to avoid. The Digital Imaging Technician is a key player in coordinating with camera manufacturers and rental houses, editorial and the post-production facility to make sure that a newly designed workflow is executed properly. Every show is different and there is no one pre-scribed path. Camera systems don't stand still. They continue to evolve with new updates, recording methods and formats. Because the role of DIT crosses boundaries between the camera department, editorial and sometimes sound (if they happen to be given the task of syncing dailies), there have been disputes and disagreements among the unions over which group can best represent the DIT.

3.1.2 DIGITAL LOADER

The Digital Loader (or Wrangler) is in charge of taking the magazine from the camera and making perfect copies and back-ups. The data is then verified using a check sum utility and by referencing camera and sound reports to ensure that all recorded footage is present and accounted for. Visual spot checks are made by scrubbing through the material to see if any corruption/**artifacts/drop-outs** have occurred in each shot. Once the loader is satisfied and at least two back-ups have been created, the card or magazine is erased and returned to the camera team for reuse.

If time allows, dailies can be prepped for the cutting room by transcoding and creating proxies. Moreover, almost anyone can immediately stream footage on-set. LightIron Digital offers a video assist app for the iPad called "LivePlay" that allows key creatives to watch and add comments to clips as they stream from the DIT cart.[2] Sound can also be synchronized to picture at this stage using smart slates and timecode (see section 3.3.5, "Dual-system sound and Syncing") Alternately, the raw footage is shipped to the lab or near-set facility (with accompanying paperwork) for **transcoding** and syncing.

FIGURE 3.1

Basic data management gear includes a laptop and external drives along with chair and folding table

Managing large amounts of data requires a tremendous amount of organizational skill and discipline. Attention must be paid to maintaining the **metadata** and file folder structures, along with accurate records of the transfers. This is not a task that can be assigned to either the First or Second Assistant Camera (or any crew member with other responsibilities) as it requires continuous monitoring for quality control.

3.1.3 DIGITAL IMAGING TECHNICIAN

The DIT provides the knowledge and experience to bridge the gap between production and post by working with the camera team to achieve the best image possible, using the correct standards and specifications and managing and preparing the footage before hand-off to editorial. He understands the end-to-end workflow: from the time data is recorded in the camera until it is delivered to the editorial team, ensuring no glitches or corruption along the way.

While the job is highly technical in nature it should also be pointed out there is a great deal of creative input that comes from the DIT in advising the director of photography (DP) on aspects of camera operation for achieving looks, providing "**best-light**" color correction and communicating all of this information to the editors.

The responsibilities for the DIT expand and contract as needed and usually include:

- Downloading and securing of data
- Media management
- Setting looks, applying/generating LUTs/color decision lists (CDLs)
- Prep for editorial/lab processes/streaming
- Transcoding and syncing dailies on-set (optional)
- Camera technician responsible for menu/settings management
- Advising the DP on camera-specific considerations for lighting/exposure

The German Society of Cinematographers has detailed its own list of duties:[3]

OUTLINE OF DUTIES: DIT

JOB DESCRIPTION: DIGITAL IMAGING TECHNICIAN (DIT)

(also Digital Film Technician (DFT), Camera Supervisor, Camera Consultant, Digital Camera Consultant (DCC), Digital Camera Supervisor (DCS), HD Supervisor (HDS), Digital Imaging Supervisor)

Preliminary Remarks

The increasing digitalization of individual steps, as well as the whole of the process of image recording or image processing, and the corresponding changes in means and forms of production have an influence on the work of the director of photography that is not to be underestimated. At the same time there is increasing pressure on all departments to produce ever more quickly and efficiently.

Digital production often needs an additional, appropriately specialized, person in the camera department who takes over new additional tasks and advises the team.

If necessary, she or he can carry out preliminary technical quality checks of the recorded material already on location. This does not replace the final technical control of the image material in post-production but can contribute greatly to production safety with the aim of ensuring the best possible technical quality of the digital film records.

The DIT is an independent specialized technician and adviser of the camera department. This technician supports the camera crew in their technical creative work using an electronic camera. She or he works during preparation as well as during production and can act as a link between location and post-production.

Professional background and prerequisites

Up to now, no recognized training exists in Germany.
The DIT has:

- Knowledge of the processes of film and TV production, as well as of possible differences in respective production and post-production techniques
- Extensive knowledge of customary cameras, storage media, and their respective possibilities and limitations
- Basic knowledge of lighting, optics and filters, color theory, and technical and creative light exposure
- In-depth knowledge of video and digital technology and of measurement technology used in practice, such as waveform monitors, vectorscopes and histograms
- Good knowledge of the use of computers and relevant accessories (e.g., to be able to assess the data security of different storage media for image recording or to make camera-specific adjustments)
- Basic knowledge of possibilities and workflow in post-production (e.g., of color correction and transfer to film)

Duties and activities

Preparation:

- Advising the DP in the choice of the production system
- Planning the workflow
- Testing the visual concept of the DP with respect to its feasibility during production and post-production
- Intensive testing and preparation of the equipment in collaboration with the first assistant cameraman and post-production
- If required, calibration and look management of the equipment
- If required, fine-tuning of data structures / data management in consultation with post-production
- Assembly and choice of equipment in collaboration with the first assistant cameraman
- Carrying out and if necessary correcting the set-up of the equipment, controlling technical functioning (e.g., adjustment, or matching) when working with several cameras
- Planning and organization of equipment in consultation with the first assistant

During Shooting

- The DIT supports the DP in implementing the desired image character using the appropriate technical options
- First technical checks on location (digital gate check)

- Responsibility for maintenance of the technical workflow during shooting and data storage, during filming at difficult (e.g., high-contrast) locations or while working with chroma key (blue / green screen)
- Data management on location / checking samples; if necessary, data storage
- Operation of special equipment (e.g., recorders, signal converters)
- Close collaboration with the first assistant cameraman (e.g., for control of focus and exposure, as well as with other departments, such as sound)
- Repairing small technical defects, as far as possible on location
- Setting up and adjusting the set-up of equipment (video village, measurement technology, monitoring, recording) in collaboration with the first assistant cameraman / video operator
- Changing the recording parameters for optimizing the desired image characteristics

Post-Production

- If required, technical/visual check of the image material at the post-production facility using appropriate equipment
- If desired, preparing the production of dailies/rushes or of working copies or similar in consultation with post-production
- Equipment logistics (e.g., for handing the recordings over to post-production, data storage, data transfer, etc.)
- Return of equipment in collaboration with the first assistant cameraman

3.1.4 DATA MANAGEMENT TOOLS

The professional DIT will provide a cart and his own set of professional tools for viewing, managing, backing up, transcoding and transmitting footage. While the "state-of-the-art" continues to advance, the basic toolset consists of:

- A computer (sometimes two) to view, process and render the footage
- Additional hardware to accelerate performance for renders and for displays
- A high-end calibrated display that receives a signal from either the camera or the computer
- A vectorscope
- File management software
- Color correction software
- Back-up drives and/or RAID
- LTO (optional)
- Hardware/software for wireless streaming on-set

FIGURE 3.2

DIT Cart with HP Z820 and Davinci Resolve

Data Management in Practice

3.2

Data management is not a simple robotic operation that is performed by dragging and dropping files on a computer desktop. It requires organization and discipline and must be managed in such a way as to prevent bottlenecks or slowdowns, identify and correct problems early in the production pipeline, and transmit the data effectively to the various departments for viewing, editing and archiving.

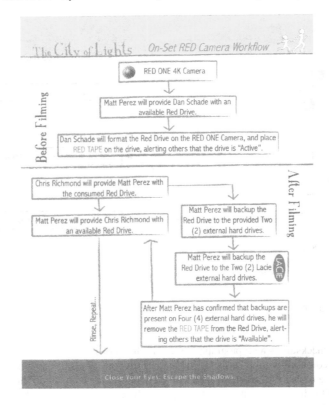

FIGURE 3.3

Prior to the start of production, the roles of any team members involved in the handling of data should be clarified and a memo disseminated on the first day of production that clearly conveys this information

The challenge for data managers is to copy and verify footage during the heat of production, which means working quickly and accurately and staying two steps ahead of the camera team. A simple operation may be a laptop, card reader and a handful of USB drives. The more complex rig features a cart containing a RAID (redundancy array of independent disks) and tower, uninterrupted power supply and perhaps an LTO (linear tape-open) back-up unit. In either case, the systems and methodology should be worked out and tested well in advance.

3.2.1 CHECKSUM VERIFICATION

The original files generated during production constitute what is known as the "camera original". Extreme care must be taken while copying the files to ensure that no data is lost or corrupted. Once a camera magazine (or mag) is filled, the first order of business is to make a duplicate set of files. The next critical step in the chain is to *verify* that the second file is a perfect copy and that no corruption has taken place. This is accomplished by using **checksum** verification.

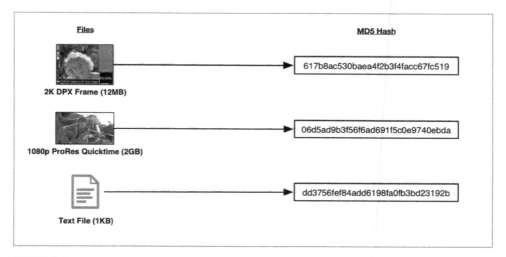

FIGURE 3.4

Cryptographic hashes

The result of a checksum is a cryptographic hash of what looks to be random numbers and characters, (not to be confused with a "hashtag," which is a Twitter term). By generating checksum files after copying, the hashes of the original file and the duplicate are compared. This is not the same as comparing the file directly, as that would be a byte-for-byte comparison and take a very long time. A checksum is analogous to DNA markers or a fingerprint which is used to quickly identify if there is a problem in transfer or corruption in the data. It isn't a complete picture of the data, but it is sufficient to verify if there is a match.

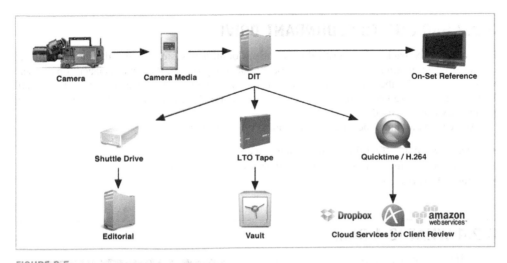

FIGURE 3.5

Original files, duplicates and copies to editor creatives

When errors are introduced during your workflow, the best place to detect and correct them is early in the process. Because camera files are copied many times and distributed to various departments, finding out that your clips have problems must happen before shooting wraps. The on-set data manager must determine, as soon as possible, that all the shots are present and will scrub through to ensure they play back properly.

3.2.2 SHOT VERIFICATION (PRODUCTION REPORTS)

The data manager will check each file coming off the camera against the script supervisor's report, as well as the camera reports. Any discrepancy must be immediately reported to the camera team to ensure that all clips are accounted for. It may be possible that during transfer of the original files a shot was dropped. It sometimes happens that the operator rolls camera late or cuts early and the data is not recorded or is truncated. The operator may have even missed the call to roll camera. Regardless, this verification process (like the checksum process) must occur throughout the shooting day and be completed before wrap. The reasons for this are painfully obvious: if at the end of that day a set is struck or a specific location wrapped, or an actor excused, there is no going back another day for reshoots without incurring unexpected expense.

Possible reasons/scenarios for data footage loss:

- Camera did not roll
- Shot was corrupted during shooting in camera
- Transfer of files is incomplete
- Files are dropped (forgotten/misplaced) during transfer

3.2.3 BACK-UP TO REDUNDANT DRIVES

Redundancy (i.e., back-up) is a critical requirement for all data systems. Since the camera original is irreplaceable, multiple back-ups are necessary. Each day on set, the data manager copies each volume recorded by the camera and sound departments. The portable drives may be off-the-shelf USB drives that have been formatted and tested before use. Alternatively, a RAID offering built-in redundancy could be used.

At the bare minimum the "3-2-1 Rule" should be employed:

• Keep three copies of all files (original and two copies)
• Record on two different media types (hard drives, RAID or optical media)
• Keep at least one copy in a different (offsite) location

3.2.4 WHAT IS A RAID?

A RAID (redundant array of independent disks) comprises a system of multiple hard drives that work together to provide greater levels of performance, reliability, and/or larger data volume sizes. The intent of a RAID is to offer redundancy and security while supporting multi-stream high bandwidth HD workflows.

In a RAID, drives are formatted to work in parallel, which offers faster data throughput (and faster than any individual drive). In a RAID 5 configuration an internal controller arranges for parity on a section of each drive, which allows for extra space to provide backup should one of the drives fail. There are different ways to configure a RAID that deliver either speed, redundancy or both, depending on the workflow requirements.

While no storage solution can ever guarantee 100 percent reliability, a RAID remains a

FIGURE 3.6

Drobo RAID systems are configured with Gig-E, Thunderbolt or USB3 connectivity.

valuable tool in the data manager's arsenal. Current consumer-grade systems typically feature SATA drives connected either via SAS (SCSI attached storage) or USB. Newer RAID systems feature Thunderbolt interface technology, which allows the user to connect directly to the PCI bus and effectively doubles the data transfer rates offered by USB 3.0.

RAID CONFIGURATIONS

Non-RAID (Single Disk)

Cheap

No built-in redundancy
Low performance

Good for off-site archival
Good as a shuttle drive for deliveries
100% of raw storage available

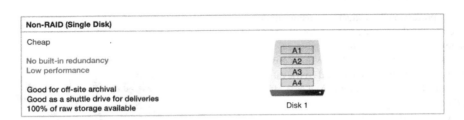

RAID 0 - Striped (Min. 2 Disks)

High performance

No built-in redundancy
Highest chance of critical failure

Good for non-critical online storage
Good for high-bandwidth data
100% of raw storage available

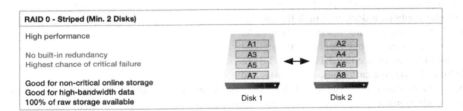

RAID 1 - Mirrored (Min. 2 Disks)

Excellent redundancy
Multiple drives can fail without loss

Low performance
Higher cost per data

Good for nearline storage and archival
50% of raw storage available

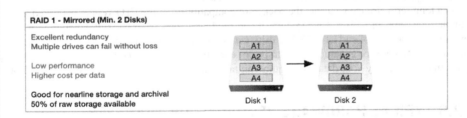

RAID 5 - Distributed Block-Level Parity (Min. 3 Disks)

High performance
Good redundancy
Balance cost, performance, redundancy

Single drive can fail without loss

Good for critical online storage (SANs)
Available storage varies by RAID size

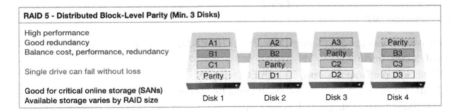

Blocks are sequences of bits or bytes of a fixed length, defined by physical and logical constraints.

Parity is an error prevention measure that effectively serves to rebuild lost data without requiring a 1:1 redundant copy of the entire data set. If one drive fails, it can be replaced with a spare drive and rebuilt from the parity information and the data on the other drives. Parity is occasionally calculated through an exclusive-or (XOR) operation between the other data sets. (A1 XOR A2 XOR A3 = Parity)

FIGURE 3.7

RAID configurations

3.2.5 LTO TAPE ARCHIVE

Larger professional productions using multiple cameras and those generating a lot of data frequently employ an **LTO** (linear tape-open) system to back up on-set or at the lab. While considered relatively slow for storage and retrieval compared to a RAID, an LTO remains a cost-effective method of handling large amounts of data.

As footage is downloaded and copied to either a RAID or separate hard drives, a second copy is placed on an LTO tape. A chassis with a controller contains a dock in which the removable LTO cartridges are inserted. Data back-ups are committed incrementally throughout the shooting day onto either LTO-5 (1.5 TB) or LTO-6 (2.5 TB) tape cartridges. The chassis and

FIGURE 3.8

LTO chassis and cartridge

SAS controller cost approximately US$4,000, but the individual tapes are a modest $70. A small indie production company usually can't afford this and will opt to buy drives off the shelf as needed. However, a large production intending to shoot with many cameras over several months will employ LTO back-ups as a reliable and affordable method of data security.

As a long-term storage solution, the backward compatibility of the LTO system is limited. If, for example, you have an LTO-5 drive system, it can *read* cartridges from its own generation and two generations prior (LTO-4 and LTO-3). The drive can *write* data to its own generation and to a cartridge from an immediate prior generation in that prior generation format.[4] What this means over the long haul is that periodically your data will require migration to newer formats as they become available.

3.2.6 TYPICAL HARDWARE REQUIRED FOR TRANSFER

Basic inventory/checklist for DIT CART
For minimum DIT:

Workstation class tower or laptop (Mac Pro or HP Z800) – 128 GB SSD Internal drive, 8GB RAM, 8-core Intel 64bit,
NVidia GeForce Graphics card, 23 inch LCD display,
G-RAID drives (USB3) (expendables supplied by production),
Uninterrupted power supply (UPS) back-up,
RedcineX Pro, R3D data manager / Shotput Pro color management software – Davinci Resolve Lite

For high-end, full-time professional DIT:

Workstation class tower (Mac Pro or HP Z820) – 250 GB SSD Internal drive, 32GB RAM, 32-core Intel 64bit, NVidia GeForce graphics card, 23 inch LCD Display,

17 inch to 20 inch monitor, Waveform / Vectorscope, SDI Video I/O Card,
eSata PCIe expansion card,
Shock-mounted local storage RAID (eSata, SAS or Thunderbolt) – 6-10 TB
Client-supplied drives for daily delivery to editorial (eSata),
2 X uninterrupted power supply (UPS) backup,
RedcineX Pro, RED Rocket or Red Rocket X (Dragon), R3D Data manager / Shotput Pro /
color management software – Davinci Resolve

For Sony F65 DIT basic inventory of hardware/software:

Workstation class tower (Mac Pro or HP Z820) – 128 GB SSD Internal drive, 16GB RAM,
8-core Intel 64bit
NVidia GeForce Graphics card
SR-PC4 Card Reader (connects via 10 gig NIC) or USB3 Reader, eSata or USB3 RAID,
Uninterrupted Power Supply (UPS) Backup

DIT operators will not only carry additional central processing units (CPUs) in their inventory in order to process dailies and multitask, they often bring a set of back-up boot drives, so that should a drive fail, they can recover quickly and not miss a beat. Demands of production require that they always be able to process the footage without any downtime or interruption. However, producers should never assume the DIT will automatically provide enough back-up or be able to loan out additional storage drives. The conversation must take place before the first day of shooting to avoid having to send a personal assistant out to a big box store to purchase additional storage at the last minute. Some cameras are also capable of recording to different formats on different record media simultaneously. For example, the Arri Alexa can record ARRIRAW via T-Link to codex and record ProRes to onboard SxS cards, thus increasing the complexity of data management.

Digital Dailies

The immediacy of digital is both a blessing and a curse. Today, dailies are often viewed by people alone in their homes, in the office, on a tablet or computer screen, and the excitement that once existed has been diluted. When key creatives used to gather in a darkened room to watch the circled takes, it meant something magical was about to happen. They could offer feedback in person and collectively address issues for the next shooting day. Something may have been lost in the communal aspect of filmmaking when digital appeared. On the flip side, having digital dailies means that more people such as clients or producers can review and offer feedback on shots almost immediately. Editors can quickly assemble material and advise directors as to how they might cover a scene more effectively. Quality control is easier to manage when there is little or no wait time for viewing. Yet, it opens the opportunity for a lot of second-guessing. With digital dailies there is much more flexibility, but it also means that you have to work harder at communication:

> "Watching dailies as a collected group off the set is invaluable for every department. This allows a genuine feeling of collaboration to be had by all. There is no time or place for this to be happening on the set during shooting and by looking at a monitor. On-set you will not have all department heads present so someone will be missing out. You need to see dailies in the correct format for which it is intended. The close-up on a monitor is not the same as watching it projected on the big screen. That is where you will become aware of the details in an actor's face and look in the eyes which are the windows to the soul."

> Johnny Jensen, A.S.C.

3.3.1 THE FUNCTION AND EXPECTATION OF DAILIES HISTORICALLY

Dailies (or rushes) have been a tradition in filmmaking since its inception over 100 years ago. After the original camera negative was processed overnight, a work print was created for viewing of the previous day's work. At the beginning (or end) of each shooting day, the director and editor, along with other key creatives, sat down to review the material and share notes. This time-honored tradition has largely been relegated to the dustbin of history, but there are many compelling reasons why productions should screen footage in a communal fashion:

- More technical problems can be quickly identified and corrected with fewer screenings
- Each department is allowed a chance to assess the quality of their work

- The editor has the opportunity to receive notes and reactions from the director and provide immediate feedback
- A valuable pause in shooting allows for serious reflection

If dailies can't be scheduled every day through principal photography, then at least during the first few weeks, the keys of each department must be given the opportunity to see their handiwork. Lighting and critical focus, hair and make-up, costumes and sets should all come under close scrutiny early on in the process to ensure that the production is firing on all cylinders. The only people who should be specifically banned from viewing the material are talent, unless their contracts stipulate that they see the footage. It is not uncommon for actors, having watched dailies, to come away with their own impressions, and attempt to adjust their performance in ways not intended by the director.

3.3.2 PARADIGM SHIFT IN ON-SET COLOR MANAGEMENT

Before digital, managing color representation on the film negative was fairly simple. The director of photography (DP) chose a film stock that was appropriate for the scene (either tungsten or day- light), exposed it in a normal fashion (or if there were artistic reasons), under or overexposed it), communicated any notes to the lab via the camera reports, and waited the next day to hear if there were any problems.

The lab timer would then create a one-light or best-light exposure for the resulting work print and at some later date the entire movie would be retimed for release.

This method gave the DP enormous power that was sometimes considered "magical" since the director had to take it on faith that the look he was hoping for would be visible the next day on the screen. There may have been times that dailies resulted in disappointment on behalf of the director when certain elements promised by the DP failed to materialize:

> "I don't like the betrayal of dailies. I don't like going in and seeing, and getting swept up with a performance and then seeing it go out of focus on a 25-foot screen and knowing that there's no way to retrieve that."

> David Fincher, director, *Side by Side* (2012)[5]

Today, the immediacy of digital dailies has eliminated much of that guesswork and afforded enormous flexibility in color management and lighting on-set. But there are liabilities as well. Everyone with access to the footage via distribution or in the "video village" may second-guess and make assumptions about the eventual look of the film without having all of the facts. Also, stopping to review footage may delay production and it is not uncommon for DPs to hunker down inside of a tent or truck and pay too much attention to the monitor and not enough time on the floor managing shots. This can slow down production; some directors, such as Werner Herzog, forbid playback on-set for this very reason.[6]

3.3.3 ON-SET, NEAR SET OR AT THE LAB?

In an ideal situation, the digital imaging technician (DIT) alongside the data manager would have the time and the equipment to not only back up and verify the data, but also prepare the dailies for the editors. Based on the constraints of production, this is not always practical or feasible. Therefore, a decision has to be made upfront whether to prep the dailies on location, or near set, or ship them directly back to the lab or cutting room.

Some of the factors in making this decision:

- How many additional crew are needed to work on-set?
- Can a separate base camp be established nearby?
- Can dailies be completed by the end of the work day by the DIT and thus not generate overtime expenses? Or does another operator need to do this on the night shift?
- How often are company moves?
- Is sufficient power available (even after wrap) to complete dailies' transcodes?

It is not uncommon for data management (including watching dailies) to take place in a special customized van or trailer. However, smaller productions choose not to carry additional crew members and instead hire vendors to set up shop outside the perimeter of the locations and refer to this as "near set." The third option is to copy the data to shuttle drives and ship them directly back to the lab for further processing.

3.3.4 EDITORIAL PREP FOR OFFLINE DAILIES

Example of dailies' cycle prep for features or episodic television

7pm Production wrap resulting in up to three hours of dailies.
 Footage is backed up and verified by the DIT before transport via a PA.
9pm Footage and paperwork is received at the digital lab:
 Arri Alexa data is contained on SxS cards.
 Go-Pro and Canon DSLR data is contained on USB drives.
 Sound files contained on CF cards or CD-ROM.
9:30pm Digital negative is copied to a local RAID server.
10pm GoPro footage is converted using proprietary software.
 Davinci Resolve transcodes Alexa, DSLR and GoPro data to MXF.
 Camera and sound reports along with script notes and comments from the DIT are checked against the original clips.
 LUTs relayed from set are used to impart the look of the show.
12am Sound and picture bins are ready in Avid project for syncing.
 Footage is now "offline" at DNxHD36 resolution.[7]
 Audio timecode is visible in smart slates and has been jam sync'd to the camera (see section 3.3.5, "Dual-System Sound and Syncing"). Sound is "married" (sync'd) to picture.
 Errors and anomalies are recorded in the dailies' report.
2am Avid bins and MXF files are transferred via secure server
 or delivered to the editors on a USB drive.
 Three to four hours' footage equals nearly 65Gb of "offline" data.
4am Sync'd dailies are complete and ready for the editors.

Q & A with Antonio Baca, data manager for *The Vineyard* reality show (ABC Family)

What cameras are you using and how many?
We are shooting on four Canon C300s with a HD/SD wireless video system.

For how many hours a day do they roll?
On average we shoot about seven cards per day per camera, and each card is a
40-minute load which equals about 280 minutes per camera.

What codec are they generating?
The camera records to CF cards as an **MPEG2** 50MB 4:2:2 codec with an
MXF wrapper.

What cards or volumes are they recorded to?
We use 16GB compact flash cards that can handle 40 minutes per card.

How much data is generated per day?
On average, around 300-350GB per day.

What software is used for checking footage?
I use ShotPut Pro to offload the media using a MD5 checksum. We offload to one
shuttle drive, and then two master back-up drives. The shuttle drive gets shipped
daily to LA.

Transcoding?
All the footage is brought into Avid via an **AMA** process for instant dailies, but in LA
everything is transcoded as two different DNxHD formats for offline and online.
We are using a custom-made program to handle all the transcoding.

How is the footage transported back to LA?
Footage is shipped daily back to LA on a 1TB Lacie Rugged drive.

3.3.5 DUAL-SYSTEM SOUND AND SYNCING

Although modern camera systems have the capacity to record sound, it remains common practice
to record audio separately using a "double system." This keeps the camera from being "tethered" to
audio cables and is one less issue for the camera operator to be concerned with. Instead, the location
sound mixer is charged with making sure microphone placement is correct and each take is logged
and recorded accurately. The duality of sound and picture departments working in tandem remains
the rule rather than the exception for modern film production.

In some cases it may be prudent to capture sound with the camera to be used as a back-up and as
a "guide track" that allows for quick screening of dailies with sound. It can also be used in conjunc-
tion with a software program such as PluralEyes to match the waveform with the separately recorded
audio tracks and to automate and speed up the process of syncing dailies.[8] However, no level of
automation can replace the assistant editor who must still check every track against picture to ensure
everything remains in sync and there are no errors such as drift.[9]

With the increased use of smart slates and the technique known as "**jam syncing**," the process
of synchronizing dailies has been made even easier. This involves generating matching timecode
on-set and recording to both picture and sound. Editing systems such as Avid can quickly pair up
sound with picture. As a fail-safe, should a problem arise, the smart slate provides both a visual
reference (visible timecode) and an aural reference (clap) at the point of impact when the sticks
are closed.

Despite all the latest innovations, there remains the issue that many new camera systems do not
record proper **SMPTE timecode**.[10] In practical terms, this means the assistant editor must sync each

take manually. Since each synchronized clip must be checked for accuracy in any event, the added time required to mark and sync them up by hand should not be considered onerous, but instead factored into the regular dailies' routine (see Figures 10.6 to 10.8 in the Appendix).* Note to Reader: Video examples on how to prepare dailies using Resolve and syncing them with Avid are available on the companion website:www.focalpress.com/cw/arundale.

3.3.6 COMMUNICATING COLOR INTENT

Periodically throughout the shooting day, the DP may have time to view the footage with the DIT in order to set the right look. While this may not always be possible due to time constraints, a dailies' screening should be scheduled for the beginning or end of the day (or during lunch). The viewing station can be located under a tent, in a truck or trailer, or in an adjacent office space. Monitors and video signal should be calibrated to reflect an accurate color pipeline.

With current toolsets, it is possible for the DP to communicate a set of color decisions on-set, sometimes referred to as "**best light**," that can be carried through the entire post process using a **CDL** (Color Decision List).

Here is one possible scenario:

- The director, DP and DIT review footage using Resolve and make adjustments for dailies grade using **LIFT, GAMMA, GAIN** and **SATURATION**
- The above values are converted to Slope, Offset, and Power (CDL) are "baked in" to the dailies upon transcode
- The metadata of each clip and grade is exported as an Avid ALE and carry the CDL data
- Editors receive dailies as MXF files and import the ALE file to relink them in Avid. The grade is stored with each Avid master clip
- Upon picture lock an EDL and AAF are exported, each containing CDLs per shot
- During online using Resolve or another grading software, the final edit is assembled from the camera original files via the EDL or AAF
- The original grade can be reapplied using the same CDL values via the EDL or AAF – namely, LIFT, GAMMA, GAIN and SATURATION before final color takes place

WHAT IS THE AVID ALE?

The ALE is short for "Avid Log Exchange." This file is essentially a bin containing references to each separate clip that can be relinked to the MXF files, which is the dailies' footage. It also contains all the essential metadata related to those clips, such as Reel ID and Timecode (necessary for reconforming at a later date to the original footage) as well as Color Decision Lists.

WHAT IS AN AAF?

AAF is short for "Advanced Authoring Format," which provides better management and easier sharing of picture and sound information and metadata across multiple computer platforms and authoring tools. Events such as transitions, color shifts and audio parameters are contained and transmitted using AAF files. The Advanced Media Workflow Association has published a whitepaper detailing this format.[11]

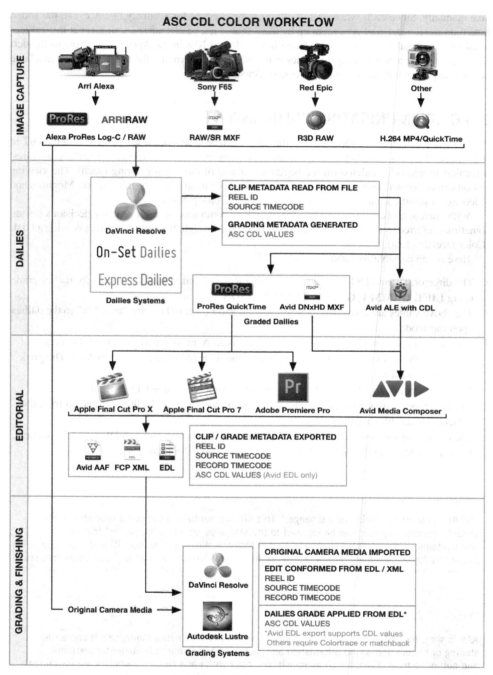

ASC CDL COLOR WORKFLOW

IMAGE CAPTURE

Arri Alexa

Sony F65

Red Epic

Other

ProRes ARRIRAW
Alexa ProRes Log-C / RAW

RAW/SR MXF

R3D RAW

H.264 MP4/QuickTime

DAILIES

DaVinci Resolve

On-Set Dailies

Express Dailies

Dailies Systems

CLIP METADATA READ FROM FILE
REEL ID
SOURCE TIMECODE

GRADING METADATA GENERATED
ASC CDL VALUES

ProRes
ProRes QuickTime

Avid DNxHD MXF

Avid ALE with CDL

Graded Dailies

EDITORIAL

Apple Final Cut Pro X Apple Final Cut Pro 7 Adobe Premiere Pro Avid Media Composer

Avid AAF FCP XML EDL

CLIP / GRADE METADATA EXPORTED
REEL ID
SOURCE TIMECODE
RECORD TIMECODE
ASC CDL VALUES (Avid EDL only)

GRADING & FINISHING

DaVinci Resolve

Autodesk Lustre

Grading Systems

Original Camera Media

ORIGINAL CAMERA MEDIA IMPORTED

EDIT CONFORMED FROM EDL / XML
REEL ID
SOURCE TIMECODE
RECORD TIMECODE

DAILIES GRADE APPLIED FROM EDL*
ASC CDL VALUES
*Avid EDL export supports CDL values
 Others require Colortrace or matchback

FIGURE 3.9

Metadata & color intent workflow

NOTES

1. "Key Creatives" is a term generally referring to the director, producer, cinematographer, editor and production designer, among others.
2. "LightIron Digital product page," http://lightirondigital.com/products/live-play, accessed October 2, 2013.
3. Reprinted by permission, BVK-German Society of Cinematographers, "Outline of Duties: DIT," http://www.bvkamera.org/english/bvk/bb_dit.php, accessed September 20, 2013.
4. "Ultrium LTO Frequently Asked Questions," http://www.lto.org/About/faq.html, accessed October 17, 2013.
5. *Side by Side*, DVD, directed by Christopher Kenneally (Los Angeles, CA: Company Films, 2012).
6. Jeffrey Ressner, "The Mystery of Werner Herzog," 2010, http://www.dga.org/Craft/DGAQ/All-Articles/0904-Winter-2009-10/DGA-Interview-Werner-Herzog.aspx
7. While DNxHD36 has been the baseline data rate for offline, many editors now request DNxHD115 due to increased storage and bandwidth capacities.
8. This software can be particularly useful in syncing up audio to multiple camera sources: http://www.redgiant.com/products/all/pluraleyes/ – RED Giant – Products – PluralEyes 3.
9. Steve Cohen writes a terrific blog examining the problem of having two separate clocks and the inherent problem of drift (see http://splicenow.com/2011/01/12/syncing-dailies/ – Syncing Dailies – Splice Now).
10. SMPTE is the acronym for Society of Motion Picture and Television Engineers, which developed the industry standard for timecode. Camera systems that do not conform to the standard include most pocket HD cameras and DSLRs.
11. Brad Gilmer, "AAF Whitepaper – EBU Technical Review," July 2002, http://www.dga.org/Craft/DGAQ/All-Articles/0904-Winter-2009-10/DGA-Interview-Werner-Herzog.aspx

Editing and Post-Production

Offline Editing

Offline Editing refers to the time when the majority of editing decisions take place. Choices are made regarding scene and take selection, performance issues and building a temp soundtrack. This stage is referred to as "offline" because the editing room may be situated in a home or office, physically removed from the lab or post facility. The footage is sometimes highly compressed using proxies and is therefore not considered suitable for broadcast. In order to remain cost conscious, projects usually edit offline, and then do a final online edit for color and conform once **picture-lock** has been achieved. This minimizes time spent utilizing very high-end workstations at the post-production facility.

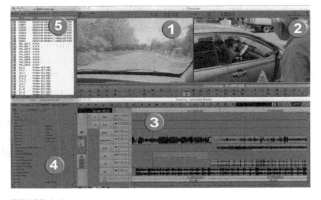

FIGURE 4.1

The Avid editing interface is comprised of (1) source monitor; (2) record monitor (composer window); (3) timeline; (4) project window; (5) bin window

During the offline edit, versions are created with a "temp" soundtrack. They can be previewed in the cutting room or presented to executives and larger test audiences in theaters. After a defined time, the picture is then "locked," meaning that no more picture changes are allowed and the project can be turned over to Sound Effects, Music and Visual Effects departments.

4.1.1 STEPS TOWARDS LOCKING A PICTURE

During production and following completion of principal photography, steady progress is made towards determining what the final picture will look like. It starts with the **Continuity** and Shot **logs**, which are the work of the Script Supervisor, and defines the coverage of scenes based on the **lined script**. It is usually up to the assistant editor to sync dailies and make sure nothing has been lost or misplaced. However, this job may be performed by someone else, on or near set, at the end of each day. Dailies are then distributed and viewed by producers, the director and the other key creatives.

It is crucial to allow the editor ample time to create his own version of the movie, as he is in the unique position of being the first person to see the footage and make sense of it. This is based on the footage produced, guided by the script and accompanied by notes from the director. Objectivity towards the material can often be shaded by being too close to it or familiar with it. Veteran editor

Walter Murch has a personal policy of never visiting the set in order to maintain a unique and fresh perspective as the dailies roll in. Directors sometimes lose that perspective as they have been working on-set in close proximity to the actors for weeks or perhaps months.[1]

Early cuts of the movie, such as the editor's first cut, are often closely held and may not be widely distributed. Instead, the key creatives will have to wait until the director has taken the time to supervise the creation of an even more polished version. He may work closely with the editor and oversee several draft versions of the movie before presenting it to the producer or showing it to the studio. The Directors Guild of America (DGA) has specific rules for the time allowed for a director to supervise the cut (four days for a one-hour TV episode and ten weeks for a feature film) with the right to be consulted and present throughout the entire post-production process.[2] It is assumed that as each new version is created, the total running time (TRT) is shortened as material is removed and scenes are tightened.

The major steps of a long-form television show or feature film comprise:

- **Dailies**: viewed by many with subsequent comments
- **First Cut Assembly**: this may be as simple as removing slates and placing footage in scene order (note: the word "assembly" is considered an affront to the editor as the first cut may not be an assembly but rather the "editor's cut")
- **Editor's Cut**: depending on the schedule, this may not happen, but this is an essential step in the process for which time should be allowed
- **Director's Cut**: this usually results in progressively shorter and tighter versions. They may be closely held or shared with producers and executives in charge of production
- **Producer's Cut**: depends on who has final cut and may be based on changes made at the behest of the parent company or studio
- **Studio's Cut**: see above
- **Network Cut**: for TV only
- **MPAA Revisions**: theatrical / **Standards and Practices**: TV broadcast
- **Versioning** for television/airlines/military/foreign

4.1.2 THE CUTTING ROOM

A fully integrated offline editing system should provide:

- Computer (CPU) with mouse and keyboard and two high-resolution monitors
- Client monitor capable of displaying HD video
- Pair of **near field** audio speakers (self-powered or with a separate amplifier)
- Audio mixer with multiple inputs and a microphone
- Local and/or networked storage
- Printer
- CD/DVD/Blu-Ray player for quick previewing of material
- Uninterrupted power supply (**UPS**)
- DVD burner and/or video tape recorder for output of cuts
- Video router and/or patch bay
- Furniture such as a chair and console to hold all of the above gear

Additional rooms to house servers and tape storage are recommended. Shared network storage may be placed near the assistant editor or in an adjacent room. Additional computers and an editing workstation should be available for labeling, clerical work, logging and digitizing of materials by the apprentice or post PA.

Sound and light considerations are crucial when setting up rooms. Windows must have black-out curtains to avoid light reflections. There should be adequate soundproofing to allow for loud sequences to play without disturbing the neighbors. Sufficient power to run all the computers and peripherals are "must-haves," as well as proper air conditioning.

4.1.3 EQUIPMENT RENTAL VS. PURCHASE

Major studios and production companies typically prefer to rent editing equipment from outside vendors rather than own their systems. Why? The main reason is the level of support that rental houses can provide. They have staff on call 24/7 who can show up and fix systems that are experiencing technical problems. They can also deliver additional gear as needed, such as console furniture, additional storage and video decks. Studios take comfort in knowing they have access to the very latest equipment and that it is always running smoothly, and once the show is over they simply call the rental house and have them cart it away. Studios are willing to pay the premium of higher rental costs in exchange for not having to carry and upgrade expensive equipment on their balance sheets or having to hire additional support staff to maintain them.

Post-production facilities often provide their own rooms with editing systems and are willing to rent them with the understanding that your production will use their services to create the final masters in their online facilities. They may be able to offer significant discounts for rooms because of this. Producers often look for these package deals because a turnkey solution which includes tech support, telephones and parking is often more attractive and a lot easier than finding short-term office space and having to set rooms up from scratch.

4.1.4 NETWORK SERVERS AND CONFIGURATION

By having a central Brain, in essence, you have enormous efficiency.[3]

Dean Devlin, director

As production has moved from a film-centric to a data-centric work-flow, the primary engine of post is now the large, centralized storage solution. In 2008, Dean Devlin and his post-production supervisor Mark Franco embarked on a series entitled *Leverage* for TNT which aimed for a 100 percent tapeless workflow. The first season was shot on location in Portland, Oregon, using the RED One and footage was flown back to their offices and editing rooms in Los Angeles. The RAW data was ingested into a server known as a **SAN** (Storage Attached Network) and the material was shared in-house among sound and picture editors, as well as visual effects teams. By the fifth and last season, the workflow that had begun on Final Cut Studio (FCP 7) migrated to Final Cut Pro X with a SAN holding nearly 42 TB of material.[4]

Bad Robot Productions is renowned for successful TV shows (*Alias, Lost, Fringe*), as well as blockbuster films (*Mission Impossible, Super 8, Star Trek*) and is located in Santa Monica, California. Its production facility houses cutting rooms, a theater, sound mixing rooms and a visual effects department, all tied to an ISIS 5000 server totaling 64 TB of storage. The time and budget savings are considerable, as each post-production team can work in tandem; sound editors

FIGURE 4.2

Avid ISIS 5500 is a robust SAN system designed for the rigors of post-production and stores up to 8 million files while supporting Media Composer, ProTools, Symphony, NewsCutter and Interplay, as well as Final Cut Pro 7 and Adobe Premiere

create their design in ProTools, picture editors work using Media Composer, and the visual effects team create new compositions on multiple platforms. Director J. J. Abrams was able to screen the director's cut of *Star Trek* in 5.1 Dolby surround sound without having to leave the building.[5] By leveraging shared media under one roof, the opportunities for real-time collaboration have streamlined and actualized the post-production process.

Avid Media Composer operates as either a standalone or networked system and is optimized for sharing bins and media. Early standalone systems featured storage docks with swappable drives connected via **SCSI**. In 2006, Avid launched the Unity (along with Interplay), (see section 4.1.8 for a discussion of Interplay and its successor Avid Sphere) which was one of the first storage solutions to accommodate small and large workgroups in either a compressed or uncompressed environment.[6]

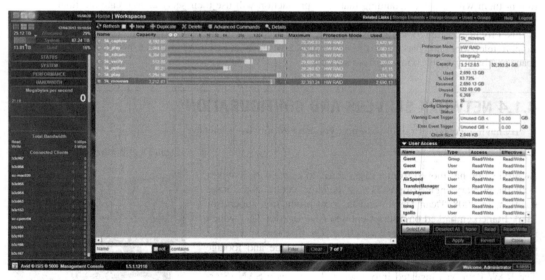

FIGURE 4.3A

Avid ISIS products have a convenient web management console that administrators can use to manage storage allocation and bandwidth for users and groups

The latest version of Avid **ISIS** features a proprietary RAID system consisting of a set of **blades**, or group of **SATA II** drives using **Gig E** connections (Ethernet over Fiber) in either a single or dual mode.[7] Newer systems use 10 Gigabit network interface cards (**NIC**) and can support as many as 90 users (or seats) requiring a **switch**.[8] Depending on the chassis, ISIS provides from 16 TB up to 300 TB of RAID 5 storage. Early versions of ISIS (such as Unity) required a separate PC Controller with administration software,[9] but newer systems are currently managed with the ISIS Management Console which can be accessed using a **Flash**-enabled web browser such as Safari or Internet Explorer.[10] If a drive were to fail, the system would automatically begin the process of rebuilding by moving data to a spare drive. While ISIS offers considerable security and protection of data, drive failures (or **corruption**) can lead to system slowdowns as the system attempts to rebuild.

FIGURE 4.3B

Fiber cable connects client computers to the SAN

4.1.5 STORAGE REQUIREMENTS AND DATA RATES

CALCULATING STORAGE REQUIREMENTS

Calculations for storage depend on which format is chosen for offline editing (see Figure 4.4). The data rate for each is represented by the number at the end of the format name. The lowest bitrate tier for DNxHD is 36Mbps. Assuming a frame rate of 23.976, this format requires approximately 16 GB per hour of dailies storage. Higher data rates (i.e., less compression) are available at either DNxHD115 or DNxHD175 (equaling 51 GB and 77 GB per hour, respectively). Assuming 100 hours of dailies is 1.6 TB, then a minimum of 4 TB is needed to accommodate for **redundancy/mirroring** in the system. Extra room will also be needed as media is added or created for titles and **renders** and **conforms** and may include a backup of the uncompressed cameral original material. A show should allow for a minimum of 8 TB to safely store footage. Since entry-level ISIS systems offer 16 TB, they should have enough capacity to serve most projects.

While it is not possible to add more drives to a configured ISIS, storage can be increased by adding a second chassis, which is comparable to adding a second engine. This will not increase the speed and performance of the network but instead will expand it. It is common practice in many larger facilities for multiple projects to operate on the same ISIS through the use of **workspaces**. A systems administrator will use the System File Manager to allocate storage for each project and maintain separate environments that effectively quarantine them.[11]

SELECTING THE RIGHT FORMAT/DATA RATE

While it may seem tempting to transcode all the dailies at a rate higher than DNxHD 36, storage may ultimately run in short supply when extra footage unexpectedly arrives. For preview purposes on a 2K monitor, DNxHD 36-encoded footage is a solid choice as it does not appear noticeably different than footage encoded at higher bitrates. The same difference in resolution between DNxHD 36 and DNxHD 115 is also not discernable to audiences in theaters, except for those seated in the first few rows. However, if the editor needs to do a resize or punch-in which effectively blows up the image and therefore softens it, then it may be prudent to switch over to DNxHD 115 or higher encoding.

Avid DNxHD (1080p/23.976)

DNxHD 175x	1920x1080	0.91 MB/frame	21.82 MB/sec	1.31 GB/min	78.55 GB/hr
DNxHD 175	1920x1080	0.91 MB/frame	21.82 MB/sec	1.31 GB/min	78.55 GB/hr
DNxHD 115	1920x1080	0.60 MB/frame	14.39 MB/sec	0.86 GB/min	51.79 GB/hr
DNxHD 36	1920x1080	0.19 MB/frame	4.56 MB/sec	0.27 GB/min	16.40 GB/hr

PRORES (23.976 fps)

ProRes 4444	1920x1080	1.55 MB/frame	37.16 MB/sec	2.23 GB/min	133.79 GB/hr
ProRes 422 HQ	1920x1080	1.03 MB/frame	24.70 MB/sec	1.48 GB/min	88.90 GB/hr
ProRes 422	1920x1080	0.69 MB/frame	16.54 MB/sec	0.99 GB/min	59.56 GB/hr
ProRes LT	1920x1080	0.48 MB/frame	11.51 MB/sec	0.69 GB/min	41.43 GB/hr
ProRes Proxy	1920x1080	0.21 MB/frame	5.03 MB/sec	0.30 GB/min	18.13 GB/hr

FIGURE 4.4

Data rate table

Arri Alexa 4K (23.976 fps)

Alexa ProRes	1920x1080	1.55 MB/frame	35.00 MB/sec	2.10 GB/min	126.02 GB/hr
Alexa ProRes	2048x1152	1.66 MB/frame	39.80 MB/sec	2.39 GB/min	143.28 GB/hr
ARRIRAW 4x3	2880x2160	9.30 MB/frame	222.98 MB/sec	13.38 GB/min	802.72 GB/hr
ARRIRAW 16x9	2880x1620	7.00 MB/frame	167.83 MB/sec	10.07 GB/min	604.20 GB/hr
ARRIRAW OpenGate	3414x2198	11.30 MB/frame	270.93 MB/sec	16.26 GB/min	975.34 GB/hr

RED ONE 4K (23.976 fps)

RC42 / 16:9	4096x2304	1.83 MB/frame	43.88 MB/sec	2.63 GB/min	157.95 GB/hr
RC42 / 2:1	4096x2048	1.45 MB/frame	34.77 MB/sec	2.09 GB/min	125.15 GB/hr
RC36 / 16:9	4096x2304	1.56 MB/frame	37.40 MB/sec	2.24 GB/min	134.65 GB/hr
RC36 / 2:1	4096x2048	1.24 MB/frame	29.73 MB/sec	1.78 GB/min	107.03 GB/hr
RC28 / 16:9	4096x2304	1.20 MB/frame	28.77 MB/sec	1.73 GB/min	103.58 GB/hr
RC28 / 2:1	4096x2048	1.05 MB/frame	25.17 MB/sec	1.51 GB/min	90.63 GB/hr

RED EPIC 5K (Full Frame) (23.976 fps)

3:1	5120x2700	6.19 MB/frame	148.41 MB/sec	8.90 GB/min	534.28 GB/hr
5:1	5120x2700	3.74 MB/frame	89.67 MB/sec	5.38 GB/min	322.81 GB/hr
8:1	5120x2700	2.38 MB/frame	57.06 MB/sec	3.42 GB/min	205.43 GB/hr
10:1	5120x2700	1.88 MB/frame	45.07 MB/sec	2.70 GB/min	162.27 GB/hr
15:1	5120x2700	1.26 MB/frame	30.21 MB/sec	1.81 GB/min	108.76 GB/hr
18:1	5120x2700	1.05 MB/frame	25.17 MB/sec	1.51 GB/min	90.63 GB/hr

DPX DATA RATES (23.976 fps)

4K Spirit S35mm 4-perf	4096x3112	48.63 MB/frame	1165.95 MB/sec	69.96 GB/min	4197.43 GB/hr
4K 2:1	4096x2048	32.01 MB/frame	767.47 MB/sec	46.05 GB/min	2762.90 GB/hr
4K 16:9	4096x2304	36.01 MB/frame	863.38 MB/sec	51.80 GB/min	3108.15 GB/hr
4K DCI Flat	4096x2160	35.40 MB/frame	848.75 MB/sec	50.93 GB/min	3055.50 GB/hr
4K DCI Scope	4096x1716	28.10 MB/frame	673.73 MB/sec	40.42 GB/min	2425.41 GB/hr
2K Spirit S35mm 4-perf	2048x1556	12.16 MB/frame	291.55 MB/sec	17.49 GB/min	1049.57 GB/hr
2K Spirit S35mm 3-perf	2048x1165	9.11 MB/frame	218.42 MB/sec	13.11 GB/min	786.32 GB/hr
2K Spirit S35mm 2-perf	2048x775	6.06 MB/frame	145.29 MB/sec	8.72 GB/min	523.06 GB/hr
2K Spirit S16mm	2048x1236	9.66 MB/frame	231.61 MB/sec	13.90 GB/min	833.79 GB/hr
2K 16:9	2048x1152	9.01 MB/frame	216.02 MB/sec	12.96 GB/min	777.69 GB/hr
2K 2:1	2048x1024	8.01 MB/frame	192.05 MB/sec	11.52 GB/min	691.37 GB/hr
2K DCI Flat	2048x1080	8.90 MB/frame	213.39 MB/sec	12.80 GB/min	768.19 GB/hr
2K DCI Scope	2048x858	7.00 MB/frame	167.83 MB/sec	10.07 GB/min	604.20 GB/hr
HD	1920x1080	7.92 MB/frame	189.89 MB/sec	11.39 GB/min	683.60 GB/hr

FIGURE 4.4

4.1.6 MONITORING OPTIONS

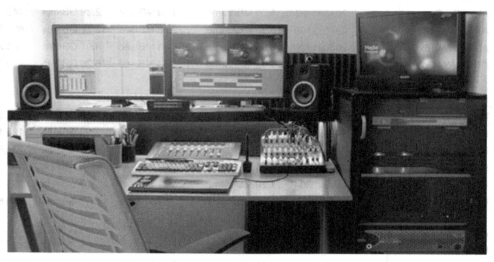

FIGURE 4.5

Avid three monitor setup: bins on left; source/record/timeline in the middle; client monitor on right

Nonlinear editing systems have very dense graphical user interfaces (**GUIs**), which often necessitates using large monitors that take up a good deal of space. Professional workstations are usually equipped with at least two 24 inch monitors, most often connected via DVI. A digital input is required to achieve optimal resolution. One contains the **source** and **record** windows atop a **timeline**. The second monitor can be dedicated to showing the **bin** contents. On high-end consoles you may notice a third display, or Producer/Client monitor. This may be larger than the others to allow people in the back of the room to comfortably watch a cut. In order to provide an HD signal to the third video monitor, an extra card or breakout box is needed to transmit color accurate video signal to a monitor via HDMI or SDI. AJA, Matrox, and Blackmagic Design all produce an array of devices for doing just that.

FIGURE 4.6

Matrox MX02 Mini breakout box

For more precise monitoring of broadcast quality images, an **SDI** connection to a high-end **reference monitor** may be useful for offline color correction and maintaining quality control. In such cases, it is not so much the size of the reference monitor that counts. Rather, it is the precision at which it displays and features full control over **brightness**, **contrast**, **gamma**, **RGB gain** and **lift tuning**, as well as a blue-only button for quick phase checking.

Newer display options include Thunderbolt technology developed by Apple and Intel, which allows laptops and PCs to connect to high-end displays, as well as connected devices such as e-SATA drives. The Thunderbolt single port is an extension of the PCI-E card and provides for increased data throughput (as well as 10 watts of power), while supporting a hub or daisy chain of additional Thunderbolt-enabled devices such as high performance video and audio capture devices.

4.1.7 EXHIBITION AND SHARING CUTS AND PREVIEWS

Traditionally editors and assistants have worked in collaboration either by passing bins and sequences back and forth between on-site rooms or even across town. It is also becoming more common for editors to bring their work home using a portable drive. But once a version is assembled and ready to present for feedback, a communal screening among the key players is often the best way to gauge reactions.

The well-equipped cutting room comes with a couch and chairs and features playback on a decent sized (40 inches or more) client monitor with good sound for a handful of people. While this is a perfectly acceptable method of previewing a project, at some point during the post-production schedule it may be necessary to show it to a larger test audience in a theater, or alternately send it to a key creative in another city for comments.

Some of the options for sharing over long distance:

- Burn a DVD and Blu-Ray disc and make multiple copies for distribution
- Post a film online with password protection using either YouTube or Vimeo
- Stream the film using a secure server or Virtual Private Network (**VPN**)
- Use Dropbox, YouSendit or File Transfer Protocol (**FTP**) to share a large file
- Prepare a QuickTime or Digital Cinema Package (**DCP**) for playback in a theater

Testing a film with a larger audience using focus groups can provide useful feedback to help in crafting the final version. Companies such as the National Research Group (NRG), a Nielsen company, can provide this service to a production by booking a theater, recruiting a test audience, and soliciting feedback via comment cards after the film.[12] Studio executives rely heavily on this early feedback to help gauge a film's broader success. Great care is taken to recruit "non-industry" filmgoers to these screenings in order to solicit unbiased reviews. The film, after all, is a work in progress and may not be fully formed. The cards filled out after the screening are closely guarded and measured for their responses. Critical feedback includes: Were scenes funny or moving? Were there plot holes or moments that were confusing? And, most importantly, would you recommend this film to your friends? Sometimes a focus group is arranged to take place immediately after a screening to give the filmmakers a chance to quiz the audience members in person.

Figure 4.7 provides a questionnaire created by writer John August (*Frankenweenie*, *Big Fish*) that serves as a good example of the type of questions posed to an audience.

THE NINES

August 30, 2006

Did you like it? YES SORT OF NOT REALLY NO

Given a pair of magical scissors, is there anything you'd snip out?

Anything you'd like more of?

Were there any moments/scenes you particularly liked? (please list)

Were there any moments/scenes you particularly disliked, or felt didn't work? (please list)

Were there any moments you felt annoyed, frustrated or confused-in-a-bad-way by the movie? (please list)

FIGURE 4.7

The Nines, survey, 2006

How would you rate the following elements? You can elaborate in the margins, or the space below.
(1 = Excellent , 5 = Poor)

	← Better	Worse →			
The ending	1	2	3	4	5
The music	1	2	3	4	5
The humor	1	2	3	4	5
The pace	1	2	3	4	5
The story	1	2	3	4	5
The beginning	1	2	3	4	5
The drama	1	2	3	4	5
Part One	1	2	3	4	5
Part Two	1	2	3	4	5
Part Three	1	2	3	4	5
Ryan Reynolds (Gary, Gavin, Gabriel)	1	2	3	4	5
Hope Davis (Sarah, Susan, Sierra)	1	2	3	4	5
Melissa McCarthy (Margaret, Melissa, Mary)	1	2	3	4	5
Elle Fanning (Noelle)	1	2	3	4	5

Any other comments or suggestions? We're all ears.

Thank you very, very much for filling this out. It's a big help.

FIGURE 4.7

Continued

4.1.8 OFFSITE COLLABORATION AND THE CLOUD

"The cloud" refers to a method of data storage which is by nature decentralized, offering both data redundancy and ready access almost anywhere on the planet. The concept is a little misleading since "the cloud" is not really up in the sky as the name suggests; rather, it involves remote computing from distant locations and allows users access to shared files and applications. Managing and securing the data is often provided by third-party vendors. Globally, thousands of companies offer license or subscription-based services, which are paid on a per-month, per-gigabyte or per-project basis.

At the most basic level, production companies need to show footage to clients and receive comments. Production has become international in scope, requiring collaboration across cities and countries around the world. Consider, for example, a feature production with cutting rooms in Los Angeles; visual effects houses in China, Taiwan and India; a producer in New York; and a director in Santa Fe. The score is to be recorded in London and the final mix scheduled to take place in Marin County. For a production on this scale, hiring an experienced firm with a proven track record is critical to share media effectively and communicate with each other in a fast, secure environment that does not requiring purchasing additional servers or information technology (IT) support.

There are many companies that offer cloud-based solutions tailored to fit different needs. For the large studio project that has satellite offices spread around the globe, companies such as PIX or DAX support nearly every stage of filmmaking, from pre-production and pre-visualization, location scouting and art direction, all the way through shooting and editing, sound mixing and visual effects. From a production management standpoint, they offer a central hub and secure "online production office"[13] from which files and schedules can be shared and distributed: photos and clips, sound effects, budgets and breakdowns, all of which reside in one ecosystem.

From a post-production standpoint, their essential service is content storage and delivery, buttressed by ironclad security, which is of primary importance to the major studios. Strong data encryption is standard, along with watermarking (including individual user tagging) and transfer logs that record all movement of files in and out of the virtual private network (VPN). But even with all of these measures constantly at work, data transmission between sound, picture, visual effects, marketing and distribution is seamless.[14]

> For those needing high-speed connectivity, a fiber connection is a better option depending on location. Current bandwidth over high speed internet may be as high as 100 Mbps, or if you are willing to pay for a fiber connection, data rates can reach as high as 1.2 Gbps, which means an uncompressed project file can be transferred in mere minutes.

> A cloud environment can be created on your privately owned server or it can be outsourced to companies such as Amazon or Sohonet. While it may be tempting to want to own your own cloud environment for flexibility of management, it is a costly upfront and ongoing expense. Consider first the costs of inhouse IT support and equipment/software upkeep vs. leasing the service from an outside vendor.

An overview of some of the services that cloud-based companies provide:

- Remote or local servers based on clients' needs
- Ingest/transcoding/creation of Proxies
- Archiving/storage/content distribution

- Encryption and watermarking of footage[15]
- Monitor usage and provide activity logs
- Upload/download/streaming of material including mobile devices[16]
- Calendars/email notification/watch folders
- User logging/annotation/comments of dailies or cut sequences
- Online applications for collaborative viewing/logging/editing
- Support for Application Programming Interface (**API**)[17]
- Database search functions

For major broadcasters who create sports, news and reality TV programming, the post-production cycle is very different. While geography is only one hurdle for remote production, the schedules (fast turnaround) and amount of footage (measured in hundreds of hours) present a significant challenge to content providers. Large post facilities usually have a substantial investment in infrastructure that includes servers, editing platforms and online broadcast services. What they need is integration of their existing workflow into a shared workgroup environment that is fast, easy to use and can safely handle asset management and distribution across a wide network.

FORscene is a system created by Forbidden Technologies that enables such collaboration using cloud-based tools for editing and review of large volumes of source material. Footage that is shot in the field can be uploaded, reviewed and logged just as easily by the editor, producer or correspondent in the field. The web interface allows for shared editing and review online by multiple participants. Original footage that is copied to the local server is automatically uploaded to the cloud as proxies. While it offers a fully functional timeline editing system as part of its package, it can also import or export an EDL to or from Avid.[18]

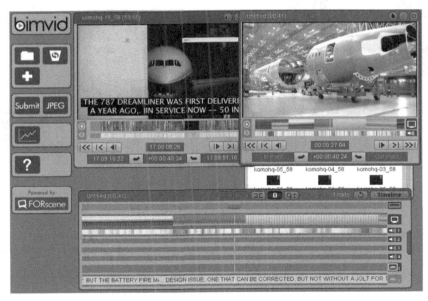

FIGURE 4.8A

ForScene cloud-based editing interface

Both Avid and Adobe offer their own solution to this seemingly daunting task: How do you provide access to thousands of hours of material and enable collaboration among a wide variety of users without missing a beat? Producers, loggers, editors and colorists – not to mention sound and visual effects departments – all need to work in parallel under tight deadlines to craft a show. Examples that come to mind might be the Olympic Games with hundreds of hours of live broadcast feeds that require repackaging or repurposing for later air times. Alternately, a show such as *America's Got Talent* features live and remote recordings using multiple cameras spread out over New York City while its executives in Fremantle's Toronto office need to view the material and provide instant feedback as the show completes its edit.[19]

Avid Interplay Sphere is the latest generation of software to support content creators, editors and videographers working within a facility or across the globe. It leverages the existing workflow and infrastructure of both Media Composer and NewsCutter using an ISIS storage system as the backbone. It connects multiple editors to the same footage who are able to work on the same project using proxies while the original footage is being ingested. The material can be instantly searched, logged or edited in any location and transcoded in parallel, allowing for faster turnaround.[20]

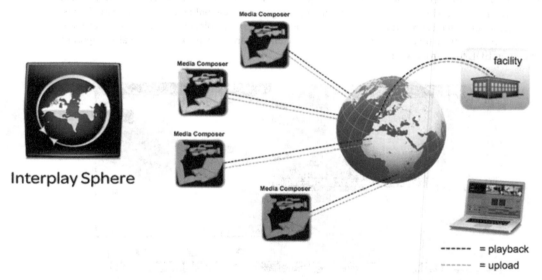

FIGURE 4.8B

Avid Interplay Sphere enables users in the field to capture and ingest media remotely and upload that media to the facility. They can also stream media from the facility and work seamlessly with remote and local media

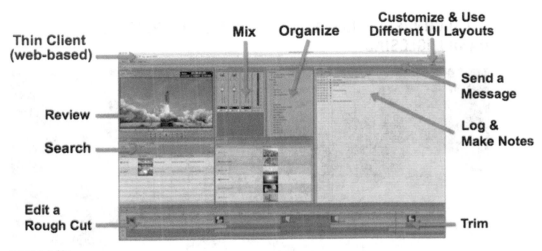

Thin Client (web-based)

Mix **Organize**

Customize & Use Different UI Layouts

Review

Search

Edit a Rough Cut

Send a Message

Log & Make Notes

Trim

FIGURE 4.8C

Avid Interplay Central provides a simplified editorial interface that runs in a web browser. This enables users to remotely or locally log media and produce a rough assemble all without needing a full Avid Media Composer workstation. Work can be done from home or while traveling using only a laptop and a secure VPN connection to the facility. This provides producers with an effective way of communicating their story ideas to the editors working in the field or back at the facility

Adobe Anywhere takes a slightly different approach to connecting multiple users of Premiere Pro, After Effects and Prelude. Like Avid, Adobe elected to use a centralized asset management and storage system, but they have chosen not to use proxies. Adobe acknowledges the creation of proxies takes up time and additional storage, so to solve this they created a scalable streaming system known as Adobe Mercury Engine. Depending on the network connection, the server can throttle back the data rate while playing back the native file format. The other core component of this system is the Collaboration Hub, which contains the database of project information and metadata, and resides on a separate server[21] (see Table 10.9 in the Appendix).

4.1.9 CONVERSATION WITH MUSIC VIDEO DIRECTOR DANIEL IGLESIAS

FIGURE 4.9

Jonas Brother music video "The First Time" (2013), director ENDS

Q: On the Jonas Brothers' *The First Time* music video, you placed the camera into the hands of your artists. How many cameras were there and how did you approach directing it in that manner?

Iglesias: Basically we do this kind of mechanism, where we go in and out of their handheld shots as the Jonas Brothers, as a first person type of POV [point of view]. Then we jump back into a more beautiful, outside, positioned look. We'll shoot them and you'll see them holding the little cameras and then we'll jump in to their camera's POV. We do that frequently throughout the whole video and that's because we had two shoulder-mounted RED Epics. That was very run and gun, using two main cameras A and B and then we had four Hero 3 GoPros that are the small, handheld, kind of action packed one that we put in the hands of all of our subjects.

And we would follow them around and shoot them as they were, self-documenting their weekend in Vegas. Whenever they would do something that seemed interesting or cool with the GoPro, we would make sure that we had an Epic pointed at them. That way we could do that cool "adjust to position" where we show them recording themselves as, say, they're about to jump in the pool and right when they do it, we would cut to the GoPro so you see them recording themselves as we jump to that footage. So we had a six camera setup where it was mostly a bunch of GoPros and then a couple of main cameras with better quality to document them.

Q: It's actually very clever because it not only places the audience into more of an intimate relationship with the Brothers, but it also allows you to cover a lot of material and events in a way that lends itself to low budget filmmaking.

Iglesias: Exactly. The brothers, they brought a whole troop of their friends and they all split up and did different things. One of the people was Wilmer Valderama. He's a pretty popular actor. He was on *That 70s Show* and he was really cool to work with. When Wilmer went off, when it was nighttime, we were going to follow Nick and a couple of his friends over to the roulette table. And while we were shooting all that, a bunch of their friends went off and did their own things at different clubs. So I just literally gave a camera to Wilmer and I said "Yo dude, go wild, just shoot whatever you want and we'll look at the footage when it comes back." So he took the camera with him and while we were shooting our scene, Wilmer was out there recording a bunch of fun little escapades at a club. So I had a whole other scene of footage just because I gave him a camera.

Q: What was the budget?

Iglesias: The budget on that video was $30,000.

Q: And how did the post-production go? How did you deal with downloading footage in Vegas and bringing it back to Los Angeles?

Iglesias: We had the whole DIT [digital imaging technician] team there for us. We had a couple of guys that were dedicated just to DIT in a hotel room, dumping all of our footage and transcoding.

I do everything with my partner, Zack Sekuler. I do my editing on Avid and Zack does all of his on Adobe Premiere. Premiere can actually work directly with RED Epic files. There's no need for a transcode. One of the coolest things about Avid is I don't actually have to spend all this time transcoding and I don't have to dedicate additional storage space by creating a bunch of MXF files. I can just mount an AMA volume. I could go in there and find all my RED files. Once our DIT team had compiled the footage for us and gave it to us on a big G-RAID drive. I mount all the files in a volume using AMA.

So instead of recreating a bunch of media, it references all that media and when I finish building all my sequences, I then export it as a reference file known as AAF that Adobe understands and send it over to Zack.

Workflow wise, we'll get all the footage together, place them in one big folder on a G-drive and then we'll split up different sections to work on. I'll say to Zack, "I have a really cool idea for what I want to do for the whole first verse. I'll work on that while you work on the chorus." So we'll each take different sections, creatively, and we'll both work alongside each other, checking each other's work until we have a bunch of different sequences to make up the whole song.

And then I'll export these references, give them to Zack and he'll put them into a single timeline on Adobe and then we'll just export from Adobe.

Q: So you are each editing on different programs, and you're exporting an AAF to your partner and both of you can link to the .R3D files

Iglesias: That's a relatively new feature with Avid, by not having to create proxies. It saves times, it saves space and if you're working with two platforms, it's a really good conduit to work with.

Q: So how long did it take to do the editing?

Iglesias: Zack and I pretty much grinded through that entire edit over a weekend. And that's typically how it has to work, especially right now just because I'm still in school. We don't really have time to hang out all week and just go through

all the scenes during the week. We'll shoot over the weekend. I'll come back to school. I'll spend my whole week at school taking classes and then on Thursday night, I'll drive up to Zack's place in LA and then I'll crash at his place from Friday through Sunday. We'll just literally grind through Friday, Saturday and Sunday and get the whole edit out in like three days.

Q: How was the video received?

Iglesias: In terms of the clients, and the Jonas Brothers team in particular, they're in the middle of recreating their image in a sense. They had this little hiatus because before, they were very "Disney" and now they've grown up. Their music is mature, their look is mature and they came to us wanting to recreate a cool, sexier vibe. If you look at the video in comparison to any other videos they've released, it's strikingly different in terms of style and feel. While all the other videos are very poppy, very glossy, and this video is a little more cinematic and cool in the way it's cut, especially.

And that was in the way we shot it. We go in and out of focus a lot, there's a lot of soft usage in there. It's definitely a totally different vibe from a lot of other stuff they went for. And that's actually worked pretty well in our favor because Zack and I spend a lot of time thinking about how we want to brand ourselves. Originally, Jonas Brothers definitely wasn't a part of our whole image and our whole look. But we did it and I'm glad we did because despite the fact that Jonas Brothers might be a name and despite how high profile and big and great they are – since our video is so unique when you put it against any of their other videos – then that makes people ask: "Who are these people? Who made this video? This is interesting. This is different."

The company that I created with Zack is called ENDS. And it becomes less like ENDS did a Jonas Brothers music video and it looks more like Jonas Brothers did an ENDS music video, which is huge for us when we're developing our career.

Q: So have you gotten many calls since then?

Iglesias: Yes, the Jonas Brothers [were] in late June, early July and we've put out another two videos since then. One for a band called X Ambassadors for Interscope, and then one for The Neighborhood. We just put out a really awesome video out for them.

Q: Describe the process by which you colored and finished the project.

Iglesias: Editorially speaking, Zack and I will get in there, we'll grind and do all our edits. We'll have to go through management and label and band and get all their approvals and get their notes. Go through another round of revisions based on their notes. Then once we get approval of everyone on the cut, we go into color. Zack and I don't typically color ourselves. We go through another coloring house that specializes in that. For the *First Time* video, we went with a company called Varnish, a guy named Bossi Baker, who's a great colorist. He spent a couple days, actually just a long day and one night and colored the whole video for us.

Once we had approval on color, we were pretty much done. When we are showing them approval copies, we don't like to send them files. We usually post a private link on Vimeo. For the final deliverable we upload the final file to a server that the label provides. We usually make a ProRes 4444, if not an H.264 in the best quality possible, and then we'll hand over the drive to the label.

Q: How would you describe the state of the industry for music videos and what would you say to young filmmakers who want to enter the business this way?

Iglesias: Music videos are your best conduit to do so because you have the most creative control and artistic freedom. It's kind of like the Wild West right now. There are so many different avenues and opportunities to do things. Like for us, the reason we got discovered was from doing music videos. The internet is so powerful and places like Vimeo and YouTube are very much centered around music videos.

If you look at the way that we got discovered, around the time The Neighborhood was just getting started. Zack and I took a 7D to the beach and around Hollywood and we had this idea in our head and we shot a bunch of stuff and put it together on our laptops and just submitted it. The song blew up and the video blew up along with it and, because of that self-made music video with no budget, we ended up having people think: "These guys have a bit of a creative vision. Let's give them a little more money and see what they can do."

If you compare that to commercials, which are extremely hard to get into, because they are so brand oriented and there is so much money involved. That is not a route you can just jump into the way you can with music videos. Unless you make one "on spec," but even then you're always doing it under agency direction. There's usually much less creative control.

And then there are short films. If you want to make your own short, that's great, but you're not going to find as much funding to make your ideas really come to life unless you have some amazing Kickstarter plan. And you're probably not going to get as much viewers or traffic to your film simply because most traffic is geared towards music and the artists. For example, if I make a video for the Jonas Brothers and I put it out there, it's going to get 3 million hits in a week. And that's because it's a Jonas Brothers video. But if you put your short up on YouTube, how are you going to get people to see it? It's going to be difficult. If you happen to land a gig with a band that's already started attracting viewers and their whole marketing and fan base is pre-existing, then all you have to do is make a video and then all the band's traffic gets to see your work.

So music videos are a great way for you to expose yourself and they're a great way to find a lot of creative and artistic fulfillment. It's not like a "holstered" idea the way a commercial is.

Q: Did you say "holstered" as in gun?

Iglesias: Yeah, when I think of the word "holstered", I think of confinement, like being caged. It's not released and free. You have much less creative control. You're doing the agency's idea, whereas with music videos, you're doing your idea. All of this opportunity in the music video world has shaped us artistically and dynamically and there's a lot of opportunity for young artists to really get exposure and get their ideas out there.

Daniel Iglesias is one half of the directing team (with Zack Sekuler) known as ENDS. He is a recent graduate of Chapman University, Dodge College of Film and Media Arts.

The Jonas Brothers video can be viewed at http://vimeo.com/69652698

Online Conform

We frequently associate the term *online* with searching the internet, and alternately when we are *offline* it suggests that we may be disconnected from the grid and enjoying some downtime. However, in film terms, offline has a very different connotation as it suggests the editors are working with **proxies**, apart from a major facility and not tied to a larger network. By contrast, the online edit typically means using the full resolution files requiring all the powerful tools available at a post house or lab with the goal of creating a finished master of the assembled sequence.

Conform is another term that is often misunderstood. To conform a picture usually requires taking a completed offline sequence and moving it to an online edit bay in preparation for final mastering. The conform involves using the offline version as a guide and matching the online version shot for shot (to the exact frame).

As computers increase in processing power and storage solutions become less costly, the gap between online and offline becomes narrower. The path from online to offline remains a vital part of the workflow for the foreseeable future.

4.2.1 HOW DOES ONLINE DIFFER FROM OFFLINE?

The term online refers to an editing session where powerful computer systems connected to large, fast servers are able to assemble the final edit according to an **EDL** (edit decision list). The resolution of the material is "master quality" and may consist of uncompressed clips. It is during the online that final audio, titles and final visual effects are assembled and combined with the final picture. Because of the high cost associated with online, it is essential that it be completed in a timely fashion and requires careful preparation by the assistant editor.

Offline video editing is more flexible and can be performed in a variety of environments. Due to budgetary considerations, most productions choose to edit offline using compressed video (proxies). Offline editing systems are less expensive and allow the filmmakers the time needed to assemble the material. Offline is not always physically tethered to a post house or larger infrastructure but instead can be performed at home or in the office or even on-set. While offline sessions may result in limited color correction and temporary sound and visual effects, the key goal is to arrive at a "locked" picture, where the remaining post-production processes can occur.

Online vs. offline editing:	
Billed by the hour	Systems rented by the week or privately owned
Expensive	Inexpensive
Requires fast CPU	Can be performed on a laptop

Large, fast servers	Portable USB drives
High-quality monitoring of sound and picture	Consumer monitoring of sound and picture
Waveform monitors/scopes for checking broadcast quality	Limited waveform/scopes
Full-color correction	Limited color correction
Visual effects	Temporary visual effects
Audio layback	Audio layback
Connects to machine room as part of a post facility offering tape layback	Work at home, the office or on location

4.2.2 WHAT IS A CONFORM?

The conform is the precise matching of each shot in a sequence from the offline proxy version to a high-quality (usually uncompressed) version. This can be a fairly straightforward process assuming that an **EDL** or **XML** file is provided containing accurate metadata such as reel name (or clip name) along with timecode. The online editor will ensure the accuracy of the new sequence by playing it opposite a QuickTime movie generated by the offline editor featuring a timecode **window burn**. This is sometimes referred to as a **confidence check** or offline reference.

FIGURE 4.10

Gefilte Fish (2014), director Shayna Cohen. Note the window burn (at bottom) containing essential timecode and REEL ID

The importance of the window burn placed in an offline version cannot be overstated as this represents a form of "insurance" against some unforeseen calamity. The picture from the offline can also be used for comparing sizing changes, such as repositions and blow-ups. With only the burn-in window – reflecting the clip name or reel ID with timecode – a project can be conformed easily.

The primary method by which conform information is relayed from one platform to another is via an EDL. For years the CMX3600 was the preferred format for this list. Today we recommend using the 32 character list, which supports longer filenames generated by the newer cameras (see Figures 10.3 and 10.4 in the Appendix). The alternate file methods are **XML** and **AAF** which allow one system to read and conform media to another's timeline. However, some values may not be conveyed properly such as speed changes, transitions, repositions and resizes.

4.2.3 PROXIES VS. UNCOMPRESSED FILES

The completed offline proxy sequence (or project) may be transported to the lab or post house where the online takes place by relinking to a higher resolution version of the footage. However for short-form projects, some filmmakers may prefer to cut with camera original material (sometimes 4K RAW or high resolution QuickTimes) using the same platform. Final Cut Pro X and Premiere Pro have both proven to be adept at such workflows and have attracted filmmakers who wish to attempt this. However, not all computers are up to the task due to the extreme bandwidth and processing demands of 4K. To solve this issue, Final Cut Pro X offers an easy method to relink back and forth between 4Ks and proxies.[22] Premiere Pro offers a slightly different path to conform using its "Link & Locate" system, which offers a **matchback** (with **handles**) to the camera original files and to the final graded shots.[23]

4.2.4 GENERALIZED ONLINE WORKFLOWS

- The Avid, Final Cut or Premiere offline sequence is finalized and locked
- If the conform is taking place using the same software program and the "camera original" files are available, then it may be possible to unlink the proxy files and relink to the uncompressed files

If the project is to be onlined or exported to another platform, then the following steps are required:

- EDLs are exported, or alternately an AAF or XML file is created
- A QuickTime file of the finished sequence known as a "confidence check" is created and used to match back and double-check each shot for accuracy
- After the picture is conformed it can be color graded. This may require transcoding the original files to a suitable format for grading, such as DPX
- The sequence is rendered (new media is created) containing the new color information, resizes, repositions and dust removal
- Titles and visual effects are added along with special transitions such as wipes or fades, as well as speed ramps and changes
- Final audio mixes ("**bounce-out**" from ProTools) are matched to picture
- Final sequence is used to make additional versions for different types of archival and exhibition
- Other deliverables such as DCP, high-resolution QuickTimes, and web streaming versions can be exported

4.2.5 ROLE OF THE ASSISTANT EDITOR IN PREP FOR ONLINE

One of the assistant editor's many tasks is to get the show ready for online. He must manage all the material related to picture and sound, track all elements (VFX, sync sound, stock footage and titles), and make sure that they all show up for the online session. Final mastering of a show is frequently at the last minute, tightly scheduled and costly to create. There can be no hang-ups or delay during this process. Production relies on the organized assistant editor to deliver a successful online.

The online may be performed by a different editor using a high-end nonlinear editing platform such as Avid DS Nitris, Avid Symphony, Lustre or Autodesk Smoke. An online can also be performed by Final Cut Pro and Premiere. As the online editor may not be familiar with the show, the editor, or the assistant, should be on hand to supervise the session, troubleshoot as issues arise, and make sure to check the assembled sequence once it is complete.

Upon locking the picture the assistant editor will create a QuickTime copy of the sequence to accompany the EDL for use as a "confidence check." He must identify and fix anomalies in the list such as mislabeled reels, missing clips and incorrect metadata. Speed ramps, timewarps, transitions and VFX should be flagged; in some cases, copies of these shots are placed at the end of the sequence for additional processing. If titles and text are to be added, a **textless** clean version should be saved separately (on tape masters they are often placed at the end of the show, after black). Banners, bars and tone, countdown leaders and black are added by the online editor to properly format the assembled master prior to output.

The Assistant Editor's job also includes prepping timelines for online by simplifying them into as few tracks as possible, often organized by camera/format type, opticals, VFX etc.

i.e. V1 - Original Camera Negative (OCN),
 V2 - VFX (from vendor)
 V3 - Opticals or Titles to be created in the online session.

Color Grading/Digital Intermediate (DI)

One of the essential steps before mastering is to grade your project. For precise color grading, suites must be carefully calibrated to provide a true and accurate representation of how the final image will look. Rooms are dimly lit using recessed lighting fixtures and feature neutral gray wall backgrounds to create the most effective and consistent professional viewing environments. Grading decisions take place in front of a high-end video reference monitor (for broadcast) or with a digital light projector (DLP) that emulates the

FIGURE 4.11

Dolby reference monitor

digital cinema environment. While not every suite can afford a high-end monitor (see Figure 4.11), some colorists prefer *not* to use current plasma screens to make color-grading decisions, but instead continue to employ the "tried and trusted" older **CRT** (Cathode Ray Tube) monitors. At some point it is assumed these legacy boxes will have to be retired, but for now they remain part of the modern suite of tools.

ESTABLISHING A LOOK

Colorists will grade and match each scene, shot for shot, to impart a look to the film and maintain visual continuity. The emotional impact of a story can be underscored through careful coloring. Some of these techniques were developed during the heyday of music videos that attempted to draw in audience attention by presenting exotic and compelling color schemes. Finally, the color grade is considered a final polish which gives the material a gloss or sheen that may not have been readily apparent in the original material. You could compare this stage to a final wax and buff to a car before unveiling it. Making adjustments to the entire image in a global fashion is referred to as **primary color correction**. These changes affect the blacks (shadows), gamma (midtones) and whites (highlights) by manipulating the RGB (red, green, blue) levels. Further isolation and treatment of specific parts of the frame is referred to as **secondary color correction** (see section 4.3.7 "Case Study: Resolve 10").

While it would be ideal for the cinematographer to always be intimately involved in the grading process, sometimes this is not possible due to scheduling. In such cases the colorist may make inferences about the intended look of the project based on detailed notes generated during production, or based on a longstanding relationship with the cinematographer that lends insight into what he would want. Other times, a cinematographer may be involved on a limited basis, expressing concerns about problem areas with lighting and color balance, as well as establishing "looks" for passages of the film which can then be applied more broadly by the colorist. The director, producer and post supervisor may also participate as needed and sign off on final color.

WHAT IS A DPX FILE?

Digital Picture Exchange (**DPX**) is a file format created by Kodak intended for use in color grading and visual effects. Each frame is represented by one file sequentially numbered in a sequence. DPX is typically a 10 bit uncompressed file encoded in logarithmic RGB color space. Log encoding is best matched to the characteristics of film while linear is intended for video (see "Log vs. Linear Encoding" in the Appendix). This makes DPX extremely versatile for file sharing among different post facilities and for moving back and forth between video and film elements.[24] The original format Cineon (which is nearly identical to DPX) was designed to be the output file for film scanners such as the Spirit 4K (see Figure 2.6).

FIGURE 4.12

Images recorded in Log colorspace offer greater dynamic range and are considered a more accurate representation of the film; however, to the viewer they appear flat (low contrast)

FIGURE 4.13

These 16mm frames show the different characteristics of log encoding (left) vs. linear (right)

4.3.1 NO LONGER A "DIGITAL INTERMEDIATE"

The term "digital intermediate" was originally coined to describe the stages of post-production between the scanning of the original negative and a finished film print. In the early days of DI (and due to its initial high cost), only select visual effects shots requiring computer-generated imagery (CGI) and digital compositing would undergo the digital intermediate process. Film was scanned to 2K or 4K DPX sequences as visual effects plates. After compositing was completed, new DPX sequences in a matching **film-log colorspace** were rendered and printed back to film (referred to as a "**filmout**"). As computing technologies have advanced and costs are lower, it is now possible to scan, store and play back an entire feature film using file-based workflows. A whole new

set of color-grading tools is available for directors of photography (DPs) and colorists to use with extraordinary creative results.

While most films today are "born digital," and nearly all are presented in theaters digitally, the term "digital intermediate" has lost some of its meaning. It is still faithfully used throughout the industry, but today DI is just another way of referring to high-end, feature film color grading and finishing.

4.3.2 WHY NOT COLOR CORRECT IN A NONLINEAR EDITOR (NLE)?

Today it is certainly possible for filmmakers to author high-quality videos on consumer-grade desktops and laptops. Apple's Final Cut Pro and Adobe Premiere Pro have been essential components of the filmmaker's arsenal for some time. In response, Avid (the industry leader in finishing content) dropped the price of Media Composer to make the product more accessible to independent filmmakers. This has prompted producers to ask the question: why bother with color grading using another program, or even use a colorist? Why not use the toolsets currently on hand and avoid a trip to the color-grading suite altogether?

There are many cases where it is more cost effective to perform color correction tasks within the editing application. This assumes the editor has some experience in color correction as well as the extra time needed to perform such tasks. For industrial and corporate projects this path may be perfectly acceptable. Projects destined for web or broadcast can certainly get by with this and often do.

In feature films, television shows, commercials and music videos, it is expected that every shot will undergo some form of color correction. Often complex looks will be applied to produce creative effects. Other times only subtle adjustments are necessary to match shots within a scene or to balance skin tones. In all cases, efficiency is key. Color-grading applications have a variety of powerful tools that can be quickly applied on a shot-by-shot basis. These applications are designed specifically for color grading using real-time playback and high-speed performance even with high-resolution, uncompressed files.

Offline editing in Avid, Final Cut Pro or Premiere typically involves the use of proxies, or offline dailies, often in the form of DNxHD MXFs or ProRes QuickTimes. These are not well suited for final color correction. The alternative, which is to work in full resolution using camera original media, is not always practical. While some can handle editing and compositing of camera RAW files, these NLEs are primarily intended for video workflows and a Rec. 709 video pipeline. They are engineered to work with **output-referred** imagery, or images that are already in a Rec. 709 HD video colorspace. They are not always designed for 32-bit floating-point processing, or for sophisticated color science, both of which are critical to preserving the highest image quality throughout grading.

Digital intermediate color-grading systems (such as Lustre, Scratch, Nucoda, Baselight, etc.) are designed to work with *scene-referred* footage, or images where code values are proportional to real-world scene measurements. These images consist of data that is representative of the camera sensor's complete dynamic range. Output-referred video images do not make full use of the camera's dynamic range and clip highlights and crush shadows, and already have a look "baked in," limiting your color-grading flexibility and, ultimately, discarding valuable scene detail.

Feature films intended for theatrical release must be presented as either a **Digital Cinema Package (DCP)** or film print. DCPs, film and positive print stocks each feature different colorspaces with different **gamuts** that are markedly different from Rec. 709 video. Theatrical films are graded with a target colorspace of **DCI P3** which matches the Digital Cinema gamut. DCPs are created from 16-bit **X'Y'Z' TIFF**s, or alternately film **inter-negatives** are recorded from log DPXs with an image transform applied to accurately match what the colorist was seeing on his digital display.

In order for a film to be accurately played back in theaters around the world, a great deal of care, science, and precision is needed so that the filmmaker's intentions are realized. That precision, quality and flexibility is only found in DI color-grading applications and systems and often only at experienced post houses or labs.

4.3.3 GOALS OF COLOR GRADING

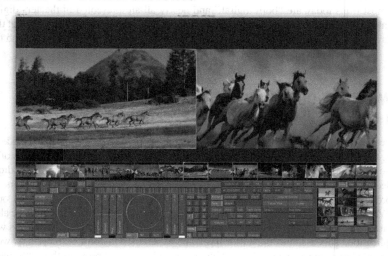

FIGURE 4.14

Autodesk Lustre color grading session

Color grading falls into two main categories: color balancing and creative look effects.

Even on the most controlled film sets, shots never match perfectly. Differences in camera, lighting, lenses, time of day, filtration, and exposure are all factors which contribute to disparity or discontinuity between shots. Two identical cameras using matching lenses can produce images with subtle differences. It is difficult and time consuming to capture images in a way that doesn't require some color correction to allow shots to cut together seamlessly. Maintaining consistent skin tones throughout a scene is essential for continuity.

On many films, the look is created in the digital intermediate. DPs who appreciate and understand the strengths of color grading will often build the look there, where it can be much easier and faster to manage color than it is on set. Color grading tools help DPs to pick their battles, leaving some issues to be solved in post where it might be faster than fixing on set. The DI should not be considered a cure-all, however, and a good DP will not knowingly create problems that otherwise might be solved. A DP must creatively pick their battles and choose the most optimal solution for the task at hand, be it a practical on-set solution or a post-production solution.

"Film looks" are usually designed before the film is shot and often involve the collaboration of a DP and a colorist in pre-production. When possible, they will grade the camera tests and establish a baseline expectation for how the film will be shot and how it can be manipulated in post. Once principal photography is completed, the DP and the colorist may create a color bible (or "look-book") that contains key frames that are representative of the major scenes in the film. This provides producers and VFX artists with a specific reference for how the film will ultimately look.

Whenever possible, it is preferred that a colorist non-destructively pre-grade visual effects plates before they go to the VFX vendors (see section 5.1.8 "VFX Color Management"). Shots are balanced and graded in advance so that the VFX artists return matching effects shots back to the digital intermediate during the finishing process. This avoids drastic regrading to match shots and eliminates inconsistencies in the visual effects elements.

4.3.4 WORKING WITH A COLORIST

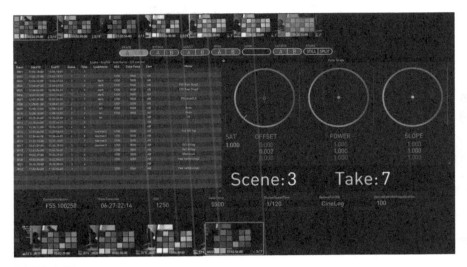

Scene: 3 Take: 7

FIGURE 4.15

Colorfront On-Set Live! grading session

How we view color is highly subjective as no two people see color the same way. Because of this, when maintaining a look for a project it is important to eliminate as much guesswork as possible and to communicate your intentions clearly to the colorist. There are two methods by which color information can be relayed from the set to the color-grading suite.

The first option is to establish a set of LUTs (look-up tables) that relate to day or night, exterior or interior setups. These are typically created during camera tests in pre-production and sent to the colorist as reference. They can also be transmitted to the lab for use as **"best light"** for dailies. Once this baseline is established, then the colorist can adjust the timings as needed during final color correction.

The second method is to record the color information to a **CDL**, or color decision list, and include this as part of the metadata that accompanies the footage sent to the editors and the colorist (see Figure 4.16) .

Many color grading systems can be used on set for look management. The digital imaging technician (DIT) alongside the DP generates this color information through a live grading application such as Resolve or Colorfront's On-Set Live. The DP's intent can then be measured and recorded for later use while leaving the camera original unchanged.

FIGURE 4.16

Technicolor's DP Lights system is used on-set to manage color intent via CDL and to create "looks" for later use in dailies and finishing

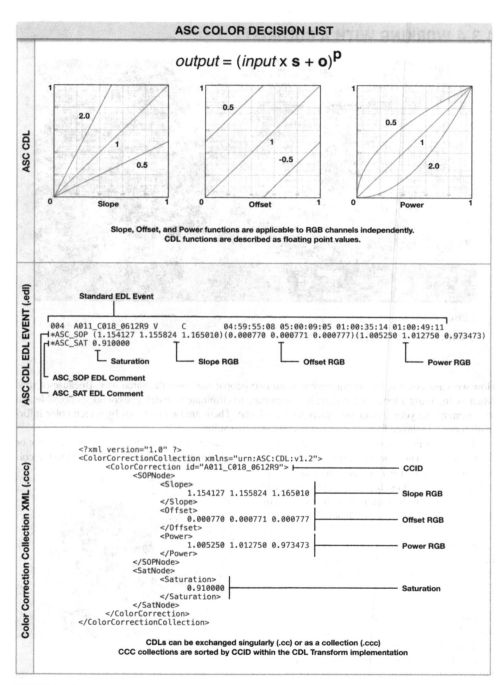

ASC COLOR DECISION LIST

$$output = (input \times \mathbf{s} + \mathbf{o})^{\mathbf{p}}$$

Slope, Offset, and Power functions are applicable to RGB channels independently.
CDL functions are described as floating point values.

ASC CDL

ASC CDL EDL EVENT (.edl)

Standard EDL Event

```
004  A011_C018_0612R9 V      C        04:59:55:08 05:00:09:05 01:00:35:14 01:00:49:11
*ASC_SOP (1.154127 1.155824 1.165010)(0.000770 0.000771 0.000777)(1.005250 1.012750 0.973473)
*ASC_SAT 0.910000
```

Saturation Slope RGB Offset RGB Power RGB

ASC_SOP EDL Comment
ASC_SAT EDL Comment

Color Correction Collection XML (.ccc)

```
<?xml version="1.0" ?>
<ColorCorrectionCollection xmlns="urn:ASC:CDL:v1.2">
    <ColorCorrection id="A011_C018_0612R9">                    CCID
        <SOPNode>
            <Slope>
                1.154127 1.155824 1.165010                     Slope RGB
            </Slope>
            <Offset>
                0.000770 0.000771 0.000777                     Offset RGB
            </Offset>
            <Power>
                1.005250 1.012750 0.973473                     Power RGB
            </Power>
        </SOPNode>
        <SatNode>
            <Saturation>
                0.910000                                       Saturation
            </Saturation>
        </SatNode>
    </ColorCorrection>
</ColorCorrectionCollection>
```

CDLs can be exchanged singularly (.cc) or as a collection (.ccc)
CCC collections are sorted by CCID within the CDL Transform implementation

FIGURE 4.17

Anatomy of the ASC Color Decision List (CDL)

4.3.5 SUPERVISED VS. UNSUPERVISED GRADING

The rental of color-grading suites and the billable hours of a colorist are both expensive. To keep producers and clients happy, they strive to ensure that the artistic vision of the project is achieved using the time allotted for grading in the most efficient manner. The first step in this process is known as the "pre-grade." Before a client walks into the room, the supervising colorist (or a junior assistant) will have gone through the entire reel and established a consistent baseline look. At that point the client can make comments and adjustments during a supervised session. The advantage here is that each shot is not being graded from scratch and subsequent grading decisions can quickly be applied uniformly to shots in the sequence. The client can approve looks in real time in the same viewing environment as the colorist, eliminating guesswork and establishing a collaborative language between the client and the colorist.

Producers, directors and DPs often have other time commitments and are not always available to supervise color grading from start to finish. Therefore a schedule should be defined as to how much supervised vs. unsupervised time a project will be allowed for grading. It is also possible to schedule sessions in a remote viewing facility using high-quality image transmission known as T-VIPS.[25] Another method is for QuickTime stills to be sent to the client as samples. While neither method can replace being in the same room with a colorist, it does allow work to continue without interruption during a hectic post schedule.

4.3.6 MASTER GRADING AND TRIM PASSES

Projects intended for a variety of distribution platforms will end up creating different versions targeted for different display devices and colorspaces. Theatrical films will likely grade in rooms featuring a DLP projector whereas a project intended solely for broadcast or home video will grade on a high-end plasma. Projects scheduled for multiple deliverables must have a clearly defined workflow for each. This starts with creating a high-resolution master sequence which contains all the final color grading decisions. This is referred to as the "hero pass" where the bulk of the work is done and is usually targeted for the theatrical film version. Subsequent grading sessions known as "trim passes" allow the colorist the opportunity to make global adjustments and fine-tune each version to match the specific platform and colorspace. For example: theatrical grading is generally the master grade or hero pass. Following that is a trim pass to grade the film for Rec. 709 home video release.

4.3.7 CASE STUDY: BLACKMAGIC DAVINCI RESOLVE

Historically, access to color-grading systems has been limited. During the 80s and 90s, color correction required banks of tape decks, telecines, and racks of hardware. Capital investment was substantial as these systems were comprised of rare and expensive hardware while software-based systems were still in their infancy. When digital intermediate became the standard workflow for feature films, the use of video hardware for color correction substantially decreased, and file-based software approaches were adopted. Grading software still cost upwards of US$30,000 per license plus hardware investment, which was a significant price reduction compared to the full hardware cost of previous systems. However, the total cost to build a color grading system remained cost prohibitive for independent owners.

One of the pioneers of high-end color grading technologies was DaVinci Systems. Their history dates back to the early 1980s when analog videotape was the standard for video finishing. At the time, feature films were still going through an optical print-light timing process for theatrical release. Electronic tools were only employed in the color correction of home video and television. DaVinci Systems' 888, 2K and 2K Plus became the standard for telecine color grading. They are big,

expensive, "heavy iron" systems which are still in use today in many post-production labs. The days of telecine-to-tape grading are over now, but when paired with a DVS Clipster (which can be slaved like a tape deck), the DaVinci 2Ks are still viable systems in a file-based world.

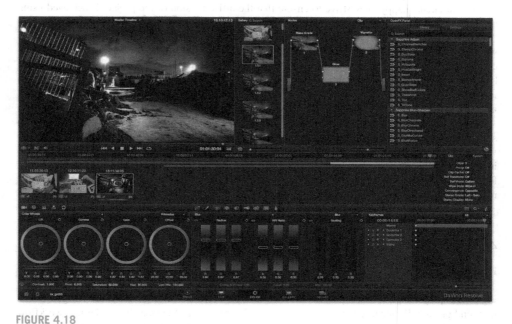

FIGURE 4.18

Resolve color session

In 2004, DaVinci Systems released its software-based digital intermediate solution, DaVinci Resolve. Resolve was quickly adopted by many post-production companies and used heavily in feature film, commercial and television grading. Resolve has always operated on commercially available, off-the-shelf hardware running a flavor of Linux and continues to be powered by Nvidia's high-performance graphics technology.

In 2009, Blackmagic Design purchased DaVinci Systems and integrated Resolve into its product line. Blackmagic made a commitment to continue to develop and support Resolve and bring Resolve to Mac and Windows. However, they made a significant change in the color-grading landscape: they made it free – or basically free. Since its release under the Blackmagic banner, Resolve comes in three versions: Resolve Lite (Free), Resolve Software (aka Resolve, US$995) and Resolve on Linux ($29,995) which includes the price of the Resolve hardware control panels. Each successive version has added features relevant to different markets. These prices do not include computer hardware, video monitors or storage. However, Resolve Lite and Resolve are operable on many high- and low-end systems. While previously it required Nvidia CUDA acceleration to function, Blackmagic has since embraced OpenCL, allowing access to AMD graphics users and those using Intel integrated graphics solutions. This is also a welcome sign for adopters of the new Mac Pro. While lower-performance graphics processing units (GPUs) result in less-than-ideal color grading performance, Resolve still runs smoothly on MacBook Pros and some iMacs and even recent versions of the MacBook Air (using Intel HD graphics). Resolve also runs on Windows with countless

hardware configurations. The sky's the limit and the hardware configurations are flexible to accommodate different markets and different needs. For example: grading 720p HD material requires a lot less power and performance than grading stereo 4K so the necessary hardware cost varies based on need.

Blackmagic turned the color-grading business model on its head by making color grading available to everyone instead of having to visit a costly post facility. Regardless of the level of production - from amateur filmmaking to corporate video to web series to features and television - color grading is now readily available. Anyone who has ever wanted to learn how to be a colorist is no longer restricted by the prohibitive cost of and limited access to the gear. Owning color-grading software by itself does not make you a good colorist, but access is crucial to learning how to become one. Now that the barrier to entry is lower, the real value that facilities, boutiques and owner-operators have to distinguish themselves is their experience and their artistry.

Resolve has made waves not only as a color-grading solution, but as a versatile workflow tool. Capable of faster-than-real-time debayering of camera RAW footage, Resolve has become popular in the dailies arena. Resolve offers customers of varying budget levels the tools to prepare their media for editorial in many flexible workflows. With full support for export and import of ASC CDL data and Resolve's trademarked **ColorTrace** function, Resolve is able to export color decision data to other systems and can support round-trip grade matching.

Resolve 10 introduced Resolve Live, color grading from real-time video signal for on-set grading. This enables cinematographers to grade the raw signal from their cameras and present clients with a graded image, on-set, before they've even recorded a frame. Snapshots of the video can be saved along with grading metadata so it can be later applied through ColorTrace to the full-length shots once they have been recorded and downloaded by the DIT. This can serve as an important tool in conveying the cinematographer's intended look through a pipeline to dailies, VFX and, ultimately, the final color grading.

Like many color grading systems, Resolve offers a full suite of tools for editorial and color grading:

Conform: Resolve is capable of conforming from EDL, Final Cut Pro XML and Avid AAF with original camera media using over 140 various codecs and formats.[26] Resolve is able to timewarp, resize and reposition shots during the conform and eliminate time-consuming eye-matching against an offline cut. Resolve 10 adds high-quality optical flow retiming (similar to Twixtor and Kronos) for smoother speed effects. Resolve is also able to automatically perform **scene detection** to identify each cut in cases where a program exists as a single sequence without an EDL. This is especially useful in restoring old titles or projects where metadata is unavailable.

Primary Color Correction: globally affects the entire image by adjusting RGB values through lift/gamma/gain, as well as logarithmic controls for shadows/midtones/highlights and printer offsets. Additionally, manipulation of curves for overall luminance, individual RGB channels, as well as hue and saturation adjustments can be made. Color-grading values can be animated over time using **keyframes**.

Secondary Color Correction: applies all of the tools of primary color correction through selective areas of an image defined by **roto** shapes (or power windows), color or luminance keys (similar to keying a green screen), or external mattes (pre-rendered, usually from VFX). Once a shape is drawn around a subject, Resolve's 2D object tracker can automatically analyze the translation, rotation and scale of a region over time. This tool makes it easy to quickly apply a complex grade over a shot with moving subjects. Further refinement through additional key-framing is possible for perfecting the grade.

Secondary tools are often used for creative effect to direct the viewer's attention, highlight certain characters, selectively change the color of an object, or "re-light" the scene.

OFX Plugin Support: opens the door for third-party effects developers to provide creative tools, adding more functionality and without requiring a roundtrip to compositing applications. Tools like Genart's Sapphire are useful for lens flares, flicker, camera shake, noise and grain. Combined with secondary roto shapes and tracking, blur and re-grain tools, Sapphire is well suited for aesthetic fixes and beauty retouching. OFX plugin support offers creative tools to the colorist and client that are usually reserved for a visual effects suite.

Hardware scalability: Resolve is dependent on GPU hardware acceleration for real-time image processing and color grading. As new graphics cards by Nvidia and AMD are released, customers can easily and affordably upgrade their Resolve systems without having to buy a whole new computer or pay for an expensive software upgrade. Resolve can utilize more than one GPU in a system or expansion chassis, making it easy to expand Resolve's processing power when working at 4K or in 3D.

Color Science: Resolve supports the latest in ACES color science as well as the ability to generate and apply 1D and 3D floating-point LUTs for viewing, **global input**, **global output**, or on a per clip or per-**node** basis. This makes dealing with multiple sources from different colorspaces (i.e., mixing **Arri LogC**, **Sony S-log2** and Rec. 709 material in a single timeline) efficient. All internal grading processes are performed in **32-bit float** precision. Successive grading operations are non-destructive, making the best looking image possible.

Delivery formats: Resolve can export to a variety of file formats as well as record-out to tape. Resolve includes **JPEG2000** export and third-party integration with **EasyDCP** for direct export to Digital Cinema Packages (requires an EasyDCP license). Metadata burn-in also allows for embedding timecode, reel ID, watermarks, and many other useful burn-ins for intermediate deliverables, such as dailies and review copies. Resolve can **batch queue** multiple renders from different projects so render times are managed more efficiently.

4.3.8 ESSENTIAL COLORSPACES

When discussing cameras, workflows and film technologies, the terms *color space* and *color science* are mentioned often. There are many different **color models** that are used in a variety of industries. Most people are familiar with **RGB** (red, green, blue), which is widely used in film, television, computer graphics, web design and more. Others include **YUV**, which has a long history in broadcast television and describes a color value using one channel for **luminance** and two for **chrominance**. **CMYK** (cyan, magenta, yellow, black) is a common working color model in the print world. Another model that is central to theatrical film exhibition is **XYZ**, which presents color based on the actual characteristics of light, instead of abstract values that *translate* to colors when projected.

Color models such as RGB define how color data is stored, but not how it is represented. **Color spaces** are models that describe the way in which the encoded values are represented on a display. For example, any 8-bit RGB value set can be anywhere in the range of 0–255 for red, green and blue. But a color space is necessary to define how the values of colors appear on a display. A color space does this in two ways: first, by mapping maximum red, green and blue primary values and combined white point to real-world chromaticity values. This defines the color gamut or range of producible colors within the color space. Doing this describes a measurable target against which manufacturers can calibrate their displays. Second, the relation between brightness in the encoded values and the

light output by the display is defined. Most color spaces have a gamma curve to shape the image for best representation on certain display technologies.

sRGB

The display characteristics of computer screens vary greatly between manufacturers' different models, display technologies (**LCD, LED, CRT**) and manufacturing processes. There are substantial differences in color reproduction when the same code value is output to multiple displays. sRGB (standard RGB) is a standardized target color space that manufacturers aim for by using hardware and software calibration. sRGB is meant to set the standard for the average RGB display and provide consistency across a wide array of consumer and professional products. When two sRGB displays are properly calibrated, the same image should appear very similar on both. While most color spaces are defined by a single gamma value, sRGB has a piece-wise gamma curve, which is linear (1.0) near black, and slopes upwards to 2.3. Therefore, it has an *approximate* gamma of 2.2. sRGB has a **white point** (of x,y = [0.3127,0.3290] D65) on the **CIE chromaticity model**.

Rec. 709

Rec. 709 is the standard color space and color encoding specification for HDTV and many video deliverables. Rec. 709 has a reference gamma of 2.4 but shares the same color primaries and D65 white point as sRGB. As a result, images compared on sRGB and Rec. 709 displays look very similar but have a slight difference in contrast and richness due to the differences in gamma.

Rec. 709 can be encoded in either legal (64–940) or full (0–1023) range. **Legal range** can be referred to as broadcast levels or TV levels. **Full range** is also referred to as extended range or data levels. These ranges do not provide a difference in dynamic range, but full range provides more increments in code values (quantization steps) between signal levels.

Log

Log encoding is a method of encapsulating scene-referred data in a logarithmic fashion. Instead of treating scene-referred values linearly, log code values represent stops rather than photons. Log images represent a high dynamic range with more data dedicated to mid-tones and less to shadows and highlights. Not all log encoding spaces are identical. **Cineon Log** is the standard in film scanning, and some digital cinema camera manufacturers can debayer or record to Cineon Log. Others have their own variations that are best suited for their camera, such as Sony's S-log, Arri's LogC and Canon's Canon Log. When packaged in a video format, log encodings are generally mapped in full range.

Scene Linear

Scene-linear encoding (aka scene-referred linear or linear light space) means that digital code values are linearly proportional to real-world light measurements. For example, the doubling of light (in photons) on-set results in a doubling of the recorded code value. As its name suggests, scene-linear encodings are completely linear (gamma 1.0) and they are often encoded in 16-bit half float or 32-bit full float, instead of integer encoding like most other imaging formats. This is done to accommodate extremely high code values in a linearly encoded scene where there is no maximum luminance. For example, the difference between a person sitting in the shade and the sun setting behind them could be over 24 stops, or 1,600 million cd/m^2. In order to potentially record both the shadows and the highlights in that scene, one needs an encoding system capable of describing both values while preserving their relation, or distance, from each other.

Rec. 2020

Rec. 2020 was designed for the new generation of Ultra-High Definition of displays (**UHDTV**) that can provide for expanded colors not seen in Rec. 709. It offers a bit depth of either 10 bits or 12 bits per color.[27] Rec. 2020 can support two resolutions: 3840 x 2160 and 7680 x 4320. It handles all frame rates (progressive only) up to 120p.

DCI P3

The Digital Cinema Initiative (**DCI**) specification defines the standards for digital cinema mastering and theatrical exhibition delivery format as well as **colorimetry**. DCI P3 is an RGB color space with a gamma of 2.6 and a reference white point of $48cd/m^2$ or 14fL (for 2D) with a wider gamut, which is noticeably larger than sRGB and Rec. 709. In theatrical feature grading, it is common to work in DCI P3, as it provides a clear path from the RGB color model. Before a film is distributed, it is converted to XYZ.

X'Y'Z'

The X'Y'Z' container is used to describe colors as they directly relate to real-world chromaticity values. Created in collaboration with manufacturers (Barco, Christie and Texas Instruments), XYZ is the language projectors use to describe colors. Anytime you are grading something in an RGB working space like DCI P3 and viewing it on a projector, the projector is translating the RGB values to XYZ values for projection. This is done using LUTs that either the manufacturer has defined or that a color science expert at your post facility has created. Even though it may appear simple, this is a complex set of parameters when presenting the finished film to theaters for exhibition.

When presented with clear target values that can be directly measured with a **spectrophotometer**, exhibitors face fewer challenges so that ultimately the finished film will have the look the filmmakers intended.

4.3.9 ACES WORKFLOW

"Standards are essential to this industry which is why there are so many of them."[28]

Digital Cinema has been around for nearly 20 years and with it has come an explosion of new cameras, codecs, displays and color spaces. While labs and post facilities have managed to keep up with the changes, a new standard was needed to maintain some semblance of order in the area of color science. The Academy of Motion Picture Arts and Science (**AMPAS**) in cooperation with the American Society of Cinematographers (**ASC**) set out in 2011 to come up with a logical approach to image encoding known as ACES: Academy Color Encoding System.[29] ACES is one component of a standard known as the Image Interchange Framework (IIF) and defines the post-production pipeline in a way that is manufacturer independent.[30] While staying above the commercial fray, it still takes into account the multitude of specs offered by the major camera systems and normalizes the process from acquisition through final display.

An essential building block for this new pipeline is **OpenEXR**, an open source format developed by Industrial Light and Magic (ILM), released in 2003. OpenEXR was designed as the successor to Kodak's Cineon/DPX format by providing greater dynamic range using 16-bit floating point precision. While the DPX (or Digital Picture Exchange) format has served the industry well for the past

20 years, its main role has been to provide a bridge, or intermediate, between film and digital.[31] Noted color scientist and lecturer Charles Poynton anticipates a long and healthy career for the OpenEXR format, stating "it is likely to last us at least 10 or 20 years."[32]

OpenEXR is the container in which the image data is stored. It doesn't define the way in which the image data is going to be viewed and what colorspace it exists in. That's where ACES comes in. The ACES gamut is far greater than the extent of human vision, thus "future proofing" it (see Figure 4.19). Rec. 709, Rec. 2020, P3 and film all have gamuts far smaller than ACES and are all

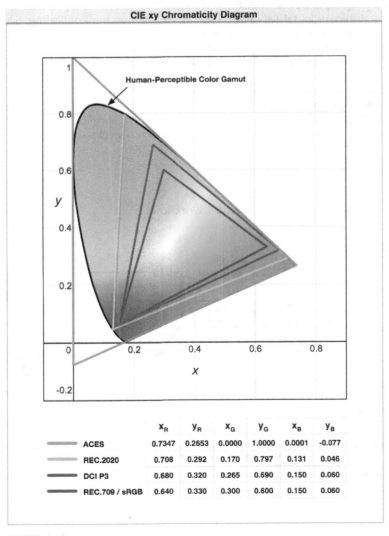

	x_R	y_R	x_G	y_G	x_B	y_B
ACES	0.7347	0.2653	0.0000	1.0000	0.0001	-0.077
REC.2020	0.708	0.292	0.170	0.797	0.131	0.046
DCI P3	0.680	0.320	0.265	0.690	0.150	0.060
REC.709 / sRGB	0.640	0.330	0.300	0.600	0.150	0.060

FIGURE 4.19

CIE x,y chromaticity diagram

contained within ACES. OpenEXR supports upwards of 30 stops of dynamic range.[33] Currently, digital cinema cameras are recording up to 16 stops of dynamic range. Because of the expanded dynamic range of OpenEXR and ACES, it can safely encapsulate the recorded image of any camera now or in the near future without clipping data.

"ACES is an enormous palette that encompasses the visible spectrum and more."[34]

Josh Pines, vice president imaging science, Technicolor

To get all the various image sources from different cameras into the same ACES color space requires a conversion using **Input Device Transforms (IDT)**. In order to achieve this, an IDT must remove "any capture characteristics related to their cameras, lens, sensors or recording methods"[35] and, in essence, strip away the proprietary curves or treatments provided by the manufacturers. What remains is a representation of physical light on the scene. For every camera and its color science, there is a specific IDT. While accuracy is important, what is even more critical is the notion of consistency and repeatability.

The advantage to this method is that it makes it easier to color match different cameras in the DI. It is not uncommon for productions to combine RED, Alexa, DSLRs and film in a single sequence, and while ACES cannot magically extend the dynamic range or gamut of lesser cameras, it allows for all dynamic ranges and puts the various source images in the same color space.[36]

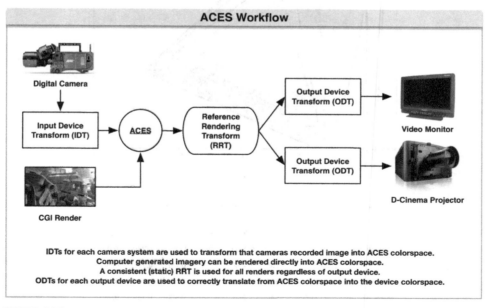

IDTs for each camera system are used to transform that cameras recorded image into ACES colorspace.
Computer generated imagery can be rendered directly into ACES colorspace.
A consistent (static) RRT is used for all renders regardless of output device.
ODTs for each output device are used to correctly translate from ACES colorspace into the device colorspace.

FIGURE 4.20

ACES allows footage to be color graded, displayed, mastered and archived using a modular approach at each stage of the workflow

Once footage is in ACES, it is much easier for colorists to manage their looks and for CGI and composites to be introduced as they all conform to a single encoding specification. This means that compositing operations and arithmetic filters apply uniformly to material from different sources.

Before an ACES image is viewed on a display, it must undergo two additional transformations. The first is the Reference Rendering Transform (**RRT**), which is a static transform within the ACES pipeline and not an interchangeable one. It applies an idealized tone mapping from scene-linear into an output-referred space. Somewhat controversially, the RRT serves as an idealized "look" curve which has been the subject of much discussion, as many people have differing opinions on what that singular transform should be.

After the RRT is the Output Device Transform (**ODT**), which accounts for the display technology and the input colorspace it anticipates. This is where transforms to sRGB, Rec. 709, Rec. 2020, DCI-P3 and X'Y'Z' are made. All grading is performed through both the RRT and the ODT. The RRT is not user definable because there is only one RRT, but the ODT is selected based on the display the content is being viewed on (i.e., projector, plasma, **OLED**, computer monitor, etc.). Upon final delivery for DCP creation or film-out, the proper ODT must be selected to correctly transform the image into that destination color gamut and gamma. There are many advantages to the ACES workflow:

- Eliminates guesswork during color grading and mastering
- Accommodates existing pipelines
- Allows for future capture, master and display technologies
- Provides an agreed-upon industry standard as well as cost savings

From the AMPAS site:

For cinematographers:

- Eliminates uncertainty between on-set look management and downstream color correction
- Preserves the full range of highlights, shadows and colors captured on-set for use throughout the post-production and mastering processes
- Preserves the ability to "light by eye" rather than relying on video monitors
- Enables future expansion of the creative palette by removing the limitations of today's legacy workflows

For visual effects and post-production facilities:

- Enables reliable, unambiguous interchange of images from all film and digital sources
- Enables flexible workflow design
- Preserves the use of "custom looks"
- Simplifies visual matching of different cameras
- Provides colorists with a better starting point and is designed to deliver the full dynamic range of progressive generations of digital motion picture cameras

For content owners:

- Offers simpler re-mastering for non-theatrical distribution platforms
- Uses a standardized archival file format
- Preserves the highest quality images for use with next-generation display technologies

Dirt Fixes, Adding or Removing Grain and Noise

It is ironic that many modern digital productions have employed methods in post to artificially add hair and scratches, film weave, tears, burns and blemishes to suggest an aged, analog film experience that suggests a now-historical authenticity. Even today, non-digital film elements continue to go through lengthy, painstaking restoration processes specifically to remove these unwanted elements and leave behind a pristine master that can be archived for the future.[37] While there are automated systems used to analyze and correct these issues, the final arbiter must be a set of human eyes. Computer programs may offer a cost-effective solution to the problem but they risk compromising the quality of the final product by softening the image or introducing unwanted artifacts.

4.4.1 FILM DUST-BUSTING AND DAMAGE REMOVAL

It is an unfortunate reality of working with tangible film stock that they attract a fair amount of dust over time. The preferred method for physically removing this dust is sonic cleaning, which uses a combination of a fluid solvent and sound waves to literally shake the dust particles off. However, this method will not remove 100 percent of the offending dust, grease or dirt particles and they will be visible once the reel is digitally scanned. Dust on the negative appears as a bright dot that may be a few pixels wide. Systems such as Autodesk Lustre can automatically identify digitally scanned frames for dirt and eliminate them by interpolating pixels much like Photoshop's "Healing Brush." Many post houses will employ a dirt removal system (DRS) prior to final color correction so that the eventual master of the film is as pristine as possible. Another method is to hand the reel over to a specialist who visually checks it during playback for dust. In this case, a manual or semi-automated system is used in order to replace the area in question with pixels from a frame immediately before or after the event. Alternately, adjacent pixels are cloned to cover up and paint over the blemish.

Damage removal may require further analysis of each problem area to come up with a creative solution. While not always 100 percent successful for restoration, damage removal can "take the curse off" (i.e., make problems less noticeable).

Common types of film damage:

- Scratches, tears, and hair
- Film weave
- Discoloration and fading

Intense scratching or hair may require the attention of a digital artist to rebuild a sequence using methods similar to rig and wire removal.[38] Film weave can originate in camera, in printing, in optical VFX, and in scanning. Image stabilization techniques can sometimes fix these issues. However, most stabilization algorithms will subtly zoom in the image with a resulting trade-off of subtle reframing and softening. Discoloration and fading can be addressed in the color correction sessions. All of these issues require additional process and rendering time.

> Film labs used to offer a technique known as "wet-gate printing" to remove surface scratches from original negative. This involves adding a liquid layer to the film surface which effectively fills in the scratches to make them less visible. Today there is a similar technique known as "wet-gate scanning" which combines the liquid process with an algorithm that measures adjacent pixels and replaces them where scratching occurs. While this can't entirely remove dirt or fix deep scratches, it would be the first step in restoring damaged negative.[39]

FIGURE 4.21

Ultrasonic cleaning system

4.4.2 GRAIN MATCHING AND ADDITION FOR EFFECT

Grain can be defined as the clumping of silver halide crystals in the film, which adds texture to the image. Depending on the type of project, this may be desirable to the filmmaker or an unwanted side effect. For years audiences became so used to seeing grain in film that no one really noticed until it was absent from the digital image. Filmmakers sometimes add grain back in for creative effect to provide lyrical expression or for the recreation of historical imagery.

Just as no two shots entirely match in terms of color, consistency of grain between shots has become an issue. We see frames today with such clarity and precision that the presence of grain (or lack thereof) has become more noticeable to the casual viewer. Grain patterns are more visible when shots are blown up, different film stocks are used or when the film has been pushed (overexposed) in the camera. *Nebraska* (2013) shot on the Alexa and added film grain and the black-and-white look in post.

4.4.3 GRAIN MANAGEMENT AND DIGITAL NOISE REDUCTION (DNR)

As existing film libraries are re-mastered for the digital realm, content owners must contend with the issue of grain and make a decision whether to remove it or leave it "as is." Purists may elect to keep the original grain whereas some distributors prefer that it be gone. Choosing either path has certain trade-offs. Preserving grain in the digital copy means risking artifacts. Depending on the level of compression, some grain clumps may appear as square blocks. Blu-Ray authors sometimes need to

leave room on the disc for promo and other bonus materials, thus requiring the main feature to be compressed at a lower bitrate. If increasing the encoding bitrate is not possible, there are video noise reduction (**DNR**) systems available at most post houses. While these systems are highly automated resulting in cost savings, they produce an unfortunate byproduct in that they tend to soften the image, resulting in faces that look waxy and unnatural.

FIGURE 4.22

Digital noise is loosely analogous to film grain

GRAIN OR NO GRAIN?

When studios first began to re-master their back catalogs for high definition (HD), the general consensus was to scrub every frame clean. However, cinephiles balked at this notion and in time the studios backed away from "sanitizing" their old movies. There are very powerful tools that can minimize grain or add it back in depending on the needs of the client. Grain management in updating films is now part of a larger discussion, as restoration expert, Tom Burton, explains:

"As recently as six or seven years ago, there was a mentality in the industry to try and make everything that was old look like it was just made yesterday. And the argument was: "Our audience is so used to seeing everything in HD now, that when they see film grain in movies, they think there's something wrong, so we need to take it out." There were a lot of new image repair tools on the market at that time – and I think everybody just felt obligated to set the meter at 10 or 11 just to see how much they could take out. There has since been a 180 degree turnaround and I think it is due in part to the studios getting a lot of negative feedback from the dedicated viewer base out there who were saying: "What have you done to this movie? Why is it so plastic-y and smooth in a very false way?" And some studios took a lot of criticism for it.

So now, thankfully, they're back to: "Touch nothing unless there is a very good reason to do it." And that reason is typically very specific – often, when we're reconstructing these vintage films, at the end of the day we're not using a single element. We could be using

part of an original negative, part of a fine grain that might exist, part of a protection IP and we're integrating all of them because there's damage or missing sections in any one element. So when you put those all together – elements created from different sources, different laboratories, different film stocks, sometimes years or decades apart – frankly, they don't match. So at that point, you've got to do some controlled image manipulation to get the grain to match across all sources, in order to return the film to its original look."

Tom Burton, executive director restoration services, Technicolor

NOTES

1. *The Cutting Edge: The Magic of Movie Editing*, DVD, directed by Wendy Apple (Hollywood, CA: American Cinema Editors, British Broadcasting Corporation and NHK Japan, 2004).
2. "Summary of Directors' Creative Rights under the Directors Guild of America Basic Agreement of 2011," Director's Guild of America, http://www.dga.org/Contracts/Creative-Rights/Summary.aspx, accessed October 7, 2013.
3. "Leverage: All Digital," web video, 4:35, http://www.electricentertainment.com/news/leverage-digital-workflow/, accessed October 7, 2013.
4. Ibid.
5. "Offsite Collaboration and the Cloud Bad Robot – The Rough Cut," YouTube video, posted by "Avid," http://www.youtube.com/watch?v=hdk2CYKJqKA, January 9, 2013.
6. "Avid Technology," http://en.wikipedia.org/wiki/Avid_Technology.
7. "ISIS 5500 – The Benchmark for Shared Storage Value," http://www.avid.com/static/resources/common/documents/datasheets/ISIS_5500_ds_A4_sec.pdf.
8. Contemporary feature film or network TV shows typically start with three or four seats to accommodate editors and assistants.
9. "Avid Unity ISIS Whitepaper," http://fp.avid.com/resources/whitepapers/ISIS_storage.pdf, accessed September 17, 2013.
10. See https://www.photron-digix.jp/support/isis/files/AvidISIS_ReadMe_v4_2.pdf.
11. Interview with John McCabe, renowned Avid technician and digital doctor.
12. Edward Jay Epstein, "Hidden Persuaders: The Secretive Research Group that Helps Run the Movie Business," *Slate*, July 18, 2005, http://www.slate.com/articles/arts/the_hollywood_economist/2005/07/hidden_persuaders.html.
13. "Pix System Overview," http://www.pixsystem.com/pdf/PIX, accessed October 13, 2013.
14. "Distribution via DAX," http://www.daxcloud.com/distribution, accessed October 13, 2013.
15. "Pix System Mirror," http://www.pixsystem.com/pdf/PIX, accessed October 13, 2013.
16. DAX was awarded an engineering Emmy in 2013 for its Digital Dailies® "Winners Announced for the 65th Primetime Emmy Engineering Awards," Academy of Television Arts and Sciences press release, http://www.emmys.com/news/press-releases/winners-announced-65th-primetime-emmy-engineering-awards, accessed October 20, 2013.
17. API is the language (or protocol) used between two separate computer programs to facilitate the sharing of files and media.
18. "Wall to Wall Case Study," http://www.forscene.co.uk/wp-content/uploads/2013/09/Wall-towall-case-study.pdf, accessed October 15, 2013.

19. "Fremantle Case Study,"
 http://www.forscene.co.uk/wp-content/uploads/2013/09/Fremantlecase-study.pdf, accessed
 October 15, 2013.
20. "Avid Interplay Sphere," http://www.avid.com/static/resources/common/documents/datasheets/
 interplay_sphere/avid_interplaysphere_broadcast_a4_us.pdf, accessed October 15, 2013.
21. "Adobe Anywhere Whitepaper," http://wwwimages.adobe.com/www.adobe.com/content/dam/
 Adobe/en/products/anywhere/pdfs/adobe-anywhere-whitepaper-june.pdf, accessed October 15,
 2013.
22. "Final Cut Pro X RED 4K Workflow with Sam Mestman," YouTube video, 25:45, posted by
 "Michael Horton," May 16, 2013, http://www.youtube.com/watch?v=i9MLGaiJOZY.
23. Oliver Peters, "Offline to Online with Premiere Pro or Final Cut Pro X," http://digitalfilms.
 wordpress.com/2013/10/24/offline-to-online-with-premiere-pro-or-final-cut-pro-x/, accessed
 October 22, 2013.
24. Jack James, *Digital Intermediates for Film and Video* (New York, NY: Focal Press, 2006), 124.
25. T-VIPS was created by a Norwegian company of the same name that supports high-quality
 video transport over IP (http://www.nevion.com).
26. See http://www.blackmagicdesign.com/media/5407521/DaVinci_Resolve_9.1_Supported_
 Codec_List.pdf.
27. "BT.2020: Parameter values for ultra-high definition television systems for production and
 international programme exchange," International Telecommunication Union, August 23, 2012.
28. Memorable quote from an anonymous engineer.
29. "ACES Color Encoding Specification," http://colorgrader.cname.se/index.php/dictionary-a-
 tutorials/color-theory/207-aces-academy-color-encoding-specification.html, accessed
 October 20, 2013.
30. "The Image Interchange Framework,"
 http://www.oscars.org/science-technology/council/projects/pdf/iif.pdf, accessed October 20,
 2013.
31. Industrial Light and Magic Press Release, http://openexr.com.
32. "Scene Linear Workflow – ACES," http://www.poynton.com/notes/events/SLW.html.
33. Mike Seymour, "The Art of Digital Color," August 23, 2011,
 http://www.fxguide.com/featured/the-art-of-digital-color/.
34. "The Image Interchange Framework – Science & Technology Council AMPAS,"
 http://www.oscars.org/science-technology/council/projects/pdf/iif.pdf.
35. Ibid.
36. Kevin Shaw, "Final Color Ltd. Whitepaper, 2012," http://www.finalcolor.com.
37. Numerous plugins and filters are available for NLEs to customize these effects; some
 even are drawn from 35mm film scans, such as Gorilla Grain:
 http://gorillagrain.com/fcpx-35mm-pro-pack-plugin.
38. Jack James, *Digital Intermediates for Film and Video* (New York, NY: Focal Press, 2006), 331.
39. Douglas Bankston, "Wetgate Scanning by Imagica," *American Cinematographer Magazine*,
 August 2006, http://www.theasc.com/ac_magazine/August2006/PostFocus/page1.php.

Visual Effects and Titles

Visual Effects

"In the 80s animators were called technical directors. One person could literally roto, track, model, animate, light, and render a shot all on their own. But it was really hard to find enough 'generalist' people who could do all the things needed on a shot well. Over time the number of VFX shots in a film increased dramatically which caused a factory mentality to prevail. Instead of one person doing everything in the shot, groups of people were asked to specialize in one task, thereby allowing hundreds of shots to be completed in a short period of time. Quantity won over quality and efficiency won over the artist completing a single shot on their own."

Nancy St. John, VFX producer

Informal survey of number of VFX shots in recent major motion pictures:

Title	Year of release	Number of VFX shots
Captain America: The Winter Soldier[1]	2014	2500+
Sin City 2[2]	2014	2000+
Pacific Rim[3]	2013	1551
Ender's Game[4]	2013	941
Life of Pi[5]	2012	690
Avatar[6]	2009	1800+
300[7]	2007	1300
The Spirit[8]	2006	1906
Gladiator[9]	2000	134
James and the Giant Peach[10]	1996	500
Babe[11]	1995	115
Terminator 2[12]	1991	54

Films have always had the ability to transport us to faraway, fantastical places. Historically this was done with elaborate sets and painstaking miniature work. Today visual effects are the preferred method for achieving and maintaining suspension of disbelief among audiences. VFX provides freedom and flexibility to filmmakers[13] by expanding the range and scope of storytelling without breaking the bank (or so we hope). From film's earliest days directors did not let themselves be constrained by the literal world in crafting their stories. In 1902 George Méliès made *A Trip to the Moon*, which included then groundbreaking effects such as stop-motion animation, backdrops, forced perspective and clever editing. In the modern era of filmmaking, visual effects have become ubiquitous. They range from sweeping landscapes in which nearly everything we're seeing is computer generated to subtle adjustments

within a practical frame that are meant to be indistinguishable from what's real. The "digital backlot" has become a common tool not just for blockbusters, but also for period-specific film and television shows. *Boardwalk Empire*, *Mad Men* and contemporary comedies such as *Ugly Betty* make extensive use of green-screen photography to place characters in believable worlds. Beauty re-touching and aesthetic fixes on actors are also frequently employed at many levels of production.

Enhancements made by visual effects can be broken down into general categories:

- Creating virtual worlds and environments
- Creating and extending sets or backgrounds
- Adding actors, characters or creatures
- Changing actors faces or facial expression
- Adding objects or props
- Removing objects/wires/rigs and other unwanted elements
- Speed ramps or changes
- Creating motion of the frame and within the frame
- Fixing or enhancing lighting, color and framing

Nearly all of the top 100 grossing films of all time involved significant visual effects.[14] High-grossing movies will likely have more visual effects because tentpole pictures tend to be space/fantasy/action based. This trend has created an interesting dilemma around awards season. Some question whether films such as *Gravity* (2013) should be given academy consideration in the animation category rather than in the live action category.[15] What's different about *Gravity* is that nearly everything in the frame consists of digital animation except for the actors' faces. That's a relatively new development, even when compared against films featuring extensive computer generation (CG) such as the *Lord of the Rings* trilogy.

5.1.1 CGI AND COMPOSITING

CGI, or computer-generated imagery, can be broken down into two basic areas: 2D and 3D drawing and rendering. Filmmakers have succeeded in portraying depth and volume in a 2D landscape since the early days through the use of scale, light and shadow. Along with receding planes and overlapping objects, they serve as basic depth cues. But with sophisticated software and ever more powerful processors comes the world of 3D virtual objects and environments. 3D animation should not be confused with stereo 3D photography. While both are capable of representing the volume of a person or object, 3D drawings are combined with 2D compositions to create an illusion of depth. 3D and 2D CG animation therefore are not mutually exclusive, but form the backbone for many of the animated sequences that we see today.

2D CGI is capable of painting, moving and lighting images, and is useful for everyday animation

FIGURE 5.1

Graph of X, Y and Z coordinates representing three dimensions

on inexpensive computers. Adobe After Effects is one example of this type of software, and like most 2D programs has the ability to combine 3D elements via compositing. 3D CGI requires more computing horsepower and is capable of creating whole characters, objects and environments that can be viewed from all sides. The artist is able to change the point of view within the frame by either moving the object (or alternately the virtual camera) to literally place the audience within a certain environment or scene.

2D animation can be compared to hand-drawn animation, as in frame by frame, the way old Disney films were made. Like, if you had a flip-book and you can see the ball bouncing up and down. That was basically 2D animation. Today, we also have 2D animation using computers mostly for things like motion graphics and text scrolling. If you want it to move or just scale it down to fake the movements, we can do that in 2D.

But 3D not only uses your X and Y space, which is up and down or left and right, but now we're incorporating the Z space for depth. So, it's basically taking that bouncing ball as an example, and instead of sketching it out on paper, you're making a clay model of the ball, only you're doing it inside a software program. And you can actually move that ball around and inside a room, but you're doing it using a 3D software program instead of in a practical space.

Laura Jones, visual effects producer, Zoic Studios

5.1.2 ANIMATICS AND PRE-VISUALIZATION

During the planning stages of an animated sequence involving visual effects, a storyboard artist is hired to create drawings of the proposed action scenes. These drawings can either be drawn on a computer, or drawn on paper and scanned into a computer. A series of storyboard stills can be placed into the nonlinear editor (NLE) timeline and edited for pacing along with temp dialogue and sound effects. They can be "animated" through a series of crossfades, push-ins, pull-outs, pans and effects to produce a template for the director's vision for the film. These mock-ups are commonly referred to as **animatics** and are a cost-effective way to workshop the action and blocking of any scene. The combination of storyboard stills and temp audio helps to estimate the length of scenes and shots.

> *Star Wars Episode II* was not only the first major feature film to be shot in HD video, it also featured an innovative form of pre-visualization known as "videomatics."[16] Using an inexpensive video camera, director George Lucas had assistants act out scenes in front of a green screen. Then, editor Ben Burtt would use CGI to create a rough backdrop and bring the composited shots to the set to show the actors. Lucas refers to this as being able to "direct the film in the editing room."[17]

Pre-visualization (previs) is a computer-generated series of 3D animated storyboards. These may be created by the visual effects house bidding on the project, or the production might hire a company that specializes in previs to produce them. There are many inexpensive programs that allow for a variety of camera angles, choice of lenses, and placement of characters and objects. Previs affords tremendous creative freedom to directors and editors and provides essential tools for planning and pre-production for production designers, VFX supervisors and producers.[18]

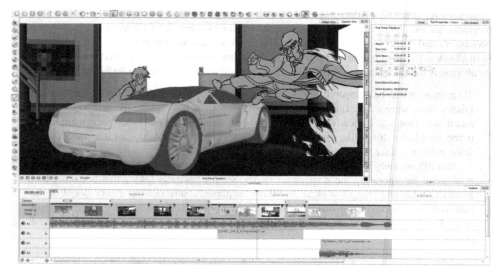

FIGURE 5.2

Applications such as Frame Forge, Maya and Storyboard Pro (shown above) offer the filmmaker powerful toolsets during pre-production

5.1.3 GREEN SCREEN, COMPOSITING AND SET-EXTENSION

Chroma-key is a common technique used to isolate and "hold out" part of an image based on its color and value characteristics. Because green and blue are very strong colors that do not intersect with skin and earth tones, they are often the colors that are keyed out. There are cases where characters are photographed against partial or complete green screens and the key is used to separate the character and foreground elements from a background that is going to be generated and composited later through visual effects. Sometimes keying is used on foreground elements that need to be removed, such as in *Forrest Gump* where Lieutenant Dan, played by Gary Sinese, has an amputated leg. This was achieved by wrapping the leg in green cloth and keying it out later to produce a stump.

ROTOSCOPE

Before computers were able to digitally track objects, rotoscoping was achieved by physically drawing and tracing people or things in order to separate them from the background. *A Scanner Darkly* (2006) is a good example of an animated movie relying almost 100 percent on rotoscope. When colored screens are not used on set or if a decision is made later on just to use the foreground, rotoscope is the preferred method. By placing trackers onset and guided by software tracking systems, complex matte shapes are created that are enormously helpful for compositing and in the color correction process. Today roto work is highly automated but not entirely foolproof, which means that VFX artists often have to tweak and adjust scenes manually.

By covering or isolating elements onset with green and blue screens, considerable time can be saved over having to **rotoscope** the shot. Complex detail such as hair and clothing may be a challenge to rotoscope accurately if they blend into the background. For background replacement, shooting against a green screen is almost always the preferred approach. It can, however, be difficult to determine parallax and the relative depth between the foreground elements and the background. That is why visual effects supervisors and their onset team place tracking markers on the green screen and sometimes on middle and foreground elements (see Figure 5.3 for an example of tracking markers). Even if this means they must do minor rotoscope or remove the trackers later, it's better to have more tracking data than less.

FIGURE 5.3

Chroma-key

FIGURE 5.4

Ugly Betty, ABC Series (2006–2010)

Ugly Betty was a hit TV series that ran for four seasons on ABC (2006–2010). Although the show is set in New York City, the first two seasons (except for the pilot) were shot in Los Angeles. Audiences didn't seem to notice this since the characters appeared in and around Manhattan exteriors regularly (see Figures 5.3 and 5.4). The production was able to enjoy considerable savings by shooting many of the street scenes against a green backdrop and compositing the city backgrounds in post.[19]

FIGURE 5.5

Boardwalk Empire (HBO) used extensive CGI to recreate Atlantic City in the 1920s

When *Boardwalk Empire* debuted on HBO in 2011, it featured incredible production design that accurately portrayed the Prohibition Era of the 1920s. Using old postcards and original advertising from the 1920s as inspiration, digital compositor Chris Wesselman was able to create Atlantic City from the ground up, using green-screen compositing and set extensions.[20] While the boardwalk was real and located in Brooklyn, huge green screens were erected around it to key in the beach and ocean and extend the views of the city (see Figure 5.5). Period extras were added digitally, thus providing added savings on what would normally be a very expensive period production.[21]

For the shooting of Christopher Lee's lightsaber duel with Yoda in *Star Wars II: Attack of the Clones,* a stunt double filled in for the 80-year-old actor. Except for the close-ups, his face was later seamlessly added into the scene using CG techniques.[22]

Today it is possible to digitally stitch together different takes of a scene without the use of green screen but rather with split screen, allowing for enhanced performances. This kind of surgical precision usually goes unnoticed by the audience but has been used for maximum effect in films by David Fincher, such as the opening scene in *The Social Network* (2010). The main character (played by Jesse Eisenberg) is in a crowded pub with his girlfriend (Rooney Mara). The dialogue is fast and furious and sets the tone for the rest of the movie. Different takes of each actor using split screens are combined into one seamless shot. By having so many choices of line readings and performance, the editor, Angus Wall, needed three weeks to assemble this sequence![23]

5.1.4 RIG AND WIRE REMOVAL

Characters in action movies are often seen flying through the air, free-climbing skyscrapers or hanging from helicopters. These stunts can safely be achieved through the use of onset practical effects. Wires, rigs, and harnesses are needed to defy gravity, making their removal during post commonplace. In simple shots, where the background is relatively static and not highly detailed, semi-automated temporal and spatial **inpainting** processes can be used to remove a wire and reveal the background. However, static shots are rare since many sequences involve fast camera movement and detailed background elements passing behind the wire. In more complex shots, roto painting is the necessary solution. Clean background plates can often be made from multiple key-frames and then tracked over the shot. Then the visual effects artist will matte out the wire using similar techniques and replace it with the clean plate. There is rarely a single solution to wire removal and a variety of techniques may be necessary to remove the offending wire without degrading the image.

There are many other "rigs" that commonly need to be removed. They may be lights, stands, power cables, boom mics, crew reflections and shadows, puppeteers, stunt-men, telephone poles and power lines. For example, a stage light may be used to simulate the light coming from a CGI effect that is going to be created in post. In order for the lighting scheme to be accurate, the stage light must be placed squarely in the shot, thus requiring that it be removed in post. Boom mics and their shadows are common offenders and often require painting a clean plate of the intersecting region, tracking and compositing it over the original image. Rig removal is an important part of the art of compositing (see Figure 5.6 and 5.7). By carefully combining onset, practical effects and post-production techniques, visual effects supervisors and producers can save time and money while enhancing the believability of the effect.

FIGURE 5.6

Wire and rig removal (before)

FIGURE 5.7

Wire and rig removal (after) is frequently employed in shots which contain offending objects

5.1.5 BEAUTY WORK

Much like the fashion industry, agents, managers and studio executives never want their actors to be seen as having cellulite, wrinkles or shadows under their eyes. Even during strenuous action sequences, actors are expected to look their best. Depending on the aesthetic of the project and the desires of its financial backers, beauty work is required to provide a glossy, elegant look that improves upon the natural world. Long hours, night shoots and inconsistent nutrition are common on

film sets, and represent challenges for an actor or actress trying to stay in peak condition. The talent may have a bad skin day from time to time and the make-up artists can only do so much to cover up. It then falls upon visual effects artists to help out.

Beauty work, sometimes referred to as "aesthetic fixes", is a subtle yet integral aspect of visual effects. There are relatively simple processes to remove blemishes, acne and enhance skin tone. There are also more complex effects such as body contouring which can help talent lose a few digital pounds. This is also called a "vanity pass" and may be written into a star's contract, which producers must allow for in their budgets. Many of these fixes can be accomplished in the digital intermediate grading suite. All of these enhancement techniques are meant to go unnoticed by the audience.

Aging and de-aging are common in films today. It used to be difficult for actors to vividly portray older versions of themselves, and even harder to play younger versions. Masterpieces such as *Citizen Kane* and *Back to the Future* have demonstrated the limits of practical make-up effects without the benefits of CG. Contemporary films have required significant CG facial reconstruction, such as *Tron: Legacy* (2010), where Jeff Bridges plays both himself at his current age and also as he appeared in the early 1980s. It was deemed critical to accurately match his appearance, as many fans recall what he looked like in the original film.

In the *Curious Case of Benjamin Button* (2008), Brad Pitt portrays an old man who ages "in reverse" and ultimately becomes a child. This called for changing his body size and facial structure over a significant number of years. In *The Social Network*, Armie Hammer was cast as the two Winklevoss twins and required that his face be composited over a body double. In *Captain America: The First Avenger* (2011), Steve Rogers is rejected from military service because of various health problems and his short stature. A multitude of compositing techniques were used to reduce Chris Evans to his pre-captain size.

5.1.6 2K VS. 4K FOR COMPOSITING AND CGI

As 4K acquisition and exhibition become more common, what about visual effects? How should they be handled? The obvious answer might be: if the film is being finished in 4K, the VFX needs to be done at 4K as well. In a perfect world, this would be the case.

Because a 4K frame has four times as many pixels as a 2K frame, all elements of the workflow increase by a factor of four as well: rendering times, needed CPU horsepower and resulting file sizes. That means working in 4K effectively costs four times as much! Even in cases where producers are willing to commit the additional funds, there may not be enough resources (artists, hardware, pipeline, facilities) to accomplish the work during a typical production cycle. Visual effects schedules are often compressed as studios put pressure on producers to turn around their films more quickly.

As 4K VFX may not be financially or logistically feasible for every production, it is up to the producer to determine whether to finish at 2K or 4K.

In shots with high-frequency details that are sharp, in focus and not lost in motion blur, the benefits of 4K may be obvious to the viewer and represent a trade-off in terms of time and labor ($) necessary to produce this content. However, the majority of visual effects in modern feature films are complex, fast-paced action sequences with a lot of camera movement and resultant motion blur. The pace of cutting is so quick that many details are lost to the viewer because there is not enough time to visually register the entire frame. It's common for VFX shots such as these to "cheat" in the details. This means that less time and resources are allocated to background textures and models. Backgrounds might be pre-rendered as 2D plates instead of complex 3D scenes. Particle simulations such as dust and debris not clearly visible through the motion blur could be skipped or replaced by 2D plates (sometimes at 2K resolution) to speed up rendering. A visual effects artist's job is twofold:

they are responsible for making compelling visual imagery, but also manage their time and resources with care. If every shot was done strictly by the book with closer attention to every detail, VFX would take longer to accomplish and cost more than it already does, with the audience perceiving only marginally higher quality.

It's more important to allocate resources aimed at perfecting the *animation* or the *performance* of CGI characters instead of rendering all shots at 4K. At the end of the day, the audience is going to remember the movie for the story and creative visuals, not for its resolution. Eventually we will reach a point where work in 4K is economically viable; but this means there will be fewer opportunities for VFX artists to cheat their shots and they will have to spend more time on the minor details. The bottom line result will be little or no net savings.

5.1.7 VFX EDITORIAL

The VFX editor on a feature plays one of the most critical roles in modern post-production. Historically, the assistant picture editor would be tasked with managing the limited number of VFX assets for the project, but with modern films routinely incorporating 1,500 to 5,000 VFX shots, teams of dedicated VFX editors and their own assistants and coordinators have taken over this crucial responsibility.

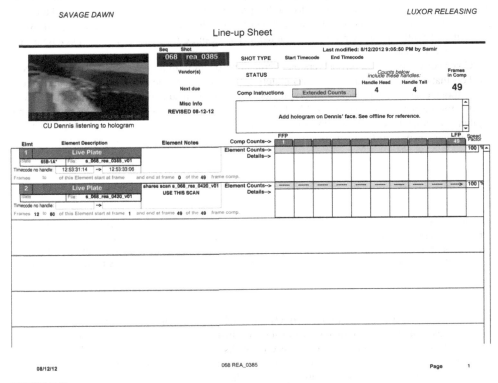

FIGURE 5.8

Line-up sheet from *Savage Dawn* (2012)

"Managed chaos" is the best way to describe such a workflow, beginning with a custom database such as Filemaker Pro or industry specific systems like Shotgun. Each shot or sequence is broken down and detailed using a count sheet that details clip and reel names, timecode and other essential information. Plates are "pulled" (or scanned to DPX or EXR) and sent to the various visual effects houses charged with creating the composites. These artists may be working across town or across the globe and it is not uncommon for a Hollywood feature film to employ as many as 20 VFX companies:

> "On a show like *Captain America*, the VFX editor's primary function is "comping" shots, as elements come in, in the Avid. So the editors can see what works, and if it's comprehensible. He's also organizing all the data that's required to identify shots, naming them, organizing them in a database, collating all the scans, and delivering those scans. All the information needed to go back and forth between the effects vendor and editorial department goes through the Visual Effects Editor."

> Thomas Calderon, first assistant editor, *Captain America: The Winter Soldier* (2014)

The previs acts as a placeholder in the Avid timeline and as rendered composites (comps) come back from the VFX houses, they are laid into the cut. The VFX editor therefore acts as an intermediary between the editors and everyone else involved, including VFX coordinators, supervisors and producers, as well as the artists responsible for compositing the shots.

Other essential tasks include the creation of temp effects and mattes inside the NLE. While it may be necessary to take a shot or sequence to another program such as After Effects, the VFX editor may prefer to work directly in Avid doing color correction, wire removal and rotoscoping. Doing this work inside the NLE allows for the preservation of the metadata and for making numerous quick revisions as the sequence changes.

Color correction of the offline version is crucial particularly in regard to the visual effects. Not all shots that come back from VFX are accurately color graded with the same dailies grade as the rest of the footage and when it comes time to preview the film for an audience, the last thing filmmakers want is for the new shots to be noticeably different in a sequence. Therefore, VFX editorial has to be vigilant and allow time for correcting shots to match the rest of the film or impose a comprehensive color management workflow between them, their lab or post house, and the VFX vendor.

THE IMPORTANCE OF HANDLES WHEN CREATING VFX

Between four and eight frames are usually added to any visual effects shot to allow for the editors to make adjustments to the cut as it progresses. If there happens to be 500 or 1,000 VFX shots, then the amount of extra frames can really add up, resulting in increased costs and render times. In these cases, the necessary number of handle frames may be the subject of negotiation with the VFX house.

In television, schedules for creation of effects are much tighter than feature films. The VFX house may have as little as 15 working days from start to finish. Therefore, coordination amongst remote teams and robust broadband infrastructure is crucial. As an example, consider a possible scenario in which the VFX designers are in Vancouver and the cutting rooms are in Los Angeles. In this case it is likely they would use a pipeline with high-speed data or black fiber for expedient asset transmittal. Backplates and temp effects are already laid into the Avid timeline by the editor as placeholders. When a new effect shot has been rendered (with handles) it can automatically be replaced, essentially dropped in by the VFX house without having the assistant editor perform the task. This means that

an hour-long episode scheduled to air on a Friday night will have a deadline for the Tuesday of that week in time to have all of the VFX approved and placed in the show. However, under extenuating circumstances, and due to the speed of modern post-production, it may be possible to replace a few shots as late as Wednesday night or Thursday morning.

5.1.8 VFX COLOR MANAGEMENT

Accurate color management is critical to producing high-quality visual effects. One of the golden rules is that image regions devoid of visual effects should not be modified in any way. Additionally, the final VFX shot must retain all of the same image quality (resolution, dynamic range, sharpness and detail) as the original plate. For example, if a plate is delivered to a VFX house from the camera original media, the VFX house must deliver the final shot in the same color space at the same quality without any loss of data unless otherwise dictated by the production. As a result, VFX facilities have specific pipelines that their technical directors (TDs) design and which their artists must follow.

10-bit log-encoded DPX plates are still the standard format for film scans. A log DPX workflow offers ease of use and compatibility between large VFX houses, smaller boutiques and the digital intermediate. Almost all digital intermediates grade DPXs. While it is less common, the adoption of OpenEXR continues to grow.

OpenEXR is a format developed by Industrial Light and Magic and was first used in *Harry Potter and the Sorcerer's Stone*, *Men in Black II*, *Gangs of New York* and *Signs*.[24] OpenEXR is designed to be a scalable image format with higher dynamic range than 10-bit formats through 16-bit and 32-bit floating point encoding. OpenEXRs contain multiple layers, so they are ideal for CGI work where multiple passes (i.e., beauty, ambient occlusion, specular, diffuse, refraction, emissive, velocity, normal) are commonly rendered. By combining all of those passes into a single file, VFX producers and compositors benefit by having fewer files to manage. OpenEXR is most commonly used for CGI renders, even if the camera original plate is DPX.

It's often a good strategy to pre-grade visual effects plates before they are delivered to the VFX vendors. Because VFX sequences are often worked on out of order and sometimes by different vendors, it is difficult for VFX artists to predict how the shot will be color graded unless a pre-grade has been done. However, it is not ideal to "bake-in" a grade as it could negatively affect the VFX artist's ability to pull clean green or blue-screen keys or track a scene. It is important that the VFX artists receive the highest quality unaltered footage possible, yet still be able to see the pre-grade.

Instead of baking the grade into the footage that is delivered to the VFX artists, creating accompanying color metadata is a non-destructive alternative. Updates are easy to manage if the grade changes during post-production and can be tracked throughout the process. Simple color corrections employing **lift/gamma/gain** and **saturation** math are quantified using ASC CDL values. CDLs use a simple formula of **slope**, **offset**, **power** and **saturation** values applied to the red, green and blue channels to transform the image. These numbers can easily be communicated using Avid **EDL**s, **ALE**s, or **CCC XML**s. These decisions might even originate from the dailies color-grading session as they are interchangeable between almost all color-grading systems (see section 3.3.6, "Transmitting Color Intent"). Alternatively, **3D LUT**s can be used if the grading is more complex and involves **hue** shifts and hue-specific saturation, or tools that are not compatible with ASC CDL.

During compositing the VFX artists will work from the original plate (ungraded) and use the CDL values (or LUT) to preview the color grading in their viewing space. As a result, they are able to preview their composite and see exactly what the colorist and client will see when the final shot makes it back to the DI. The CDL or LUT can be used for preview or, alternatively it could be baked in to the final VFX render so that grading work does not have to be replicated in the DI. This depends upon the agreed workflow decided by the VFX vendors and the post house or lab.

5.1.9 VFX INTEGRATION IN COLOR

Most production cycles are not entirely linear and involve a lot of overlap in delivery schedules. It is common practice to begin color grading before all the visual effects shots are completed. Even as late as the day of delivery, shots are frequently updated and replaced with better versions that fix artistic or technical issues. This is true for many types of shots, both simple and complex. It is recommended while waiting for the final shots to come in that you grade the original background plate or a temp VFX shot so that it is relatively close in color characteristics to the final look of the piece. Because VFX shots are often completed at the 11th hour, close to a film or television show's delivery date, it is important to do as much color work ahead of time as you can.

As new versions are delivered to the colorist, they can merge their previous work with the new shots so as not to repeat laborious work and maintain consistency. Depending on the nature of the shot, grading may involve complex **secondaries** (tracking or animated masks or keys). In simple cases where a **primary** grade is applied, it is just a matter of copying and pasting the grade data from the previous version to the new version. If the composition of the shot changes – for example, if a CGI character's action is different from one version to the next – it may be necessary to make adjustments to animated or tracked secondaries and appropriate time must be allocated for this. Sometimes it is as simple as copying and pasting the previous version's grade data onto the new version and offsetting the global position (as it relates to the shot in its entirety) of a mask or roto. In other cases, the difference between two versions of a shot can be so great that a mask or roto needs to be redrawn and animated or tracked from scratch.

Because VFX shots often involve the integration of new CGI assets (characters, vehicles, buildings, etc.) or the combination of multiple live-action plates (character on green screen against a background plate), precise and detailed mattes will have already been generated by the VFX artists. CGI renders include matte passes used by compositors to blend the CGI elements with the live-action elements. Because these mattes already exist, it is redundant for a colorist to rotoscope composited characters or elements in a VFX shot. Additionally, it is difficult and time intensive to rotoscope a character with enough precision to give a colorist complete creative control. By using pre-rendered mattes from the VFX artists, a colorist can quickly "dial in" corrections on foreground characters, background plates, effects without having to roto or track anything, and without introducing noticeable matte edges from an imperfect roto.

These mattes are updated with each successive update to the VFX shot. That way when a character animation is altered between versions, the colorist can copy and paste the original grade (referencing a matte instead of roto), and it will match without any matte refinements having to be made. This maintains consistency and quality while keeping the process quick and flexible.

5.1.10 CONVERSATION WITH NANCY ST. JOHN, VFX PRODUCER

Q: What would you say to a young person getting out of school who wants to get into visual effects as a producer? We're not talking about someone who paints or draws or knows how to run the box.

St. John: Well, clearly my career path was as a visual effects producer. As a producer you don't have to sit on a box but you do need to understand the entire production process. It's similar to being a general contractor who builds a house. You understand and appreciate what each of the trades do. In VFX the plumbers, electricians and other trades are the modelers, trackers, roto people, animators and lighters.

As long as you know and understand what all the different trades in the visual effects pipeline do and how to schedule their work, then you can be that VFX general contractor and it's actually a really interesting job. You get involved in all aspects of production from meeting with the director and producer right from the very beginning to delivering the last shot at the very end.

VFX is a technical category and so it is the VFX Supervisor who receives all the credit. That's okay if you're not an ego driven human being and don't mind having the job behind the scenes orchestrating. They say every good general sits in his tent and orchestrates. I kind of like being behind the camera, so to speak.

The director ultimately gets the credit for everything that is shot during principal photography and takes the blame if the movie doesn't succeed. In VFX we are here to help the director achieve his or her vision.

Being in post-production is very satisfying. A lot of creative minds come up with great scripts. They go out and they shoot a bunch of great stuff with great actors and together with the editor they assemble the movie. This is when VFX can come in and really help polish the movie. VFX has its greatest impact during the post-production process.

For many directors, they get to post-production and they're completely overwhelmed. They were set up to choose actors and shoot. They knew what locations they wanted and costumes for their actors. But sometimes when they see the movie assembled they realize how much more work there is to do.

That's when VFX can really impact the post-production process as we collectively rally around our director. The post-production process is all about finishing up sequences on a shot by shot basis. We ask how can we make this better? What does this sequence need to make it work? How do we collectively create all the different elements needed to make the shots work?

As the VFX producer I try to get the director and producer to focus on each sequence and to think about the rhythm of the movie. What part of the story does each sequence tell? Is the story being moved forward by each sequence? How can VFX help tell those stories? During principal photography there is a whole team there to help the Director tell his or her story. There's the DP and the camera dept. There's the scenic and costume people, hair and makeup and so on. Each day onset they are asking the director for his input but in post, we get him all to ourselves. In post-production it's all about fine-tuning the movie and crafting it.

Q: You mentioned that, in 2005, the studios became gun-shy about green lighting big-time VFX movies when the accountants appeared to take over.

St. John: Back in the day producers had an instinct about a story that they felt needed to be told. They felt that if the story was told correctly and the actors did their part to make the story come to life in a genuine way there would be an audience. Today before a script is green lighted a team of accountants determine what the potential worldwide box office is. For a studio to invest in a movie its risk needs to be minimum and potential return on investment needs to be high. Filmmaking is a business investment, no longer is it an art.

I think, what you see now is a trend. Sony Pictures has just announced that it needs to cut US$250 million out of its budget this year. So how does one go about doing that? Well you can lay off a few people and that accounts for a few million. But what it means is that you have to go into risk management mode and start looking at your slate of pictures, see how expensive they are, start placing odds on

who the winners and the losers are and manage your risk and return on investment, putting money where you think you're going to get your biggest bang for the buck.

All the studios are doing it. They're rolling the dice on a few US$150 million to $300 million movies and reducing the overall number of pictures they produce each year. As a result, a new version of the same vehicle is being distributed each year. For the accountants this is a safe bet as the movies have already found an audience and they want to tap into that audience as long as they can. If there is an audience for *Iron Man #7* then they will make that movie.

There will always be a handful of less expensive movies that will get made. The hope is that the studio will get a winner out of the bunch and create a franchise.

Q: And so the lower budget pictures don't lend themselves to CG necessarily?

St. John: Yes, look at *Paranormal*. The last two have been made for US$5 million each and have easily made their money back. The VFX are fairly simple and don't cost a lot. No fighting Robots to bring the costs up.

So I think each studio is looking at their A, B and C class movies. Look at *Silver Linings Playbook*. There are no visual effects in that movie. It won all kinds of awards and was a fantastic movie and they made a ton of money. The tent pole movies with the big budgets also tend to have the biggest VFX budgets. If the studios are willing to create those movies then the big name VFX facilities will be there to create those visual effects.

Q: You mentioned that contemporary directors seem to rely too much green screen and CG when they run out of ideas. And, maybe you could elaborate on that.

St. John: I really wish I knew why this was happening. Maybe it's because actors are only available for a short time, maybe the money isn't there to build proper sets or to travel to real locations but more and more productions are shooting on green screen and deferring most of the decisions into post-production.

A lot of movies are organized and structured around the timetables of the actors. Actors work both in TV and film and have schedules that need to be shot around. Long gone are the days when the cast stayed with first unit through until principal photography was completed.

Budgets don't allow for sets to be built. So now it's just super simple: "Let's just shoot the whole thing on green screen. We'll worry about everything else later." Directors have started to get a little lazy too: "Well if I don't have to choose a location ahead of time, then I won't" or "If I don't know what the background is going to look like now, I'll put it off until later because I want to concentrate on the actors."

More of principal photography is now being pushed into post by doing it the green screen way. It's unfortunate because, when you get to post, the production designer's gone, the costume designer's gone, the makeup people are gone, the scenic people are gone, the DP's gone. None of the people that were involved in the decisions during shooting are there. At that point you're just relying on your director. All he's got is his visual effects supervisor and producer and that's it. Now they have to complete the movie in six to eight months.

That's the trend that I've seen. When you think about it, if an actor or actress gets US$30 million per shoot and they're only available for 20 or 30 days, everybody else scrambles. And the irony is that the actors don't like it. Now, they're acting a scene with no props, no background, no nothing. They're just on a green screen. And they don't like it either. It's what the business has become.

Q: The movie *300* really proved that concept that it's possible to shoot a whole movie in a warehouse in Montreal, which in that case was shot against blue and they didn't have to worry about the backgrounds or at least not have to deal with them right then and there.

St. John: Now decision-making can be put off to post-production, so they will do that. When you defer decision-making that would normally be done during principal photography into post, you're causing the cost of post-production to go up. Now we're asking everyone in the post-production process to make up for the fact that you didn't make those decisions when you shot the movie. That's why so many visual effects companies go out of business. They are being asked to do production and post-production without the funds to cover the additional costs.

VFX companies are asked to give a bid before shooting even begins. They have no idea that two thirds of the things that they thought were going to be done in principle are now pushed into post. And then they're asked to eat the difference. And as a result, visual effects companies go bankrupt. They just go under from the demands of completing the movie that was not managed during principal photography.

The larger well-affiliated VFX facilities will survive. Disney is going to give their tent-pole VFX shows to ILM. Sony's going to give theirs to Sony Imageworks. Weta's going to get Peter Jackson and Jim Cameron movies. And then there'll be a bunch of little boutiques that'll cover the rest of the work. It will be about tent-poles and then smaller movies.

Like on *Limitless*, with director Neil Burger and Bradley Cooper starring, there were just under 400 shots. We did a really bitchin' opening sequence that was super cool and did some great VFX shots too. But the movie was not about visual effects. The movie was not about robots killing robots. *Limitless* had actors being actors on location and onsets in a traditional filmmaking way and VFX was in service to the movie, filling in where needed. That's where I hope we are going in the future.

Trailers and Promos

5.2

From the first frame of shooting through the life of your project, it is essential to create brand aware-ness, generate buzz and connect with your audience using elements such as viral videos, behind-the-scenes footage and filmed interviews. The traditional method for getting crowds into theaters has always been the movie trailer, teaser or TV spot, but to effectively manage all of these elements and present them as a cohesive whole to the general public often requires engaging a company or creative partner who is experienced in the following:

- Titles, motion graphics and visual effects
- Writing and editing
- Branding and identity
- Social media
- Trailers and promos
- Music supervision

Many of these companies have their roots in the gaming industry and are adept at attracting a youth audience – one of the most highly sought after demographics among filmgoers. Because a marketing campaign for a TV show or feature requires substantial lead-in time, the footage and cut sequences must be made available to trailer houses early in a post schedule. This often takes place during the time when editors and their assistants are focused squarely on finishing the show, not the trailer. This potential bottleneck can be avoided by producers by including the additional time and labor needed for such requests in the schedule and budget.

> In the case of trailer schedules where raw footage and cuts are turned over prior to picture lock, it happens more often than not that scenes end up in the trailer that were excised from the final cut. Care should be taken to avoid this as many filmgoers may become aware of this and generate negative word of mouth. One example comes from *R.I.P.D.* (2013), which ostensibly is a sci-fi comedy and flopped upon release. In the trailer, the character played by Jeff Bridges utters a very funny line to an alien creature with eight to ten eyes, stating: "I don't know what eyes to shoot you between."[25]

5.2.1 CONVERSATION WITH JOHN DAVID CURREY, OWNER OF FRESH CUT CREATIVE

Q: Share with us a little bit about your background. How did you get into the business?
Currey: When I was 12 years old I used to splice wires between two VCRs and cut together movie trailers. So, I knew the short-form was something I liked. When

I got into college I thought cinematography was where I was headed. But in my junior year I got to visit NBC because I knew someone there. I watched them put together a spot and that's where I definitely knew that I wanted to be.

So, I interned there in my junior year. I had applied 13 times and gotten twelve rejections before I got in. And by the time the internship was over, I didn't want it to be over, so I applied for the Academy of Television Arts and Science internship, which I knew would take place at NBC, and so I went back.

When I graduated, I got a job as a production coordinator at NBC and worked my way up over the years - from room producer, to writer/producer, to senior writer/producer, to director of comedy, vice president of comedy and drama, and then SVP of the department. It was kind of a fun run. I was there for about 13 years.

Q: And your department was for creating promos?

Currey: Yes, the name changed over the years. They came up with the concept: *Must See TV*. While I was there I was lucky enough to get to work on *Friends* and *Frasier*, some of those last classic TV shows. And *ER* was my main show that I was cutting.

Q: And so you were cutting them as well as supervising other editors and producers?

Currey: Yeah, I spent my first three or four years cutting. NBC differs from some of the industry. They have writer/producers who write and edit the spots. I always believed that's the best way to go. I've always enjoyed that model. Some people prefer having a producer and an editor. But for me it's always been nice to be able to sit down and use the Avid as your notepad.

Q: Television has always been considered a writer's medium. That's why so many producers are also writers. But if you consider editing to be the final rewrite, then of course it makes sense to combine the producer role with editor in the creation of promos.

Currey: Absolutely. I used to tell my class: the difference between editing a movie and editing a promo is, when you sit down to edit your promo or your trailer, you have a blank timeline. There's no script. You sit down and you've got to create something from scratch. Some people like to write a script and then work with it from there. But it really is a very unique form of editing where you are both production and post-production.

Q: Tell us about your company, Fresh Cut Creative, and what you're trying to do there.

Currey: The easiest way to say this is: "We're a trailer house." To other people I say: "We do on-air marketing." But our specialty is short-form on-air marketing. Anything between 5 and 15 minutes is what we specialize in.

A trailer house has become so many different things. I was just on Facebook and one of our spots was on there. It isn't just a 15 second spot that you slug into the TV break anymore. One of our guys right now is working on a 90 second recap for a show that is placed at the front of a show. So we often do stuff that is actually considered content for the show. So, I would say that the 30 second spot has evolved greatly since the days of *This Week on Bonanza*.

Q: What are some of the goals for creation of a network promo?

Currey: The assignment would be something like: "We need a 30 second spot that highlights 'X' in the show for 'Y' audience." And those are two very different and very important elements. You need to know who you are doing this for. With anything in marketing, you've got to know who your audience is. Then it's up to

us to watch the show and figure out the best way to attack that. We do that with a balanced combination of editing, music and writing.

Q: And so the "Y" in that case, would that be a certain demographic of the audience or a specific target audience?

Currey: Sure. With broadcasters there's definitely a reason they use the word "broad" because the target is typically men and women, 18 to 49 years of age. When we work with some of our cable clients the demographic could be male – late 20s to early 40s. That's a pretty specific demographic compared to something like a broadcaster. It's also important to know what the brand voice for that network will be. What does an ABC spot sound like vs.a Spike spot? Broadcasters differ from each other as well.

Q: When an hour-long show is sent over and you assign it to a producer, what's the next step?

Currey: It depends on the producer and depends on the show, but typically we'll both watch it, either together or separately. And then hand it over to the producer and let them have the first cut. Sometimes as creative director I will say: "I think we ought to go after this, or do it in this way." It just depends on the project. But typically we like to watch it and then talk about it and say: "I think this is the angle we need to take on this." Then it's up to the writer/producer to execute that.

Q: And how long does it take them to turn it around on the first pass?

Currey: It's funny, someone just asked me this yesterday. We've done promos anywhere between two hours and two weeks. We literally got a call once at 2:30 pm saying it's airing at 5 pm!

Q: You're located in Seal Beach, California. How you do you interface with the clients remotely vs.having to go in and visit in person?

Currey: I don't believe we could've done this four years ago. When we started Fresh Cut about two years ago, there was a change in the business. Fortunate or not, links seem to be the new way to review creative work. What I mean by links is that you click on something in your email and the spot comes up.

And we got into this, being far enough away, where it started making sense. If there was a company working for you off-site, they would normally be within 5, 10 miles. A messenger would bring a tape over and everyone would gather in an office to watch the tape. Now it's much different. Being 50 miles away is arguably the same as being next door when it comes to viewing. When someone says I want to see a spot, they'll ask me for a link instead of asking me to come over with a tape.

Q: What are some of the dangers of not being on the lot, or in the same room, when it comes to gauging client reaction and getting feedback?

Currey: I'm old school. I used to think one of my best attributes is being able to watch the boss and really know what they thought which could be different than what they say. What I've learned is, because this is the new norm, notes are being given in a way that are easier to understand over the phone or over email. After time you begin to develop a shorthand with the client, and a good creative relationship forms. So yeah, for me, it's a little bit easier in that respect.

Q: Is it possible for written notes to be misconstrued?

Currey: Absolutely. We're fortunate enough that we have clients who are very good at what they do and know what they're asking for. We've had clients before that are not good at that. In those situations you end up running in circles trying to find something that may not exist. But I would say it's also our duty to the client

to make sure that we understand what they want. It's never a good idea to say: "I THINK I know what you want."

Q: How do you see your company adapting to the changes in the TV industry?

Currey: I think any company that's doing this needs to make sure that they are good storytellers and good marketers. Hopefully that skill set will follow whatever changes are going on in the industry. You can't solely rely on the 30 second spot anymore. We always talk about campaign-able ideas. Ideas that don't just work in a 30 second spot. They also work in a print ad or on a digital app. They work in a lot of different ways.

I think campaign-able ideas are very important moving forward. There are some people in the promo and trailer world who might feel like those campaign-able ideas sometimes hinder them because it gives them a road map when they used to just have that blank Avid timeline.

But I don't believe it takes away any creativity. Sometimes it gives you more creative opportunities. I think the main thing nowadays is, you've got to say the same thing consistently and say it well, in a lot of different mediums. The 30 second television commercial – it's not that it's an endangered species, it's just has to work in conjunction with other platforms. There may come a day when the live commercial break just won't be there anymore. But I don't think that means we're not going to continue to see trailers and promos. The question's going to be where will we see them.

5.2.2 WHO CREATES THE TITLES AND CREDITS?

During the post-production phase, it is the responsibility of the editors and assistants to create a set of titles or credits for the opening or close of the movie. These "temp credits" are useful for timing an opening sequence or for previews and can be easily drawn up on any NLE platform. Adobe After Effects, Apple Motion and eyeon Fusion are examples of powerful tools that can generate sophisticated titles and graphics. For low-budget projects, these cards may happily serve as the final credits or for festival use, but on higher-end productions, the online post house will recreate the titles. Alternately, a titles or trailer house can be contracted to do the work.

Highly complex title sequences usually involve a title designer and may require shooting additional footage, and in such cases the cost of a title sequence can run into the tens of thousands of dollars. A clever opening sequence can make a great film that much more memorable and is an integral part of extending the larger branding and marketing campaign for the film.

> In many cases, marketing and distribution is handled by a separate department within a network or studio and they are also in charge of creation of the trailer, usually with an outside vendor. Their trailer release schedule precedes the release (or air date) of the show and often requires that footage/cuts be made available early in the post schedule (before picture lock). It is not uncommon for scenes to end up in a trailer which have been excised from the final cut of the film.

For the end crawl, a document detailing everyone in the crew and including vendors, song titles, logos, etc. should be drawn up by the producers and double checked by key crew in each department, as well as attorneys, to ensure there are no spelling errors, omissions and that all contractual agreements are honored. This process can be time consuming and should be in progress well before the picture is locked and the show is completed.

A placeholder for the end credits should be inserted in the timeline to help estimate the final running time of the movie. A common problem for major releases has been that the running time of the end crawl is so long (to accommodate the hundreds of people who worked on the film) that a second song is necessary to play over this section.

5.2.3 TEXTLESS MASTER

Scenes that require cards or descriptive text over action (e.g., *Brooklyn, New York 1892*) can be timed and laid into the offline cut and later recreated at the post house during finishing. However, for foreign distribution, a textless master must be created that shows the scene *without the title cards*. Local distributors can then add their own language, as needed, based on an English language text document provided by the filmmaker. This is often delivered in the form of an EDL with accompanying text and time-coded events.

For economy's sake, some distributors will request that if the textless version involves a short sequence such as where the opening titles should go, then just that section should be added at the end of the show after black. A slate at the head of the tape will indicate where the textless version can be found. The local distributor will then reassemble and create their own texted version using the clean backgrounds.

5.2.4 SUBTITLES AND CLOSED CAPTIONS

Foreign distributors may present the original language version with subtitles for their audiences, or a dubbed version, and sometimes both. Once the picture is locked, a transcript of the dialogue is created with corresponding timecode in-times. This text document is considered part of the deliverables and can be used to create three different methods of subtitle streams (see section 8.1.5, "Sample Delivery Schedule"):

- Traditional subtitles are rendered onto the picture. Legibility is a factor in the timing and placement of these cards and is crucial to the understanding and enjoyment of the film. It is left up to the foreign distributor to handle this task through the lab or subtitle house
- DVD and Blu-Ray authors will use the same file to create a text stream that can be turned on/off by the viewer and may include multiple language versions. In North America, the commercially released DVD sometimes offers a choice of English, Spanish or French subtitles. Blu-Rays are now capable of including a dozen or more language tracks
- Closed captions (**CC**), which by law U.S. content providers must include in all programs intended for broadcast, satellite, cable, and now even for the web.[26] Closed captions are meant to assist the hard of hearing and contain additional sound track information such as music and sound effects. The text stream is encoded into the master tape or file. Analog NTSC Video reserves Line 21 in the vertical interval for the closed caption stream to be encoded. ATSC Digital Video offers both Line 21 information as well as CEA-708 captions, which viewers can call up using the remote for their display.[27] Formatting for closed captions is an additional cost that is frequently overlooked by producers when budgeting for deliverables

NOTES

1. See http://www.hollywoodreporter.com/behind-screen/captain-america-winter-soldier-visual-697270.
2. "Prime Focus World Bags Sin City 2," July 18, 2013, http://www.boxofficeindia.co.in/prime-focus-world-bags-sin-city-2/.
3. Carolyn Giardina, "'Pacific Rim': John Knoll on 'Operatic and Theatrical' VFX for Guillermo del Toro," *Hollywood Reporter*, July 15, 2013, http://www.hollywoodreporter.com/behind-screen/pacific-rim-john-knoll-operatic-585468.
4. Conversation with VFX producer Nancy St. John.
5. See http://www.cgmeetup.net/home/making-of-life-of-pi-visual-effect-by-rhythm-hues-studios/.
6. See http://www.techradar.com/us/news/video/the-making-of-avatar-658031.
7. See http://entertainment.howstuffworks.com/inside-3002.htm.
8. Conversation with VFX producer Nancy St. John.
9. Ibid, St. John. Number includes 12 shots that were added to replace actor Oliver Reed's face on a body double after he unexpectedly passed away during principal photography.
10. Ibid.
11. Ibid.
12. Ibid.
13. "The Value of Visual Effects," Effects Corner blog, http://effectscorner.blogspot.com/2012/07/value-of-visual-effects.html, accessed October 20, 2013.
14. "All Time Box Office: Domestic Grosses," BoxOfficeMojo.com, http://boxofficemojo.com/alltime/domestic.htm, accessed October 22, 2013.
15. "Oscars: With Films Like 'Gravity,' Where Does Animation Branch Draw the Line?," *Variety*, http://variety.com/2013/biz/awards/eye-on-the-oscars-with-films-like-gravity-where-does-toon-branch-draw-the-line-1200806697, accessed October 20, 2013.
16. *State of the Art: The Previsualization of Episode II*, produced by Gary Lera, (Marin County, CA, Lucas Films, 2002).
17. *The Cutting Edge: The Magic of Movie Editing*, DVD, directed by Wendy Apple (Hollywood, CA: American Cinema Editors, British Broadcasting Corporation and NHK Japan, 2004).
18. Charles Finance and Susan Zwerman, *The Visual Effects Producer* (New York, NY: Focal Press, 2010).
19. Michael Zhang, "Amazing Effects From Popular TV Shows," http://petapixel.com/2011/02/15/amazing-effects-from-popular-tv-shows/, accessed October 24, 2013.
20. Michael Lipkin, "DUMBO biz Brainstorm and Martin Scorsese team up for HBO project 'Boardwalk Empire'," *New York Daily News*, http://www.nydailynews.com/entertainment/tv-movies/dumbo-biz-brainstorm-martin-scorsese-team-hbo-project-boardwalk-empire-article-1.393946, accessed October 25, 2013.
21. "The Amazing Special Effects of Boardwalk Empire Are what Make the Show Beautiful," *Gizmodo*, http://gizmodo.com/5878291/the-amazing-special-effects-of-boardwalk-empire-are-what-make-the-show-beautiful, accessed October 24, 2013.
22. *The Cutting Edge: The Magic of Movie Editing*, DVD, directed by Wendy Apple (Hollywood, CA: American Cinema Editors, British Broadcasting Corporation and NHK Japan, 2004).
23. "Interiors: David Fincher," *Arch Daily*, June 3, 2013, http://www.archdaily.com/380775/.
24. "OpenEXR," Industrial Light & Magic, http://www.openexr.com/.
25. Chris Hicks, "Sometimes Trailers Reveal Scenes that Aren't Even in the Movie," *Deseret News*, August 1, 2013, http://www.deseretnews.com/article/865583966/Sometimes-trailers-reveal-scenes-that-arent-even-in-the-movie.html.
26. Michael Grotticelli, "Internet Captioning Now the Law of the Land," March 29, 2013, http://broadcastengineering.com/regulation/internet-captioning-now-law-land.
27. "Closed Captioning," http://en.wikipedia.org/wiki/Closed_captioning.

Sound Design and Final Mastering

Modern Sound Design

6.1.1 CONVERSATION WITH WRITER, DIRECTOR, COMPOSER ROY FINCH

Q: Let's talk about sound design.

Finch: From a sound design perspective you can look at *Apocalypse Now* as the birth of the modern film soundtrack. The fact that it was mixed using six-track magnetic dubbers is mind-blowing when you think of what they achieved. That film still sounds amazing! When you've got, maybe, five or six dubbers lined up in a machine room, bouncing tracks and combining them in the analog world was cumbersome to say the least.

As ProTools was expanding, that helped to drive the art of sound design. We now have hundreds of tracks at our fingertips. The Macbook Pro is infinitely more powerful than anything used in the 1970s. But the computers and plug-ins are merely tool sets. The most important sound tool, as any accomplished designer will tell you, is what's between the ears.

Q: What do they do with a hundred tracks?

Finch: One is the idea of sonic layering – the modern sound designer as a sculptor. To create something that's sonically and emotionally complex. Simple things like a punch. Take this South Korean film, *I Saw the Devil*. There's a section that's very brutal with punching and bones breaking. It's not simply pulling something from a library and sticking it on the track. It's about blending sounds to create an impact. The elevator scene in the film *Drive* is another good example. Hyper-real, yet grounded in a brutal reality. When you start to layer things together, you could have three, four, five layers just going into one event, it becomes visceral, and you can feel it. Sound designers are much more aware of this and I try to make my students aware of this; that a lot of the art is in the layering and how you blend these things together which are like the ingredients in cooking.

Q: So that allows you to leverage the power of multi-track. To create these layers efficiently and quickly.

Finch: Yes, and good sound design takes time. One of my favorite films is *City of God*. There's a scene in the film and I was privileged to have the sound designer come and speak about it to a class. He made a QuickTime of his ProTools session, a simple little shoot-out, lasts maybe 90 seconds in the film. There are 60 tracks, so not only the bullet hits, but all the ricochets, like the same detail in *Saving Private Ryan*. To me sound is effectively the fourth dimension of film.

Q: I just saw *Gravity* in IMAX 3D in Dolby Atmos and it had enormous dynamic range. At one point, there's dead silence and they throw a tiny radio voice, way off to the right and I'm thinking, it has to be the usher talking to the projectionist on his walkie-talkie, but then it becomes very loud.

Finch: I wondered if that was the same feeling when you first saw *Apocalypse Now*, after having lived with mono and maybe stereo for most of your life. That was the birth of surround sound in a way. Helicopters flying over-head and through the theater and the way the ambience and music surround the audience was mind-blowing back then. It has taken 30 years since to continually refine the concept of surround sound. Advances like THX improved the sonic landscape immensely. Not to go too overboard but I feel that Atmos is the next sonic evolutionary step after surround. Yet it's still in its infancy! With Dolby Atmos there are up to 64 full range speakers in an array over the ceiling and on the sides. This is a significant change from surround which only have speakers on the left, center and right of the screen, along with left and right rear surrounds. With Atmos there 128 potential audio streams and, as I mentioned, up to 64 speakers.

Q: So it's a sound blanket, essentially.

Finch: Yes, that's a good way to put it. With the invention of Atmos the audio canvas has expanded tenfold. You can articulate sound like never before. You can place sounds in the theater space with unbelievable specificity. You can practically place the sound of a raindrop over a specific seat and that potential is something any serious sound person is excited by.

Gravity broke the rules, not only with panning the dialog, which tends to be in the center channel most of the time. Somebody walks off-screen, you might pan it to the left or the right, but you're not going to be putting it in the rear surrounds, generally. With *Gravity*, I was hearing dialog bouncing all over the place and it didn't pull my attention from the screen, because the minute it becomes distracting then you're no longer in the story. Frankly I'm much more excited about the potential for this new format than I am about putting on 3D glasses. [Laughter]

Q: How has the role of sound designer changed with this new technology?

Finch: It's not just the new technology but also about new aesthetic to expressionistic sound design. One film that I play for my class and deconstruct with my friend, the brilliant sound editor Val Kuklowski, is the film *Drive* by Nicolas Winding Refin. The first 20 minutes has a lot of expressionistic sound design. The mix reveals itself as subtly abstract. It supports the emotional story, and the protagonist's emotional state. The ticking of the protagonists wrist watch is in some cases louder that the engine of his souped-up car, and is also perfectly in sync with the police sirens, the burglar alarm, and the kick-drum heartbeat of the music.

Another film that I like to play for my students is Danny Boyle's *Sunshine*. There's a couple of fun and creative ways that *Sunshine* pushed the audio envelope. One was the use of distortion both in the music and effects. There are some crunchy, low bit-rate sounds in there that are very effective.

As a filmmaker, Danny Boyle asks himself: "How do you express the power of the sun?" Visually, there's a point where it's gold, and the camera is shaking a little bit and now it's a bright light and the light is getting bigger. Then the screen becomes bright white and you can't go any further with it. It can't get any brighter. So sound comes in to support or add that other 50 percent of the experience.

Current designers play with distortion and they are similar in a way to those early guitar players. You had the electric guitar arising out of jazz players wanting to be heard in a large ensemble. They're going to plug the guitar in and when they play they want it to be clean. Then some kid comes along and turns it up, say Pete Townsend or Hendrix in the early 1960s. He cranks it up and gets this sound. And he says, "Wow, that's kind of good", but the older folks are saying: "That's wrong, that's illegal, you're breaking the rules. Somebody's going to get hurt!" [Laughs]

And when I was watching *Sunshine* for the first time, I thought to myself, there are probably some old union cats that are really upset with this intentional distortion. It sounds like the speakers are frying out in the theater. The sun is so damn powerful that it's causing the speakers to start to rattle. This was built into the mix, and it was very visceral and I think the emotional response is exactly what was intended by the sound designers and the director. This is where I think much of the real creative talent is going in terms of the post-modern sound design. As audiences become more sophisticated, sound designers and directors are also aware of the possibilities for more expressionistic soundtracks.

There's another reason why I like to use *Sunshine* as an example and that is the concept of musical sound design. *Gravity* does this too. Where does the musical, non-diegetic score leave off and the diegetic sound design kick in? It becomes this grey area, like looking at a rainbow and trying to pick out *exactly* where the colors turn from RED to orange. So the sophisticated designer is really somebody who is more musical these days and taking more risks. Even the idea, where in *Sunshine*, I'm told that they tuned the ship's engines to a note that was sympathetic to the score.

Q: That notion of tuning the engine or creating a sympathetic harmonic goes back to films like Peter Yates' *Bullitt* or John Carpenter's *Christine*. Let's say there's a car chase. You want to present two separate cars with two distinct personalities, so when you start to intercut between them, audiences immediately know where they're at, with a perspective shift. Dave Yewdall, the sound designer for *Christine*, was meticulous when it came to recording car sounds. He would take the car out to the desert and take the hood off, place a microphone in the tailpipe and so on. He captured the 360 degrees of that car and had all of those elements on tap while he cut the scene. But what you're talking about is an even more interpretive way, of taking things that aren't even related to that car and morphing them.

Finch: There's another great example from *The Bourne Identity*. Matt Damon is in a little Mini and he's going through the streets of Paris or Budapest, and he's being chased by the cops. The stock response from a designer might be: "Let's go out and record a Mini, take it to the racetrack and we'll rev it up and do some things." But will that emotionally support what you're seeing on the screen and what the actors are feeling in that Mini? How will it carry across?

On the DVD extras for *Bourne*, one of the sound designers talks about the fact that it's not a Mini at all. The fundamental two ingredients are this motorcycle that's been pitched down to sound a little throatier and fuller, and an old funky Cadillac that is missing one of the spark plugs, because this Mini gets more beat up as its going down these stairs. So the Cadillac is pitched up, and the motorcycle pitched down and they kind of meet in the middle to create this fantasy car. That's visual storytelling supported by sound.

Beasts of the Southern Wild is another great example, where I actually play a scene without the picture in a full sized theater to my students. It's the storm sequence where the father and daughter are in their little shack and this hurricane is raging outside. I ask them to describe what they think the scene looks like. You're hearing branches breaking and trees are falling over and metal, corrugated metal is being ripped up and it's mayhem. Then I play the scene with no sound and we're looking at two people in a little tiny shack. The set looks like it cost maybe 150 bucks. There's some fabric and a fan off-screen blowing some wind around and rain dripping. Then the father goes outside for one minute and there's a night shot where you see some rain, but other than that, it's minimal. Put the two together and all of a sudden sound has enhanced the production value of this film. Now you've got this big epic scene. You've added maybe hundreds of thousands of dollars' worth of production value. When you watch the scene, you're not thinking about it from that perspective. You're feeling the power of this huge storm. Sound design can operate in visual unity as a set extension!

> Roy Finch is a writer, director and composer and teaches sound design
> at Chapman University, Dodge College of Film and Media Arts.

6.1.2 WHAT IS A TEMP TRACK?

While the editorial department is responsible for all aspects of post-production, including test screenings and previews, the picture editor and his assistant lead the way in the early creation of a soundtrack. The audio tracks may be heard as a rough sketch of the final version, yet they must never contain holes where dialog, music, sound effects and backgrounds are concerned. This is referred to as a "fully filled temp track."

Editors understand the impact that sound has upon an audience and they rely on sound during previews to help carry a picture and thus be able to "sell" their cut. An experienced editor will always spend time shaping the temp track (or have the assistant do it) before previewing in front of an audience.

The first order of business is the dialog. Is it all there? Is it audible? Are any **wild lines** needed? Can readings from other takes be borrowed and fitted to the picture? The assistant editor will keep a list of the lines needed to be re-recorded during the **ADR** (Automated Dialog Replacement) session. Alternately, a microphone should always be on-hand in the cutting room to record temp lines directly to the timeline (see Figure 6.1).

Next up is background and ambience. Editors will make sure that all offending noises, clicks and pops are removed and replaced with clean, steady backgrounds. Location sound

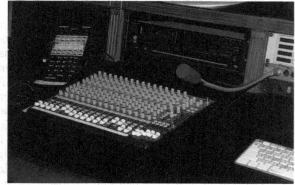

FIGURE 6.1

Essential tools on the editing console: Mackie 1604-VLZ mixer for handling multiple audio sources and room levels and a microphone for recording temporary dialogue

recordists should provide various **room tones** from each location. Quiet sections during takes can also be "looped" (i.e., repeated to fully fill the dialog track to avoid any dropouts).

Pre-recorded sound effects (SFX) are drawn from a library or taken from production sound. Experienced picture editors come equipped with their own collection of SFX to use as "temp" on every show. The editor (and assistant) should also be able to provide a collection of temp music gathered from previous shows they have worked on or from commercially produced soundtracks.

AUDIO SWEETENING FOR PREVIEWS

Building and maintaining temp tracks is time consuming and must be factored into the editorial timetable. Picture editing may need to be paused briefly to allow time for the temp tracks to be cut and shaped. On large feature films it is not uncommon for a crew to be hired for the sole purpose of building and maintaining the temp track. After a cut has been handed over to the temp sound crew, they will make the necessary updates in order to "sweeten" the audio so that when it comes time to preview the film, there is little or no wait time.[1]

AVOIDING TEMP LOVE

During the editing process, directors and producers become accustomed to hearing specific music cues and SFX contained in the temp track. In the end, most if not all of these tracks will be replaced in the final mix. The director or producer often experiences a level of disappointment when they hear the replaced cues. This is known as "temp love." Well-known (i.e., expensive or unavailable) music cues should not be placed in temp tracks to avoid this situation.[2] However, while the music is usually re-recorded, it is still common to use portions of the temp SFX and place them in the final mix.

6.1.3 WHEN SHOULD A SOUND DESIGNER BE INVOLVED?

When should a sound designer (or supervising sound editor) be involved? The short answer is: as soon as possible. The prudent producer will consult with a sound designer in advance of principal photography for two reasons – budgetary and creative:

- The sound designer will be able to assist in scheduling and estimating the cost to complete a project, including final deliverables
- Busy sound houses need time in advance to hire crews and schedule recording and mix sessions
- Sound designers should attend preview screenings in order to better anticipate the creative demands for the final version

While it may not be cost effective to start the supervising sound editor and crew before picture locks, there is a tremendous advantage to having the sound designer provide the temp tracks and mixes for preview screenings. This work can then lay the foundation for creating the final tracks during an expedited post schedule. While creating the schedule, the producer or post supervisor will set a date that all parties can agree to when the picture will be "locked" (see section 8.1.1, "Scheduling and Hiring"). At that point the project will be turned over to the sound department and a spotting session is scheduled.

6.1.4 SCHEDULING SPOTTING SESSIONS

Once the picture has been locked, two separate meetings are scheduled. One is for the music spotting session and the other is for sound spotting. They are held in the cutting room or a room that allows for the "locked" picture to stop, start and rewind. The assistant will place a large visible timecode window in the display so that everyone can refer to specific "in-times."

For the sound spotting, the director, editor, assistant editor and sound designer (also known as sound supervisor) will be present. Notes are taken by everyone in the room. Some sound designers like to make an audio recording of this session so they can capture every comment or instruction.[3] These sessions may run long as scenes are run and then repeated. Stops and starts may be frequent and there is much discussion as ideas are floated. The importance of this session cannot be overstated. At this meeting the director and editor make specific requests for sounds and ambience which they expect to hear in the recording studio (dubbing theater) during the final mix. Once they get to the final mix, there is precious little time to go back and find additional sound effects. The spotting session is the essential first step in the march towards a completed soundtrack.

The music spotting session may be a little more free form as the composer will run the film with the creative team to discuss ideas, moods and themes. Specific sequences may be targeted for either score or source cues. Some composers will audition music cues in their library of previous works or be invited to come back with some newly composed music to see how it fits the picture.

6.1.5 PRE-DUBS

Mixing motion picture sound tracks involves re-recording (or dubbing) of hundreds of elements or tracks. Audio is fundamentally different from picture in that sounds can be endlessly layered and combined. After careful selection and placement of tracks by sound editors, they are handed off to the mixer to be balanced and equalized (**EQ**'d). For a mixer with two hands, the management of up to 100 tracks during a session is not practical. Even by adding a second or third set of hands at the console, there is a limit to the amount of channels available and not all tracks are mixed at the same time. Generally speaking, it is more time and cost effective to mix-down or combine the tracks in a prior session known as a **pre-dub**.

Dialog pre-dubs are an essential step as the mixer will spend a great deal of time to ensure that all the lines are clearly audible and all the "looped" lines (ADR) and **walla** have been incorporated. The sound supervisor is present for all of these sessions and the director and editor should sit in on the dialog pre-dub if possible.

Sound effects account for the largest number of recorded tracks, including hard effects, Foley and backgrounds. By pre-dubbing these elements and combining them into separate **stems**, the task of final mixing is made that much easier. Dialogue, music and effects (D, M & E) are the three basic stem components (with an additional stem for Foley) that comprise the final soundtrack.

6.1.6 AUTOMATED DIALOG REPLACEMENT (ADR)

Location sound mixers are tasked with capturing all of the words spoken in front of the camera. Often there are background noises such as a generator, horns or car doors that prevent the words from being recorded cleanly. It is essential for every line of dialogue to be "clear" of such noises in order to be remixed and placed in the final track without the clutter. In many situations, recordists try to go the

extra mile to record **wild lines** well away from the offending sounds and without the camera rolling. Oftentimes dialog was never recorded in the first place. Alternately, directors may be unhappy with an actor's performance and decide to replace line readings. For these reasons, it is almost always necessary to schedule an ADR session.

> Automated dialog replacement (ADR) should be considered a misnomer. There is very little automated about the process. An editor or sound supervisor decides that a line of dialog is to be replaced. The line is written to a cue sheet. Once the picture is locked, an ADR session is scheduled for the actors to repeat their lines or add new ones. The recording studio is set up to facilitate playback of the motion picture and to cue the actors when they say a line. The ADR editor will then edit the tracks to adjust sync to fit the picture or may combine portions of different takes to complete each line of dialogue.

In addition to recording the new lines of dialog for each actor individually, a group or **walla** session is recorded at the end of the session. A **loop group** consisting of a handful of men and women is brought in to recreate crowd scenes and reactions for specific locations such as restaurants or theaters.

Frequently, the actors are in a different city on another show and unable to travel to the ADR session. In such cases a remote session is arranged where the talent reports to a local ADR stage and reads the lines while watching the performance.

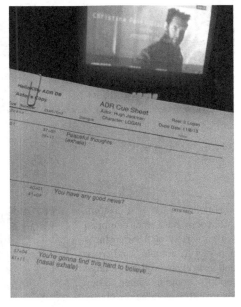

FIGURE 6.2

Director Bryan Singer tweeted this photograph of *Wolverine* actor Hugh Jackman during an ADR session conducted via satellite remote

6.1.7 FOLEY

Foley artists (also known as Foley walkers) record all of the incidental sounds that are featured on-screen. These are not hard SFX such as gunshots or car doors. Rather, they reflect all of the subtle smaller sounds that humans create as they move about. Foley can be broken into three different categories: feet, props and cloth.

Feet (or footsteps) is the most obvious example. Every pair of shoes and every surface makes a different sound, whether cement, carpet, marble or dirt. The sound of a man or woman walking must feel right and be in sync with the picture.

Props means anything with glasses, silverware, car keys, books, shopping carts. The list is endless and involves anything the actors are using that emit a sound.

Cloth movement is a subtle but necessary element in the creation of a soundtrack. As we move so does our clothing, and it makes a sound. It may be as simple as rubbing two pieces of cloth together to simulate walking, a pat on the shoulder or someone getting dressed.

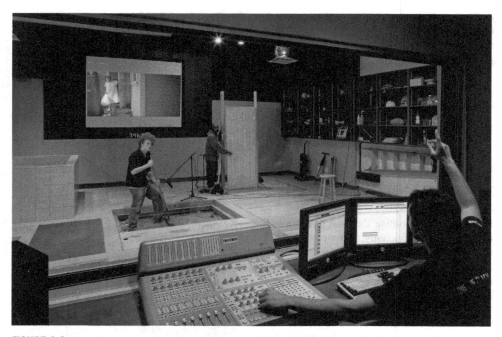

FIGURE 6.3

A Foley studio in action

The Foley studio is a custom-built room that comes equipped with a variety of floor surfaces and pits to contain sand, rock and gravel as well as a large tub to contain water. They also feature a large inventory of props such as wheelchairs, balls, glasses, silverware, bags, boxes, tools, squeaky doors and other gadgets.

It is not uncommon for a large feature to spend more than a month recreating these sounds, while an episodic TV show may be given just two or three days to record Foley. As the Foley artist rehearses and performs in front of a large

FIGURE 6.4

Foley studios feature multiple pits containing rocks, gravel and sand, as well as many hard surfaces including wood flooring, cement and brick

screen, a recordist in the booth next door monitors the sounds and offers advice (see Figure 6.3). The resulting mixdown of these tracks ends up being referred to as the "Foley stem."

The point of recording the sounds in front of a screen is to record them more or less in sync with the action. After the session, a Foley editor may have to pull up and correct any effects which are not in sync.[4] However, for shows such as episodic TV, the tracks must be recorded in sync, as they are shipped directly to the mixing stage "as is."

Why is Foley necessary? Many sounds of props and movement are missing from the location sound because they are not closely mic'd. The location sound mixer's primary responsibility is to record the dialog, and sound effects are secondary. Audiences expect to hear these sounds and editors can choose to employ specific subjective sounds and amplify them in order to manipulate the viewer. Examples might be a punch in the jaw during a bar fight, a body fall on carpet or a pat on the back.

There is another essential reason for recording Foley: for a foreign release, the English language soundtrack is stripped out and replaced with dialog in a different language. Once the original dialog is gone, all of the incidental sound effects and backgrounds go with it. Foreign audiences expect to hear such sounds, for without them the depth and realism of the scene is lost.

6.1.8 MIXING

The final mix takes place once the pre-dubs are completed. Ideally a mixing studio is also a theater with seating that recreates the theatrical experience. At a minimum the mix facility should offer 5.1 Dolby Surround mixing capability and playback with a large easy-to-see display, comfortable chairs and desks for the sound supervisor, editor, director and post supervisor.

The console (or mixing board) features a large number of sliders (or "flying faders"), which are "automated," meaning that the moves up and down made by the mixer are memorized and repeated.

FIGURE 6.5

A 5.1 surround mixing studio equipped with ProTools

While a large mix console may look overwhelmingly complex, there are usually only a handful of tracks being addressed at any one time. That is why the film is constantly run back and forth addressing specific sections with separate "passes" adjusting the dialogue, music and effects stems.

 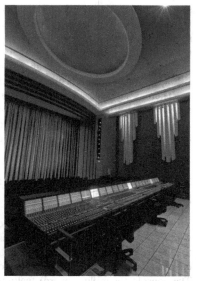

FIGURE 6.6–6.7

The William Holden mixing stage at Sony Pictures Studios is equipped with Dolby Atmos © and Auro 11.1 sound, along with the latest projection technology, including 4K and 3D capabilities

The crew consists of one, two or three mixers with the dialog mixer in charge of the room at the direction of the supervising sound editor. The editor is almost always in attendance along with the director and producer, when available.

The schedule for final mix varies according to the needs of each show and their respective budget and complexity. For a one-hour episodic TV show the mix may be completed in as little as two days. A major motion picture will take a month to mix, stretching up to six to eight weeks (including pre-dubs and final deliverables).

6.1.9 AUDIO DELIVERABLES

For the final mix, the filmmakers audition the combined tracks to make any last-minute adjustments. At this point the audio still resides on separate stems, which makes changes that much easier to specific areas of dialog, music and effects (DME). This also allows for different sets of deliverables to be created later on, once the final mix is approved.

The final mix is actually the penultimate step in the process as there are several versions that must be created to satisfy both domestic and foreign distribution requirements. Each format requires

what is known as a "**printmaster**" from which all subsequent copies are made. Dolby Stereo features a process known as **Lt/Rt** (Left total, Right total), which is a two channel recording containing the entire surround mix intended for playback of left, right, center and surrounds by use of a special matrix.[5] **Dolby 5.1** provides six separate channels: left, right, center and two rear surrounds, as well as a low frequency channel. To a lesser extent, formats such as **DTS** or the Sony-developed **SDDS** (features eight audio channels) are employed in some theaters.

DTS, Sony and Dolby are trademarked systems and require a license fee for each title that features their format. In the case of Dolby, a technician must be scheduled to come and inspect the room facility to ensure the mix and transfers are done properly.[6]

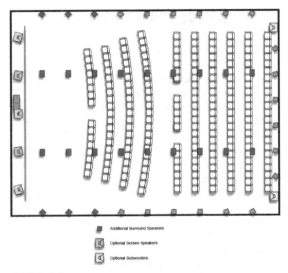

Additional Surround Speakers
Optional Screen Speakers
Optional Subwoofers

FIGURE 6.8

Dolby Atmos represents a huge shift in psycho-acoustics in theaters as seen by the increased number of speakers and their placement around the room

In 2012, Dolby debuted its Atmos system in theaters featuring 64 speakers with 128 separate audio inputs to create a 3D style audio experience.[7] Contemporary action movies such as *Gravity* (2013) and *The Amazing Spider Man 2* (2014) feature this new "large canvas" speaker format. By the end of 2013, it was estimated that 250 screens worldwide were Atmos capable, with the greatest expansion forecast for India with 50 to 100 screens to be added.[8]

For foreign distributors, the mixers make a pass through the film to create a "fully filled" M & E (Music and Effects) containing no dialog track. This means revisiting the Foley and effects stems (as well as pulling any clean SFX and BGs from the original dialog stem) to replace any sounds or backgrounds that are missing. Sound mixers go to great lengths to ensure that the M & E is complete and without holes or silent passages. A subsequent quality control (**QC**) check on behalf of the foreign buyers may result in the reels being returned to the sound house at a later date for corrections.

For TV shows and films intended for a theatrical release, there is a laundry list of deliverables that are delivered on LTO tape, DVD-R, DA88 and sometimes on 35mm film stock:[9]

- 5.1 Surround Mix Dolby SRD
- Dolby Stereo (SVA) from which an optical track is created
- M & E in 5.1
- M & E (LCRS)
- TV mix and TV M & E
- Stereo DM & E (fold down of dialog effects and music)
- 5.1 Master of all music and source cues (minus level changes)
- Stereo copy of all music and source cues used

6.1.10 CONVERSATION WITH SOUND EDITOR HARRY CHENEY

Q: Tell us about your most recent projects.

Cheney: I just finished Foley on a big budget feature for Universal called *The Best Man Holiday*, which was a big Christmas release. My partner and I get hired because we work for less than other people. So producers save money. We get a flat fee and work for as many hours as it takes to get it done.

Q: Which part of sound editing do you enjoy most?

Cheney: I like to edit dialog, only because then I don't have to hire anybody. I don't have to find a stage for Foley. I don't have to deal with other personalities. It's just me editing in my little room. However, Foley is mostly what I do.

Q: So you're known for your expertise in Foley.

Cheney: I guess so, because I keep getting hired. People keep saying: "Call Harry because he's done it before. And he's good at it."

Q: So essentially, you're an independent contractor and you do Foley, dialogue and sound effects.

Cheney: Exactly. I did a low-budget feature in May. I did everything: dialogue, sound effects, supervised the Foley. I didn't walk the Foley, however.

Q: After you're done cutting these reels, do you send them to a dubbing theater up in LA for final mix?

Cheney: Yeah, eventually it goes to a mixer. So we edit it, prepare it for the final mix.

Q: Do you ever go up to LA to supervise?

Cheney: Never. Because there are supervising editors who are in charge of everything. We do the work for them and send it off and then they mix it.

Q: So you create a ProTools session. Does that include a set of cue sheets?

Cheney: We don't use cue sheets anymore. Haven't for years. It's all up on the computer screen now. I used to do that. The last time I used printed cue sheets, they laughed at me.

Q: How early in the process do you think producers should get someone involved to supervise the sound?

Cheney: People talk about hiring the supervising sound editor early on. I don't believe in that theory, generally, because you really don't know what you've got until they're finished cutting. You don't know what they have until they're done and you get to see the picture and you start thinking about it and coming up with ideas. I've heard supervising editors talk about getting hired right at the very beginning. You design the sound to fit the picture, and if you don't have the picture, it's awfully hard to design the sound.

Q: Have you seen crews assigned the task of solely working on a temp soundtrack for previews?

Cheney: Every movie that's ever done nowadays has a temp track and it's usually the editor and assistant editor who are putting in the sound effects. On *Two Guns*, the Denzel Washington movie, we worked on a temp version first, then went back and did the final.

When we did *Poltergeist*, they actually had a big shot sound crew, but they hired me and some staff editors at MGM to do the temp. And we did a great job, but they gave it to the pros to finish it. They ended up $50,000 over budget so they should have left the job to us.

Q: How much of the temp tracks can be repurposed for the final mix?

Cheney: They use it all. Here's the way it works now. Because the business has gotten so screwed up, what they do on big features is create a temp version and the temp version is expected by and large to be a full edit. It's not just a few sound effects; it's the big deal, the whole deal. And then they'll lay everybody off and just keep a few editors on to do fixes. So the temp version in some cases is the final version with just a few changes. They'll have the big crew come in, do the temp and then they'll lay off everybody except for one or two people.

Q: What about on smaller shows where the picture editor and the assistant have created a temp track? Even though you've gone to great lengths to replace tracks for a final mix, when you get on the stage do the producers or director ever experience "temp love"?

Cheney: The rule is that you always leave the editor's stuff in. You never take the editor's stuff out. Whatever they cut in, you leave in. The game plan is to make the editor's tracks available at all times if needed, except for the music of course.

Q: Because somebody's going to say: "You know that car door you put in Harry? We don't like it. We want to go back to the original".

Cheney: Yes, and for a feature, leading up to the final mix, the picture editor's responsible for the mix, and they expect to hear stuff that he or she has cut in.

Q: How important is the spotting session?

Cheney: Well, it's important for the sound editors because we get to hear what the director wants and after screening with the director and supervising sound editor, we kind of kick around ideas. We get to feed off of each other. Basically, you want to find out what they expect to hear later on when you get to the mixing stage.

Q: So a session involves sitting in a cutting room with the Avid and a big visible time code window available with everybody jotting down notes.

Cheney: You take a lot of notes.

Q: Have you had any final reels rejected?

Cheney: God, I wish you hadn't asked me that. [Laughs] So if we look back to the old days, everybody cuts their own reel. A movie was split into ten reels and you were given a reel to cut. And if they didn't like your work, they would take the reel down and you would have to recut it, which is called being "bounced." Having your reel bounced is a horrible thing to happen.

I hate to admit this but on the movie we just finished, *The Best Man Holiday*, there was some stuff that they hated that we had turned in. Hated it, and so we had to redo it. Actually they redid it. They recut the footsteps themselves.

Q: It wouldn't be the first time, for any reason, that people object to the work and send it back.

Cheney: There was a misunderstanding. There was one section where they didn't like it and it's always embarrassing. So it's kind of like having your reel bounce. So it does happen from time to time. Usually they like everything you did and think you're wonderful.

Q: At least there is the advantage of digital, where you don't have to take the reel down physically and send it back to the cutting room. If you get word that there's a problem, you can just pick it up at your own workstation.

Cheney: It happens a lot now. People are cutting on the stage while it's happening. People are cutting as it's being recorded, like the ADR. On TV shows the ADR

editors will be recording and cutting at the same time. So when the ADR section is done, everything is cut and ready to go. I can't do that. I'm not quick enough.

Q: And the Foley is the same way? It's supposed to all be in sync before it's sent along, correct?

Cheney: For TV, you record it until it's in sync. You don't have time to cut it. For features, you have to cut it and shape it.

Q: What is the average time it takes to record Foley for either an hour long episodic or a feature film?

Cheney: I don't know if there is an average time. This movie that we just did took us maybe three weeks. For a TV show, an hour show, two days tops. I hire the walkers and we record the Foley here in Orange and at a place in LA.

Q: And it's always in sync?

Cheney: It's never in sync. I mean for TV, you're always out a little bit, but they get good enough where if you play it straight without stopping and slowing it down, it looks in sync, so you're good. [Laughs]

Q: Why do we need Foley? Why can't we just use the English language dialog track?

Cheney: Well, there's a bunch of reasons why. First of all, if they're recording correctly, all they're getting is dialog. So all the movement, everything that they're doing is lost. They're not recording it. For example, if you put your hand down on a table or pick something up, it's not there. You're not hearing it. You're adding all of that to create a sense of realism for the picture. Or it could be recorded badly, in which case, if they're patting their arm or leg while they're talking and you lose the dialog, you lose the leg pat so you have to replace that.

It's also faster to record Foley because you're recording it to picture, rather than search the sound effects library, trying to find the right effect. You're actually performing the sound to the picture and customizing the sound on the spot. It really ends up being cheaper in the long run because it's quicker. You can't find walla or ADR, group sounds; it's hard to find customized groups or people talking in the background in a library. So it's all a matter of just customizing it and performing it to the picture at the moment.

You asked me earlier what young producers need to know and what they may not be aware of. A lot of their money is made overseas and so you have to do an M & E. You recreate virtually everything that's happening on the screen. So if somebody touches their face, moves their leg, touches a table, picks up a phone, you literally replace every single one of those sounds. When you do an M & E, you've lost all the dialog and so anything happening under the dialog is gone. And so you replace every single movement.

On the last movie we did, a low budget thing, it was mostly people sitting around talking. You could play the Foley and sound effects without the dialog and it was like they were really there, only you couldn't hear them talking. It was spooky how good it sounded. So that's the way a finished product should be. You should be able to feel like you are in the room, you just can't hear their voices.

Q: What's so important about "German QC?"

Cheney: That is so funny because I just got a note from the QC people for *The Best Man Holiday*, and in one scene there were people walking way on the other side of the street. You could see them walking and I didn't cue it. We didn't do it because I thought: "You're never going to hear them." So the note I got back from one of the editors was: "You know what? We better do those footsteps because

the Germans are going to ask for it." So the Germans are very picky about their M & E. They want it completely filled and beautiful or they kick it back. The Germans are the ones you want to make happy.

Q: How essential is it to work from a locked picture and how do you handle changes after that?

Cheney: The people that I did this show for were totally screwed because they had to do the changes. We don't do the changes. They get us at a discount and so they're supposed to give us a locked picture and we're not required to do the changes. Because they were in such a hurry they ended up doing them. But there are software systems that will help you with the changes and make it a lot easier than it used to be.

Q: How has the business changed in the last ten years?

Cheney: They expect you to do the job quicker with fewer people and they expect the same quality. So you just have to work harder with fewer people and the quality has to stay the same.

Q: Are schedules being compressed?

Cheney: Yes, fewer people, shorter schedules, but they still want the same quality. So you just have to work harder and faster. To give you an example, in the old days, you would be hired on a feature and you might work six months. Now you're hired on a feature, and you work a month if you're lucky, and then get laid off. They might bring you back, or they might not, for another two weeks.

Q: You started in film and made the leap to digital. How has ProTools and digital sound been treating you?

Cheney: I love it. There's almost nothing I miss about cutting film. Just the days of having your chair roll over the film while it's under the Moviola and tearing it and fixing it. Ordering reprints, the racks and racks of reels. Then they make changes and you have to go back and conform all those reels. "Take 12 frames out of 450 feet." The sound is better now, you can do more, make better fixes, it's just ideal, I love it. I love digital editing.

Q: What about adding a 2-Pop at the beginning and end of each reel? Should it be done on every track of audio?

Cheney: I do it on every track because if you're doing conforms, if there's been changes in the picture and it's only on the first track, you're not sure if the other tracks are going to sync. So you need the sync pop at the beginning and end. The tail pop is the scary one. Because it might be a frame off and, "Oh my God, where's the frame off?" I hate when that happens. [Laughter]

Harry Cheney is a sound editor and professor at Chapman University, Dodge College of Film and Media Arts.

Mastering and Quality Control

You've taken your project through the pipeline from offline to online conform. Next comes the color grading and adding visual effects and titles. The completed mixed soundtrack has been "married" to the picture. Each step has been checked for accuracy and you are confident all the pieces are there and in the right place. There remains the "last mile" in the process. It involves taking the finished masterpiece and committing it to several different formats of high-quality media in order to deliver it to your client or distributor. This is referred to as "mastering." Tape and film master reels may not be required or even considered for smaller short-form projects in which case the sole master may be a high-quality digital file.

While care should be taken to monitor the quality of the sound and picture throughout the entire post-production process, this penultimate step requires a quality control check of every element that is considered part of the final deliverables (see Section 8.1.4, "List of Deliverables"). The essential nature of quality control (QC) stems from the concept that while it may be convenient to make copies and distribute your project without checking it, flawed or defective versions can easily be disseminated if this very important step is omitted and those elements may be difficult to recall.

6.2.1 DIGITAL CINEMA PACKAGE (DCP) CREATION

The DCP (or Digital Cinema Package) is a complete set of files necessary to project your project in a Digital Cinema. It contains all the sound formats, subtitles and closed captions which can be selected by the projectionist at each venue before it screens. Preparation for the DCP involves several intermediate steps, and each stage must be saved and preserved in order to avoid having to repeat the work later on. Assuming the film is being graded for theatrical exhibition, it will likely be graded in DCI P3 colorspace, which conforms to all venues using the D-cinema specification.

Digital Source Master (DSM): a graded *log* DPX master will be rendered (without the DCI P3 LUT baked in).

Film Out Master: this is a conversion from a set of digital files back to film negative. Digital film recorders such as the Arrilaser use three separate red, green and blue (RGB) lasers to burn a new negative. From the log DPX master, film print look-up tables (LUTs), provided by the lab, will be used to convert the log master to log space appropriate for the intended film I/N and print stocks. This requires a second set of DPX files.

Digital Cinema Distribution Master (DCDM): from the original log DPX master, a LUT will be applied to convert it to XYZ colorspace. These are rendered as 16-bit TIFF files in the appropriate DCI resolution (2K – 2048x858 for Scope, 1988x1080 for Flat) This is the last stage before creation of the DCP.

Digital Cinema Package (DCP): the DCP will be made from the printmaster audio (24 fps, uncompressed PCM) and the DCDM TIFFs. If the DCP is intended for public exhibition, it needs to be encrypted using a KDM that is generated at this stage of the process. The private key for the KDM can be hosted by either Deluxe or Technicolor Digital Cinema. For a one-off screening or festival, where security is not an issue, the KDM can be omitted.

Mastering for home video and non-theatrical distribution:

Rec. 709 Master: the DSM (log) is transformed through a Rec. 709 output LUT and a trim pass (requiring additional work of approximately 40 to 80 hours) is done to make it best match the original creative intent from the projection master (DCI P3, 14fL for 2D), yet suitable for consumer TV light levels (30 fL in a dim surround backlight at gamma 2.4). These are rendered and stored as DPXs. This set of files will be mastered to tape (HDCAM SR) and becomes the source master for all other distribution formats and mezzanines (iTunes, Netflix, Hulu, etc.).

Rec. 709 Mezzanine: this remains an unofficial format as every post house approaches it differently. A mezzanine stage is a mid- to high-level format that is suitable for storing and creating further outputs. Storing and transferring an entire film or library of DPX files is costly, takes a lot of time and can be burdensome for distributors (YouTube, Hulu, Netflix, DirecTV, etc.) who might need to create different encoded versions. There is no DVD/Blu-Ray authoring software that accepts sequential frame formats, let alone DPX. They expect to receive a self-contained movie which is usually a ProRes 4:2:2 HQ QuickTime file. ProRes 4444 is preferable, though uncommon. If an author can read a 422HQ file, they can read 4444. Many archival titles are being re-mastered and archived as ProRes instead of DPX. Even though drive space is inexpensive, it can still add up, and ProRes is *visually* indistinguishable from DPX, which is always uncompressed. Since anything being made from the ProRes is going to be of significantly lower quality downstream (i.e., compressed and sized for the web and portable devices), this is a solid mezzanine format.

> When creating ProRes mezzanine files, a good rule of thumb is to include stereo audio. The DVD/Blu-Ray author is going to lay it back to tape and will likely have to remap the audio or recompress it into a different container (AC-3, DTSHD-MA, etc.) anyway, so embedding the surround in the QuickTime file is of little benefit. The stereo can be ignored and picture-only used by anyone authoring. By including stereo, however, anyone can open the QuickTime and actually watch the movie or make a DVD for internal review, and compress it for Vimeo, all without having to re-sync audio.

For DCP creation most labs will accept the following:

- 10-bit DPX log files with an output-referred LUT
- 10-bit DPX Rec. 709 or DCI P3
- 16-bit TIFF (uncompressed) X'Y'Z'
- D-5, HDCAM SR or HDCAM (Rec. 709), Apple ProRes HQ 422 or 4444

Additionally, there are software solutions to the creation of a DCP, such as EasyDCP Creator, which is a standalone program. One caveat when creating your own DCP: the volume or drive containing the DCP must be formatted to EXT2 or EXT3 using Linux. Alternately, there is a plug-in available for use with Davinci Resolve which is capable of creating a Digital Cinema Package. Users must purchase a license from EasyDCP to enable this feature.[10]

FIGURE 6.9

DCP drive in shipping case

6.2.2 WHAT IS AUDIO LAYBACK?

Audio Layback refers to the final "marrying" of sound to picture using the head and tail reference beeps (2-Pop) to align them perfectly in synchronization. The audio files (.wav, .aiff) are placed in the nonlinear editor (NLE) timeline to discrete channels during final mastering and then output to tape (and/or rendered to separate file formats).[11] The layback of stereo (Lt, Rt) and 5.1 Surround mix (L, C, R, LFE, Ls, Rs) is performed in real time to a master HD video reel and checked against picture for any issues related to synchronization, audio mapping, drop-outs or other anomalies. Because sound and picture may arrive at the mastering stage at different times, it may be expedient to do audio

layback in a separate pass. D-5 and HDCAM SR decks are capable of recording video and audio separately or at the same time using what is known as an **insert edit**.

FIGURE 6.10

Audio layback "2-Pop"

FIGURE 6.11

Audio layback "Finish"

THE ESSENTIAL NATURE OF THE 2-POP

Managing synchronization of picture and sound elements comes down to a simple method of adding head and tail sync pops. Exactly 2 seconds before first frame of picture (FFOP), we should hear an audible tone of a duration of one frame. Likewise, at 2 seconds after last frame of picture (LFOP), we hear the same tone.[12] Each reel of picture will contain a visual reference at head and tail. This serves two essential purposes: the first is it allows accurate lineup and **matchback** of audio, and the second is that if for some reason the pop is not heard at the correct place, or there are multiple audible pops, this indicates a problem with synchronization.

Correct Mapping of the Audio Channels

D-5 is capable of recording 8 audio channels, while HDCAM SR carries up to 12 channels, which means both stereo and Dolby surround mixes can be included on the same master reel:

1　Left
2　Center
3　Right
4　LFE (low frequency effects)
5　LS (left surround)
6　RS (right surround)
7　LT (left, stereo)
8　RT (right, stereo)

6.2.3 FINAL ASSEMBLY IN PREPARATION FOR MASTERING

The master videotape (either HDCAM SR or D-5) should be **blacked and coded** in advance of the final output starting at TC **00:58:00:00**. At least two minutes of **pre-roll** is needed before first frame of picture (FFOP) to allow for **bars and tone**, banner and **leader** (black slug), etc. In cases where the videotape has not been blacked and coded prior to output, an **"assemble edit"** may be performed which lays down continuous timecode information along with picture and sound.

Program start always occurs at TC **01:00:00:00** on the timeline. The final audio mix ("**bounce-out**" from ProTools) is placed in the timeline and synchronized using the 2-Pop as reference. Align the 2-Pop frame 2 seconds before program start at TC **00:59:58:00** and check sync. Place any final titles cards and last minute visual effects to complete the picture, render if necessary and you are ready to output to tape.

Suggested clip placement:

60 seconds of bars and tone **(00:58:30:00 - 00:59:30:00)**;
10 seconds of black **(00:59:30:00 - 00:59:40:00)**;
10 seconds of slate **(00:59:40:00 - 00:59:50:00)**;
8 seconds of academy leader **(00:59:52:00** - 2-pop lands at **00:59:58:00)**;
logos and/or title sequence start at **01:00:00:00**;
rendered movie and synced soundtrack;
add at least 60 seconds of black to end of program;

FIGURE 6.12

Banner/Slate should include essential information about the project such as title, total running time (TRT), audio format, aspect ratio, date and if textless material is included at the end of the reel

6.2.4 QUALITY CONTROL: QC REPORTS

LUXOR RELEASING

| PASS | ☐ | HOLD | ☐ | **Page 1 of 2** |
| REJECT | ☒ | | | |

QC REPORT

Title: **SAVAGE DAWN**　　　　　　　　　　WO#　471167
Episode Name:　　　　　　　　　　　　　　PO#　TBA
Eps#:　　　　　　ID #:　　　　　　Part 1 of 1　　Length 90:00

| Element Profile | pro res | 1080 23.98fps | SavageDawn_90min_16x9_178_me20_en51_feature. | |
| Theatrical | Colour | 16x9 1.78:1 | mov | **Digital** |

TC/Comments | TC/Comments | HISTORY & ID | (Error correction at four intervals)

						1	2	3	4
Roll up	00:58:00:00	Head Logo TC	01:00:00:00	Rec Date					
Bars	00:58:30:00	Type		Rec Mach	-	A			
Slate	00:59:30:00	Notices	-	Fac of Origin	tcs	B			
Stickers	-	Tail Logo TC	02:29:55:21	Vid Barcode	-	C			
Label	-	Type	Luxor	Comm. Bks	-	D			

Technical Profile | **Specs** | **Luminance** Avg. 650 Peak 700 | **Chroma** Avg. - Peak -

Phase	Ch.	Ck'd Track Content	1K / Avg / Pk	Ch.	Ck'd Track Content	1K / Avg / Pk
Test	1	☐ English Left	-20 0 ±17	9	English 5.1 Right	-20 -6 ±16
Pgm	2	☐ English Right	-20 0 ±17	10	English 5.1 Lfe	-20 -10 ±16
Work Order	3	M & E Left	-20 -12 ±17	11		
Ch. Config.	4	M & E Right	-20 -12 ±17	12		
	5	English 5.1 Left	-20 -2 ±18	13		
Noise Reduction	6	English 5.1 Centre	-20 -2 ±18	14		
Ck'd ☐	7	English 5.1 Right	-20 +2 ±18	15		
	8	English 5.1 Left Surround	-20 -6 ±16	16		

Program Notes | Severity Scale | 1 = Acceptable | 2 = Marginal | 3 = Unacceptable

Time Code	Description	Duration	A	V	F	Scale	Chan / Sector	Pic/Audio Content	On Source
00:58:00:00	Start Of File								
01:00:00:00	Start Of Feature					N.b.			
01:00:28:11	Minor Blanking Change On Logos	Shot		•		2	L-LCR		
01:01:06:06	Audio Ticks On Music	Shot	•			1	1- 10		
01:01:13:21	Jump Frames Eg	Shot		•		2	ALL		
01:01:26:21	**Audio Peaks @ +15dbu**		•			3	1- 4		
01:01:26:22	Text In Feature Content	Scene				N.b.			
01:01:37:16	**Audio Peaks @ +17dbu**		•			3	1- 4		
01:01:38:09	Main Title " Savage Dawn "					N.b.			
01:02:02:20	Grainy Images Eg	T/out		•		1	ALL		
01:02:30:07	Text In Feature Content					N.b.			
01:02:45:08	Video Noise	Shot		•		2	ALL		
01:02:59:22	Video Compression On Archive Footage Eg	T/out		•		2	ALL		
01:03:55:09	Distortion On Dialogue	Shot	•			2	1+2,6		
01:04:11:00	Poor Adr Eg	Shot	•			2	1+2,6		
01:06:10:14	Vocal Effect On M&e - Kiss Eg	T/out	•			F Y I	3+ 4		
01:07:40:19	Audio Pop On Dialogue	1 F	•			2	1+2,6		
01:10:03:16	Text In Feature Content					N.b.			
01:10:17:10	Low Level Dialogue	Shot	•			1	1+2,6		
01:10:21:06	Burnt Whites Eg	Shot		•		1	ALL		
01:11:10:14	Text In Feature Content					N.b.			
01:11:27:23	Background Audible Dialogue On M&e Eg	T/out	•			F Y I	3+ 4		
01:13:41:21	Text In Feature Content	Shot				N.b.			
01:14:01:19	English Subtitle For Foreign Dialogue					N.b.			
01:14:30:07	Audio Tick On Dialogue	1 F	•			2	1+2,6		
01:14:59:09	Text In Feature Content	Scene				N.b.			
01:18:32:09	Text In Feature Content					N.b.			
01:19:06:19	Text In Feature Content					N.b.			
01:19:14:20	**Late Vocal Effects On M&e - Kiss**	2 Fs					3+ 4		
01:19:20:22	Audio Tick On M&e Eg	1 F	•			2	3+ 4		
01:22:44:13	**Late Vocal Effects On M&e - Kiss**	Shot	•			3	3+ 4		

Continued on Page 2

FIGURE 6.13

Quality control report

	LUXOR RELEASING		PASS	HOLD	
			☒ REJECT		

LUXOR RELEASING

☐ PASS ☐ HOLD ☒ REJECT

QC REPORT

Title: **SAVAGE DAWN**		WO#	471167
Episode Name:		PO#	TBA
Eps#:	ID #:	Part 1 of 1	Length 90:00

Program Notes Cont. Severity Scale 1 = Acceptable 2 = Marginal 3 = Unacceptable

Time Code	Description	Duration	A	V	F	Scale	Chan / Sector	Pic/Audio Content	On Source
01:33:14:18	Poor Audio Pan From Right To Left	Shot	•			2	1+ 2		
01:41:53:00	Text In Feature Content					N.b.			
01:44:43:15	Audio Tick	1 F	•			2	1-4,6		
01:45:42:02	Text In Feature Content					N.b.			
01:52:51:00	Audible Edit On Dialogue	1 F	•			2	1-4,6		
01:54:16:23	Text In Feature Content	Scene				N.b.			
02:02:44:17	Crushed Blacks Eg	Scene		•		1	ALL		
02:04:54:23	Text In Feature Content					N.b.			
02:18:50:23	Aliasing Eg			•		1	M-C		
02:19:56:12	Negative Dirt Eg	1 F			•	N.b.	L-R		
02:20:50:16	Soft Focus Eg	1 F			•	N.b.	ALL		
02:21:28:14	Text In Feature Content					N.b.			
02:24:03:07	Echo Main Title " Savage Dawn "					N.b.			
02:24:40:11	Aliasing On Credit Roller	credits		•		1	ALL		
02:30:00:05	End Of Feature					N.b.			

Textless	Ref ○ -20db ○ 0db ○ -18db	Ch 1	Ch 2	Ch 3	Ch 4	Duration	Sector Key		
02:31:00:06	textless elements	M O S	M O S	M O S	M O S	00:07	U - L	U - C	U - R
							M - L	M - C	M - R
							L - L	L - C	L - R

Comments	Summary	Sound	Good	Picture	Good	QC Profile	Type	**FULL**

Failed For - Late Vocal Effect On M&e - Kiss, Textless Repeats - This Will Need To Be Removed, Audio Peaks @ +17dbu.
Fyi: No Sync Pop 00:59:50:00, Vocal Effects On M&e (ie Kisses),

Date 25/9/2013	VT Mach. H/11
Op 1 SW/SC	Ch(s) 1-4
Op 2 AC	Ch(s) 5-10 Hrs 3.5

Signature		Op#	Accepted By

FIGURE 6.13

Continued

NOTES

1. An example of this is detailed at Bad Robot's facility in section 4.1.4, "Network Servers and Configuration."
2. Try reviewing a sequence without music every so often to determine if the music is indeed propping up a scene that needs help in the picture cutting.
3. David Yewdall, *Practical Art of Motion Picture Sound* (New York, NY: Focal Press, 2011), 187.
4. Tomlinson Holman, *Sound for Film and Television* (New York, NY: Focal Press, 2010), 163.
5. Hilary Wyatt and Tim Amyes, *Audio Post-Production for Television and Film: An Introduction to Technology and Techniques* (New York, NY: Focal Press, 2004), 266.
6. Jay Rose, *Audio Post-Production for Film and Video: After-the-Shoot Solutions, Professional Techniques, and Cookbook Recipes to Make Your Project Sound Better Audio Post-Production for Film and Video* (New York, NY: Focal Press, 2008), 390.
7. "Introducing Dolby Atmos," http://www.dolby.com/us/en/professional/technology/cinema/dolby-atmos.html, accessed October 20, 2013.
8. Xin Zhang, "Dolby Atmos Receives a Push in India," September 24, 2013, http://www.screendigest.com/news/2013_09_dolby_atmos_was_selected_by_indian_real_image_media/view.html.
9. Hilary Wyatt and Tim Amyes, *Audio Post-Production for Television and Film: An Introduction to Technology and Techniques* (New York, NY: Focal Press, 2004), 246.
10. "Blackmagic Design Announces DaVinci Resolve 10," April 8, 2013, http://www.blackmagicdesign.com/press/pressdetails?releaseID=38123.
11. Jay Rose, *Audio Post-Production for Film and Video: After-the-Shoot Solutions, Professional Techniques, and Cookbook Recipes to Make Your Project Sound Better Audio Post-Production for Film and Video* (New York, NY: Focal Press, 2008), 389.
12. Norman Hollyn, *The Film Editing Room Handbook: How to Tame the Chaos of the Editing Room* (San Francisco, CA: Peachpit Press, 2009), 237.

Restoration and Archiving

Film and Video Restoration

While contemporary filmmakers may not share the sense of urgency nor find the subject compelling, the efforts to preserve and restore our film heritage remains an integral part of the industry. More than half the films made before 1950 and 90 percent of all silent movies are gone.[1] They have disintegrated, been lost or destroyed.[2] Before 1950 most films were stored on nitrate cellulose, a highly flammable material that eventually turns to dust. After 1950, the industry turned to acetate (or safety) film stock which, while more stable, is prone to color fading. The surviving films, particularly the more popular titles which were duplicated more often, are at even greater risk

FIGURE 7.1

Paramount teamed up with Technicolor in 2012 to fully restore the classic *Wings* (1927), the first film to win the Academy Award for Best Picture

since all that may survive is a worn out negative, or a handful of release prints with visible signs of wear and tear.

Videotape originating from the latter half of the last century is at risk because it is an inherently unstable medium and many of the formats have become obsolete. The inventory of available video players is dwindling; consequently, archival tapes of old TV shows, documentaries and news programs are either endangered or extinct.[3]

Raising awareness of this ongoing challenge is the first step in the process. In 2012, the Science and Technology Council, part of the Academy of Motion Picture Arts and Sciences, took a survey of documentary and independent filmmakers and found that most were unaware of the "perishable nature" of filmed content and instead "believed that the internet and today's digital technologies offered unprecedented access to historical footage."[4]

7.1.1 VIDEO UP-CONVERSION

In some cases, a film library may consist of Beta SP, Digibeta masters or even 2 inch Quad that exist only in standard definition and there is no other original source material. A new master can be created by making an "**up-res**" of the sequence from standard definition (SD) to high definition (HD): the extra pixels of the HD format are filled in a proportionate manner that preserves the original aspect ratio of the material. If the material does not conform to the 1.78:1 aspect ratio of the HD format,

FIGURE 7.2

4x3 frame in 16x9 with pillarbox

pillar-boxes are added on the left and right to fill up any leftover space. The alternative to this sizing would be to "zoom with letterbox" or "zoom wide"; but this results in a softer cropped image. It is still possible to go through and clean up any digital artifacts, as well as dirt that may be present from the original telecine transfers. It may be necessary to fix the **cadence** and possible **interlacing** issues introduced when the original titles were added. This sophisticated combination of digital image repair and up-conversion allows for content owners to give their shows new life, with increased opportunities for distribution and revenue streams.

7.1.2 CROSS-CONVERSION

Cross-conversion is the process of taking video shot or acquired on one format and moving/matching it to another format.[5] Frequently SD material (525i@29.98) needs to be able to play back in HD (1080psf@23.976) and therefore an *up-conversion* is necessary. HD comes in a variety of frame rates and sizes. While there are software solutions that can perform this task, rendering times are often prohibitively slow. Hardware solutions such as the Kona 3 card are able to do the conversion in real time and with superior results.

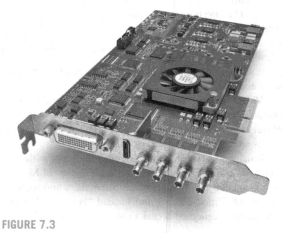

FIGURE 7.3

The Kona 3 card is a popular and cost effective choice for performing up, down and cross converts

7.1.3 INTEGRATING ARCHIVAL FOOTAGE IN A MODERN FEATURE

Acquiring old film or video and incorporating it into a contemporary production requires asking a few questions to determine the necessary workflow. Is the goal to have the footage appear aged relative to the newly shot material, or should it seamlessly blend? How will it be incorporated into the scene: full frame, composited onto a handheld device, television or movie theater screen?

In the case of *Forrest Gump* (1994), the main character was able to appear with historical figures such as John Lennon and John F. Kennedy. This was accomplished with an extensive team of visual effects artists who were able to seamlessly blend the old with the new.[6] Another example is seen in the film *Lovelace* (2013) where the main character, played by Amanda Gottfried, is being interviewed by Phil Donohue and composited within the vintage TV talk show. More recently, in Ron Howard's Formula One race car film *Rush* (2013), over 100 hours of archival footage was assembled to be used as a guide for staging the races, with many of the original shots incorporated into the final version to create authenticity.[7] In most cases it is easier to "age" the new footage rather than improve the vintage shots.

To incorporate film footage that has been transferred to tape or original video footage, certain steps must be taken:

De-interlacing: most archived video footage (as well as HDTV shot in 1080i) is interlaced, which means each frame is divided into two **fields** (each field represents an alternate scan line). The easiest method to convert an **interlaced** video stream to **progressive** is to discard one field and recreate the missing picture information using interpolation.[8] However, this represents a compromise in terms of quality because you are after all losing half of your picture and may result in smearing, artifacts or **comb** effects.

RE:Vision Effect's Fieldskit is one of many software solutions that can analyze and successfully reinterpret interlaced frames using field reconstruction and adaptive motion techniques

Interlace issues in older video are most noticeable during pans, tilts and transient motion within the frame

Inverse Telecine: when film (23.976 fps) is transferred to NTSC video (29.98), each frame of film is converted to two separate video fields. However, the frame-to-field pattern (placing four frames of film into ten video fields) requires that *every other* frame of film is split between two frames of video using the odd/even field rotation.[9] This is also referred to as **2:3 pulldown**. By using Inverse Telecine, the pulldown is effectively removed and the 24 fps sequence is restored.

7.1.4 REBUILDING VISUAL EFFECTS FROM SOURCE MATERIAL

Films with visual effects are faced with significant challenges to restore to 2K or 4K, depending on the visual effects processes employed during the original mastering of the film.

Blade Runner was subjected to a massive restoration effort. Shot in 1982, digital compositing was in its infancy and optical compositing was still the norm. Optical printing and composite work allowed for much less precision, leading to rough matte edges and inconsistencies in densities between different visual effects plates. Furthermore, the process subjected visual effects shots to multiple generations of degradation and quality loss, as complex composites required multiple transfers to new inter-negatives and inter-positives. In the case of *Blade Runner*, much of the film's visual effects plates were photographed by Douglas Trumball and company on 65mm film. During the restoration, the original plate elements were scanned at 8K to capture every bit of detail available. Next, they were digitally composited to produce an authentic restoration of the original visual effects, but in higher quality than they had ever been seen before. Additionally, the whole film was color graded through a digital intermediate process, which surpassed the quality and consistency of the original optical timing.

Special attention was paid to some sequences in the film where new effects work was added to fix issues that plagued the film during its initial release. One such effect was to replace the face of an obvious stunt double with the correct actress. Another was the correction of a discontinuity between

Harrison Ford's lip movement and the ADR recording of his line of dialogue. To resolve the issue, his son, Ben Ford, was filmed lip-syncing the line to match the rhythm of the dialogue, and his mouth was digitally composited over his father's in the scene. The audio was re-mastered in Dolby 5.1 surround and utilized many of the original magnetic audio tracks.[10]

Recently, CBS Digital has undertaken a massive restoration effort to re-master *Star Trek: The Next Generation* for Blu-Ray release. Thanks to meticulous record-keeping and preservation of the original camera negative, the series is being rescanned and re-mastered in 1080p with 5.1 surround sound. *ST:TNG* presents an interesting challenge, as the visual effects were a mix of 35mm plate photography and digital compositing, mastered to standard definition analog tape. Part of the restoration effort includes rescanning all of the original effects plates and digitally compositing them.

Most shots of the *U.S.S. Enterprise* were created by Industrial Light and Magic for the first season and reused throughout the majority of the series. However, many of the planets they visited were digitally composited behind the ship at standard definition. Similarly, phaser blasts, electricity and other special effects were created by digital artists and no high-definition master exists. For those effects, the team at CBS Digital (and other vendors) painstakingly rebuilt the effects in high definition. Much care was taken to reproduce the effect in the same manner and style as the original, with the only major difference being an increase in resolution. Under the guidance of Michael and Denise Okuda, who were the technical art directors for the series, the visual effects teams have reproduced the visual effects of *Star Trek: The Next Generation* at a remarkably high quality.

As CBS Digital begins looking at the later Star Trek incarnations, they will have new problems to tackle. In the late seasons of *Star Trek: Deep Space Nine*, many shots of new ships, fleets and space battles are completely computer generated. The effects are significantly more complex than the digital effects in *The Next Generation* and "the task of reproducing 50 different CG ships following complicated flight paths, firing at each other and exploding left right and center in grand battle sequences would border on the impossible given time, financial and resource constraints in any DS9 re-mastering project."[11]

It was believed by CBS that the original project files for those CGI scenes had been lost. It's been nearly 20 years since those scenes were produced and it is a lot easier to lose track of digital files than rolls of films. At the time, hard disk space was at a premium and it wasn't always feasible to store project files and assets indefinitely. A recent investigation has revealed that many of the original scene assets still exist, and, surprisingly, are readable by modern systems and softwares such as Lightwave, which was used for much of the original animation and rendering. Senior CG Supervisor Robert Bonchune was able to determine that re-rendering in high definition was a viable option. As it turns out, the assets were often overbuilt with a much higher level of detail than the standard definition version revealed. Re-rendering these shots will likely require a minimal amount of work to refine details such as visible polygons in models and motion blur.

As filmmakers produce films today, it is important that they preserve their assets and files. There's always a chance that your film will enjoy a resurgence in popularity 20 or 30 years from now and fans will rejoice in knowing you took such care to preserve the film for future generations.

The Road Ahead for Digital Content

Once completed, a modern show may consist of many terabytes of data stored and backed up on a server or collection of portable drives. While this short-term storage solution may appear cheap and easy, the long-term prospects for the survival of digital films remain in doubt. Newer films are "born digital," meaning there are few if any original film elements.[12] When a film is picked up for theatrical distribution, film elements can be created from the digital master files such as a "film-out" or digital negative and these should be considered for inclusion in the archive.

Since major studios have deep pockets, they can afford to maintain or rent a large digital infrastructure and manage footage in a deep storage solution. What this means in practice is that data is kept on linear tape-open (LTO) tapes using periodic checksums. It will have to be migrated to new formats as they become available. However, the future path for this data after 20 or more years is undefined.

For the independent filmmaker, the outlook is less certain. The reality of independent filmmaking is that thousands of films are made each year, yet only a handful of films are selected for film festivals. An even smaller percentage is picked up for distribution. Thus the cost of storing and maintaining the film will be borne by the filmmakers themselves until they are perhaps fortunate to receive a distribution deal. Even then, the cost of archival is rarely taken into account. And once the distribution agreement has run its course, what do you do then? The Sundance Institute in cooperation with the UCLA Film and Television Archive has made a concerted effort to create a home for all of its award-winning festival films, but this represents but a small fraction of the independent projects that face extinction.[13]

The model for distribution of filmed entertainment has experienced a profound change in the past few years with the rise of streaming delivery systems such as Amazon, Netflix and iTunes. Filmgoers used to be lured into theaters by trailers and costly advertising, with the successful launch of a movie determined by the opening weekend box office grosses. Likewise, TV audiences used to make an appointment to watch their favorite shows before the DVR allowed them to time-shift their viewing habits. Today, Video on Demand (VOD) offers not only convenience but a wider selection than what is "on the air" or featured at the local multiplex. This ever-growing inventory and back catalog of movies and television represents a golden opportunity for the independent filmmaker. In his article for *Wired* magazine entitled "The Long Tail," Chris Anderson describes the future of entertainment as existing in niche markets.[14] What this means is that while major studios continue to serve up blockbusters and tent-pole movies each year, it is during the ensuing years that alternative or fringe films will be able to pick up and retain a small audience and enjoy modest returns. For independent features and documentaries, this represents a potential stream of nickels and dimes that can add up to significant revenue over time. And since copyright protection affords owners at least 95 years to exercise control over their product, it would seem prudent to make plans to protect their film and digital assets so that they remain available to future audiences.[15]

7.2.1 MAINTAINING ORIGINAL FILM ELEMENTS

Film elements enjoy a distinct advantage over digital, as they are projected to last over 100 years if stored properly in a climate-controlled (cool and dry) environment. While there is always the risk of physical loss or damage due to fire, flood or earthquake, the reliability of film *as a storage medium* over time trumps any current digital solution. It can be argued that a blended approach of saving both the tangible physical element (such as the negative) *in addition to* the master digital files means that a film may be restored and enjoyed for many generations to come.

If born on film this may include the conformed negative, B-Roll and Trims, Inter-positive (IP) and Inter-negative (IN), Answer Prints, Textless Versions, in addition to the YCM (yellow, cyan and magenta) Separation masters. The cost of physically storing these elements is estimated by the Academy of Motion Picture Arts and Sciences (AMPAS) to be approximately US$1500 per year and includes the amortized cost of the creation of the YCM separation masters.[16]

> In addition to saving digital master files and digital negative, major studios create a set of YCM Separation Masters. They consist of yellow, cyan and magenta passes, which are recorded on sturdy polyester black-and-white film stock and can be later recombined to recreate the color picture. These are not unlike the separate three strip elements that make up the original Technicolor processes of the 1930s and 1940s.

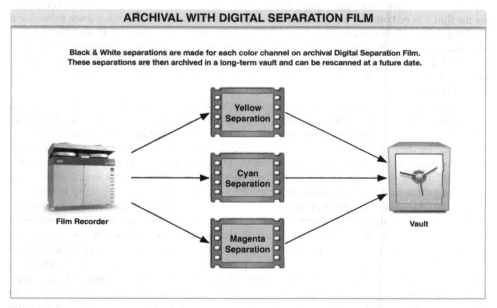

ARCHIVAL WITH DIGITAL SEPARATION FILM

Black & White separations are made for each color channel on archival Digital Separation Film. These separations are then archived in a long-term vault and can be rescanned at a future date.

Film Recorder

Yellow Separation

Cyan Separation

Magenta Separation

Vault

FIGURE 7.6

Archival with digital separation film

7.2.2 ARCHIVING DIGITAL SOURCE MEDIA

Prior to archiving your project, some issues need to be considered.

How much data can I afford to keep and for how long? While difficult to answer, let's assume you wish to save the material for a generation (20 plus years) with instructions for your heirs to continue the mission after you are gone. The good news is that storage costs will continue to drop. The bad news is that we don't know how long current technologies will last before the data has to migrate to another platform. There simply is no long-term digital solution.

What are the best methods of storage and retrieval? Spinning drives are limited in size and have a short shelf life (two to three years), making them impractical for the long haul. LTO provides a reasonable path for the near term. Enterprise storage companies and cloud-based vendors offer the most attractive solution to this never-ending problem of digital asset management. Some studios may even consider "farming out" data storage in order not to commit to a large and costly infrastructure that is continually at risk of becoming obsolete.

How can I be assured of the integrity and usefulness of my data? When it is copied to a future (as yet undetermined) format, a checksum must be performed to ensure that none of the data has been lost during transfer. This must take place every time the data is migrated as well as periodically while maintained on the LTO tapes.

What is the absolute minimum that I need to save? If saving all your data is not practical (such as camera original, B-roll and out-takes), then at the very least save a High-Definition QuickTime of the finished project and a folder containing an uncompressed image sequence (TIFF or DPX). Also, if possible, keep a copy of the Digital Cinema Package (DCP) because an image sequence can be derived or "reverse engineered."[17] This is similar to the process of "de-muxing" (de-multiplexing) a DVD title which extracts the elemental files.

What other documents should accompany the image files? The editing project (Avid, FCP, Premiere, etc.) and proxy dailies should be included in the archive. All logs and spreadsheets should be saved. All this data is modest in size in relation to the master clips. However, without a proper database of your materials, the archive will be much more difficult if not impossible to access. Preserving the metadata (to include camera information and colorspace) is essential to updating and restoring the project, particularly if it is from the DCP.

How many copies should be maintained? The best policy is to stick with the 3-2-1 rule; keep three copies in two different formats with at least one maintained off-site. Companies like Amazon and Sohonet can provide you with storage that is redundant and relatively safe. It has the added benefit of residing in a separate geographic location from the content owner. Assuming that the cloud vendor can always access two copies of your data, you should consider making a third copy, which is more readily accessible and physically in your possession.

7.2.3 INVENTORY OF FILM AND DIGITAL ASSETS

Checklist of 16mm/35mm film assets:

- Digital negative
- Answer print
- Production IP (inter-positive)
- Production IN (inter-negative)
- Check print

- Textless digital negative
- Textless IP
- Textless answer print
- Foreign main and end negative
- YCM separation masters
- Original camera negative (OCN)
- Trims and outs
- Optical sound negative

Checklist of digital file-based assets:

- Master files for digital negative (film-out)
- Master files for textless digital negative
- Digital source master (DSM – graded DPX files)
- Digital Cinema Distribution Master (DCDM)
- Digital Cinema Package (DCP)
 - Rec. 709 master files (mezzanine copy)
 - Original camera files
 - Editing project files (Avid/FCP/Premiere), including offline dailies

Checklist of videotape assets:

- Telecine dailies (HDCAMSR)
- Distribution masters and clones (HDCAMSR or D-5)

Checklist of digital audio elements:

- 5.1 domestic printmaster
- Domestic stereo Lt/Rt
- 6-track Dolby digital
- Digital cinema version
- 5.1 M & E (music and effects)
- Stereo M & E (Lt/Rt)
- Foreign dialogue stems
- Foreign language printmaster (5.1)
- Foreign language printmaster (Lt/Rt)
- Multichannel master stems
- Original production sound
- Pre-dubs
- 5.1 effects stem

WHAT EXACTLY SHOULD BE SAVED?

It is acknowledged that while it may not be practical or essential to save everything from a production, this list of assets represents what in a perfect world should be saved for posterity. With the long tail theory in mind, it is possible that added bonus footage and deleted scenes as well as directors' cuts may be added later on, not to mention newly restored versions presented in formats *yet to be invented*.

7.2.4 RESTORATION AND ARCHIVE: CONVERSATION WITH ANDREA KALAS

Q: Before coming to Paramount you worked in the UK. How is it that you came to work with the British Film Institute (BFI)?

Kalas: I was asked to apply for a job there. I had been working at Discovery in Washington, DC. I've done archiving in a variety of different places including UCLA Film and TV Archive and Dreamworks. They were looking for somebody to head up their preservation area that had experience of traditional preservation as well as new technologies.

Q: And BFI, where are they located?

Kalas: Their main office is in Soho. But they also have a conservation center which is out in Berkhamsted.

Q: Tell us about the restoration and re-release of *Wings*.

Kalas: We released *Wings* both theatrically and on Blu-Ray during our centennial year, which was 2012. And that was one of the main reasons to attack that project because we were doing a bunch of things to celebrate Paramount's 100th anniversary.

Q: How were you able to place your hands on all the elements?

Kalas: I've been at Paramount since 2009. And *Wings* was one of the films that I knew, even going in, would be on the top of the list for restoration, because of the importance of the film to the studio, and its place in film history being the first Academy Award winner, and being the first movie to actually involve flight sequences. It had never been released on DVD or Blu-Ray. So I knew that there could be potentially both a legacy and a financial incentive to restore this film.

So, that was my pitch. And we did a major budgeting project to look for materials. And it gave me a chance to do an enormous amount of research, which was really necessary for a title of that age, and try to do my best to look around the world for the best possible elements. We also knew that we might have in our music archives a copy of the original score for *Wings*. That was important to me too because, I think, with silent films, there's been a trend where people actually make new scores for films. And, I just thought it would be terrific if we could actually recreate the original score. So that helped to make it as authentic to the original theatrical experience as possible.

Q: When you say score, do you mean the sheet music?

Kalas: Yes, the printed score. We worked with people that we knew had been involved in silent film music. Dominik Hauser recorded a midi track with the basic score. And then we hired other musicians, like a violinist, a pianist and others to sweeten the score.

The final mix was done by Ben Burtt, who was a sound designer for *Raiders of the Lost Ark* and *Star Wars*. He has an affinity for this film, for *Wings*, and has for many years. It goes back to even when he was a teenager and made his own version of *Wings*. And he was fascinated with sound effects and the fact that the original release of the film included not only this great score but the sound effects that went with the movie. So he had authentic plane sounds and machine gun sounds that he could add to the final mix.

During the time *Wings* was being released, sound was just coming in. So they wanted to make it as full of sound as possible in its original release. There were versions where, in major cities, like in New York, it played for over two years, and featured a live orchestra and including live sound effects. In smaller theaters, there were actual printed instructions for adding whatever sound effects you could at various points in the film. So it was released as a silent film but, of course, silent films were never really silent when they were shown in theaters. There was always some sort of accompaniment.

Q: Two years seems to be a long run for a film in general release. Was that typical of the era?

Kalas: No, it wasn't. *Wings* was enormously popular, a blockbuster of its time. I think a lot of people had probably seen World War I footage, maybe, a little bit in newsreels. But they would've been static type of images such as reviewing the troops or aftermaths of a battle. So I think the curiosity about World War I and also the curiosity about aviation, which was relatively new, was huge in the public imagination. And *Wings* definitely fill the bill.

Q: So, as far as the elements were concerned, how far flung did you have to go to retrieve these for *Wings*?

Kalas: We probably spent close to a year really making sure that we had the best material we possibly could. It had been restored once before, by Kevin Brownlow, in the UK. So we reached out to him to see what he'd used. We always reach out to the major archives – Library of Congress, British Film Institute, Cinematheque Francaise – those places that have major collections and could have elements. Even the Academy helped us, since it's an Academy Award winning film, so they were involved with us in the restoration and they reached out to other archives more broadly.

What we found was, what we actually had in our own archives were the best elements. Unfortunately, what we had wasn't fantastic. It was a dupe of a print made in the 1960s. And thus it had printed-in nitrate deterioration, and just a host of other issues that you'll see when you have a print, scratches and dirt, projector dirt. So we had our work cut out for us.

Q: What about the hand painted elements such as the muzzle flashes? Were they in the original release?

Kalas: That was definitely in the original road show release. I'm sure they didn't put those prints in every theater. But the road show release and the major cities definitely had them because there were instructions for the sound which indicated you should play the sound when this special color arrives.

There was this process called Handschiegl color that was used on prints that probably went to the major cities in what was called the road show release. The Handschiegl particular process is actually kind of a precursor to Technicolor imbibition printing where you actually print ink onto a print. And that was before more sophisticated photochemical color processes, which Kodak was responsible for. This was how color was being thought about, stencil color was being used and other types of color or tinting.

There were tints in *Wings* as well. We had a continuity script which told us exactly what colors of tints and where they should occur. So we knew where to put the Handschiegl color on our restoration. We knew what tint to use based on documentation we had. So, we could recreate that digitally.

Q: What other elements might you draw from if you find there are missing reels or frames?

Kalas: The ideal for any restoration or preservation effort is that you have an intact original element with as much information as possible. But that rarely happens. So then you do a comparison of other elements that are still around. The next generation for black and white would be a fine grain or for a color it would be an inter-positive. That's always a good element.

And then you go generationally from there, you know, an inter-negative. But the point is you compare these elements, because even though there might be some part of the film that is more original, it may be so compromised through issues like scratches or deterioration or other things like that, that you may need to use the next generation element to make a sort of patchwork of things. That happened when we restored *Sunset Boulevard*. We even used a print for a few frames and several sequences where those frames didn't exist anywhere else.

Q: So, what's currently under consideration for restoration and what do you have in the works?

Kalas: Well, knock on wood, if all goes well, we'll be doing some work on *A Place in the Sun*, the George Stevens film from 1948. That's a film that we'd very much like to restore. Like a lot of black-and-white films from that era, mostly the original negatives were used to make prints. And when that happens, you eventually destroy the original negative. *Brief Encounter*, *Dr. Strange Love*, *Sunset Boulevard*, *A Place in the Sun*, these are all films without original negatives, sadly.

Q: Is it true that the studios keep all of their YCM separation masters and all their elements deep in salt mines?

Kalas: Yes, that is true. Since around 1990, and Paramount was really one of the first studios to do this, there's been an effort to keep elements separated from each other for disaster management purposes. We will place a copy of our future films, and include a variety of different elements, not just separations, to keep them separate. And we're building out a digital archive as well and that will have that same theory built into that. So we'll have multiple copies of digital files and they'll be geographically separated as well.

Q: Does management grumble as they come to terms with the cost and resources needed to preserve these assets?

Kalas: Everybody grumbles when they have to spend money. It's a sort of truth of life. At Paramount, and at the other studios too, there's an interest in maintaining the assets of the company, so from a business perspective there's definitely a consciousness of the legacy that the archive represents for the company. People are really trying to think about the future too by focusing on how we preserve digitally because we're keenly aware that process needs attention. And so those three things together help move the financing of archives forward. I have found within my own studio that people really get it. They really understand just how critical it is to support those efforts.

Q: So, what discussions do you have with current shows that have just wrapped or are now preparing to put everything to bed? Are they saving the out-takes? What's the philosophy as far as saving the digital intermediates and mezzanine copies and so on?

Kalas: Yes, we are really fortunate. We work very closely with the post-production group, which is essential for a good archive because managing those materials and receiving them into the archive near the end of production is essential.

We have a list of what we call our "digital preservation elements," so the final digital intermediate, all the audio materials we archive as un-encrypted DCP. We archive all the original camera files, if the film was shot digitally. Or if it's shot on film, it's still called the trims and outs. So, yes, we take it all in and have different ways of making sure that those elements are around for a long time.

Q: So is LTO still the best medium for digital archive?

Kalas: We're building out a much more complex managed infrastructure. The philosophy we have is that digital is just a different animal completely than film. Film likes to sit on shelves in very cold dry temperatures and likes to be left alone. And that's how it best survives. Digital likes to be constantly fed and watered and touched and moved and managed.

Q: Well said.

Kalas: It's true. I think it's the responsibility of the archivist to treat the medium that they care for in the manner it should be treated. And, so our managed infrastructure will essentially keep track of every preservation asset that we have within this network of, you know, software and hardware and tape libraries and make sure that it's okay by checking it annually. And by doing this massive constant health check, there will be tape migrations. We'll be able to migrate from whatever platform we will have in the future. The point is we'll know about the asset, not what it sits on. That's the more important thing. The actual digital file is the thing that we will really focus on. There are people who want to find the perfect medium to store digital, so it will be good for a thousand years. And maybe they will figure that out. But I think it's much more important to keep an open managed infrastructure.

There are so many different ways that people are shooting digital now. It's just changing constantly. And being able to understand how to read all those various formats in the future is going to be complex enough without having to move things off of tapes on shelves. Having them all within a managed infrastructure gives the ability to find new ways of reading those files, finding new ways of translating them to formats that people can use if they need to.

We work closely with our finance people to look at what that expense would be. We found that we had to do a 30-year lifetime to look at what it would be. The costs actually go down, it becomes incredibly manageable. It's not so crazy. The cost for technology will definitely go down even if you're really conservative about estimating it. The software will improve and the hardware cost will go down. But I think it's a pretty good educated guess based on the last 30 years of technology. Most of us use what we call either media asset management or digital asset management software. Ours was built in house, other people, you know purchase them from vendors. Whatever software you use, the critical thing is actually the documentation or the cataloging of those assets. The word metadata that's been bandied around so much almost means nothing anymore.

Our responsibility to the next generation of archivists is that they can find these assets and find them to be healthy no matter what. So no matter what software this information gets migrated to, no matter what hardware the assets get migrated to, there's a transparency of information about those assets that's easy to find and easy to use in the future. That's really the philosophy. We have a repository for that information but we make sure it could move to another database or another system if it needs to.

Andrea Kalas is senior vice president, archive and
restoration at Paramount Pictures.

NOTES

1. Dave Kehr, "To Save and Project – Restored Films at MoMA," *New York Times*, http://www.nytimes.com/2010/10/15/movies/15restore.html, accessed October 15, 2013.
2. "About Restoration," UCLA Film and Television Archive, http://www.cinema.ucla.edu/restoration/about-restoration, accessed October 15, 2013.
3. "Media Format Guide," SummitDay Media, http://www.summitdaymedia.com/format.html, accessed October 14, 2013.
4. "The Digital Dilemma 2 Perspectives from Independent Filmmakers, Documentarians and Nonprofit Audiovisual Archives," Academy of Motion Picture Arts and Sciences, http://www.oscars.org/science-technology/council/projects/digitaldilemma2/, accessed October 16, 2013.
5. Before the advent of HD this was referred to as *standards conversion* such as transferring PAL material (originating from parts of Europe and Asia) to NTSC (North America).
6. *Forrest Gump: Through the Eyes of Forrest Gump*, DVD extra, directed by Robert Zemeckis (Los Angeles, CA: Paramount Pictures, 1994).
7. "For Hanley and Hill, Editing is a 'Rush'," https://www.editorsguild.com/FromtheGuild.cfm?FromTheGuildid=412, accessed October 16, 2013.
8. Jack James, *Digital Intermediates for Film and Video* (New York, NY: Focal Press, 2006), 434.
9. In the case of PAL video, which records at 25 fps, many European productions chose to film at the same rate that allowed for a one-to-one transfer of film to video frames. Alternately, film that was shot at 24 fps was simply sped up by 4.3 percent, resulting in a significant pitch shift in the audio.
10. See http://en.wikipedia.org/wiki/Versions_of_Blade_Runner#Differences.
11. "Deep Space Nine in High Definition: One Step Closer?," *Trek Core*, May 10, 2013, http://trekcore.com/blog/2013/05/deep-space-nine-in-high-definition-one-step-closer/.
12. Academy of Motion Picture Arts and Sciences, "The Digital Dilemma 2 Perspectives from Independent Filmmakers, Documentarians and Nonprofit Audiovisual Archives," http://www.oscars.org/science-technology/council/projects/digitaldilemma2/.
13. "The Sundance Collection at UCLA," UCLA Film and Television Archive, July 18, 2011, http://www.cinema.ucla.edu/collections/sundance
14. Chris Anderson, "The Long Tail," *Wired*, October 12, 2004, http://www.wired.com/wired/archive/12.10/tail.html.
15. "How Long Does Copyright Protection Last?," Library of Congress, http://www.copyright.gov/help/faq/faq-duration.html, last modified March 10, 2010.
16. Ibid, "The Digital Dilemma: 2 Perspectives from Independent Filmmakers, Documentarians and Nonprofit Audiovisual Archives."
17. "DCP – Decrypting, Unwrapping, Reverse Engineering, Unpacking," January 20, 2012, http://carouselmediacompany.com/blog/?p=219.

Budgeting and Scheduling for Post

Budgeting and Scheduling for Post

During the hectic days of pre-production, one of the first things that usually gets pushed back and delayed is the planning and scheduling for post-production. It happens more often than not because of other seemingly more pressing issues, such as obtaining financing, juggling actors' schedules and incorporating last-minute script revisions. Just because editing comes *after* principal photography does not mean it should be placed on the back burner. The wise producer will hire an editor early in the process (and if the budget allows, a post-production supervisor) with whom to consult during pre-production. Every decision made during production has a ripple effect through post, and bad decisions made early on tend to amplify cost overruns later. It is also essential to have the answers to all questions regarding post-production *before shooting a single frame of film* so as to avoid surprises.

Determining the actual costs of post line items is contingent on the size and scale of your budget. Whenever a post facility sales rep is asked the question: "How much will it cost?" their answer is usually in the form of the question: "How much have you got?" There is the low/ no budget rate, the studio rate and the card rate. Nobody pays the **card rate** if they can help it. Free is considered a very good price. The point here is that *everything* is negotiable.

The next question your sales rep is likely to ask is: "How soon do you need it?" This information provides a clearer picture for post houses and supervisors because it allows them to factor in the most important point of the budgetary triangle.

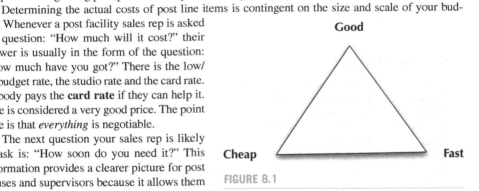

FIGURE 8.1

Bidding triangle

No one will ever acknowledge that quality (good) should be sacrificed. After all, who in their right mind sets out to make a "bad" movie? However, only two tips of the triangle can be achieved, usually at the sake of the third. Do you want it fast or do you want it cheap? It is nearly impossible to achieve all three at the same time.

8.1.1 SCHEDULING AND HIRING

There is an old saying that "editing is never completed, only abandoned." The truth in this comes from the fact that no matter how much time is allowed for post, filmmakers always want to keep tinkering. Therefore, a clear time allocation for each step (with a "drop dead" delivery date) should be communicated to all parties.

When creating a schedule, the natural inclination is to pencil in the days and weeks *going forward*, where in fact it is often more practical to use the final release or delivery date and then *backtime* each key step and deadline for the project.

The Directors Guild of America (DGA) has specific rules regarding how much time a director must be given to present his cut. For a feature film, ten weeks is the minimum, whereas episodic television allows for as little as four days.[1] Networks and studios also need their own time to develop notes and evaluate changes. Sound mixing and visual effects, along with music scoring, automated dialogue recording (ADR) and Foley all need to be accounted for and can't start until the picture is "locked."

THE IMPORTANCE OF THE "LOCKED PICTURE"

Accurate budgeting and scheduling for post-production hinges on the notion that after a certain point in time there will be no more picture changes. Sequences are essentially frozen in terms of continuity and duration, so that visual effects and sound effects departments can do their work in the remaining time allotted. This concept may be anathema to the director and editor who wish to continue making changes. Before embarking on a post-production schedule, all interested parties must acknowledge that there is a certain time and date when they must walk away from the editing console and allow the final stages of post to take place in an orderly fashion. To ignore this rule invites disaster in missing a deadline or, at the very least, increased labor costs due to overtime payments, resulting in significant cost overruns.

The key steps and deadlines for a feature film may look something like this:

Week 1:	Camera and workflow tests
Week 2–11:	Principle photography
Week 12:	Editor's cut
Week 13–22:	Director's cut /MPAA screening
Week 23:	Producer's cut
Week 24:	Studio's cut
Week 25:	Test screening and final changes/picture lock
Week 26–32:	Dialogue and music spotting/ADR and Foley
	Pre-mixing/final mixing/online picture conform and color grading
	Titles and VFX added
Week 33–34:	Final deliverables and versioning

Every film has a unique timetable based on its complexity, which is why it is crucial to consult with the creative experts – namely, VFX Supervisor, Sound Designer, Composer and, of course, the Editor. They should be given an early draft of the script so that they can assess the special needs of the project. Invite them to comment on both the creative goals and practical aspects of finishing the movie. They may be able to offer useful ideas and solutions, and provide valuable information that helps in formulating a final schedule and budget.

These experienced consultants may also wish to bid on your project and can offer the benefits of a package deal. Post houses, sound houses and visual effects companies welcome the opportunity to be a "one-stop-shop," and the capable producer will seek out more than one quote for services to ensure the best price.

8.1.2 ESTIMATING COSTS

The following is a breakdown of many of the line items associated with post-production. The estimated costs and allowances are intended simply as a baseline, as each project will vary widely depending on their schedule and needs.

The Post-Production Crew and Salaries

Editors' salaries are outlined in the Motion Picture Editors Guild Local 700 agreement. Most editors are "on-call" and paid by the week, which means the number of hours worked may vary and if they are "over scale" they may not ask for any overtime payments. However, the prudent producer will make allowances for the seventh day worked both as a courtesy and as a precaution should the hours become excessive.

Union assistant editors are paid by the hour with a weekly "guarantee" of 45 hours. Typically they will work anywhere from 50 to 70 plus hours a week. Therefore, overtime and seventh day allowances should be factored in to the budget.

Non-union shows can negotiate flat rates for editors and their assistants. While this arrangement may seem like a good idea, it leaves productions open to the risk of being organized by the **IATSE** (International Alliance of Theatrical Screen Employees) during production, resulting in costly over-runs. It is very difficult for shows with budgets over US$1 million to be able to fly "under the radar."

Alternately, there are low-budget IATSE agreements that may suit your level of production and provide for health and welfare.

> *Editor's rates: US$1500–$3500 per week (range between non-union and union over-scale).*
> *Assistant's rates: $1000–$1800 per week (range between non-union and union scale for 45 hours).*
> *Post supervisor: $1000–$2400 per week.*
> *Post coordinator: $1000–$1600 per week.*
> *Production assistant: $500–$750 per week.*

ADVANTAGES OF USING A PAYROLL COMPANY

Since most of the crew (including editors) are not independent contractors, a payroll company is the most efficient way to handle wages and salaries. There are companies that offer both union and non-union payroll services and operate under one roof. The important thing to remember is that they are *signatories* to any union agreement, which means that the payroll company acts as the "*employer of record.*" This allows an independent production company to avoid signing any collective bargaining agreement. In addition, this makes life easier for independent producers because they need not carry additional accounting staff to calculate fringes and issue checks.

Post-Production Offices

You will need dedicated cutting rooms, and short-term (15 to 30 weeks) office rentals can be expensive. A cost-saving strategy might be to set up cutting rooms in the production offices during principal

photography and ask the editor to squeeze in next to the art department or transportation. While this may seem like a good idea on paper, it is not always practical as it can be very disruptive to require the editors to pack up and move to another location in the middle of a busy post schedule.

Another important consideration is that many office buildings are not suited for housing cutting rooms. Many are not open 24/7 and the air conditioning or elevators may shut down after a certain hour. Some offices are not soundproof, nor do they always have adequate power to service all the computers and servers.

A popular arrangement is to find a post facility that rents cutting rooms as well as editing systems. When negotiating your post deal you may wish to ask for space at a low or reduced price with the promise that you will produce all your final mastering and deliverables there.

There are tremendous advantages to renting through a post facility as they offer a "one-stop-shop" when it comes to scanning dailies, outputs and screenings, final mixes and mastering. These facilities may feature a kitchen, or if they are upscale will cater lunches for their staff and clients. They also can provide phones, reception, furniture and parking so that producers can keep their overhead to a minimum during the post-production process.

Estimate for post-production offices/cutting rooms: US$500–$2000 per week.

Editing System Rentals and Storage

Avid systems average between US$800 and $1200 per week. A second system can usually be negotiated at a discount. Storage usually comes at a premium. Rental contracts should include free delivery/installation/pick-up and 24/7 tech support. When negotiating long-term agreements, additional discounts may be available.

Estimate for editing system rentals and storage: US$1000–$3000 per week.

An 8 to 16 TB Raid array is recommended for onset footage as well as "runner" drives (2 X 2 TB). You may want to contract with your lab or post house to provide a second backup. Producers now frequently require a third backup. The challenge for production is that with 7 TB of original footage you will need at least 24 TB for the camera original files, and this does not include the offline footage in the cutting room!

Allow US$3000 for digital management and security.

CG/Effects/Titles

Package bids may be most effective here as CGI and Effects Artists start at around US$250 per hour. While temp titles and visual effects may be created on the Avid, time and money should be reserved for creating professional-looking elements. Contracts should specify number of revisions and "re-dos" as it often requires more than one pass to satisfy the filmmakers.

Allow US$10,000 for titles.
Allow $25,000–$250,000 for CGI/animation/visual effects.

Conform and Color

A temp conform and color grade for preview screenings can be achieved using Avid and/or Davinci Resolve. The additional time needed to prep for test screenings should be factored into

the schedule. The time allotted to do the final color can vary widely from a couple days to a week.

Allow US$250 per hour for final conform.
Allow $250–$450 per hour for color grading (includes fee for colorist).

Music and Composer

Is the score the product of one person and a synthesizer, or a full orchestra requiring a recording studio? Will the music be delivered exactly to match picture, or will the services of a music editor be needed? How much time is needed after picture-lock to deliver the score?

Allow US$10,000–$100,000 for score/source cues/music supervisor.

Sound Mixing

The sound mix is the most likely candidate for finding a package deal to include Foley, ADR, Sound Design and SFX editing and mixing, as well as the laundry list of deliverables, including Stereo (Lt/Rt), Dolby 5.1 Surround, M & E (music and effects stem with no dialog – intended for foreign release).

Allow US$15,000–$150,000 for sound package.

Final Layback and Mastering

Render and output digital files to Sony HDCAM SR
Audio layback
Clones
Down-convert to Digi Beta (DBC)
DCP

Allow US$25,000–$75,000 for mastering.

Film-out/ArriLaser Recording

Allow US$20,000–$100,000 to create a new film negative from your master files.

Final Deliverables and Quality Control (QC)

Inter-positive/inter-negative
Check print
Textless version
Dolby license/technician
QC report
MPAA rating
Dialog continuity/legal script
Closed captioning

Allow US$40,000–$100,000.

8.1.3 SAMPLE POST BUDGET

Acct No	Description	Amount	Units	X	Curr	Rate	Subtotal	Original	Total	Variance
45-00 FILM EDITING										
45-01	Editors									
	Shoot	5	Weeks	1		3,000	15,000			
	Post	15	Weeks	1		3,000	45,000			
	Total							60,000	60,000	0
45-02	Assistant Film Editors									
	Shoot	5	Weeks	1		1,500	7,500			
	Post	25	Weeks	1		1,500	37,500			
	6th Day	0	Days	12		11.215	0			
	Total							45,000	45,000	0
45-07	Post PA									
	Prep	25	Weeks	1		750	18,750			
	Total							18,750	18,750	0
45-09	Post Production Supervisor									
		1	Allow	1		20,000	20,000			
	Total							20,000	20,000	0
45-10	PostProdAcct									
		15	Days	12		22.43	4,037			
	Total							4,037	4,037	0
45-15	Equipment & Room Rentals									
	Systems x 2									
	Room	5	Weeks	1		1,500	7,500			
	Room	20	Weeks	1		1,500	30,000			
	Phone	4	Months	1		250	1,000			
							38,500			
	Total							38,500	38,500	0
45-16	Film Shipping & Messenger									
		1		1		200	200			
	Total							200	200	0
45-20	Supplies									
		1	Allow	1		300	300			
	Total							300	300	0
45-41	Viewing Cassettes									
		1	Allow	1		200	200			
	Total							200	200	0
45-85	Other Costs									
	Craft	1	Allow	1		800	800			
	Total							800	800	0
Account Total for 45-00								187,787	187,787	0
46-00 MUSIC										
46-02	Composers-Lyricists									
		1	Allow	1		15,000	15,000			

FIGURE 8.2

Sample post budget

Continuation of Account 46-02

Acct No	Description	Amount	Units	X	Curr	Rate	Subtotal	Original	Total	Variance	
	Total							15,000	15,000	0	
46-05	Music Supervision										
		1	Allow	1		10,000	10,000				
	Total							10,000	10,000	0	
46-46	Music Rights										
	Sync & Master Use Worldwide in perpetuity	4	Allow	1		5,000	20,000				
	Total							20,000	20,000	0	
46-85	Other Costs										
	Music editor	1	Allow	1		5,000	5,000				
	Total							5,000	5,000	0	
Account Total for 46-00								**50,000**	**50,000**	**0**	
47-00	**POST PRODUCTION SOUND**										
47-01	Sound Package										
	Complete ALL-IN										
	pre-dub, sfx, mix, foley, adr	1		1		40,000	40,000				
	Total							40,000	40,000	0	
47-91	Stereo										
	Dolby	1	Allow	1		10,400	10,400				
	Tech	1	Allow	1		600	600				
	Total							11,000	11,000	0	
Account Total for 47-00								**51,000**	**51,000**	**0**	
48-00	**POST PROD. FILM & LAB**										
48-10	Stock Footage										
	Porn										
	NFL										
	NBA										
	Movies										
	Beer commercials										
	TV Misc+ Tapes	20	Allow	1		1,000	20,000				
	Xfer	1	Allow	1		5,000	5,000				
	Total							25,000	25,000	0	
48-19	Editorial Reprints										
		1	Allow	1		1,000	1,000				
	Total							1,000	1,000	0	
48-20	Sound Optical Neg -Shoot & Develop										
		1	Allow	1		4,500	4,500				
	Total							4,500	4,500	0	
48-26	Ans Print / Protect Masters - ONLINE										
	Digital Negative	9,000	Feet	1		0.32	2,880				
	Total							2,880	2,880	0	
48-28	Digital Intermediate										
	Assembly (inc. main/end titles)										
	Editorial & Conform	1	Allow	1		23,700	23,700				
	Color timing	1	Allow	1		18,000	18,000				
	Film Record	1	Allow	1		26,692	26,692				
								68,392			
	Video Delivery										
	x1 set Video Master	1	Allow	1		15,750	15,750				
	DCP	1	Allow	1		7,000	7,000				

FIGURE 8.2

Continued

Continuation of Account 48-28

Acct No	Description	Amount	Units	X	Curr	Rate	Subtotal	Original	Total	Variance
							22,750			
	Total							91,142	91,142	0
48-30	Delivery Items									
	Interpositive	9,000	Feet	1		1.062	9,558			
	Wet gate I.P.	9,000	Feet	0		0.0	0			
							9,558			
	Internegitive	9,000	Feet	1		0.924	8,316			
							8,316			
	Check print(rel PRT $)	9,000	Feet	1		0.25	2,250			
							2,250			
	Lo-Contrast Print	9,500	Feet	1		0.0	0			
	Wet gate Lo-con	9,500	Feet	1		0.0	0			
							0			
	Textless Titles	1	Allow	1		1,500	1,500			
							1,500			
	Re-mix M&E-NO ALLOW									
							0			
	A/D/C(incl Closed Caption)	10	Rolls	1		200	2,000			
	Spotting lists	10	Rolls	1		200	2,000			
							4,000			
	MPAA Code	1	Allow	1		5,000	5,000			
							5,000			
	Theatrical trailer	1	Allow	0		13,000	0			
	Total							30,624	30,624	0
Account Total for 48-00								155,146	155,146	0
50-00	Total Fringes							45,137	45,137	0

FIGURE 8.2

Continued

8.1.4 LIST OF DELIVERABLES

For delivering a feature film, an extensive list of items must be created and turned over before final payment is due from the studio distributor. Producers and post supervisors need to pay careful attention to the specifications detailed in the contract, or be subject to delays in getting paid. They may also end up in the unenviable position of having masters returned because they are incorrectly formatted or don't pass QC (quality control):

- HDCAM SR final master reel containing the completed picture and sound of up to 12 audio tracks
- The original ProTools session containing the final audio stems of dialog, music and effects (DME)
- Standard definition versions of the film in both anamorphic and letterboxed pan and scan
- Video masters of the trailer
- Dialog and continuity script for feature and trailer
- Copy of the final shooting script
- Closed captioning files
- Billing blocks
- Publicity and promotion stills
- Press kit and electronic press kit (EPK)
- Key artwork

Additional documentation may also be provided to include:

- Laboratory access letter – allows distributor access to original camera/audio masters
- Copyright registration
- Chain of title
- E & O (errors and omissions) insurance
- MPAA certificate
- Certificate of origin
- Copy of main and end titles
- Credit statements/paid ad restrictions
- Dolby license or other sound license
- Music cue sheet
- Music clearances including composer agreements, sync and master use licenses
- Stock footage licenses
- Cast and crew agreements
- Lists of all union players (SAG, WGA, DGA, AFM)
- Tax forms (W-9)
- Final negative cost

8.1.5 SAMPLE DELIVERY SCHEDULE

SAMPLE DELIVERY SCHEDULE

At no cost to Distributor, Company shall deliver materials and documents listed in this Delivery Schedule as follows:

All physical materials shall be delivered, unless otherwise specified,

to: _____or such other address or individual as _____ shall determine.

All marketing materials should go to:_____

All legal documentation should be sent to :_____

Delivery of any elements to any other person, unless explicitly approved in writing (email or otherwise) by Distributor, shall not be considered a fulfillment of Delivery for that item. Contact Distributor for approval to amend or delete any listed items based on the nature of production, post-production, rights, and type of processes used, PRIOR to any delivery or access letter. Items listed in section A below may also be described in sections B through H below and, if accepted, delivery thereof will be applied to satisfy the delivery requirements of both section A and sections B through H below. All video elements identified in this Delivery Schedule must be delivered in NTSC format (PAL versions will NOT be accepted).

A. "AD / PUB" Initial Delivery – IMMEDIATE delivery required:

1. Video & Audio Elements

 a. One (1) standard definition video master of the Picture on Digibeta NDFTC
 b. One (1) dialogue, music, effects audio master of the Picture on DVD (must sync to above video master) **please specify wav or aiff file type**
 c. One (1) video master of the trailer for the Picture on Digibeta or HDCAMSR.
 d. One (1) narration, dialogue, music, effects audio master of the trailer for the Picture (must sync to above video master) **please specify wav or aiff file type**
 e. One (1) DVD-R screener of the trailer for the Picture

2. Key Art

 a. One (1) set of still images for the Picture in accordance with section G
 b. All available artwork prepared for the Picture as defined in section G below

3. Documentation

 a. Motion Picture Association of America (MPAA) Certification & Rating Administration (CARA) rating certificate
 b. Billing block with all production logos (.eps file format)
 c. Complete and accurate U.S. copyright line
 d. Credit Statements as set forth in section H.12 below
 e. Aspect ratio, runtime, and audio configuration information
 f. One (1) digital copy of the dialogue/continuity script for the Picture

B. VIDEO MASTERS OF THE PICTURE

All high definition video masters are required to be HDCAMSR 1080p/23.98. All standard definition video masters are required to be 29.97 NonDropFrame Timecode. Their quality must adhere

to current motion picture and broadcast industry standards for first class motion pictures of major studios. Each master is to be fully assembled, color corrected and sweetened, with final approved main and end Titles, and complete textless main, end, and all narrative text and subtitled sections attached at the tail sixty seconds after picture end. All master tape stock must be brand new, and shall not have any physical damage including but not limited to spots, scratches, abrasions, dirt, stains, cracks, or tears.

*** A quality control check report from a Distributor-approved post-production facility must be provided for each video master delivered to Distributor or Distributor's designee. ***

1. HDCAMSR 1080p/23.98fps 16x9 in the original aspect ratio (in which the picture was photographed and/or projected theatrically) of 2.35, 1.85, or 1.78 version of the Picture.

HDCAMSR Audio Channel configuration should be SMPTE standard as follows:

Ch. 1—L	Ch. 2—R	Ch. 3—C	Ch. 4—Lfe
Ch. 5—Ls	Ch. 6—Rs	Ch. 7—LT	Ch. 8—RT
Ch. 9—M & E	Ch. 10—M & E	Ch. 11*—Dolby	Ch. 12*—Dolby
			*if available

(If not delivering on HDCAMSR, contact Distributor for alternative configuration)

2. Digibeta 29.97 NonDropFrame timecode 16x9 anamorphic in the original aspect ratio (in which the picture was photographed and/or projected theatrically) of 2.35, 1.85, or 1.78 version of the Picture.

3. Digibeta 29.97 NonDropFrame Timecode 4x3 1.33 pan & scan, or 1.78 letterboxed version of the Picture (2.35/1.85 letterboxed or center extractions will NOT be accepted).

Digibeta audio channel configuration should be as follows:

Ch.1—LT	Ch. 2—RT	Ch. 3—M & E	Ch. 4—M & E

C. SOUND TRACK AUDIO MASTERS OF THE PICTURE

All sound track masters are required to be delivered as a ProTools compatible session conformed to the high definition master described in section B.1. on DVD-R 48k/16bit. Quality must adhere to current motion picture and broadcast industry standards for first class motion pictures of major studios. Each master is to be fully mixed and conformed to the feature or television high definition video master of the Picture. All master tape stock must be brand new, and shall not have any physical damage including but not limited to spots, scratches, abrasions, dirt, stains, cracks, or tears.

*** A quality control check report from a Distributor-approved post-production facility must be provided for each audio master delivered to Distributor or Distributor's designee. ***

1. 5.1 + LT/RT English printmaster
2. 5.1 + LT/RT M & E fully filled master
3. Dialogue, music, effects master (6 Track D, M, E)
4. 5.1 mixed dialogue stems
5. 5.1 mixed music stems
6. 5.1 mixed effects stems

Please note: If any masters are rejected during the initial quality control inspection, additional quality control costs will be paid by the Company and will be deducted from the minimum guarantee when applicable.

D. VIDEO MASTERS OF THE TRAILER

Trailer video masters shall be of the same quality and specifications as the feature video masters. They shall be "Approved for All Audiences" by the Motion Picture Association of America.

1. HDCAMSR 1080p/23.98fps 16x9 2.35, 1.85 or 1.78 version
2. Digibeta 29.97 NonDropFrame timecode 16x9 2.35, 1.85, or 1.78 anamorphic theatrical version
3. Digibeta 29.97 NonDropFrame timecode 4x3 1.78 letterboxed (2.35, 1.85, or center extractions will NOT be accepted)

E. SOUND TRACK AUDIO MASTERS OF THE TRAILER

Trailer sound track masters shall be delivered as ProTools session on DVD-R. They should be of the same quality and specifications as the feature sound track masters. The 5.1 & LT/RT printmasters shall be within TASA specifications (if used to create a MOD).

1. 5.1 & LT/RT English printmaster
2. 5.1 M & E fully filled master
3. Narration, dialogue, music, effects (8 Track N, D, M, E)

F. FINISHING MATERIALS

1. One (1) copy of the final shooting script
2. Closed captioning in SDH, HD & SD .cap file format and .scc format in 29.97fps For Standard Definition & 23.98 for HD
3. Dialogue & continuity script for feature and trailer

G. CREATIVE MATERIALS

1. One (1) key artwork or poster artwork as a Photoshop layered file (4"x4" 300 dpi)
2. One (1) billing block that fulfills the contractual obligations for the Picture with all production company logos and copyright line as a Photoshop layered file; if a layered file is not available, the billing block information may be submitted as a document (see section H.10 below), however the production company logos must be delivered as .eps files
3. One (1) Digital Betacam edited electronic press kit "EPK" including "behind the scenes," deleted scenes, gag/blooper reel, "B-roll" footage, interviews with principal actors and filmmaker and selected clips from the picture (Note: if this material was originally captured and edited on a format of higher quality than Digital Betacam, then delivery in that format is preferred)
4. One (1) set of production stills of all available (to include a minimum of 50 approved images), original color images depicting relevant scenes in the Picture with members of the cast appearing therein; delivery of this artwork may be digital files 600 dpi high resolution on CD ROM or external drive suitable for print reproduction; all photos must be scanned at the highest possible resolution and clearly labeled by captions identifying the actor, character name and a brief scene description
5. One (1) set of sample publicity materials, including a press kit (with a complete cast and crew list, synopsis of the Picture, production notes and biographies of the principal cast and filmmakers), brochure, flyer, and one sheet (if and when available)
6. All available artwork prepared for the Picture, including ad slicks, poster art transparencies (4 X 5 or 8 X 10), title treatments and billing block
7. Copies of all available reviews and stories published concerning the Picture.

H. DOCUMENTATION

All documents and paperwork below shall be (i) delivered in the English language, (ii) fully executed, if applicable and (iii) clearly legible. Documents delivered by CD-ROM must be clearly labeled.

1. Laboratory Access Letters: Fully executed Laboratory Access Letter(s), in substantially the form attached hereto as Exhibit "LA," with inventory lists attached, granting Distributor irrevocable access during the Term to all Picture elements identified in this Delivery Schedule. The Laboratory Access Letter(s) must be fully signed by the Laboratories and Company and must include but not be limited to:

 a. Original camera masters
 b. Original production audio masters
 c. All DI files and edited masters
 d. Pre-mixed audio stems
 e. All theatrical film elements, including IPs, check prints, optical tracks + MOD

2. US Copyright for Screenplay: Copy of the Form PA (or Form CO) Certificate of United States Copyright Registration stamped by the Library of Congress for the Picture's screenplay. If the stamped certificate has not been returned from the Library of Congress, Company shall deliver a copy of the application for filing and proof of payment of the registration fee that accompanied the application to the U.S. Copyright Office. Company shall deliver one copy of the stamped Certificate of Copyright Registration for the Picture's screenplay once Company has received the same from the Library of Congress.

3. US Copyright for Motion Picture: Copy of the Form PA (or Form CO) Certificate of United States Copyright Registration stamped by the Library of Congress for the Picture. If the stamped certificate has not been returned from the Library of Congress, Company shall deliver a copy of the application for filing and proof of payment of the registration fee that accompanied the application to the U.S. Copyright Office. Company shall deliver one copy of the stamped Certificate of Copyright Registration for the Picture once Company has received the same from the Library of Congress.

4. Chain of Title: One set of all documents comprising the full and complete chain-of-title for the Picture, along with a concise summary cover sheet briefly describing each document. All documents in the chain-of-title must be fully executed. Such chain-of-title documents shall include (i) an assignment of rights in and to the underlying property, (ii) the certificate of authorship from the writer(s) of the screenplay on which the Picture is based, (iii) all agreements with respect to the music utilized in the Picture and trailers (e.g., all composer agreements and synchronization and master use licenses, soundtrack agreements, if any, and complete music cue sheets) (see below); (iv) documents establishing Company's rights in the Picture and Company's valid copyright, and the registration thereof, under applicable law, of the Picture; (v) a US Copyright report and legal opinion that the chain of title is complete and sufficient to grant the rights purported to be granted under this Agreement; and (vi) a title report and legal opinion indicating the title of the Picture is cleared for use (unless otherwise agreed in writing, copyright and title reports and opinions must be issued by Thomson & Thomson, Edwin Komen or Dennis Angel). In addition, if the Picture is based upon or incorporates, in whole or in part, the life stories of any real persons, whether currently living or deceased, or in any way is based upon, or draws from, incidents, events or other parts of such persons' lives, or in any other way is related to any such persons so as to make necessary or desirable releases, consents, waivers or any other authorizing documents from such persons in connection with the Picture (collectively, "Personal Releases") then the chain-of-title documents will include fully executed copies of such Personal Releases. Copies of all chain-of-title documents shall be delivered by Company to Distributor not later than thirty (30) days from the date of this Agreement. If any such documents are not timely

furnished to Distributor, or if Distributor disapproves any such documents after having notified Company of its concerns with respect thereto, Distributor shall have the option of terminating the Agreement and recovering immediately any unrecouped payments made by Distributor under the Agreement. If any chain-of-title documents are in a language other than English, Company shall provide, in addition to the original language copies thereof, English-language translations thereof which have been rendered, and are certified by, a professional translator. If any documents are not so translated, or if for any reason Distributor believes, in good faith that any translation provided is unreliable or otherwise unacceptable, then Distributor may elect to obtain its own English-language translations.

5. E & O Certificate and Endorsement: Company shall procure and maintain in full force and effect standard producer's and/or distributor's errors and omissions liability insurance issued by a nationally recognized insurance carrier licensed in the states or countries where Picture will be distributed and assigned an A.M. Best Guide Rating of at least A:VII covering the Picture with minimum limits of at least $1,000,000 for any claim arising out of a single occurrence and $3,000,000 for all claims in the aggregate. Company shall deliver to Distributor an original certificate of insurance and additional insured and primary/non-contributory endorsements signed by an authorized agent of the insurance company as part of Delivery in accordance with this delivery schedule. Such insurance:

 a. shall provide coverage for a period of 2 years from date of Delivery of the Picture ("Coverage Period');

 b. shall carry a deductible no larger than $25,000. Company shall be responsible for all deductibles and retentions under Company's policies;

 c. shall be endorsed to name Distributor, its parent(s), subsidiaries, licensees, successors, related and affiliated companies, and their officers, directors, agents, employees, representatives and assigns as additional insureds (collectively & individually the "Additional Insureds");

 d. shall be endorsed by the insurance carrier to indicate coverage is primary and any insurance maintained by the Additional Insureds is non-contributory;

 e. shall include an endorsement stating it is not subject to any non-standard exclusions from, restrictions of or limitations in coverage in accordance with industry standards;

 f. shall include an endorsement stating the title of the Picture, music, film clips and copyright coverage is included;

 g. shall provide coverage for any claims related to the Picture, and advertising and promotion materials with respect thereto, during the Coverage Period; and

 h. shall require 30 days advance written notice to the Additional Insureds prior to cancellation or non-renewal.

6. MPAA CARA Certificate: If requested by Distributor, a Classification & Rating Administration certificate from the Motion Picture Association of America rating for the Picture with a rating no more restrictive than "R".

7. Short Form Assignment: Two (2) original, signed and notarized short-form assignments in the form attached as Exhibit "A" to the Agreement.

8. Mortgage of Copyright and Security Agreement: Two (2) original, signed and notarized mortgage of copyright and security agreements in the form attached as Exhibit "B" to the Agreement.

9. Certificates of Origin: two (2) original, notarized certificates of origin.

10. Billing Block: Stat of the contractually correct billing block for the Picture which must include:

 a. exact placement, wording and size of each paid advertising credits

 b. stats of any Company logos and all required logos that must to be affixed to such billing block

 c. the copyright line for the Picture

11. Main and End Titles: A PDF copy of the final main and end titles of the Picture.
12. Credit Statements/ Paid Ad Restrictions/ Name and Likeness: A complete, accurate and typewritten statement (or statements, as the case may be) in the English language of any and all third-party screen and paid advertising credit, name and likeness and other third party obligations, restrictions and approval rights with excerpts from each applicable third party agreement setting forth the precise extent and nature of such obligations, restrictions, consultation rights and/or approval rights (including any tie-in obligations) attached thereto. The format of the statement should include all individuals and entities that are accorded credit in the billing block and shall be listed in the order of how those individuals appear in the billing block. If there are no screen credit obligations, paid advertising and credit obligations and/or name and likeness restrictions, a signed written statement to that effect upon which Distributor may rely must be provided by Company.
13. Dubbing/Subtitling Restrictions: A complete, accurate and typewritten statement in the English language of any and all restrictions as to the dubbing of the voice of any player, including dubbing dialogue in a language other than the language in which the Picture was recorded or of any cutting/editing restrictions (other than as set forth in the Agreement), If there are no so such dubbing or cutting/editing restrictions, a signed written statement to that effect upon which Distributor may rely must be provided by Company.
14. Sound License: A copy of the fully executed sound license for the Picture (i.e., Dolby SR and SRD), or if there is no such license, a signed written statement to that effect.
15. Music Cue Sheet: A PDF copy of the music cue sheet, in the English language, showing the particulars of all music contained in the Picture and any completed Trailers delivered hereunder, including the title of each composition, and with respect to each composition; (i) the names of composers; (ii) the names of publishers (including percentage of ownership if more than one publisher); (iii) the usages (whether background instrumental, background vocal, etc.); (vi) the place for each composition showing the film footage and running time for each cue and the (v) performing rights society involved. All the information above should be included within one document. If applicable, one (1) copy of any narration agreement(s) used in connection with the Picture or any trailers delivered by Company to Distributor pursuant to the Agreement. If any composition is within the public domain, Company shall identify such composition(s) in writing.
16. Music Documentation/ Composer: One (1) copy of each of the signed composers, lyricist and/or publishing agreements entered into for the original music composed for and embodied in the Picture. One (1) copy of all agreements and other documentation relating to the music rights (and evidence of payment in full with respect to all such documents) including, without limitation, all composer/songwriter agreements; recording artist/master recording; producer agreements; copies of any applicable union or guild agreement and session reports; day players/vocalist agreement; master use licenses; synchronization and performing licenses; and film clips (including music track portions thereof); certificates of authorship; and phono record agreements if done by Company. All licenses must be and remain in full force and effect and must permit the reproduction and distribution in all media, now known or hereinafter devised, throughout the Term and in the Territory at no additional cost to Distributor (including, but not limited to, all future media (including the internet) as defined in the Agreement). In addition, the information in the licenses must agree with the information provided in the music cue sheet.
17. Music Documentation/ Master Use and Synch: Copies of each of the synchronization and performing right licenses (fully executed) and all master use licenses (fully executed) for all non-original music embodied in the Picture. Company shall be provided proof of payment for all synchronization and master use licenses. All licenses must be and remain in full force and effect and must permit the reproduction and distribution in all

media, now known or hereinafter devised, throughout the Term and in the Territory at no additional cost to Distributor (including, but not limited to, all future media (including the internet) as defined in the Agreement). In addition, the information in the licenses must agree with the information provided in the music cue sheet.

18. Cast and Crew Agreement: If requested by Distributor, copies of all agreements or other documents relating to the engagement of personnel in connection with the Picture not set forth above (including those for individual producers, directors, artists and conductors) for all individuals and entities accorded credit in the billing block.

19. Stock Footage Licenses and Additional Clearance Documents: All other clearance documentation for the Picture not set forth above as may be requested by Distributor in form and substance satisfactory to Distributor. If the Picture contains stock footage and/or film clips, Company shall deliver a list of scenes (identified by slate, take and key numbers with a brief description of the scene) which contains the stock footage and/or film clips. Such stock footage and/or film clips must be cleared for worldwide use in perpetuity (including any music soundtrack portions thereof). Delivery must include any applicable stock footage/film clip fully executed licenses. If there are not stock footage/film clips, a signed written statement upon which Distributor may rely must be provided by Company.

20. Guild/Union Residual Schedule: A list of all applicable guilds/unions used for the Picture (ex. SAG, WGA, DGA, AFM, IATSE, etc.), if any, together with, for each such union or guild, a description of what, if any, residual obligations exist (with specificity) in connection with Distributor's exercise of its distribution rights in the Picture and copies of all documents and information necessary to comply with such residual obligations, including, without limitation, copies of any special agreements related to residuals negotiated between producer and guilds (e.g., Low or Modified Low Budget Agreements, etc.), an itemized statement of the total amounts paid to each director, writer, artist, musician and technician employed or in connection with the Picture together with the number of days worked by each, the social security number (or other applicable identification) of each thereof and the name of the guild or union having jurisdiction. Company warrants that it shall deliver a complete residual schedule and agrees to indemnify Distributor against any penalties, fees, charges, expenses, and the like which Distributor incurs as a result of Company's failure to deliver a complete guild/union residual schedule.

21. SAG: If the Picture is subject to Screen Actors Guild jurisdiction, a copy of the Screen Actors Guild final cast list (the "SAG Final Cast List") and, if and to the extent not included therein, the following information: (a) for the Picture: shooting location(s); start and completion dates; production company name, federal and state identification numbers, address (including zip code), phone number and contact names; and, if applicable, conversion rates used for payments made in foreign currency; and (b) for each SAG member and other cast member who worked on the Picture: name, social security number, and, if applicable, personal service company name and federal identification number; address (including zip code); number of days and weeks worked; start and finish dates; location(s) worked; gross salary; base salary; salary units; time units; total units; player type; type of contract (i.e., daily or weekly); and guild membership. The text of any special provisions that pertain to residual payment processing such as talent's days guaranteed if in excess of the amount of days actually worked, foreign proration, etc. If the Picture is subject to proration, the prorated percentage applicable OR the total salaries for all foreign performers.

22. DGA: If the Picture was produced under the jurisdiction of the Directors Guild of America, the name, social security number, loan-out information (where appropriate) and job description of all DGA members engaged on the Picture; and the DGA approval of the final main and end title credits, signed by an authorized representative of the DGA. A DGA Determination Letter if the Picture has more than one individual in any category (e.g., Director, UPM, 1st AD, 2nd AD).

23. WGA: If the Picture is subject to Writers Guild of America jurisdiction, the name, address, social security number and loan-out information (where appropriate) for all writers receiving credit on the Picture; a copy of the final WGA notice of final determination or credit on the Picture, signed by an authorized representative of the WGA; and the WGA approval of the final main and end title credits, signed by an authorized representative of the WGA.

24. AFM: If the Picture was produced under the jurisdiction of the American Federation of Musicians, copies of all contracts for all AFM members engaged on the Picture; if the Picture is subject to proration, the prorated percentage payable to the Film Musicians Secondary Market Fund OR the following information: (a) total salaries of all AFM musicians AND (b) total salaries of all musicians, both AFM and non-AFM.

25. Other Guilds/Unions (e.g., IATSE): If any part of the Picture is produced in the United States, the seal of each guild and/or union having jurisdiction with respect thereto, if any (e.g., International Association of Theatrical and Stage Employees), and a statement of whether the Picture is subject to proration and, if so, either (a) the Check List for Proration of Post '60s and Supplemental Markets Monies OR (b) a statement of the prorated percentage payable to IATSE.

26. Certification to Attorney General: A copy of any and all certification(s) provided to the Attorney General in connection with the Picture in compliance with 18 U.S.C. 2257A(h) and any successor statute or similar law or regulation.

27. Tax Forms: A U.S. Form W-9 and such other tax forms as Distributor may reasonably request with respect to the Picture and the transactions contemplated by this Agreement.

28. Canadian Production: If the Picture is a Canadian production, one (1) original certificate issued by the Canadian Audio Visual Certification Office (CAVCO) consisting of Part A: Canadian Film or Video Production Certificate and Part B: Certificate of Completion.

29. Final Negative Cost: If requested by Distributor, one (1) final certified negative cost statement certified by the Picture's completion guarantor (and if no completion guarantor was engaged for the Picture, then by certified public accountants approved by Distributor) evidencing a minimum negative cost.

NOTE

1. Director's Guild of America, "Summary of Directors' Creative Rights Under the Directors Guild of America Basic Agreement of 2011."

Case Studies

Case Study: Theatrical Feature – *Don Jon*

9.1

FIGURE 9.1

Don Jon (2013)

Don Jon (2013) with Joseph Gordon-Levitt, Scarlett Johansson and Julianne Moore.

Logline (from IMDB.com): a New Jersey guy dedicated to his family, friends and church develops unrealistic expectations from watching porn and works to find happiness and intimacy with his potential true love.

Visual style: shot in 35mm in warm, bright and vivid colors appropriate for this romantic comedy with some fairly graphic lovemaking scenes. It also features several short yet provocative montages of porn stars in various states of ecstasy.

Synopsis: Jon is happy to be single, hang out with his friends, work on his physique and nail every girl who comes across his radar. He also happens to be hopelessly addicted to online pornography. One day he meets the perfect "10" (or a "dime" as he calls her) and to the chagrin of his pals, he embarks on a serious relationship with Barbara (Scarlett Johansson). He even brings her home to meet his blue-collar family. But dating represents a challenge to Jon when Barbara makes demands and insists he enroll in junior college to improve himself. She also harbors suspicions about his proclivity to porn when she sees something pop up on his screen. Jon vigorously denies his bad habits to her, while telling all on a regular basis to the local priest during confession. At school he meets an eccentric older

woman, Esther (Julianne Moore), and forms an unlikely friendship when she discovers his dirty little secret. Eventually Barbara discovers that, indeed, Jon has been lying about his habits and she breaks off the relationship. Jon is faced with the fact that he is not capable of real intimacy with a real, albeit demanding, partner. He's not ready, that is, until he begins dating Esther, who shows him that it is possible to live and love in the real world and move past the world of online fantasy partners.

Released by: Relativity Media (North America), Voltage Pictures (International).

Running time: 90 minutes.

MPAA Rating: R.

Budget: US$4 million.

Box office:[1] opened September 27, 2013 in 2,422 screens – ranked #5 with weekend gross of US$8,677,009. In release for 12 weeks with total domestic BO of $24,477,704. As of January 1, 2014 it was still in release in foreign territories at just under US$6 million for a worldwide gross over $30 million.

Conversation with Editor Lauren Zuckerman on the Editing of *Don Jon*

Q: Tell us how you came to work on this project.

Zuckerman: My agent called and said she was sending me this sort of weird script, she said it was a small film but really interesting. After I read it I met with Joe (Joseph Gordon-Levitt) and the producer, Ram Bergman. I didn't hear back for almost a month. About three days before they were to start production I got called back in for a second meeting. I was hired the next day.

Q: So you didn't know the director, Joe Gordon-Levitt, before this.

Zuckerman: No.

Q: It seems to be always the case that you have an interview and the meeting goes really well. Then nothing. And then they call you, usually on a Friday, before the Monday.

Zuckerman: Yes. Sometimes I have a meeting and think I've nailed it. I think people that meet with lots of people get really good at making you feel great about yourself, like you're the one, and then, well, eventually you find that you're not. I also think they get involved in other more pressing parts of production and post often gets pushed to the back burner.

Q: How did you watch the dailies? Were you able to sit in the same room as the director or was it all done by remote control?

Zuckerman: I watched the dailies on my own in the editing room. I think it's rare on a small budget film (especially one where the director is also the writer and the star of the movie) to meet for dailies. I would assemble the footage and meet with him for a few hours on the weekend. We would go over the footage and scenes he shot during the previous week.

Q: So you didn't have regular scheduled dailies?

Zuckerman: I watched them on my own everyday but, no, I haven't watched dailies with the rest of the crew in years, not since I cut on film. Back then we would screen dailies every night, everyone would meet after their really long 18 hour day and watch dailies together at the lab or if on location, editorial would set up a projector and everyone would watch together.

Q: Don't you miss that?

Zuckerman: Sometimes I do. It's always great to see footage projected early on and, of course, hear what people say about the footage but on the other hand . . . long day. I hope for good script notes and try and retain that first impression. I'm also checking very carefully for any problems.

Q: What was the schedule like?

Zuckerman: They shot for five weeks in Los Angeles and then they went to New York and New Jersey to shoot for almost a week. Shortly before they left for New York, Ram asked if I could show an assembly to Joe. I usually have about a week *after* production to finish an assembly.

Q: That's a lot of pressure.

Zuckerman: It was, but Ram said to just use a master shot on the scenes I didn't get to yet. They wanted to look at the film and see if there was anything they might be able to pick up in New York if necessary. They were also worried about the length. The film moved very fast, Anyway, looking at it like that was incredibly useful; we realized that there were beats missing, especially towards the end. For example, you never saw Barbara Sugarman after the fight. She is just gone. We felt you needed some kind of resolution with her. So Joe added the scene when he meets Barbara one last time outside at the coffee shop. I thought it was a good bookend to their first date outside the restaurant. Also, originally, Jon went to look for Esther after he tries to jerk off without porn, that seemed really quick, he needed more time on his own to think about things, to be with himself, and think about what she had said. A few beats were added, he goes to the market and stands in the checkout lane and sees the magazine covers, and he quietly drives around at night. Also a few scenes before Jon ever approaches Esther, a scene was added where Jon observes Esther reading a book. The scene in the housewares store, the "Swiffer" scene, was also added and shot in New Jersey. We felt the nagging scene in the restaurant wasn't quite enough to push him over the edge to break up with her. I think Joe wrote the Swiffer scene on his way to New York and worked with Scarlett on the dialogue. It's one of my favorites.

Q: Was there any discussion as to why *Don Jon* was going to be shot on film?

Zuckerman: Not with me. I think that Joe wanted to shoot on film while he still could. He likes the way it looks. I remember Ram saying it was cheaper now to shoot on film. I don't really understand how.

Q: Where were the locations?

Zuckerman: There were some in downtown LA. Jon's apartment was shot on a stage. The movie theater was in the Valley somewhere. Jon and Barbara's first lunch date was on the Universal back lot. They intentionally wanted it to look like a back lot, like an old romantic Hollywood movie.

Q: I thought the integration of all of the locations with the scenes shot in New Jersey was very well done. The other thing that I liked is that Joe Gordon-Levitt is tapping into a subculture that we still refer to as the "bridge and tunnel crowd." Yet, he really didn't go so far as to offend anyone or exploit them. I thought all of the sidekicks and characters were very well drawn.

Zuckerman: I think so too. I read that there was an Italian American group that wasn't happy about the portrayal of the family. It was the same group that was upset with *The Sopranos*.

Q: So shooting in May, four or five weeks of principle photography? And you had the rest of the summer to cut it, work with the director.

Zuckerman: . . . and June. Joe was out a few times for press junkets. He was in four films that were released while we were in post.

Q: Did he view anything remotely and transmit notes or was it pretty much all in the same room?

Zuckerman: We did load footage onto rugged drives so he could work while on the road but I don't think he was able to get to it. He was never gone for very long.

Q: But were you given enough time to cut your version?

Zuckerman: After production we just started working together. I never really had my "cut" in a traditional way. I actually hate assemblies and never feel those cuts are really representative of what "my cut" would be. For me it's a time to kind of memorize the footage and see how it all fits together. "My cut" would be a collaboration with the director.

Joe had a very clear vision of how certain sequences would play, especially all the montage scenes with internet porn, voiceover and music. Those scenes were designed down to the frame. The cadence of Jon's VO were like lyrics in a song, the porn sounds coming from the laptop and the images were carefully orchestrated and cut to the score. Joe has a brilliant sense of editing.

The porn was really hard to get right. There were a lot of us going through internet porn. It was incredibly tedious trying to find the right clips. Remember every scene with porn had a very specific purpose and illustrated things that the character Jon was saying. So to find a good clip that would work for the whole entire sequence wasn't easy. Additionally it had to be appealing. You had to believe that this guy wanted to watch porn after he's just been with his ideal woman. There was a deal made with a company that owns several internet porn sites but even with access to all that, there were still clips that came from other sites.

Q: Yeah, I saw there was some product placement for some of their sites.

Zuckerman: The logo was used four times.

Q: You submitted to Sundance as a premiere, not for competition?

Zuckerman: Right. Joe loves the festival and was really hoping to premiere there.

Q: You've been there a bunch of times, I would imagine. What is it like as an editor to go to Sundance and represent a film?

Zuckerman: It's exciting, of course. The first screening was great. It was at the Eccles, which I think holds 1200 people. I think it played three more times after that.

Q: Did Joe do some press?

Zuckerman: Yeah, exhausting press. I don't know how he does it.

Q: The film was produced by Nicholas Chartier's Voltage Pictures. At what point did Relativity Media come along?

Zuckerman: They bought the film at Sundance. I understand there was the classic bidding war into the wee hours of the night. They decided to go with Relativity because an additional US$25 million for prints and ads was promised.

Q: That's a home run.

Zuckerman: I think they paid US$4 million for the film in addition to the P & A deal.

Q: But at this point your job is not over. It's just beginning.

Zuckerman: Well, more like continuing. We always knew that we were going to open the film up again after Sundance. We knew the version that screened at Sundance would probably get an NC 17. Joe's intention was always to have an R rating. We had tried a lot of different ways of showing the porn. The first few cuts we didn't block anything out. We tried a version with blurring and finally ended with careful cropping but that still wasn't enough to get an R. I guess it still appeared pretty graphic to those that weren't as jaded as we were. [Laughter] The MPAA of course rated it NC 17. The lucky thing was we heard the MPAA liked the movie, and that they wanted to give it an R rating. That was really great because they could have just said: "There's just no way, this is an overall thing."

It's cumulative and this isn't going to ever get an R, which I know has happened before. There's a documentary by Kirby Dick about the MPAA called *This Film is Not Yet Rated* (2006), which is really interesting if you haven't seen it.

Q: How many times did you submit it to them?

Zuckerman: Four or five times, I think.

Q: And so they're sympathetic. They want it to pass muster, but yet you're getting notes back. And they are very specific, aren't they?

Zuckerman: Yeah, and sometimes it seemed arbitrary, we knew certain things weren't going to cut it but we were surprised by other things that didn't either. We would send them a cut and several days later, like on a Wednesday, we would get their notes and we'd quickly turn it over by the end of Thursday or Friday morning and then we wouldn't hear back from them until the following Wednesday. It dragged on for a long time. The notes would say things like: "There's too much thrusting," or a particular shot's too long. We would address the notes but it was important to not compromise the vision. In fact, Joe feels strongly that it's much better now than it was before; he didn't want it to be about the pornography.

Q: I thought it was very tastefully done. The movie itself has attracted both men and women. This is a character-driven movie. It's not really so much about his addiction. It's more of his coming of age.

Zuckerman: Right. The title was originally *Don Jon's Addiction* and Joe and the producers felt that the word "addiction" made it seem darker then it was and brought too much attention to porn addiction.

Q: So was that the MPAA suggesting you drop that?

Zuckerman: No, Joe decided. I think it was a conversation between him, the producers and the distributor; he was much happier with the shorter title.

Q: So at what point did you test the finished film in front of an audience?

Zuckerman: After Sundance, we had a marketing screening.
That was the first time we had a recruited audience with notes and cards, etc. We had previously screened it for groups of friends and colleagues followed by discussions and notes.

Q: So then you've cleared the hurdle of test audiences, the MPAA signed off on it, and you've got a name change. But you're still at that point, you've got to lock the picture and

Zuckerman: The film didn't have an opening title sequence. All the titles intentionally played at the end of the film. The film started quite intensely which seemed pretty cool at first, but Joe wanted to lighten it up a bit and give the audience a better understanding of where Jon was coming from. He had this idea for a title montage using the exploitative media that Jon would have been exposed to growing up. Everything from cartoons, TV and ads to beauty contests and horror movies. The collection of imagery started out very organically, Joe made a list of categories and we started looking for things on the internet . . . again, back to our laptops. After we collected a bunch of potential clips we met with a clearance person from Relativity. We went through our list of clips to see what would be realistic and what would be impossible to license. She sent some stock footage alternatives but not that much of it was working. This was probably the hardest and most tedious part of working on this movie. It just dragged on forever. The hardest clip to find was a horror sequence. You'd think there's so many horror sequences exploiting cute teenage girls, but to get the right moments and to get that across wasn't easy. Meanwhile Joe went back to work with the composer, Nathan Johnson, to write a new piece of score for this sequence. I love what he did because it contains all the different themes of the movie in that one sequence.

Q: So how would you characterize your relationship with the director? Is he like his character in the movie?

Zuckerman: Yes, he's pretty charming. [Laughter] Joe is really precise and very detail oriented, and extremely confident in his vision and yet very collaborative. I think he is a great artist.

Q: Where did you do the final mix?

Zuckerman: At Skywalker with Gary Rizzo.

Q: So how long was the mix and were you there for the entire time?

Zuckerman: Yeah, it was short, about a week, with a week of pre-dubs before we got there.

Q: That is fast. A week is quick.

Zuckerman: It's super quick, but they had done a few partial temp mixes before we locked.

Q: How elaborate was your temp track and did any of that make it into the final mix?

Zuckerman: Yes. They didn't seem to have a porn sound library up at Skywalker. [Laughter] Those sounds were so important as far as the rhythm of the sequences. Before we went up there, I pulled tons of extra sounds from various clips I had in my Avid, just in case we had to change something. I had the whole movie on portable drive with Avid on my laptop.

Q: How important is it for an editor to supervise the sound from beginning to end, starting with the spotting sessions?

Zuckerman: I think it's really important.

Q: Was there much need for ADR and looping?

Zuckerman: No, there wasn't. Joe recorded his own voiceover and then there was the priest, and maybe a line or two from some of the smaller parts. None of the main actors had ADR, except for a few lines from Julianne Moore because we cut and changed some dialogue from the scene in her living room.

Q: So how did you come up with the white frame orgasm sequences?

Zuckerman: Those were conceived by Joe. They were written in the script. Those flash frames aren't actually white frames. We temporarily used flash frames we found in dailies (an advantage shooting on film). Later we went through the film and chose particular frames and color schemes for each orgasmic sequence and sent them to a friend of Joe's in England, an artist called Wirrow. He designed each frame. If you ever have the opportunity to look at those frames, you will see they were all very seriously considered, the colors, what images where chosen.

Q: So what kind of a reaction from the general public did you receive when it was released? Was there any blow back from Middle America?

Zuckerman: Originally, I was worried that people would think we were further promoting the exploitation of women by showing the pornography; but I really don't think we did and I don't think other people thought that, or at least I haven't heard or read anything. I have some relatives from a small town in Arkansas; they drove two hours to go see it in Jonesboro and the person in the box office warned them "that a lot of people were walking." They loved it though; they just wanted to make sure I didn't show it to my kids.

I think this is the only film I've ever worked on that didn't have deleted scenes. There were those added scenes I mentioned earlier, and one scene was reshot for tone, but still, it was incredibly satisfying to see this one person's focused and thoughtful vision work out as he planned.

Case Study: Documentary Feature – *Tim's Vermeer*

FIGURE 9.2

Tim's Vermeer (2013) Tim Jenison assembles one of the experimental optical devices he built. © 2013 High Delft Pictures LLC. All Rights Reserved

Logline (from IMDB): inventor Tim Jenison seeks to understand the painting techniques used by Dutch Master Johannes Vermeer.

Visual style: using a variety of RED Epic and digital single-lens reflex (DSLR) cameras, the film uses a no-nonsense, unflashy documentary style that works effectively to accurately display the colors, lights and tones of the world that Vermeer created in his studio and which Tim Jenison was able to recreate in his industrial space in San Antonio, Texas.

Synopsis: Tim Jenison is an inventor and successful businessman with many interests that span the arts and sciences. After reading a book by David Hockney that suggests Vermeer used lenses and mirrors to capture the images and help paint them on canvas, Tim sets out to see if the hypothesis is correct. When he mentions his project to Teller (of Penn & Teller), the idea of a documentary film is raised. Over the course of five years, Jenison painstakingly builds by hand a scale model of Vermeer's studio, including all of the props and furnishings. He then sets out to paint Vermeer's "The Music Lesson." Jenison travels to Delft in Holland to see where Vermeer lived as part of his research. He also pays a visit to Hockney in the north of England and is fortunate enough to be able to get inside Buckingham Palace and inspect the actual painting. While we don't get to see his visit, Tim recounts

his wonder and awe directly to the camera of seeing up-close the "real deal." The business of actually painting follows and takes over a year or more with cameras set up to record every brushstroke. The dedication to detail takes its toll on Jenison but in the end he comes up with the goods – a faithful reproduction of the original. It is truly remarkable that a non-painter is able to achieve such success. When he shows his work to Hockney, he too is humbled by Tim Jenison's patience and fortitude at uncovering what was heretofore merely a suspicion and is now confirmed: Vermeer used advanced technologies to help in the creation of his masterpieces.

Production Co: High Delft Pictures.

Released by: Sony Pictures Classics.

Running time: 80 minutes.

MPAA Rating: PG-13.

Budget: N/A.

Released in North America on January 31, 2014.

Conversation with Producer Farley Ziegler and Editor Patrick Sheffield in November 2013 Prior to the Release of *Tim's Vermeer*

Q: Tell us about the genesis of the movie.

Ziegler: We started shooting in August of 2009. Penn and Teller and myself went to San Antonio for the first time and we filmed Tim with his comparator mirror, basically demonstrating it to us. So we just filmed Tim in his home and a little bit at his office and then started to shoot, for real, in September of 2009 when we went to Holland to film with Tim and Teller as director and myself. But at that point we hadn't set up our workflow.

Q: What cameras were used?

Ziegler: The main cinema cameras were the RED One, and later the RED Epic, also Canon 5D Mark II. But the first stuff that we shot in August 2009 was a Canon XHG1A. And then there were some Canon VIXIA, different HFs, R200, G10, G30 and R11. There's different Canon camcorders used when we were filming abroad and filming on the fly.

Teller was going to direct the film and it was a true documentary in the sense that we knew that Tim Jenison was going to try to paint this Vermeer, but no one, including Tim Jenison, knew exactly how, knew whether he would succeed in his experiment and we didn't know all of the adventures we'd have along the way. We thought that the shoot was going to be over in a year. We had no idea how long or how vast it would be since it ended up taking nearly five years.

Q: So how did you get the ball rolling?

Ziegler: I have had the great pleasure of working with the team of Penn and Teller who have a nightly show in Vegas. And we have Tim Jenison, who is the founder and owner of NewTek. He invented the Video Toaster and his company makes LightWave software. So he's an ace technologist and he served as DIT [digital imaging technician] and he made three sets of drives; one for himself, one for me and once we brought on our editor Patrick Sheffield, one for him as well. We also had Penn in Las Vegas, with his own audio studio there for all of the voiceover, because he narrates the film. So we had technology at our disposal, which was, for this tiny little movie, quite boundless.

Q: Patrick, at what point did you come on board?

Sheffield: Well let's see. It was a year and a half because Farley started in August and I was brought on in March of the year after that.

Ziegler: We had shot quite a bit but we'd not yet shot the main painting experiment.

Sheffield: But Tim hadn't built the room yet.

Ziegler: Tim realized he was going to have to recreate Vermeer's studio as closely as possible in order to paint under the same conditions. That ended up taking him almost a year. He had no idea that was going to be the case.

So at every juncture things took longer and were more intense. Then Tim, because it took him so long to build the room, basically from scratch by hand, he thought that was going to be the hard part. He hadn't yet started his painting experiment. And we didn't have any idea how long his painting experiment would take. So when Patrick came on, there was already a lot of footage, but he hadn't yet embarked on shooting what would end up being the most footage.

Sheffield: When I came on, there was already workflow established. They had already made a decision with shooting at 30 frames per second. I had wished, at the time, that it was 24 but that's just probably for esthetic reasons. But then it turns out that frame rate was problematic for theatrical release because all of the digital projectors in all of the theaters run at 24, not at 30. There isn't an approved standard for DCP [Digital Cinema Package] of 30 frames per second yet. So, in the end, we had to do a conversion of all the film from 30 to 24, which worked OK, but there was definitely artifacting that we had to deal with.

Q: So what was the rational for shooting at 30 fps?

Sheffield: I wasn't entirely privy to why that was decided. I think it's because Tim felt like 30 frames per second gave it better temporal resolution and it didn't look like video shot at 60, so it seemed to be a way of going with better quality. And I think that's why they made the decision to go with 30 fps.

Ziegler: We weren't thinking, and we hadn't steeped ourselves in deep knowledge of theatrical production and that the DCP needed to be 24.

Q: And then you had shot in some fairly distant locations. . . .

Ziegler: So our main subject, Tim, lives in San Antonio. Your editor, Patrick, is located in North Hollywood and producer, Farley, is based in Santa Monica, with Penn and Teller situated in Las Vegas. We flew to The Netherlands in September, 2009 and assembled a crew there. Then we filmed in San Antonio, back with Tim, as he was building his Vermeer room. Then Penn and Teller were going to go to London to do live shows, so we made that into a shoot and assembled a crew in London.

Patrick: By that point, Tim had purchased his own RED camera for use on the film.

Q: So as collaboration after the shoot, how did you work in terms of presenting cuts and sharing notes?

Sheffield: Initially, there was an editor's drive on which they converted the RED material to be edited in Final Cut Pro and so they converted it all to ProRes. When I came on, I requested that I just get the RAW footage because even though it saves time not doing the conversion, I needed access to the RAW footage in order to do blowups and repositions and stuff like that. So, then, it just became a matter of sending a copy of each drive to Farley and to me. And the fact that we had three drives was necessary when we got to final post because I needed to recapture all of the footage in high resolution. And some of the drives

that I hadn't accessed in a while would no longer spin up. I asked Farley for her copy and some of those worked and some of them had errors on them. So we ended up going back to Tim for getting the final copy for some of that material. And then we recopied both, we redid copies of the failed drives so that we still maintained three separate drives at three separate locations.

Q: And was Tim using a RAID or some other larger server to store his material?

Sheffield: No, we were just mounting them individually. I ended up with over 55 drives. Most of them were 2 terabytes, some of them were less and some of them were 3 terabytes. So that averages out to about 55 2 terabyte drives and I could only mount 16 at any given time. So it would sometimes be a juggling match to edit certain portions of the film and then copy the relevant material to my main drive. And then I could un-mount the drives that I didn't need any more and edit other parts of the film.

But to get back to your question of collaboration, Farley and I were working closely on part of the film. And we spent months where we talked on the phone every day and exchanged QuickTimes that I would post and then it was months before we actually saw each other physically.

Ziegler: We had a kind of comically remote, far-flung project in many ways, because in addition to what Patrick described, we ended up doing color correction in Austin, where our DP [director of photography] is based. And then we did post sound mix in New Orleans.

Q: Why?

Ziegler: Cost and because we had great people in both of those locales. It was our DP's favorite colorist who is in Austin and that was somewhat handy for Tim Jenison to get to and also he's a master himself when it comes to color. So he could come up to Austin when Nick Smith at Finland Finish was setting color. The reason for mixing in New Orleans was I had made contact with the great Larry Blake, who's Soderbergh's sound guy. And he has his own facility in New Orleans and was super generous and gave us just a deal to end all deals.

Q: I think that you've created a model for post and while you're not alone in that so much of what we're doing now is by remote or distance collaboration and they don't all have to be located in Hollywood.

Sheffield: So much of what we did was handled via conference call or posting a QuickTime to an FTP [file transfer protocol] or a Dropbox and then everybody would watch it and then we would get together on a conference call and take notes and then we would act on those notes. One of the problems of the initial workflow, which had been designed back when Final Cut Pro and Apple Color, were the main ways of dealing with RED material, was that we had designed everything to work that way and used one of the workflows that was defined by RED. And then over the course of production, Final Cut Pro X took over as being Apple's edit system and Resolve was the color correction system. Final Cut X didn't affect us much but Resolve was what they started using in Austin. I had prepared everything as we had initially discussed, for Apple Color and some of that workflow was incompatible with Resolve. So we needed to drive the whole set of drives that Tim had from San Antonio to Austin so some of the material could be re-recaptured to be compatible with Resolve.

Ziegler: You should bear in mind, 55 times 2 terabyte drives, that's 2,400 hours of material. Because when Tim Jenison finally sat down to paint, to conduct his

experiment, he had about nine cameras going. He typically had four or five still cameras running, which were shooting at 10 second intervals. The still cameras were: one, over the painting (north side); two, on a boom over the painting (south side); three, a fisheye toward the room mounted on camera obscura lens mount; four, in the corner of the room, above and to right of the "Roman Charity" painting; five, a fisheye outside pointed at sky. Then he typically had three Canon Vixia video cameras going: one, mounted over the painting for brushwork close-ups; two, mounted on camera obscura projection screen for over the shoulder shot; three, on tripod with wide shot of Tim working; four, occasional use of handheld camera for view through optics. Then he had his RED camera, which he used mostly for his daily video diary (and was sometimes also operated by our cinematographer, Shane Kelly). Tim also had a webcam he used for our video Skypes, but he didn't record with it. Tim rigged all of these cameras so that he could flip a remote switch and they would all run at once, because he had to have every brushstroke of his experiment covered. So Patrick was dealing with a "hella" footage, as I think the kids say, from multiple angles.

Q: If hindsight is 20/20 and you were going to do it all over again, what have you learned from this experience?

Ziegler: Well, I think we definitely would have shot in 24. We just didn't have the knowledge, foresight or confidence to think that this was someday going to be bought by Sony Pictures Classics and then screened in theaters worldwide. [Laughs]

Q: But that was an executive decision that was made by Tim.

Ziegler: Yes, I think he would have determined to do that differently. But he had on his right mindset because he was thinking of what looked best. But, in a way, you've asked an interesting question regarding 20/20 hindsight. But on this project there was no foresight involved because the nature of it was an experiment. It truly was a scientific research project for which the process and the result could not have been foreseen. Nor could we predict some of the "off-road adventures" we had such as trying to reach David Hockney for a year. Having him finally agree to meet Tim Jenison. So we were invited to go visit him at his home in North Yorkshire, but he did not want to be filmed.

And then when we got there and everyone was getting along so marvelously that at the last minute, Hockney said: "OK, you can film." So the cameramen ended up being myself and Teller. [Laughter]

Then there was Tim Jenison getting to see the real Vermeer which is owned by the Queen of England. It happened literally on the day before he left London, getting a call to say that he could go see the painting in person, but not film it. They had initially denied him and they denied us being able to film the painting because we were an independent production. So we set up shooting almost immediately upon him exiting Buckingham Palace. Just myself and Tim, having him debrief to the camera what had just happened. So it's a very *vérité* experience.

There was no foreseeing, even for Tim, who's conducting this experiment. He didn't know whether he'd be able to succeed in painting a Vermeer, nor was he sure how long it would take to actually paint. He based his time strictly on how long it took Vermeer, the average it took Vermeer; given how many Vermeers exist in the world, he estimated each one took about six months.

Sheffield: One of the things that did come up was the changing of technology in the middle of the project, because four or five years doesn't seem like that long but

it certainly saw a lot of changes in the software landscape over the course of the film.

The initial planning of using Final Cut Pro and Apple Color and even some of the test edits were color corrected using Color. Then when it came time to do the final color correction, I consulted with a colorist who thought that should be fine and then didn't realize that Resolve wouldn't load RED QuickTime. It took about three weeks to recapture everything that was originally shot in RED. I could have, instead, done the project differently so that it would have been directly accessible by the Resolve as a cut down.

Q: At what point did you all get together in the same room, or was that even possible for all of you to sit in the same room and work on the film together?

Ziegler: This was a case where, again, the marvels of technology, a project that couldn't have been made even ten years ago, or maybe five years ago. We would meet with Teller just to speak theoretically. The story was a very tough nut to crack because the optics and the science and art in the movie are quite dense. But the objective was to tell a story about Tim Jenison and try to do it in a way that would be an entertainment, first and foremost, to audiences and not where you ever feel taxed, where you didn't even have to think. And if you knew nothing about anything and you didn't have any interest in art or optics, you could still have a ride. I'd say we have accomplished that, but it took a long time to get there. And really the times that we were all in the same room together were scarce.

We had an initial screening of a rough cut in LA for about 60 friends of Penn and Teller's. It went really well, but, of course, you have to always take it with a mountain of salt because Penn and Teller have friends they love dearly. It was extended family but it went super well, but of course, you're always looking with a jaundiced eye. That's a very different audience than just Joe Q, or Jane Q Public.

Sheffield: There were times when we got together with Teller. There were times when we got together with Penn. There were times when we got together with Tim, but having all of us together in the same room, I don't think ever took place over the course of the actual editing. 99.9 percent was conference calls and usually that was once a week.

Ziegler: They all have day jobs of an interesting sort and this was my day job for five years. So I was the dedicated, eyes on the prize, there to wrangle the cats

Q: What was the motivating factor to bring it to a close?

Sheffield: We knew it couldn't last forever and . . .

Ziegler: Well, the motivating factor was the project documented Tim Jenison's scientific research project, his experiment. When the experiment ended, he had finished his painting. By then, we had forged a very wonderful, warm relationship with David Hockney. And it was natural then to bring Tim's finished work, the result of his experiment, back to England to have Hockney see the work. So the project itself concluded very naturally.

Q: How was it received at Telluride and at what point was Sony Pictures Classics interested?

Ziegler: To debut at Telluride was a dream come true. It was ideal to bring this "secret" film to a kind of "secret" film festival (because Telluride doesn't announce their lineup until the day before the festival opens). We made the film spectacularly under the radar because the research that Tim Jenison was doing

was completely confidential. In a previous era, Tim would have done his research project, written a science paper and published it in *Nature* or the *Journal of Science*. Instead, it came out as a documentary and the findings are quite remarkable. We kept it super quiet, so when it got into Telluride, there were no buyers sniffing around. No one even knew of its existence. Penn and Teller had a longstanding relationship with SPC starting back when Arthur Penn directed them in *Penn and Teller Get Killed* (1989). Sony Pictures wanted that film, but it ended up being released by Warner Bros. So they had a relationship with Tom Bernard and Michael Barker. By the time we got to Telluride, Sony was already in talks to acquire the film. We didn't go to any other buyers because they're so good at what they do.

NOTE

1. Box Office Mojo, "Don Jon – Total Gross," http://www.boxofficemojo.com/movies/?id=donjon.htm, accessed February 16, 2014.

Glossary

1080p	The most common resolution that is considered "high definition." Primarily used for Blu-Ray disc authoring and digital delivery of film and TV content.
120Hz Overdrive	A refresh rate common in modern high-definition television sets. Film content is typically shot at 24 frames per second, while television content is shot at 30 fps. To be able to play back both types of material without performing a pull-down, 120 Hz (akin to fps) was utilized. It is the lowest refresh rate that divides evenly into both 24 and 30. "Overdrive" is a marketing term and has no real added value.
2-pop	Method of marking the head of a reel to synchronize a soundtrack; placement of audio and visual cue two seconds before first frame of picture.
2:3 pulldown	Often called 3:2 pulldown; telecine technique used to convert from 24 to 29.97 frames per second (see also **inverse telecine**).
24p	A digital acquisition format consisting of 24 (23.976 if adhering to NTSC standards) progressive frames per second.
2K/4K/8K	Unlike television-based standards for resolution, such as high definition and ultra-high definition, 2K, 4K and 8K are film-based standards. 2K is defined as 2048 by 1556 pixels. 4K is 4096 by 2160. 8K is 8192 by 5120.
3-chip sensor	Early generations of video cameras used a prism to separate and record light to three chips (sensors) consisting of red, green and blue (RGB).
3D LUT	Also referred to as "color cubes"; a method of mapping a transformation; used to adjust for display gamuts (see **look-up table**).
4:4:4	Refers to video encoding scheme where an equal ratio of Y'CbCr chroma values is recorded. Alternately 4:4:4 can refer to RGB color space which has no chroma sub-sampling (see **chroma sub-sampling**).
4:2:2	Refers to video encoding scheme where the 2 chroma (color) components are sampled at half the rate of luma (brightness) (see **chroma sub-sampling**).
AC-3	File name extension (.ac3) used for Dolby-encoded 5.1 surround sound (see also **Dolby 5.1**).
Academy Color Encoding System (ACES)	ACES is both a specification and a system which tries to create a commonality in workflow; a superior wide-range color gamut.
Academy of Motion Pictures Arts and Sciences (AMPAS)	Professional organization founded in 1927 and dedicated to the advancement of motion picture arts and sciences; famous for handing out awards each year for artistic and technical achievement.
adaptive motion	Buffering many frames ahead and analyzing the extent of motion within the frame in order to utilize the most efficient interpolation method for reconstruction of that frame.
additive color	Red, green and blue (RGB) are the primaries used in additive colors; theory of how we perceive and create colors.

Advanced Authoring Format (AAF)	Method of sharing picture and sound information and metadata across multiple computer platforms and authoring tools. Events such as transitions, color shifts and audio parameters are contained and transmitted using AAF files.
Advanced Television Systems Committee (ATSC)	Industry group comprised of broadcasters, studios and manufacturers founded in 1982 to promote standards and new technologies for HDTV.
aliasing	When the edges of pixels are visible, resulting in jagged distortions in curves and diagonal lines; sometimes the result of excessive compression or viewing on displays with limited resolution.
ambience	Background sounds, while subtle, constitute the nature of the room. Sound recordists go out of their way in between takes to capture the essence of each room or location (see also **room tone**).
ambient occlusion	Shading of objects drawn in visual effects applications to simulate lighting conditions.
American Society of Cinematographers (ASC)	Founded in 1919, the ASC is a members-only group of cinematography-focused film professionals. Its mission is to advance the education and professional collaboration of its members.
American Standard Code for Information Interchange (ASCII)	Original alphanumeric code and symbols used in teletype (telex), computers and the internet; employed in high-level computer languages and programming.
anamorphic	A capture and playback format that utilizes a curved lens to store a widescreen image on a 1.33:1 film frame or digital sensor. The captured image appears squished horizontally and must be played back using a complementary anamorphic lens which correctly stretches the image to its proper dimensions.
animatics	Stills or hand-drawn frames placed in a timeline and animated using basic transitions and effect; used as placeholders in animated films.
answer print	The first positive print to be struck from a negative in preparation for final color and duplication.
API	Language (or protocol) used between two separate computer programs to facilitate the sharing of files and media.
Apple ProRes	Group of lossy codecs used in editing and mastering of high-definition video.
arbitrary output value (AOV)	CGI render passes used to convey information about a scene that is either a component of the final RGB render or a related attribute. Background, specular, reflection and diffuse passes are composited together to equal a beauty pass. Mattes, normals, motion and z-depth are used to assist in compositing.
Arri Log C	Log encoding scheme for Arri Digital Cinema cameras; similar to cineon but still different.
ARRIRAW	Data produced by the Arri Alexa camera; a codec containing RAW bayer sensor information.

aspect ratio	Denotes the relationship between the width and the height of an image. Often represented with a delimiting colon (e.g., 1.33:1, 16:9, 2.35:1).
assemble edit	Videotape editing term for recording an assembled sequence in single pass with continuous timecode.
asset	See **element**.
audio stem	Refers to separate sound elements which are combined to create a full soundtrack; group of tracks mixed together but maintained as discrete and separate elements, such as foley, dialog, music and SFX.
automated dia- logue recording (ADR)	Also referred to as "looping"; method of re-recording and replacing lines of dialog due to problems with the original location sound recording or to change a performance by an actor.
Avid Log Exchange (ALE)	A bin containing references to separate clips and sequences with all the essential metadata; file transfer method used for passing editing projects back and forth.
B roll	Television term for additional footage gathered during coverage of a news story or documentary; useful in editing for cutaways and providing inter- esting visual references.
B4 lens mount	Used for professional video cameras such as Betacam.
background plate	The component part of a composite image taken as either a live action image or animation. Often simply referred to as "plates."
bandwidth	Measurement of the volume of data that is moved over a network or device.
bars and tone	Nonlinear systems are capable of generating color bars and adding refer- ence audio tones; used in calibrating displays and VTRs.
batch render (queue)	System of rendering that is automated as part of a batch list or queue; requires little or no supervision by the operator.
bayer sensor	A square grid of photo sensors made up of RGB located on a single chip.
best light	Refers to basic color correction during dailies preparation; setting a look for a scene and the application to all corresponding clips.
Betacam/Beta SP	Sony family of industrial strength analog videotape products; still in use by broadcasters.
Betamax	Sony's consumer grade format which ultimately lost out to its competitor, VHS.
billing blocks	Talent including the "key creatives" are given space in advertisements and posters based on pre-negotiated sizes known as billing blocks.
bit budget/data allowance	Estimation of amount of data generated on a project. As more cameras are added or there is an increase in the resolution (data rate) at which the material is acquired, then more data will be the result.
bit depth	A measure of the number of data bits allocated for representing each of the color components of a single pixel.
bit rate	Usually measured as bits per second; numerical value of the amount of data assigned to compression and playback of media.

bounce-out	ProTools term used to describe the final output/render of the audio final mixed track.
blacked and coded	Blank videotape can be prerecorded with a black signal and continuous timecode to streamline the editing process.
blade	Enclosure containing a group of drives for core processing. Multiple blades usually live inside a chassis as part of a server array (see also **storage attached network**).
bleach-bypass	A lab process also known as "skip bleach," it involves omitting a bleach bath resulting in the retention of silver in the emulsion with resulting high contrast de-saturated image.
breakout box	External hardware I/O device that interfaces with a computer via a card or port and supports multiple types of connectors.
burn-in window	Visible timecode that is married (composited) to the underlying image.
cadence	Sequence of video frames and fields used to convert 24 fps to 30 fps; ordering of frames in a pulldown sequence (see also **2:3 pulldown**).
camera gate	The section of the camera that the film frame makes contact with as it is being exposed.
camera magazine/mag	A sealed chamber, permitting no light, which holds the roll of film being used. Typically there are two sides: the "feed" side of unexposed film and the "take-up" side, which holds the recently exposed frames.
camera painting	Setting the look and color of the video through on-set color manipulation of the signal prior to it reaching the recorder.
camera roll	Camera original negative is referred to as a camera roll and assigned unique ID (see also **lab roll**).
card rate	The cost of time or space shown on a rate card. Post facilities rarely charge the full card rate but instead offer discounts based on the published rate as a courtesy or incentive.
cathode ray tube (CRT)	Older model TVs and computers use CRT technology; powered by a moving electron beam through a vacuum tube onto phosphor dots contained in a glass screen.
CCD sensor	Also known as charged-coupled device that translates electrical current and converts it to digital. Digital cameras employ either CCD or CMOS sensors (see also **CMOS sensor**).
celluloid	Flexible transparent medium used to capture and transport images. Also called film. An emulsion is placed on celluloid backing then wound onto a reel.
certificate of origin	A form accompanying an exported work that verifies its country of origin.
CF card	Compact flash media; used in many camera systems.
chain of title	A document outlining the history of ownership of a copyrighted work.
check print	Sample print used to spot check quality of release print.
checksum verification	Method of verifying that a file copy is correct; use of a digital fingerprint to ensure two files are identical.

chroma sub-sampling	When utilizing a lower-quality capture format, it is the process of encoding more luminance information than chroma information due to the eye's diminished ability to detect variances in chroma, resulting in smaller file sizes and data rates.
chroma-key	The process of isolating the selected background color (either bright green or blue) and replacing it with digitally derived content.
chromaticity	Color measurement as reflected in the CIE 1931 chromaticity diagram; mapping of hue and color intensity (see also XYZ).
chrominance	Saturation and hue characteristics (color) of a video signal.
chyron	Term commonly used to mean lower-thirds title and graphics.
Cinedeck	High-resolution multi-format recording system.
Cineform	GoPro purchased the company which created a proprietary video codec for use with their cameras; a wavelet compression format also used for SI-2K RAW and includes 3D support.
CinemaDNG (Digital Negative)	Digital format initiated by Adobe to accommodate a variety of RAW image and sound files by wrapping them as MXF or DNG file sequences; intended to streamline archiving and digital exchange.
Cineon	A system developed by Kodak to support high-resolution images used in the DI process. The successor format is digital picture exchange or DPX files.
clipping	Clipping is the result of recording a signal that is beyond the minimum or maximum signal limitations of a sensor or imaging technology. When this occurs, gradations in exposure beyond the clipping point are lost and recorded as a single maximum or minimum value. A vivid example is a bright light source such as a window or light bulb that may cause the image to become "blown out."
closed caption (CC)	Government-mandated text information that can be placed over picture as subtitles; intended for the hard of hearing.
cloud storage	Method of storing data in virtualized pools via the internet. Data is replicated to multiple data centers, ensuring reliability.
CMOS sensor	Digital chip design that uses less power and faster data throughput than CCD sensors. Used in many cell phones and compact cameras as well as professional cameras.
CMOS smear	The smear or "jello effect" caused by a rolling shutter. CMOS sensors expose different parts of the frame at different intervals, resulting in artifacts (skew, wobble or partial exposure).
CMYK (cyan, magenta, yellow, black) model	Subtractive color model used in printed matter.
codec	Shorthand for compressor/decompressor. For devices to be able to play back audio or video files, they must have the correct codec.
color bible/look book	Set of predetermined color grades.
color channel	A given pixel is the combination of three color values for red, green and blue. A "channel" is the image with color information for only one of the three primary colors. When all three are overlaid the full color image would result.

color correction	See color timing.
color correction collection (CCC)	XML file containing multiple ASC CDL color corrections, each with a unique ID (see also **CDL** and **Extensible Markup Language/XML**).
color decision list (CDL)	Developed by the ASC, a CDL is a list of color values for slope, offset and power (as well as a gauged value for saturation) which facilitates conversion of color information between equipment and software in preparation for color grading.
color gamut	All the possible colors that a device can display (see **colorspace**).
color grading	See color timing.
color matrix	Grid of color sensors (see **bayer sensor**).
color science	The study of color and how it is transmitted, perceived, captured and described (see also **colorimetry**).
color timing	Also known as color grading/color correction. The word "timing" originates from the original lab process for managing color (see also **printer lights**).
colorimetry	Measurement of color and its intensity.
colorspace	A range of reproducible colors; represented by specific color models, such as CMYK or RGB.
ColorTrace	Feature in Resolve 10 that facilitates matching color grading data while chasing editorial change cuts.
combing	Artifacts occur when pixels in one frame do not line up with the pixels in the next, creating a jagged edge.
compositing	Layering and combining of images.
compound clip	Formerly known as a "nested" clip. Final Cut Pro X compound clip feature allows multiple clips to be consolidated and treated as if they are the one clip.
compression	Digital transmission and storage of data often requires compression, which is a method of throwing out redundant data (see **codec**; see also **lossy vs. lossless**).
computer-generated imagery (CGI)	The application of computers and graphic programs to generate images.
confidence check	A method of comparing an offline copy of a sequence to an online version; a video file used for reference.
conform	Taking a completed offline sequence and moving it to an online edit bay in preparation for final mastering; matching shot for shot (to the exact frame) the online version to the offline version.
contact print	Made by shining light through a negative onto photosensitive material (see also **answer print**).
contact printing	Positive print created from an original negative by physically placing the two elements together and shining light through them.
Content Delivery Network (CDN)	A distributed network of servers that provide content to be downloaded. Distribution ensures both high performance and redundancy in the event of a server crash.

crash camera	Camera placed at risk during a high impact scene; a camera that is expendable.
cross-conversion	Converting an asset from one format to another but maintaining the same resolution.
cryptographic hash	A fixed-length string resulting from an arbitrary data set. Used to quickly determine if two or more files are different (see **checksum verification**).
cue sheet	Handwritten or typed sheet indicating the timecode where an actor or sound effect should be heard.
D65 (CIE Illuminant)	A standard daylight whitepoint defined by the CIE with a color temperature of 6504K. It is the standard whitepoint of Rec. 709 and Rec. 2020.
Datacine	Film-to-digital file transfer with the use of a scanner.
DCI P3	A colorspace larger than Rec. 709 created by the major studios and intended for digital cinema projectors; approximates the color gamut of film.
de-interlacing	Interlaced video frames consist of two fields, scanned as odd and even lines. De-interlacing converts sequences to a non-interlaced frame by use of an algorithm.
de-mosaicing	Luminance information is derived from the green channel when an image is captured via a camera's sensor. For this reason there are as many green photosites as red and blue combined. In order to retain a rasterized image with equal color information for each channel, de-mosaicing algorithms look at adjacent photosites and intelligently derive chroma information from them.
de-multiplex/ de-mux	The process of separating two previously paired analog signals or digital data streams.
debayering	In a RAW image each pixel represents one color value. To convert the image into RGB format (which contains three separate values for each color channel), debayering interpolates the two missing colors.
density	Amount of silver halide crystals remaining on the negative after processing; measurement of light or dark in an image.
depth of field (DOF)	A measure of the distance between the nearest and farthest objects in frame that are both in focus. Depth of field is affected by many factors, including the length of the lens and F stop used.
diffusion pass	Attribute of layer for use in compositing; full color rendering of object to include diffuse illumination.
Digi-Beta	Digital successor to the analog betacam format; standard definition broadcast workhorse from 1993 to present day. Records component video with 10-bit YUV 4:2:2 compression. PAL resolution is 720x576, NTSC resolution is 720x486. The bitrate is 90 Mbit/s. Carries five audio channels – four main channels (uncompressed 48KHz PCM) and one cue track.
digital artifact	Too much compression or errors during encoding may cause parts of the image to show artifacts which are "block-like" in nature.
Digital Cinema Distribution Master (DCDM)	From the original log DPX master, a DCI XYZ LUT will be applied to convert it to a projector XYZ container. These are rendered as 16-bit TIFF files in the appropriate DCI resolution (2K – 2048x858 for Scope, 1988x1080 for Flat).

Digital Cinema Initiative (DCI)	Joint venture by the major motion picture studios with the goal of establishing uniform specifications for digital cinema systems.
Digital Cinema Package (DCP)	Set of files containing a digital print; carries audio and video information used in theatrical presentations with security features (KDM) to prevent unauthorized use.
digital intermediate (DI)	Term originally coined to describe steps between film acquisition and final output; refers to high-end post techniques.
digital light projector/projection (DLP)	Technology used for digital cinema projectors; supports 3D.
digital noise	Unintended variation in brightness and color information in an image that results from signal amplification that may occur in low-light shooting conditions.
digital noise reduction (DNR)	Used in mastering; process of reducing or eliminating film grain, electronic noise from sensors, comb filter artifacts, etc.
digital nonlinear extensible high definition (DNxHD)	Avid acronym. Family of lossy codecs used in editing and mastering of high-definition video.
Digital Picture Exchange (DPX)	Common file format used in digital intermediate and visual effects workflows. Originally developed by Kodak; evolution of Kodak's Cineon format.
digital single-lens reflex (DSLR)	A digital camera that combines the traditional mechanical shutter and reflex mirror. This provides the photographer with an optical viewfinder just like traditional 35mm still film cameras.
Digital Source Master (DSM)	A graded master, generally log DPX without any LUT baked in. This serves as a master that can be used for trim passes for home video and other distributions.
Digital Theater Sound High Definition Master Audio (DTS-HD MA)	Lossless audio codec/format; popular in Blu-Ray authoring.
Digital Theater Systems (DTS)	Audio playback system which uses a CD-ROM for additional tracks and synchronized by a guide track on the release print.
digital video effects (DVE)	Computer-generated effects and transitions created during an online or offline editing session, such as resize or dissolve.
digital visual interface (DVI)	Connector used to transmit uncompressed video between a computer and a display; features support for analog VGA signals.
Dolby® 5.1	Dolby® Surround sound system using six discrete channels: left, center, right, left surround, right surround and low frequency effects (LFE); playback and record system for homes and theaters.
Dolby® Atmos™	Powerful yet geographically precise method of audio mixing and playback for theaters; supports 128 discrete audio tracks and up to 64 speakers.
dolly	A platform on wheels upon which the camera can be mounted in order to achieve shots with lateral motion.

drift	When two devices fall out of synchronization; disparity in timeclocks.
drop-out	A momentary loss of signal. In video it typically results in one or more black frames.
dubbing	Audio re-recording and sound mixing. Term comes from use of magnetic recorders known as "dubbers."
DVCAM	Sony's offering in the standard definition DV family of prosumer tape formats (DV, DVCAM, DVCPRO) developed in the 1990s using a highly compressed video signal.
dynamic range/ latitude	A measure of the highest and lowest values at which detail for captured material exists and can be manipulated.
edit decision list (EDL)	File containing tape name and timecode data which enumerates each video clip used in an edit.
edgecode	Measurement of feet and frames used to locate footage (see **keycode**).
EF lens mount	Standard lens mount for Canon EOS DSLR cameras.
electronic news gathering (ENG)	Broadcast news term for video acquisition in the field.
electronic press kit (EPK)	Promotional materials for a project, usually delivered via DVD or the internet, that may contain cast and crew biographies, press photos, behind-the-scenes videos, trailers and interviews.
element	Component part of media used in the creation of a finished project such as sound, picture or titles.
emissive pass	CGI render pass used in compositing; calculation of light emitted from a surface or object.
emulsion	Photo-sensitive compound placed on film and exposed to light results in silver halide crystals after processing.
equalization (EQ)	Raising or lowering the levels of specific frequencies in an audio signal; used to minimize or exaggerate sounds for creative effect.
Extensible Markup Language (XML)	Set of rules for documents that can be read and understood by human readers as well as machines; designed to transport and store project data between multiple applications.
external serial ATA (eSATA)	Interface for connecting computers to external storage devices.
Federal Communications Commission (FCC)	Regulates interstate and international communications by radio, television, wire, satellite and cable.
fiber channel	Glass silica (or plastic) conduit used in high-speed transfer of data through the use of optical technology.
field reconstruction	In an interlaced image, taking the lower and upper fields of the frame and matching them up again to generate a complete, viewable frame.
fields	Each interlaced video frame consists of two fields, scanned as odd and even lines. They are intended to enhance motion perception and to reduce flicker in the image.

file transfer protocol (FTP)	Method of file transfer over a network that is password protected.
film gauge	The distance across the film medium as measured in millimeters. 70mm/35mm/16mm are the standard professional gauges.
film grain	The clumping of granules on the film emulsion which also adds texture to the image.
filmout	Method of transfer from a digital file to a film negative.
Firewire (IEEE 1394)	Method of connectivity between devices; serial bus interface standard used in transfer of data.
flatbed	Editing table with platters, motors, soundheads and viewers. Kems and Steenbecks are the most commonplace.
floating point processing	Floating point values (such as those contained in OpenEXR files) utilize decimal instead of integer encoding: both very large and very small values can be described without a decrease in precision.
foley	Studio recordings of human movement and interaction with props, cloth, footsteps and water, to name a few; the reproduction of everyday sounds to enhance the reality of a scene.
follow focus	Mechanical add-on for a camera that makes it easier for a focus-puller or the camera operator himself to adjust focus without having to use the focus ring itself.
frames per second/frame rate (FPS)	Temporal measurement of frames recorded or played back, sometimes measured in Hertz.
framing chart	Used in calibrating and matching the transfer of the scanned image to the intended framing of the camera. Still relevant, but often overlooked on digital shoots.
gain	A measure of the increase or decrease in the power of a signal; used in audio and video applications.
gamma curve	The gamma curve is the translation of what our eyes see as opposed to what the camera sensor sees. When a camera receives twice as much light, the signal is doubled in a linear fashion. Human perception, however, will see only a fractional increase on a graph that is seen as a curve rather than a straight line.
gate weave	Imprecise registration in a film gate may cause the film to move or drift position, causing an unstable image.
generation loss	Analog sound and picture suffer from generation loss each time a copy is made.
green screen	A solid, bright green backdrop which is meant to be replaced later by digitally derived content. The bright green color is used because it is so distinct from skin color and other objects in the scene, allowing for easier chroma-keying later on.
Group of Pictures (GOP)	Group of Pictures (GOP) is a video encoding method (usually H.264) that is highly efficient as it looks both forward and backward to see what changes have occurred in the frame.

H.264	Also known as MPEG4 or AVC (advanced video coding); a common format used in recording, compression and transmission of digital video. Best known for use in Blu-Ray technology and cable and satellite distribution.
handles	The adjacent frames located at the beginning and end of each clip.
Handschiegl process	A proprietary process of using aniline dyes to artificially color a film frame. Invented by Max Handschiegl and originally used on the Cecil B. DeMille film *Joan the Woman* (1916).
HDCAM SR	HD recording and tape system; used in many primetime TV shows as a recording and mastering medium with up to 12 channels of audio.
Hi-8	Hi-8 and Digital8 are compact consumer cameras and tape formats.
high definition (HD)	A television-based standard for resolution, consisting of either 1080 or 720 progressive lines, or 1080 interlaced lines.
high-definition multimedia interface (HDMI)	A digital interface for audio and video for use in home theaters and consumer electronics; compatible with DVI and features content protection features for digital rights management (DRM).
high frame rate (HFR)	Defined as any capture frame rate over 30 fps. Most commonly applied in the film world.
histogram	Graphical representation of pixel values and their tonal distribution.
Image Interchange Framework (IIF)	A project of the AMPAS Science and Technology Council that serves as the mechanism for encapsulating data in the Academy's color management system known as ACES.
imbibition printing	The process of creating a three-strip negative of a film, one for each primary color, using a dye process.
ingest	Method of input (or transfer) of material into a pipeline or editing system.
inpainting	Reconstruction of damaged film or video by the use of algorithms that can replace and interpolate pixels; restoration technique.
input device transform (IDT)	Conversion of camera or scanner data as part of the first step in the ACES pipeline. Each device will have its own IDT based on the manufacturer's specification. Once the conversion takes place it is then considered "scene-referred."
insert edit	Audio or video section recorded to a videotape that has been pre-blacked and coded.
insert shot	A close-up shot or cutaway.
inter-negative (IN)	A duplicate negative created from an inter-positive used in the manufacture of release prints (see **inter-positive**).
inter-positive (IP)	Duplicate made from a film negative resulting in a positive print. The IP is used to create multiple inter-negatives (IN) for large-scale release print runs (see **inter-negative**).
interlacing	Interlaced video consists of the doubling of each frame; achieved by drawing two fields for each frame, resulting in lower bandwidth and enhanced motion perception. The drawback to interlacing is that it sometimes results in artifacts or tearing of the image.

International Alliance of Theatrical Screen Employees (IATSE)	Sometimes referred to as the "IA" or "union"; part of the national group AFL–CIO which negotiates and maintains all rights under collective bargaining agreements.
International Commission on Luminance Chromaticity Model (CIE)	International organization devoted to the quantification of color and advancement of color science. In 1931 two scientists developed the RGB and XYZ models for color mapping known as the CIE 1931 Color Space Chromaticity diagram (see also **XYZ**, **RGB**).
inverse telecine	Algorithm used to remove the 2:3 pulldown and de-interlace the material converting video frames at 29.97 back to 23.976 (see also **de-interlacing**).
jam syncing	Forcing one device to follow or match timecode fed from another device; method of onset synchronization.
JPEG2000	Codec featuring either lossy or lossless compression; used in high-end graphics displays.
judder	A visual side effect of converting film-based material to digital and playing it back on a display monitor that does not support the refresh rate of the original material. For instance, a film shot at 24 frames per second played back on a 60 Hz television must incur a 2:3 pulldown to divide the number of frames evenly into 60. As a result, during that second of playback, some film frames will be reproduced more than others. During pans containing motion blur, this inconsistency in playback frames results in judder.
key delivery message (KDM)	Security feature contained in DCP digital prints; variables such as location or time of day restrictions can be set by the distributor to prevent unauthorized use.
key creatives	A term generally referring to the director, producer, cinematographer, editor and production designer, among others.
keyframes	Method of setting parameters and dynamic adjustments to clips or sequences in a timeline; a point in time where a change or event occurs.
keykode™	Kodak-patented method of measuring and identifying individual frames; a barcoding system used to count feet and frames of film negative (see **matchback**).
keyword collection	The organization of media using text as metadata.
lab roll	Labs combine several camera rolls to a single lab roll during processing to reduce handling and increase efficiency (see also **camera roll**).
layback	Pairing up the finished audio mix with the video edit.
leader	Slug or leader is placed at the head of film reels to allow for threading of the machine or projector.
left total/right total (Lt/Rt)	Two channel audio format with embedded sounds for four channels: left, center, right and surround; recorded and played back via a matrix encoder (see also **printmaster**).
legal range vs. full range	Limitations of TV broadcast signals require the remapping of the full range of data values (0–1023) to the legal range (64–940).

legal script	Also referred to as the dialog/continuity script which is based on the transcript of the final movie; legal document considered part of the final deliverables.
letterbox	Black bars at the top and bottom of an image with program content in the middle; practice of display-wide screen material at different aspect ratios than the standard display aspect ratio.
lift, gamma, gain	Basic color correction functions. Lift adjusts the black (shadows) levels. Gain adjusts the highlights. Gamma adjusts the midtones or the values between shadows and highlights.
light-emitting diode (LED)	LED displays are essentially LCD displays with LED backlighting resulting in greater contrast ratios.
Lightworks	Nonlinear editing system developed in the UK by a group of engineers (OLE). Currently available as open source for windows and linux users.
linear tape-open (LTO)	Standard developed for storage of data on specific linear tape format.
liquid crystal display (LCD)	Used in flat panel displays and laptop computers.
lo-con	Low-contrast stock used to create a print that is optimized for transferring film to videotape. Telecine tends to add contrast and this corrects for it.
log space	Color values contained in an exponential numbering scale.
logarithmic encoding	An image encoded with a logarithmic value (see **log space**).
look-up table (LUT)	Color mapping and conversion used in image processing; LUTs are used to convert images from one colorspace to another.
loop group	Group of actors hired to mimic the sounds of large and small groups; resulting tracks referred to as "walla" to include human reactions such as laughter, shouting, murmurs, etc. (see also **walla**).
lossy vs. lossless (compression)	Method by which certain compression schemes are more aggressive at reducing data rates (lossy) vs. compression schemes that retains more information and therefore more quality (lossless), resulting in larger data files (see **compression**; see also **codec**).
luminance	Measure of intensity or brightness of a video signal.
magnetic tape	A medium used to record sound and picture on long narrow strips of film coated with ferrous oxide (iron).
magnetic timeline	Term used in Apple Final Cut Pro systems; a dynamic editing and timeline feature which links and synchronizes a group of clips.
matchback	To relink or conform media to an existing sequence.
matte	Drawing around a shape or object; intended as an area of replacement with a new image or with an effect.
Media Exchange Format (MFX)	A container or wrapper of high-definition digital audio and video with full metadata and timecode support.
metadata	Additional information embedded in a file which provides a given application or the user important details about that file.

mezzanine file	An intermediate high-quality format intended for multiple destination formats.
Micro Four Thirds lens mount (MFT)	Interchangeable lens system designed with a slimmer profile to smaller DSLR cameras; shorter flange depth (distance between mounting point and sensor).
miniDV	Compact version of the DVCAM format.
mirroring	See redundant array of independent disks (RAID).
moiré	When a pattern of light and dark images (often found in clothing) are spaced too closely together, they tend to flicker or cause aliasing.
motion blur	Streaking or blur caused by transient motion in a frame or sequence.
motion interpolation	Measurement of transient motion between two points or between two frames; estimate of intermediate values.
Motion Picture Association of America (MPAA)	Trade organization which manages the assignment of film ratings for US territories and represents the business interests of the major studios.
MPEG2	Lossy compression scheme used in authoring DVDs and transmission of digital video.
multi-cam	Multiple cameras rolling at the same time or grouped by timecode.
Musical Instrument Design Interface (MIDI)	Protocol and interface for connecting musical instruments and computers; allows multiple instruments to be played by a single controller.
National Association of Broadcasters (NAB)	Trade association and lobbying group noted for hosting one of the largest annual trades shows devoted to professional production gear.
National Television System Committee (NTSC)	Legacy analog television system that was used in most of North and South America, as well as some Pacific and Asian countries. Standard consists of a 29.97 fps frame rate and 480 lines of resolution.
near-field audio	Precise, compact speakers designed for placement close to the listener featuring relatively flat frequency response (uncolored); used in professional studios and editing suites to faithfully reproduce the sound.
neutral-density filter	Placed in front of the lens during shooting, which reduces the light level of the captured image without affecting the color temperature.
nitrate film stock	Early films used nitrate stock which became highly unstable over time and deteriorated. It was also highly flammable and was ultimately replaced by the more stable "safety" stock.
Node (color grading, DaVinci Resolve)	A color correction module with a variety of image manipulation properties. Scenes can connect to one or several nodes controlling primaries, secondaries, windows, blurs and keys.
nonlinear editor (NLE)	System designed for playback and editing of footage in any order.
notching	Method of identifying each cut in a sequence. (see **scene detection**).

object tracking	Automated method of measuring movement of objects or people within a frame; used in stabilization and rotoscoping.
offline (editorial)	Refers to compressed footage; sessions that may not be connected to a larger server.
one-light	Setting a look or color parameters one time and applying to every clip on a reel (see also **best light**).
online (editorial)	Refers to uncompressed footage; high-end mastering session or platform.
OpenEXR	A high dynamic range (HDR) file format developed by Industrial Light & Magic; supports 16- and 32-bit floating point calculations.
OPEX vs. CAPEX	Operating expense vs. capital expenditure; an important distinction for companies to consider whether to rent or buy equipment such as cloud-based servers. Each has a different tax consequence.
optical low-pass filter (OLPF)	Also known as anti-aliasing filter; for use with bayer sensors, it intentionally softens the image to prevent moiré patterns (see **moiré**).
optical printer	Used to rephotograph film elements for the creation of titles and visual effects and transitions. Also referred to as a "rostrum camera."
optical track	A portion of the film frame which contains audio information encoded in an analog format.
organic light-emitting diode (OLED)	Considered an advancement in LED technology, used in many high-end displays; can achieve higher contrast ratios than LCD and because they require no backlight, OLED monitors are much thinner.
output device transform (ODT)	Maps the colors to the specification of the intended target display such as Rec. 709. Each display will have its own ODT.
output-referred images	Images encoded for exhibition on a particular standard of display or medium. For example, video encoded for Rec. 709. Encoded values no longer have a correlation to real-world scene light values.
pan and scan	A playback format in which a widescreen format film is viewed on a 4:3 television. As the entire image cannot be visible on the screen at one time, the frame will occasionally pan left and right to more properly frame action in the scene.
Panalog	A 10-bit logarithmic encoding system designed for use with Panavision's Genesis camera.
Panasonic D-5	HD recording and tape system; an alternative format to Sony HDCAM SR. With optional adapter the D-5 will encode 2K (2048 x 1080) resolution material with 4:4:4 color space.
parallax	The difference between the apparent position of an object as seen by two different lines of sight; errors in parallax may occur if the viewfinder is separate from the main lens.
parity	RAID storage systems are designed to reserve a portion of each drive volume as a method of backup. When a drive fails, the system can rebuild the data using parity information. This varies according to how the drives are formatted – RAID 0 has no parity, meaning there is no redundancy or security, while RAID 5 offers both speed and security.

particle simulation	Visual effects technique used in the recreation of natural and organic events; efficient method of drawing fire, water, dust, snow, fur and countless other objects.
persistence of vision	Film and video consists of individual frames which, when played back at a steady pace, appear to the viewer as continuous action.
phase alternating line (PAL)	Legacy analog television system used principally in Europe, but many other continents as well. Standard consists of a 25 fps frame rate and 576 lines of resolution.
photosite	Analogous to "pixel" in the nomenclature of display devices, a photosite refers to a singular picture element of a larger overall image.
pick-up shot	A shot that is acquired after principal photography has ceased utilizing that location. Often a minor or insert shot that augments the footage already acquired.
pillar-box	Black bars located on the sides of a 16 X 9 display with the 4 X 3 image in the center. Used when the image being display has a lower aspect ratio than the display (i.e., viewing standard definition content on a widescreen HDTV).
pin registration	A feature of film cameras and projectors in which pins engage the perforations on either side of the piece of film and physically hold it in place while that frame of film is being exposed or projected. This reduces "gate weave" or jumpiness, and is critical to achieving a stable image.
pixel binning	An encoding process in which clusters of adjacent photosites are averaged to produce a single pixel (minimum size 2 X 2 – e.g., four photosites) to result in an image with smaller dimensions than the raw sensor resolution without exaggerating aliasing or moiré.
PL lens mount	The Arri standard lens mount that has been used by many camera and lens manufacturers for over 30 years. This is the most common cinema lens mount and can be found on Arri, RED and Sony Digital Cinema cameras as well as film cameras.
power windows	See **secondary color correction**.
pre-dub	Also known as "pre-mix"; combining of multiple sounds and tracks in advance of the final mix stage.
pre-grade	Unsupervised grading to establish an overall look or "baseline" prior to creative grading sessions. Color decision lists (CDL) may be used to match the grading session to dailies and looks set during production.
pre-roll	A time, generally a few seconds, provided to tape decks for playback and record in order for the system to achieve a stable, fixed tape speed.
pre-visualization	Creation of a set of storyboards or other visual references intended as a guide to the finished product.
primary color correction	Affects the entire image through manipulation of RGB gamma (midtones), blacks (shadows) and whites (highlights).
printer lights	Values from 1–50 of red, green, blue as applied to the film lab printing process.

printmaster	Completed audio soundtrack includes all dialog music and effects; formatted for mass duplication and distribution via specific medium (theatrical, Blu-Ray, VOD).
progressive scan	Method of recording and playback without dividing frames into fields (see also **interlacing**).
proof print	See also **check print**.
proxy	Lower-resolution copy of captured material created for offline editorial work. Often editing stations are now powerful enough to work with high-resolution material (e.g., 2K or 4K) in real time. Proxies provide the editor enough detail to work effectively without taxing the system too heavily.
punch-in	Extreme blow-up of an image. Accomplished optically or digitally (with a DVE).
PV lens mount	Lens mount system developed by Panavision; only for use with their 16mm and 35mm cameras.
quality control (QC)	The process of evaluating the integrity of an asset, either through automation or human observation.
QuickTime	Apple's framework for encoding and playback of digital video. It remains in use in both professional and consumer systems.
raster image format	Sometimes called a bitmap; method of conversion of a digital image to pixels on a screen. The alternative method of displaying and converting images is known as vectors, which are resolution independent.
RAW image format	Original data collected from the camera sensor; analogous to film negative.
real time	Linear tape and film elements must usually be played back or recorded in real time.
Rec. 2020	Also known as ultra-high definition television (UHDTV) offering two resolutions (either 3840 X 2160 or 7680 X 4320) and an expanded color gamut even greater than DCI P3.
Rec. 709	The International Telecommunications Union (ITU) agreed on the specifications for HDTV broadcast standards known as Recommendation 709. This format would ultimately replace NTSC/PAL/SECAM as a worldwide standard.
REDCODE RAW	RED's proprietary image capture file format. REDCODE (.r3d) encodes the RAW bayer sensor data using a wavelet compression algorithm to provide a nearly lossless image at low data rates. Recorded audio is uncompressed.
redundant array of independent disks (RAID)	Used for grouping physical hard disks into logical volumes to increase performance, add redundancy or both. Management of data can occur via hardware or software.
reference rendering transform (RRT)	RRT is the transform applied to the scene-referred image in the ACES pipeline in order to make it viewable. In film terms, the scene-referred image is considered the original camera negative and RRT can be compared to the print stock.
refraction pass	CGI AOV render pass used in compositing; renders the effect of light passing through translucent and glass-like materials.

refresh rate	Refresh rate is analogous to the term frames per second. It denotes the interval at which one image cycles to the next. Historically, refresh rates have been a unit of measurement of computer monitors.
release print	Prints intended for theatrical distribution.
renders	When a clip is rendered in an application, new media is created and time may be required to process it. Renders are sometimes saved in separate folders for easy identification and take up additional storage.
resize/reposition	An image that is enlarged, reduced or re-centered.
return on investment (ROI)	Financial planners would like to know how long it takes to pay off or break even on large capital expenditures such as servers and editing systems.
reversal film	Film stock that when processed results in a positive image.
RGB (red, green, blue) model	Additive color space based on the three primary colors which are also the receptors in our eyes; basic model for computer graphics.
rig/wire removal	Onset safety wires and harnesses are removed in the post-production process and replaced with clean backgrounds. Rig removal also encompasses removing any object from a shot that is undesirable, such as crew members or film hardware.
rock & roll	The ability to play, start and stop a system in both forward and reverse.
room tone	Each room or location is recorded without dialog to capture the ambient sounds which are later used to fill gaps in the dialog tracks (see also **ambience**).
rotoscoping	Creating masks or mattes for each frame of a sequence.
S-Gamut	Color gamut (defined color primaries in x, y) of the modern CineAlta series of cameras (F65, F55, F5, F3).
S-log	Log encoding scheme for Sony cameras.
S-log2/S-log3	Increased dynamic range from S-log; optimized for newer generation of Sony cameras. S-log3 is similar to the cineon gamma curve yet mimics film more closely than S-log2.
saturation	Measurement of the amount of red, green and blue color channels combined to make an image (see **additive color**).
scene detection	Automated method of analyzing a sequence to determine where the cuts occur; useful for breaking down footage that has been imported as one continuous sequence. An alternative to manually placing cuts, which is referred to as "notching."
scene-referred images	Images that are encoded with a direct correspondence to real-world light values. The encoding follows a formula that relates directly to relative quantities of light such as stops.
scrubbing	Playback of sound or picture manually or in reverse at slow speeds.
secondary color correction	Used to isolate specific areas of the frame for color correction or adjustment without affecting the entire image.
Séquentiel Couleur à Mémoire (SECAM)	Analog television system used in Eastern Europe and France.

serial attached SCSI (SAS)	Sometimes referred to as "scuzzy." SCSI is high-speed method of connectivity or point-to-point serial protocol for computers and storage.
serial digital interface (SDI)	A standard for transmission of high-quality uncompressed picture, sound and timecode. HD-SDI is a related standard offering higher data throughput.
set extension	Use of green screen and matte paintings to create the illusion of a larger set or landscape.
shooting ratio	A measure of the duration of all film shot during production vs. the final duration of the finished film.
short-end	A length of unexposed negative leftover from a film roll.
shutter	The piece of the camera that either blocks or allows light to reach the frame being exposed.
shuttle drive	Portable drive used to physically transport data.
slate	The clapboard or "sticks" seen at the head of a take used to provide a visual ID along with written information on the slate itself (see also **smart slate**).
slope/offset/ power	Measurement of values affecting the RGB channels used to transform the image and communicated via ASC color decision lists (CDLs).
smart slate	Used to mark and identify each take by visual and audio cues; used in synchronizing sound with picture. Smart slates are usually wireless devices which can receive timecode from another device and display it (see also **jam syncing**).
Society of Motion Picture and Television Engineers (SMPTE)	Founded in 1916, SMTPE is an international professional group of engineers dedicated to defining standards in film and broadcasting; SMPTE timecode is one of their most prominent standards in use.
Sony Dynamic Digital Sound (SDDS)	Records 7.1 (effectively eight channels) on release prints.
source cue	Music generated from an onscreen source such as a jukebox, phonograph or radio.
spatial resolution	The amount of data needed to capture an image as measured in pixels.
spectrophotometer	Device used to measure reflective and transmission properties of light.
specular pass	CGI AOV render pass used in compositing; a rendering pass isolating specular highlights.
speed ramping	Changing the playback frame rate of filmed material in the middle of a given shot to achieve an artistic effect (see also **time warp**).
squawk box	Basic amplifier with volume controls connected to a magnetic reader; used for playback of sound elements.
stabilization	Stabilization software can sometimes reduce or eliminate unwanted motion in the frame.

standard definition (SD)	A television-based standard for resolution consisting of 576 interlaced lines in the European region, and 480 interlaced lines in North America.
standard RGB (sRGB)	Default color space for computer displays.
standards conversion	Conversion of one television signal to another, such as NTSC 525 lines/60Hz to PAL 625 lines/50Hz.
Steadicam	A wearable rig that isolates the camera's movement from that of the operator, resulting in ultra-smooth camera motion.
stems	Component parts of a soundtrack such as dialogue, music and sound effects (DME). By maintaining separate stems, changes to one element do not affect the other.
stereoscopy	The technique of capturing two separate, side-by-side images which, when played back and interpolated properly, create the illusion of enhanced depth of field and separation of foreground, middle ground and background elements.
stop (F stop)	A unit of measurement that denotes the amount of light being captured. One stop above the F stop being captured at results in twice as much light. One stop below equals half as much.
stop-motion animation	Method of animating dolls, clay or other medium by photographing them one frame at a time; painstaking approach of creating animation using live action.
Storage Attached Network (SAN)	Large, high-speed storage volumes shared between multiple computer systems. Typically, data is transmitted over fiber channel.
storyboard	Scene as represented by a drawing or series of still frames; useful in shot planning, budgeting and scheduling (see also **animatics**).
Super 16mm	Format that features perforations on only one side; added room allows for a wider frame to approximate the aspect ratios for 35mm and HDTV.
Super 35mm (S35) sensor	A sensor optimized for film production and designed for use with lenses pre-fitted to 35mm film cameras; approximates the Super 35mm frame, which is a film standard.
switch	Network switches are small hardware devices used to connect multiple computers within a local area network (LAN) (see also **SAN**).
SxS card	Solid state flash memory; used in camera systems to capture media.
telecine	Film to videotape transfer, sometimes referred to as a "film chain."
temporal resolution	The ability of cameras to capture an image at a given frame rate; 24 fps, 48 fps and 60 fps are the most common. High-speed cameras are capable of rates as high as 300 fps.
Thunderbolt	Newer generation of input/output (I/O) technology used to connect via daisy chain to multiple high-performance devices including storage and displays.
THX	High-quality playback systems designed for movie theaters and in the home; company founded in 1983 by George Lucas and ILM, currently owned by Creative Labs.

time warp	Change to the rate of playback of a clip causing the action to speed up or slow down, sometimes in variable degrees, including freeze frames (see also **frames per second/frame rate**).
timecode	Address of each individual frame located in a clip or sequence as measured in hours: minutes: seconds: frames (see also **frames per second**).
timing lights	See **printer lights**.
timing list	Set of numbers created at the lab used for final color grading (see also **printer lights**).
tracking marker	Visual cues (such as tape) placed in a scene to help visual effects artists measure movement and objects.
transcode	Conversion of one codec to a different codec.
trap focus	Camera feature which delays releasing the shutter until the object is in focus.
trim pass	Term frequently applied to color grading; after a global set of values have been applied, a trim pass is necessary to adjust colors to specific target media such as TV or Blu-Ray.
trims/outs	Unused part of the film; extra material.
UHDTV	UHDTV is the successor to HDTV (see also **Rec. 2020**). It is not the same as 4K but represents a significant increase in resolution.
uninterrupted power supply (UPS)	Editing and data management gear require clean uninterrupted power. The UPS is a large battery back-up that eliminates power spikes and provides a short-term solution in case of a power outage.
union scale (pay rate)	Baseline payments to union crew; overtime is factored on hours which exceed the weekly guarantee.
up-conversion/ up-res	Also known as "up-scaling", it is the process of converting an image from a lower resolution to a higher resolution.
user tagging	See **metadata**.
vanity pass/ beauty work	Visual effects techniques used to improve the cosmetic and physical appearance of actors.
vectorscope	Displays color information as an X–Y pattern; used in measuring a video signal.
velocity pass	CGI AOV render pass used in compositing; provides velocity information for each pixel in the rendered scene. This is useful for accurately simulating motion blur during compositing.
Vertical Helical Scan (VHS)	Consumer grade videotape format (see also **Betamax**).
VFX plate	Also known as background plate or placeholder; shot intended to be composited with other elements as part of a visual effect.
video graphics array (VGA)	Analog signal between computers and monitors; predecessor to the DVI format.
video tape recorder (VTR)	Linear videotape is moved past a magnetic recording head to record/ playback sound and picture.

virtual private network (VPN)	Method of extending private secure networks to users outside the physical network. Remote users can access a company's intranet while away from the office.
Vistavision	Proprietary film format developed at Paramount Studios in 1954. Notable for using spherical lenses to expose 35mm film, but having the film run through the camera left to right rather than top to bottom, adding more surface area to the exposable image. This resulted in finer-grained negatives.
walla	Crowd background sounds recreated by a group of actors in a recording studio (see also **loop group**).
watermarking	Visual tagging or marks placed in an image to identify the user or owner of the material; security feature intended to discourage piracy.
waveform	Graphical representation of luma or brightness, used in telecine, color correction and video production (see also **vectorscope**).
wet-gate printing/ scanning	Liquid is washed over the negative during printing or scanning, reducing or eliminating scratches in the emulsion.
white balance	Designates what perceptual color the encoded white in an image corresponds to. As a result of what temp is set as the white point, other colors will have an impact relative to this point – e.g., if the white point is set near tungsten (3200 Kelvin), cool colors (6500 Kelvin) will appear even bluer than normal. Conversely, if setting the white point closer to 6500 Kelvin, warm tones will appear even more orange than normal.
wild lines	Lines of scripted dialog recorded off-set or when the cameras are not rolling. Location mixers will ask to record wild lines for "protection" in cases where there may be excessive noise during shooting.
work print	Positive print struck from the negative for use in editorial and suitable for projection.
workflow	The orderly sequence of events or steps in a process by which film, video and sound elements are handled from initial capture to completion.
X'Y'Z' TIFF	File format used in the creation of the DCP; contained in the intermediate step known as the Digital Cinema Distribution Master (DCDM) (see also **XYZ**).
XAVC	Recording format introduced by Sony supporting up to 4K of resolution (see **H.264**).
XYZ model	XYZ is a wide gamut color system designed to encode all possible color perceptions.
YCM (yellow, cyan, magenta) separation master	Black-and-white film negative exposed in three separate passes containing all the color information necessary to recreate the film title sometime in the indefinite future.
YUV model	Color space defined by one luma (Y) and two chroma (U, V) components originally designed as an efficient method of analog color TV broadcast. The digital equivalent is YCb'Cr'.
zebra	Zebra patterned displays are a camera feature used to warn operators that images are being overexposed.

Useful Links and Resources

Creative/Branding/Trailers

Acme: www.acmetrailerco.com
Ant Farm: www.theantfarm.net
Aspect Ratio: www.aspectratio.com
Buddha Jones: www.buddhajonestrailers.com
Fresh Cut Creative: www.freshcutcreative.com
Ignition Creative: www.ignitioncreative.net
Imaginary Forces: www.imaginaryforces.com
Method: www.methodstudios.com
mOcean: www.mocean.tv
Mob Scene: www.mobscene.com
Open Road Media: www.openroadmedia.com
Trailer Park: www.trailerpark.com
Wink Creative: www.winkcreative.com

Blogs

2-Pop: www.creativeplanetnetwork.com
ACE Members Tech Web Discussion: www.ace-filmeditors.blogspot.com
Art of the Guillotine: www.aotg.com
John August: www.johnaugust.com
FCP.co: www.fcp.co
Philip Hodgetts: www.philiphodgetts.com
Norman Hollyn: www.normanhollyn.com
Larry Jordan: www.larryjordan.biz
LA Post-Production Users Group: www.lappg.com
Michael Miller, A.C.E.: www.filmmakersdiary.blogspot.com
Bruce Nazarian: www.thedigitalguy.com
Oliver Peters: www.digitalfilms.wordpress.com
Pro Video Coalition: www.provideocoalition.com
Shane Ross: www.lfhd.net
Ken Stone: www.kenstone.net

Professional Organizations and Associations

ACE (American Cinema Editors): www.ace-filmeditors.org
AMPAS (Academy of Motion Picture Arts and Sciences): www.oscars.org
ATAS (Academy of Television Arts & Sciences): www.emmys.org
ASC (American Society of Cinematographers): www.theasc.com
BAFTA (British Academy of Film Arts): www.bafta.org

CES (Consumer Electronics Show): www.cesweb.org
CAS (Cinema Audio Society): www.cinemaaudiosociety.org
CinemaCon (formerly Showest): www.cinemacon.com
DCI (Digital Cinema Initiative): http://dcimovies.com
DCS (Digital Cinema Society): www.digitalcinemasociety.org
HPA (Hollywood Post Alliance): www.hpaonline.com
MPAA (Motion Picture Association of America): www.mpaa.org
MPEG (Motion Picture Editors Guild): www.editorsguild.com
MPSE (Motion Picture Sound Editors): www.mpse.org
NAB (National Association of Broadcasters): www.nabshow.com
SMPTE (Society of Motion Picture & Television Engineers): www.smpte.org
UFVA (University Film & Video Association): www.ufva.org
VES (Visual Effects Society): www.visualeffectssociety.com

Trade / Publications

American Cinematographer: www.ascmag.com
Cinema Editor: www.cinemaeditormagazine.com
Hollywood Reporter: www.hollywoodreporter.com
Streaming Media: www.streamingmedia.com
Variety: www.variety.com
Videomaker: www.videomaker.com

Training

FMC: www.fmctraining.com
Steve Martin: www.rippletraining.com
J & R Moviola: www.moviola.com
Lynda Training: www.lynda.com
Diana Weynand: www.revuptransmedia.com
Video Symphony: www.videosymphony.com

User Groups

Avid-L mailing list: www.groups.yahoo.com/neo/groups/Avid-L2/info
Creative Cow: www.creativecow.net
Final Cut Pro-L mailing list: www.groups.yahoo.com/neo/groups/FinalCutPro-L/info
LA Creative Pro User Group: www.lafcpug.org
RED User: www.reduser.net

Vendors and Labs

Adobe: www.adobe.com
Apple: www.apple.com
Aja: www.aja.com

Arri Cameras: www.arri.com
Autodesk: www.autodesk.com
Avid: www.avid.com
Blackmagic Design: www.blackmagicdesign.com
Deluxe: www.deluxe.com
Drobo: www.drobo.com
Duart: www.duart.com
Fotokem: www.fotokem.com
GoPro: www.gopro.com
Kodak: www.kodak.com
Lattice: www.lut.biz
LightIron: www.lightirondigital.com
Lightworks: www.lwks.com
Matrox: www.matrox.com
Panasonic: www.panasonic.com
Panavision: www.panavision.com
RED: www.red.com
Sony: www.sony.com
Technicolor: www.technicolor.com

Visual Effects Companies

Animal Logic: www.animallogic.com
Cinesite: www.cinesite.com
D Neg (Double Negative): www.dneg.co.uk
Digital Domain: www.digitaldomain.com
The Embassy: www.theembassyvfx.com
Framestore: www.framestore.com
Industrial Light & Magic: www.ilm.com
Lola VFX: www.lolavfx.com
Method Studios: www.methodstudios.com
The Mill: www.themill.com
Molinaire: www.molinare.co.uk
MPC (Moving Picture Company): www.moving-picture.com
Prime Focus: www.primefocusworld.com
Rhythm & Hues: www.rhythm.com
The Senate: www.senatevfx.com
Smoke & Mirrors: www.smoke-mirrors.com
Sony Pictures Image Works: www.imageworks.com
Stargate Studios: www.stargatestudios.net
Weta Digital: www.wetafx.co.nz
Zoic Studios: www.zoicstudios.com

Bibliography

Benedetti, Robert et al. *Creative Post-Production: Editing, Sound, Visual Effects, and Music for Film and Video* (New York, NY: Pearson, 2004)

Browne, Steven E. *High Definition Post-Production: Editing and Delivering HD Video* (New York, NY: Focal, 2007)

Burum, Stephen H. (ed.) *American Cinematographer Manual*, 9th edition (Hollywood, CA: ASC, 2004)

Cianci, Philip J. *High Definition Television: The Creation, Development and Implementation of HDTV Technology* (London: McFarland, 2012)

Clark, Barbara and Susan Spohr. *Guide to Post-Production for TV and Film: Managing the Process*, 2nd edition (New York, NY: Focal, 2002)

Cleve, Bastian. *Film Production Management*, 3rd edition (New York, NY: Focal, 2006)

Coleman, Lori Jane and Diana Friedberg. *Make the Cut: A Guide to Becoming a Successful Assistant Editor in Film and TV* (New York, NY: Focal, 2010)

Duval, Gilles and Severine Wemaere. *A Trip to the Moon: Back in Color* (Promotional Book) Groupama Gan Foundation for Cinema and Technicolor Foundation for Cinema Heritage (Paris, 2011)

Finance, Charles and Susan Zwerman. *The Visual Effects Producer: Understanding the Art and Business of VFX* (New York, NY: Focal, 2010)

Hollyn, Norman. *The Film Editing Room Handbook: How to Tame the Chaos of the Editing Room*, 4th edition (Berkeley, CA: Peachpit, 2010)

Hurbis-Cherrier, Mick. *Voice and Vision: A Creative Approach to Narrative Film and DV Production*, 2nd edition (New York, NY: Focal, 2012)

James, Jack. *Digital Intermediates for Film and Video* (New York, NY: Focal, 2006)

James, Jack. *Fix It in Post: Solutions for Post-Production Problems* (New York, NY: Focal, 2009)

Kirsner, Scott. *Inventing the Movies: Hollywood's Epic Battle between Innovation and the Status Quo, from Thomas Edison to Steve Jobs* (Boston, MA: CinemaTech 2008)

Lancaster, Kurt. *DSLR Cinema: Creating the Film Look with Video* (New York, NY: Focal, 2011)

Levin, Melinda C. and Fred P. Watkins. *Post: The Theory and Technique of Digital Nonlinear Motion Picture Editing* (Boston, MA: Pearson, 2003)

Okun, Jeffrey A. and Susan Zwerman. *The VES Handbook of Visual Effects: Industry Standard VFX Practices and Procedures* (New York, NY: Focal, 2010)

Pincus, Edward and Steven Ascher. *The Filmmaker's Handbook: A Comprehensive Guide for the Digital Age*, 3rd edition (New York, NY: Penguin, 2007)

Purcell, John. *Dialogue Editing for Motion Pictures: A Guide to the Invisible Art* (New York, NY: Focal, 2007)

Rose, Jay. *Audio Post-Production for Film and Video*, 2nd edition (New York, NY: Focal, 2009)

Rubin, Michael. *Nonlinear: A Field Guide to Digital Video and Film Editing*, 4th edition (Gainesville, FL: Triad, 2000)

Tomlinson, Holman. *Sound for Film and Television*, 3rd edition (New York, NY: Focal, 2010)

Walter, Ernest. *The Technique of the Film Cutting Room* (New York, NY: Focal, 1969)

Wheeler, Paul. *High Definition and 24P Cinematography*, 3rd edition (New York, NY: Focal, 2009)

Wyatt, Hilary and Tim Amyes. *Audio Post-Production for Television and Film: An Introduction to Technology and Techniques*, 3rd edition (New York, NY: Focal, 2005)

Yewdall, David L. *Practical Art of Motion Picture Sound*, 4th edition (New York, NY: Focal, 2012)

Appendix

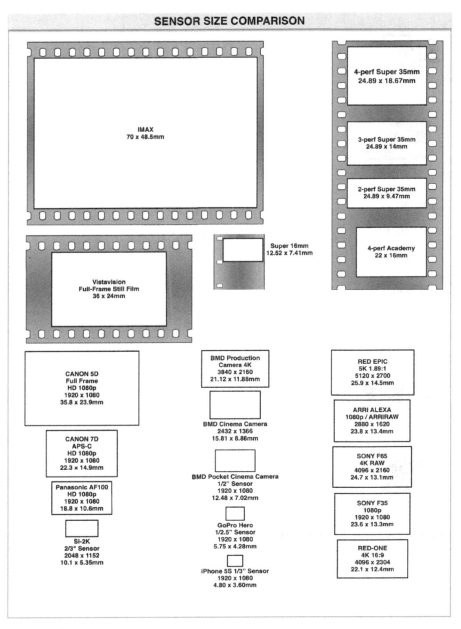

SENSOR SIZE COMPARISON

IMAX
70 x 48.5mm

4-perf Super 35mm
24.89 x 18.67mm

3-perf Super 35mm
24.89 x 14mm

2-perf Super 35mm
24.89 x 9.47mm

Super 16mm
12.52 x 7.41mm

4-perf Academy
22 x 16mm

Vistavision
Full-Frame Still Film
36 x 24mm

CANON 5D
Full Frame
HD 1080p
1920 x 1080
35.8 x 23.9mm

BMD Production
Camera 4K
3840 x 2160
21.12 x 11.88mm

RED EPIC
5K 1.89:1
5120 x 2700
25.9 x 14.5mm

BMD Cinema Camera
2432 x 1366
15.81 x 8.88mm

ARRI ALEXA
1080p / ARRIRAW
2880 x 1620
23.8 x 13.4mm

CANON 7D
APS-C
HD 1080p
1920 x 1080
22.3 x 14.9mm

SONY F65
4K RAW
4096 x 2160
24.7 x 13.1mm

Panasonic AF100
HD 1080p
1920 x 1080
18.8 x 10.6mm

BMD Pocket Cinema Camera
1/2" Sensor
1920 x 1080
12.48 x 7.02mm

SONY F35
1080p
1920 x 1080
23.6 x 13.3mm

SI-2K
2/3" Sensor
2048 x 1152
10.1 x 5.35mm

GoPro Hero
1/2.5" Sensor
1920 x 1080
5.75 x 4.28mm

RED-ONE
4K 16:9
4096 x 2304
22.1 x 12.4mm

iPhone 5S 1/3" Sensor
1920 x 1080
4.80 x 3.60mm

FIGURE 10.1

Sensor size comparison

UNDERSTANDING REEL IDs

CAMERA	FILE NAME	REEL ID

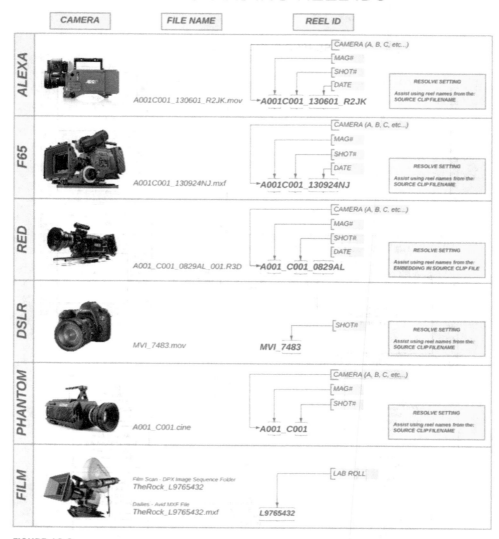

ALEXA

A001C001_130601_R2JK.mov → A001C001_130601_R2JK

- CAMERA (A, B, C, etc...)
- MAG#
- SHOT#
- DATE

RESOLVE SETTING
Assist using reel names from the: SOURCE CLIP FILENAME

F65

A001C001_130924NJ.mxf → A001C001_130924NJ

- CAMERA (A, B, C, etc...)
- MAG#
- SHOT#
- DATE

RESOLVE SETTING
Assist using reel names from the: SOURCE CLIP FILENAME

RED

A001_C001_0829AL_001.R3D → A001_C001_0829AL

- CAMERA (A, B, C, etc...)
- MAG#
- SHOT#
- DATE

RESOLVE SETTING
Assist using reel names from the: EMBEDDING IN SOURCE CLIP FILE

DSLR

MVI_7483.mov → MVI_7483

- SHOT#

RESOLVE SETTING
Assist using reel names from the: SOURCE CLIP FILENAME

PHANTOM

A001_C001.cine → A001_C001

- CAMERA (A, B, C, etc...)
- MAG#
- SHOT#

RESOLVE SETTING
Assist using reel names from the: SOURCE CLIP FILENAME

FILM

Film Scan - DPX Image Sequence Folder
TheRock_L9765432

Dailies - Avid MXF File
TheRock_L9765432.mxf → L9765432

- LAB ROLL

FIGURE 10.2

Understanding REEL IDs Chart by Justin Lutsky

HOW TO READ AN EDL
(EDIT DECISION LIST)

TITLE: THE ROCK
FCM: NON-DROP FRAME

EVENT #	REEL ID		EDIT TYPE		SOURCE START TC	SOURCE END TC	RECORD START TC	RECORD END TC
000001	B004C008_130812_R2JK	V	C		07:26:22:12	07:26:24:03	00:59:56:00	00:59:57:15
000002	B004C014_130812_R2JK	V	C		07:38:20:04	07:38:21:11	00:59:57:15	00:59:58:22
000003	B004C014_130812_R2JK	V	C		07:38:21:11	07:38:21:11	00:59:58:22	00:59:58:22
000003	AX	V	D	004	08:49:33:07	08:49:33:11	00:59:58:22	00:59:59:02
000004	B005C007_130812_R2JK	V	C		08:49:33:11	08:49:34:16	00:59:59:02	01:00:00:07
000005	B006C001_130812_R2JK	V	C		10:01:11:20	10:01:12:19	01:00:00:07	01:00:01:06
000006	B005C012_130812_R2JK	V	C		09:25:59:15	09:25:59:16	01:00:01:06	01:00:02:14
M2	B005C012_130812_R2JK			-036.0	09:25:59:15			
000007	B005C007_130812_R2JK	V	C		08:49:39:14	08:49:40:01	01:00:02:14	01:00:03:01
000008	B006C015_130812_R2JK	V	C		10:40:52:13	10:40:53:01	01:00:03:01	01:00:03:13
000009	B006C016_130812_R2JK	V	C		10:43:39:17	10:43:40:21	01:00:03:13	01:00:04:17
000010	B005C003_130812_R2JK	V	C		08:19:40:08	08:19:43:23	01:00:04:17	01:00:08:08
000011	B002C005_130811_R2JK	V	C		02:30:30:11	02:30:32:00	01:00:08:08	01:00:09:21
000012	B002C028_130811_R2JK	V	C		04:37:16:04	04:37:17:13	01:00:09:21	01:00:11:06
000013	B002C014_130811_R2JK	V	C		03:54:07:13	03:54:09:00	01:00:11:06	01:00:12:17
000014	B002C032_130811_R2JK	V	C		04:48:58:03	04:48:58:21	01:00:12:17	01:00:13:11
000015	B002C021_130811_R2JK	V	C		04:18:01:17	04:18:02:13	01:00:13:11	01:00:14:07
000016	B003C009_130811_R2JK	V	C		02:09:42:05	02:09:43:04	01:00:14:07	01:00:15:06
000017	B003C023_130811_R2JK	V	C		03:49:20:11	03:49:22:07	01:00:15:06	01:00:17:02
000018	B003C016_130811_R2JK	V	C		02:53:55:10	02:53:58:15	01:00:17:02	01:00:19:04
M2	B003C016_130811_R2JK			036.0	02:53:55:10			
000019	B003C016_130811_R2JK	V	C		02:53:58:13	02:53:58:13	01:00:19:04	01:00:19:04
000019	AX	V	D	002	01:00:00:00	01:00:00:02	01:00:19:04	01:00:19:06
M2	B003C016_130811_R2JK			036.0	02:53:58:13			
000020	AX	V	C		01:00:00:00	01:00:00:00	01:00:19:06	01:00:19:06
000020	B006C016_130812_R2JK	V	D	002	10:43:44:09	10:43:44:11	01:00:19:06	01:00:19:08
000021	B006C016_130812_R2JK	V	C		10:43:44:11	10:43:44:14	01:00:19:08	01:00:19:11
000022	B006C015_130812_R2JK	V	C		10:40:54:20	10:40:55:05	01:00:19:11	01:00:19:20
000023	B007C001_130812_R2JK	V	C		04:52:18:18	04:52:20:13	01:00:19:20	01:00:20:10
M2	B007C001_130812_R2JK			072.0	04:52:18:18			
000024	B007C001_130812_R2JK	V	C		04:52:20:12	04:52:22:16	01:00:20:10	01:00:21:03
M2	B007C001_130812_R2JK			072.0	04:52:20:12			
000025	B006C016_130812_R2JK	V	C		10:43:46:17	10:43:47:11	01:00:21:03	01:00:21:21
000026	B006C003_130812_R2JK	V	C		10:06:53:23	10:06:55:14	01:00:21:21	01:00:23:12
000027	B006C012_130812_R2JK	V	C		10:21:01:07	10:21:04:00	01:00:23:12	01:00:26:05

THE REEL ID IS THE MOST CRUCIAL PIECE OF INFORMATION. IT IDENTIFIES THE SPECIFIC PIECE OF MEDIA BEING REFERENCED. MISSING OR INCORRECT REEL IDS ARE THE MOST COMMON PROBLEM FOUND IN BAD EDLS.

C = CUT
D = DISSOLVE

SOURCE TIMECODE IDENTIFIES THE SPECIFIC FRAMES BEING USED FROM THE MEDIA REFERENCED BY THE REEL ID.

RECORD TIMECODE INDENTIFIES THE SPECIFIC LOCATION WITHIN THE OVERALL TIMELINE WHERE THE REFERENCED SOURCE MEDIA IS PLACED.

FIGURE 10.3

How to read an EDL Chart by Justin Lutsky

EDIT DECISION LIST SYNTAX

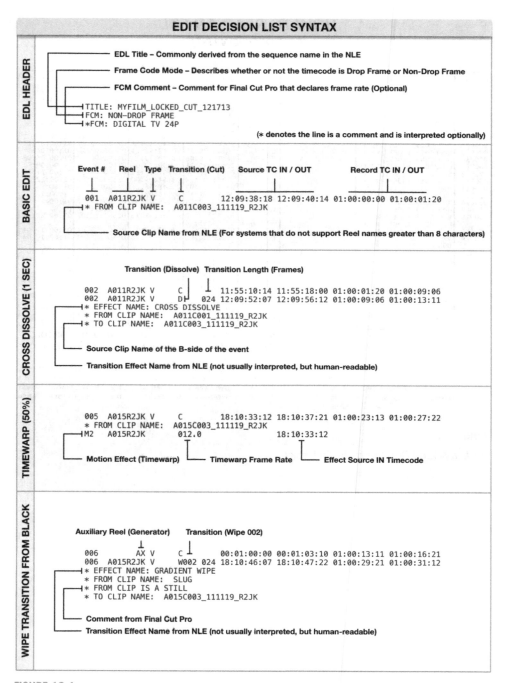

EDL HEADER

EDL Title – Commonly derived from the sequence name in the NLE

Frame Code Mode – Describes whether or not the timecode is Drop Frame or Non-Drop Frame

FCM Comment – Comment for Final Cut Pro that declares frame rate (Optional)

```
TITLE: MYFILM_LOCKED_CUT_121713
FCM: NON-DROP FRAME
*FCM: DIGITAL TV 24P
```

(* denotes the line is a comment and is interpreted optionally)

BASIC EDIT

Event # Reel Type Transition (Cut) Source TC IN / OUT Record TC IN / OUT

```
001   A011R2JK V      C        12:09:38:18 12:09:40:14 01:00:00:00 01:00:01:20
* FROM CLIP NAME:   A011C003_111119_R2JK
```

Source Clip Name from NLE (For systems that do not support Reel names greater than 8 characters)

CROSS DISSOLVE (1 SEC)

Transition (Dissolve) Transition Length (Frames)

```
002   A011R2JK V      C        11:55:10:14 11:55:18:00 01:00:01:20 01:00:09:06
002   A011R2JK V      D  024   12:09:52:07 12:09:56:12 01:00:09:06 01:00:13:11
* EFFECT NAME: CROSS DISSOLVE
* FROM CLIP NAME:   A011C001_111119_R2JK
* TO CLIP NAME:   A011C003_111119_R2JK
```

Source Clip Name of the B-side of the event

Transition Effect Name from NLE (not usually interpreted, but human-readable)

TIMEWARP (50%)

```
005   A015R2JK V      C        18:10:33:12 18:10:37:21 01:00:23:13 01:00:27:22
* FROM CLIP NAME:   A015C003_111119_R2JK
M2   A015R2JK        012.0                  18:10:33:12
```

Motion Effect (Timewarp) Timewarp Frame Rate Effect Source IN Timecode

WIPE TRANSITION FROM BLACK

Auxiliary Reel (Generator) Transition (Wipe 002)

```
006      AX V      C         00:01:00:00 00:01:03:10 01:00:13:11 01:00:16:21
006   A015R2JK V   W002 024  18:10:46:07 18:10:47:22 01:00:29:21 01:00:31:12
* EFFECT NAME: GRADIENT WIPE
* FROM CLIP NAME:   SLUG
* FROM CLIP IS A STILL
* TO CLIP NAME:   A015C003_111119_R2JK
```

Comment from Final Cut Pro

Transition Effect Name from NLE (not usually interpreted, but human-readable)

FIGURE 10.4

EDL syntax

Log Vs. Linear Encoding

Today's high-end cameras and workstations are able to capture and manipulate images featuring greater bit depth with 10-, 12-, 16- and even 32-bit files. This represents value encoding and dynamic range on a scale not previously seen, as computers used to be limited to 8-bit or a range of only 256 values for each RGB (red, green, blue) color channel. By comparison, a 10-bit file features 1024 values per color channel. This offers an enormous increase in the level of precision that can be captured and maintained. Even greater dynamic range can be achieved when recording in "logarithmic color space."

The real world of color and light features a very high dynamic range. In order to encode high-dynamic range data effectively in an integer format (opposed to a floating-point format), an alternative to linear encoding is necessary. Logarithmic encoding enjoys the high-dynamic range of floating-point encoding without the storage impact.

Logarithmic encoding is frequently used in film production because it more accurately represents light captured on film and mimics its nonlinear nature. Cineon log encoding was originally developed by Kodak as a representation of actual densities on a film negative in order to scan film to a digital file effectively and print it back to film in a digital intermediate. While film may no longer be an option in terms of acquisition media, recording in log with Digital Cinema cameras remains a preferred choice among filmmakers. Log files allow for greater flexibility during color grading since more information is retained in the light and dark portions of the image. Film (which is logarithmic in nature) and digital log formats are noticeably better in capturing and maintaining shadow and highlight detail that is otherwise lost in traditional video capture.

Even cameras shooting in RAW formats (Alexa, RED, Sony F65, etc.) are most commonly debayered to a flavor of logarithmic encoding in an integer file format (commonly DPX) for color grading and visual effects. Many manufacturers have made their own custom log curves to optimize the encoding and preserve the dynamic range of their camera, hence Arri's LogC, Sony's S-log and Canon's C-log.

Chroma Sub-Sampling

Engineers rely on a methodology known as chroma sub-sampling to save on the amount of data needed to reproduce color images. They determined that the human eye is more sensitive to changes in luminance (brightness and contrast) than it is to changes in chrominance (color information). When luma and chroma are combined, the reduction (compression) of the amount of chroma information does not perceptibly degrade the image.

Most video codecs employ some level of chroma sub-sampling. The components of a digital video signal are Y'CbCr with Y' representing the luma values and Cb and Cr representing the color difference values. The amount of compression is expressed as a series of numbers such as 4:2:0 or 4:2:2 or 4:4:4. The numbers represents how many pixels are used to sample luma (Y') and those used to sample chroma (Cb, Cr) across a range of pixels.

FIGURE 10.5A

4:2:0 – common to many codecs such as HDV, AVCHD and MPEG and used in DSLR cameras, as well as DVD and Blu-Ray; in this sampling scheme the chroma information is reduced by as much as 25 percent

FIGURE 10.5B

4:2:2 – this sampling scheme reduces the chroma information by 50 percent and is found in codecs such as DigiBeta, Apple ProRes, XDCAM and Avid DNxHD

FIGURE 10.5C

4:4:4 – offering the highest quality with no sub-sampling as each pixel is represented with full luma and chroma values

While economy of file size helps in storage and data transmission, chroma sub-sampling becomes an issue when doing chroma-key and creating CG composites. Artists may find it difficult if not impossible to pull a clean key using green screen. It also presents significant challenges during color grading, often resulting in artifacts and color banding. Projects that are intended to undergo full color correction and those with numerous visual effects will elect to work with footage with the least amount of chroma sub-sampling.

DAILIES REPORT

Savage Dawn

Project Title: NA

Production Company: NA

Shoot Date:

Shoot Day #:

Transfer Date: 20120917

Distribution: NA

TRANSFER REPORT

Magazines/Cards/LabRolls: A001R2YV • A002R2YV • A003R2YV • A004R2YV • A005R2YV • A006R2YV • A007R2YV • A008R2YV • A009R2YV • A010R2YV • A011R2YV • A012R2YV • A013R2YV • A014R2YV • A015R2YV • B001R1S0 • B002R1S0 • B003R1S0 • B004R1S0 • B005R1S0 • B006R1S0 • B007R1S0 • B008R1S0 • B009R1S0 • B010R1S0 • B011R1S0 • B012R1S0 • B013R1S0 • B014R1S0 • B015R1S0 • C001 • C001R2YE • C002R2YE • C003R2YE • C004R2YE • C005R2YE • C006R2YE • C007R2YE • C008R2YE • C009R2YE • C010R2YE

Total Number of Clips: 160

QC operator: NA

Detected flaws: Camera rolled after slate, Camera cut in middle of take, Mixer talks over clap, MISTAKE, Slated before camera speed, TAIL SLATE, C001 instead of C004, IGNORE!, Mistake after cut, Camera cut and resumed mid take, C004 instead of C001

Total Running Time: 590 min 51 sec

Delivered Format: NA

For a list of detected flaws and a complete list of transferred takes please see more detailed information on the following pages. □

FIGURE 10.6

Transfer report

DETAILED QC REPORT / SCENE AND TAKE OVERVIEW / SHOOTING DAY:

Project Title: NA

Production Company: NA

Mag/Card	CamRoll	Scene	Take	SEL	LUT	DUR	QC	POS	at Timecode	Comments
A004R2YV	A004R2YV	5A	1			03:11:10		ALL	09:45:12:19	Camera cut in middle of take
A005R2YV	A005R2YV	5A	2	•		04:44:19				
A006R2YV	A006R2YV	5C	2	•		03:05:15		ALL	10:28:11:12	Mixer talks over clap
A006R2YV	A006R2YV	5D	1	•		05:30:04				
A006R2YV	A006R2YV	5E	1			03:03:01				
A007R2YV	A007R2YV	5E	2	•		10:39:00				
A008R2YV	A008R2YV	17	1			02:07:10				
A008R2YV	A008R2YV	17	2			03:33:16				
A008R2YV	A008R2YV	17	3			00:01:03		ALL	Entire Shot	MISTAKE
A008R2YV	A008R2YV	17	3			04:06:14				
A008R2YV	A008R2YV	5E	3	•		04:33:20				
A008R2YV	A008R2YV	5F	1	•		02:51:12				
A008R2YV	A008R2YV	5G	1	•		03:51:07				
A008R2YV	A008R2YV	5H	1	•		03:07:13				
A008R2YV	A008R2YV	5J	1	•		01:30:21		ALL	Entire Shot	Slated before camera speed
A011R2YV	A011R2YV					00:32:08		ALL	Entire Shot	MISTAKE

FIGURE 10.7

Cloud-based comparisons

Sound Mixer: **Richard Ragon**
Phone: 949-290-8853 (cell)
Email: soundguy@hanaho.com

SOUND REPORT

Roll # _____
Date __9/16/12__
Page __1__ of __3__

Title: "_kid mclain_" Director: _____ Producer: _____

Recorder: 744T Bits: 24 Sample Freq: 48k Media: Flash File Type: .WAV

Framerate: 23.97 Tone: -20db Metafile Text: _____

Boom Op: Tristan Comments/Instructions:

Scene	Take	ID	SMPTE TC	NOTES	TRACKS 1	2
16	1	N01	: : :	Street / fan, NG, wireless hot.		
	2	N02	: : :	GS		
	3	N03	: : :	GS w/ fan on boom		
	4	N04	: : :	GS		
	5	N05	: : :	GS		
	6	N06	: : :	GS		
16A	1	N07	: : :	GS		
	2	N08	: : :	GS		
	3	N09	: : :	GS		
16B	1	N10	: : :	GS		
	2	N11	: : :	GS		
	3	N12	: : :	plane, plane, GS		
16C	1	N13	: : :	GS		
	2	N14	: : :	plane, GS		
	3	N15	: : :	GS		
16D	1	N16	: : :	NS, GS		
	2	N17	: : :	GS		
16E	1	N18	: : :	GS, TS		
16F	1	N19	: : :	16F ?-1 ? (marked as 18)		
	2	N20	: : :	16F-2 ?		
	3	N21	: : :			
	4	N22	: : :			
	5	N23	: : :			
18A	1	N24	: : :	wind in town		
	2	N25	: : :			
	3	N26	: : :			
	4	N27	: : :			
18B	1	N28	: : :			
	2	N29	: : :			
	3	N30	: : :			

Abbreviations: SS—Second Sticks • HS—Head Slate • TS—Tail Slate • NS—No Slate • IC—Incorrectly Called • DT—Don't Transfer • WT—Wild Track
GS—Good for Sound • NG—No Good for Sound • CN—Camera Noise • GT—Guide Track • BG—Background • WL—Wild Line • FX—Sound F/X

FIGURE 10.8

Sample transfer report

TABLE 10.1

CLOUD BASED COMPARISONS

	Target market	Intended user	view & comment	logging	editing	editing live sources	high end finishing	publishing	hosting of published content	integration with other cloud services for content creation and publishing	archiving	seachable metadata	frame accurate	ability to support 100 000 clips in one project	user learning curve
Adobe Anywhere	Broadcasters	Craft Editor	y	y	y	n	y	y	n	n	n	y	y	n	high
Aframe	Production Companies	Tagger/ Producer	y	live keyword tagging	trim & rough cuts only	n	n	y clips not sequences	n	n	n	n	n	n	minimal
Avid Sphere	Broadcasters and large scale facilities	Craft Editor	n	n	y	n	y	y	n	n	n	Y	y	y	high
FORscene	Broadcasters, News & Sports	Producer/ Editor	y	y	y	y	n	y	y	y	y	Y	y	y	moderate

Additional Comments:

Aframe is optimised for sharing content quickly and easily.

Adobe and Avid offer more high end editing tools

FORscene doesn't require expensive proprietary hardware or software and is scaleable

Aframe and FORscene are quick and easy to learn - Avid and Adobe are more complex

real time chat support & remote control	dedicated codec for editing in the cloud	uses proxy version of material	true cloud-based ???	high speed internet required	opex vs capex	software installation on local machine	enterprise hardware required	approx. setup cost	client vs server processing	mobile app available	overview	Notes	Additional information
n	y but render latency	n	n	y	o & c	y	y	high	server (high latency)	n	Centralized media management and adaptive streaming tools for LAN & WAN users of Adobe software	Creative Cloud subscription required to access software. Only works with Prelude and Premier Pro at moment - After Effects to come - must be installed on machines. Hosted on-premises with other enterprise media storage and asset management infrastructure. Private cloud environment accessed over internet via VPN.	http://wwwimages.adobe.com/www.adobe.com/content/dam/Adobe/en/products/anywhere/pdfs/Adobe%20Anywhere%20whitepaper.pdf
n	n	y	y	n	o	n	n	low	server (high latency)	n	High speed upload, manager and aggregator of content	Cloud based. Not intended for editing or logging. Mainly for viewing and comments with clip trim capability. Publish to websites & share with others.	http://aframe.com/
n	n	y	n	y	o & c	y	y	high	server (high latency)	n	Leverages existing production workflow using Avid software	Requires NewsCutter or Media Composer editing sotware and internet connection to an Interplay Production workgroup. Interplay Sphere con-nects multiple remote editors in a private cloud environment. Connect via wifi or 4G. Proxies of finished edits can precede upload of full resolution media.	http://www.avid.com/US/products/Interplay-Sphere/
y	y	y	y	n	o	n	n	low	client (low latency)	y	Hosted video platform with cloud-based tools for web and mobile.	True cloud based video editing platform with logging, searching, editing, publishing and hosting.	http://www.forscene.co.uk

About the Authors

Scott Arundale is an Assistant Professor at Chapman University, Dodge College of Film and Media Arts located in Orange, California. He received his BFA from New York University in Film Production and an MFA from USC's Peter Stark Program. Scott created a class in Digital Intermediate Workflow, one of the first of its kind to be offered at an American university. He brings to teaching 20 years of experience as editor and producer of filmed entertainment. Scott is an Apple Certified Trainer in Final Cut Pro and Avid Certified Trainer for Media Composer. He is an associate member of the American Cinema Editors (ACE), University of Film and Video Association (UFVA) and the Digital Cinema Society (DCS).

Tashi Trieu was born and raised in Denver, Colorado. He attended Chapman University's Dodge College of Film and Media Arts and received a BFA in Film Production in 2010, with an emphasis in cinematography and digital post-production. He received one of Chapman's highest honors, the Einstein Award, which recognizes the enormous contribution made by students to the film program. Tashi works as a freelance digital intermediate colorist and Smoke/Flame artist. In addition he has served as a digital workflow consultant on commercials and feature films shooting with the RED and SI-2K in Stereo 3D. With a background in visual effects, 3D animation and compositing, Tashi brings a well-rounded approach to new projects, which are consistently pushing the limits of technology.

Permissions

Figure 1.1	reprinted by permission, Bill Nale
Figure 1.2	reprinted by permission, collection of Herb Dow
Figure 1.3	reprinted by permission, collection of Herb Dow
Figure 1.6	reprinted by permission, Wikimedia Commons, GNU Free Documentation License, Version 1.2 image by Rotareneg
Figure 1.7	Rowan & Martin's Laugh-In © 1967–1973 NBC
Figure 1.8	reprinted by permission, with thanks to John Pommon, photo/web design by Irving Greisman, antiquevideo.com
Figure 1.9	reprinted by permission, collection of Herb Dow
Figure 1.10	reprinted by permission, collection of Herb Dow
Figure 1.11	courtesy of Editshare EMEA
Figure 1.12	courtesy of Editshare EMEA
Figure 1.16	© NBC
Figure 2.1	reprinted by permission, Robbie Carman, Amigo Media Llc
Figure 2.2	*Super Mario Brothers* © 1993 Buena Vista Pictures Distribution
Figure 2.3	*O Brother, Where Art Thou?* © 2000 Buena Vista Pictures Distribution
Figure 2.8	*The Hobbit: An Unexpected Journey* © 2012 Warner Brothers
Figure 2.9	courtesy of Hewlett Packard
Figure 2.10	courtesy of Panasonic
Figure 2.11	courtesy of G-Raid
Figure 2.12	courtesy of RED
Figure 2.15	courtesy of Aja
Figure 2.16	courtesy of Panavision
Figure 2.17	reprinted by permission, Oliver Peters
Figure 2.18	reprinted by permission, Oliver Peters
Figure 2.19	reprinted by permission, Oliver Peters
Figure 2.20	reprinted by permission, Oliver Peters
Figure 2.21	reprinted by permission, Oliver Peters
Figure 2.22	reprinted by permission, Foxspring Labs, Inc.
Figure 2.23	reprinted by permission, Foxspring Labs, Inc.
Figure 2.24	reprinted by permission, Foxspring Labs, Inc.
Figure 2.25	reprinted by permission, GNU Free Documentation License, Version 1.2, image by Colin M.L. Burnett
Figure 2.26	*Drive* © 2011 FilmDistrict
Figure 2.27	*Tiny Furniture* © 2011 IFC Films
Figure 2.28	reprinted by permission, *Baby Faced Assassin* © 2014, Jona Frank
Figure 3.6	courtesy of Drobo, Inc.
Figure 3.8	reprinted by permission, Helmut Kobler – http://www.lacameraman.com
Figure 4.1	reprinted by permission, Matt Feury
Figure 4.2	courtesy of Avid Technology, Inc.
Figure 4.3a	http://www.avidblogs.com/wp-content/uploads/2013-12-18_Video-Editing-Shared-Storage-Avid-ISIS-Workspaces.jpg
Figure 4.5	reprinted by permission, Wim Van den Broeck

Figure 4.6	courtesy of Matrox
Figure 4.7	reprinted by permission, John August, http://johnaugust.com/2008/test-screening-questionnaires
Figure 4.8a	reprinted by permission, Forbidden Technologies plc
Figures 4.8b and 4.8c	http://www.avidblogs.com/demystifying-avid-interplay-sphere-central/
Figure 4.9	Music video by Jonas Brothers performing First Time © 2013 Jonas Brothers Recording LLC, under exclusive license to Universal Music International BV
Figure 4.15	courtesy of Colorfront
Figure 4.16	reprinted by permission, Technicolor
Figure 5.1	reprinted by permission, Wikimedia Commons, GNU Free Documentation License, Version 1.2, image by Jorge Stolfi
Figure 5.2	reprinted by permission, Toon Boom Animation Inc.
Figure 5.3	Ugly Betty © 2006 ABC
Figure 5.4	Ugly Betty © 2006 ABC
Figure 5.5	Boardwalk Empire © 2010 HBO
Figure 5.6	reprinted by permission, photo by Chris Pritzlaff
Figure 5.7	reprinted by permission, photo by Chris Pritzlaff
Figure 5.8	courtesy of http://www.vfxshowrunner.com
Figure 6.2	reprinted by permission, The Wolverine © 2013 Twentieth Century Fox; all rights reserved, photo by Bryan Singer
Figure 6.3	reprinted by permission, Dodge College of Film and Media Arts, Chapman University, photo by Tom Bonner ©
Figure 6.5	reprinted by permission, Dodge College of Film and Media Arts, Chapman University, photo by Tom Bonner ©
Figure 6.6	courtesy of Sony Pictures Studios, Inc.
Figure 6.7	courtesy of Sony Pictures Studios, Inc.
Figure 7.1	reprinted by permission, Wings © 1927 Paramount Pictures Corporation; all rights reserved
Figure 7.2	My Three Sons © 1965 MCA Television
Figure 7.3	courtesy of Aja
Figure 7.4	courtesy of Fieldskit: http://www.revisionfx.com/products/fieldskit/overview/
Figure 9.1	Don Jon © 2013 Relativity Media/Voltage Pictures, photo by Daniel Fadden
Figure 9.2	reprinted by permission, Tim's Vermeer © 2013 High Delft Pictures LLC; all rights reserved
Figure 10.2	reprinted by permission, Dodge College of Film and Media Arts, Chapman University, chart by Justin Lutsky
Figure 10.3	reprinted by permission, Dodge College of Film and Media Arts, Chapman University, chart by Justin Lutsky
Figures 10.5a–10.5c,	http://it.wikipedia.org/wiki/File:Chroma_subsampling_ratios.svg
Figure 10.7	reprinted by permission, Richard Ragon, http://www.soundguy.com

Index